Für Johanna

Mar 1
10/2022

Profit over Peace in Western Sahara

How commercial interests undermine self-determination in the last colony in Africa

Erik Hagen Mario Pfeifer

Erik Hagen is a board member of Western Sahara Resource Watch and director of the Norwegian Support Committee for Western Sahara. He has followed the issue of the plundering of Western Sahara's resources since 2002, as both an investigative journalist and a civil society activist.

Mario Pfeifer is a visual artist and film-maker based in Berlin, Germany. Since 2011 he has travelled numerous times to the Moroccan-occupied territories, the liberated territories of the Western Sahara under the control of Polisario, and the refugee camps in south-western Algeria.

Jeffrey J. Smith is a law professor in the Norman Paterson School of International Affairs, Ottawa. He was previously counsel to the United Nations in East Timor (Timor-Leste) during that country's transition from colonial occupation to independence. He researches and writes about Western Sahara in international law, including the creation of the Sahrawi state, territorial issues, and environmental protection matters.

Preface

On a clear day, when you stand on the highest peaks of the Canary Islands, you should be able to see the territory of Western Sahara on the horizon. Africa is close to Europe, yet not many of the 13 million tourists who visit the Canaries every year have heard about the human rights abuses and the grave injustice taking place across the water from them.

Western Sahara is the last European colony in Africa. The daily injustice in the territory is maintained by EU taxpayers. This book is about that EU involvement and how corporate companies support a forgotten occupation.

The territory, which is larger than the UK, is still considered by the United Nations to be awaiting decolonization. It used to be a part of Spain, but the Spanish government never bothered to decolonize it properly. Instead, the collapsing Franco regime dumped it into the hands of a neighbouring Morocco in the mid-70s.

So far, more than a hundred UN resolutions have called for the territory's right to self-determination to be respected. The

Sahrawi people want to manage its fish stocks, to decide what national anthem to sing, and to build their own houses on their own land.

But the Sahrawis are prevented from enjoying that right. Half its people have fled, and over four decades later, they still live in tents and sun-dried clay houses, dependent on humanitarian aid. The refugees' endlessly temporary home is located on a flat desert landscape near the Algerian city of Tindouf, in unimaginably brutal climatic conditions. In the summer, the temperature rises above 50 degrees. Water is scarce and nearly all the youth are unemployed. More than 100,000 people live in these refugee camps waiting to return. From their Facebook accounts, they follow the news of the human rights violations committed against their cousins in the towns in occupied Western Sahara from which their parents once fled.

An occupying Morocco has deployed hundreds of thousands of soldiers in Western Sahara and convicts leading activists to a lifetime in jail. Its ministries sign deals

with European and international companies for its resources: for the purchase of phosphate rock, for unsustainable industrial farming, or to increase Morocco's production of energy. Off the coast, Iberian vessels are seen operating. This happens every day against the will of the Sahrawis and with total disregard for basic principles of international law.

The UN's efforts to resolve the conflict are at an impasse. In 1991, the two parties to the conflict, Morocco and the national liberation movement Polisario Front, agreed on a referendum on independence. But just when a UN mission in Western Sahara had completed the voters' list, Morocco objected to the very idea of a referendum. Since 2012, Morocco has not even wanted to take part in the UN-sponsored peace negotiations. And why would Morocco really bother to show up at such talks?

Morocco has an old ally that supports it in all matters: France. As a permanent member of the UN Security Council, France has effectively hindered both the referendum process and prevented the UN opera-

tion in the territory from monitoring human rights abuses. France also bullies the other EU member states and the European Commission to adopt pro-Moroccan positions. With the current US administration, little pressure can be expected from Washington. But the issue is not really one of the US's making – the problem lies in Paris.

Since late 2017, former German President Horst Köhler has been assigned as UN Special Envoy to Western Sahara, appointed by the Security Council to make "the parties" return to the negotiating table. Several special envoys tried before him, but they never got the necessary backing from the Security Council. Will a former German president be able to create new momentum and break through the French-Moroccan blockade of the process?

Köhler comes from a country where knowledge of the conflict is limited. Only on rare occasions does the occupation reach the attention of the German national media. Germany has deployed personnel to the UN mission, and the refugee debate in the German parliament has, on occasion,

been intense on the question of whether Morocco is a safe country of origin for refugees to return to. However, Germany is sensitive to the rule of law. Will the government be interested in standing up to French obstructiveness on the issue of human rights and self-determination for the Sahrawis?

This book comes at a special time in Western Sahara's history. In 2012 both Polisario and a civil society group in the UK initiated court cases either in national courts or in the Court of Justice of the European Union (CJEU). The consequences of these processes are far-reaching.

On 23 February 2018, the High Court of South Africa ruled that the valuable 55,000-tonne cargo of phosphate rock on board a vessel detained in Port Elizabeth belongs to the Sahrawi people, thus handing them an extraordinary legal victory. This publication charts the path to this historic victory.

In 2016, the CJEU issued a landmark judgment underlining that the territory of Western Sahara is "distinct and separate"

from Morocco, and that trade agreements signed by Morocco can only apply to Western Sahara if the representatives of Western Sahara have consented to them. The Court stressed that Morocco has not been given any international mandate to administer the territory.

More importantly, on 27 February 2018 – ironically, the national day of the Western Sahara people – the CJEU ruled that the EU-Moroccan fisheries agreement cannot be applied to Western Sahara. Forty years of dirty politics and injustice have ended. The Advocate General of the Court underlined that the territory is under Moroccan occupation, and that international humanitarian law applies.

The developments in the Court have led to total chaos in the EU institutions. Under intense French pressure, the EU is concerned to maintain its good relations with Morocco and to implicitly accept its illegal occupation of Western Sahara. At the time of publication of this book, the EU is being forced by the Court to renegotiate its trade agreements with Rabat.

This book does not go into detail about these legal developments in the EU. What it does do, however, is lay out the context. How far can the European Commission go in allowing itself to undermine the principles of democracy, law, and human rights, in order to appease its occupying neighbour to the south? What is the role of natural resources in this game over Western Sahara?

This publication is a collaboration between a visual artist and film-maker and a campaigner for Western Sahara Resource Watch – it is a compilation of timelines, essays, and conversations around the political and economic aspects of the conflict over Western Sahara.

The essays by Erik Hagen and Canadian lawyer Jeffrey J. Smith consider different approaches to the issue of natural resources in Western Sahara. Hagen looks into the totality and importance of the exploitation of resources in the occupied territory and the story of how the European Commission revealed the true – political – motivation behind the plundering of Western Sahara.

The book lays out the origins of the fisheries agreement that the Advocate General of the CJEU found to be invalid in 2018.

Smith elaborates on how the 2016 judgment of the CJEU led to the extraordinary detention in South Africa of a vessel operated by a German-owned company, a process initiated by the Western Sahara government in a South African court. The matter of national courts is crucial. Companies operating in the territory on invalid Moroccan contracts are increasingly on a weak legal basis, both in international and in national courts.

The publication also aims to shed light on the most important European player currently operating in Western Sahara on a Moroccan contract: Siemens. The German multinational is rapidly connecting the occupied territory to the Moroccan economy through the construction of windmills. The company claims to be operating legally, but it has not obtained the consent of the representatives of the territory, something that EU law and international law require. We welcome you to study how Siemens, in

its own words, attempts to explain its operations on occupied land.

We do hope this publication will help to make the urgency of the conflict more apparent. Our hope is that the publication will also find its way into Arabic-speaking countries – and into the Sahrawi refugee camps – helping to provide intellectual and discursive knowledge.

We hope, most of all, that this little book will be a humble contribution to the people of Western Sahara, as they seek to determine their own destiny by the simple means of a free, democratic vote.

Erik Hagen & Mario Pfeifer

Profit over Peace

[Western Sahara]

Key Facts about Western Sahara

1884–1885
At the Berlin Diplomatic Conference, Spain is recognized as the colonial power of present-day Western Sahara.

1947
Western Sahara's phosphate reserves are discovered in Bou Craa, 130 kilometres south-east of El Aaiún. The discovery of phosphate reserves is the first potential source of mineral revenues for the colonial power.

1963
The UN Special Committee on Decolonization declares Western Sahara a "non-self-governing territory to be decolonized" in accordance with General Assembly resolution 1514 (XV) of 14 Dec. 1960.

1965
The UN General Assembly adopts its first resolution on Western Sahara, requesting Spain to decolonize the territory (General Assembly resolution 2072 [XX] of 17 Dec. 1965).

1966
The UN General Assembly requests Spain to organize, under UN supervision, a referendum on self-determination (General Assembly resolution 2229 [XXI] of 20 Dec. 1966). The demand is repeated each year from 1967 to 1973.

1972
Spain starts to operate the Bou Craa phosphate mine. Many Spaniards find employment in the mines, as do the Sahrawis.

1973
The Frente Popular para la Liberación de Saguia el-Hamra y Río de Oro (Polisario) is founded with the purpose of obtaining independence for Western Sahara from Spain.

1973
The first military operation of Polisario against a Spanish garrison in Western Sahara.

1974
The Spanish census, a prerequisite for the self-determination referendum, registers 73,497 inhabitants in Western Sahara.

1975
A UN investigation commission that had visited Western Sahara finds full support for independence. The International Court of Justice states that the territory belonged to neither Morocco nor Mauritania prior to Spanish colonization, but that the right to self-determination had to apply.

6 November 1975

King Hassan launches the Green March, sending in forces to occupy the territory. Half of the population is forced to flee. The invasion is condemned by the UN Security Council.

14 November 1975

Spain, Mauritania, and Morocco sign the Madrid Accords without consulting the Sahrawis or the United Nations. Spain agrees to cede administrative control of the territory to Morocco and Mauritania, while retaining a 35 per cent share of the Bou Craa mine. No state in the world recognizes the transfer of authority from Spain to the two states.

27–29 January 1976

First battle of Amgala between Moroccan and Polisario forces.

February 1976

Spain formally withdraws from Western Sahara, without having fulfilled its international obligations. The liberation movement Polisario declares the Sahrawi Arab Democratic Republic (SADR).

May 1976

Establishment of first Sahrawi refugee camps in Tindouf (Algeria).

1979

Mauritania withdraws, and Morocco invades the area previously under Mauritanian control. The UN condemns the extension of the Moroccan occupation and recommends that Polisario, as the representative of the people of Western Sahara, should participate fully in any search for a lasting and just solution to the Western Sahara question (General Assembly Resolution 34/37, 21 Nov. 1979).

1991

Ceasefire. The parties agree to organize a referendum on independence and the UN Mission for the Referendum in Western Sahara (MINURSO) is sent to the territory.

1997

The Secretary-General intensifies the examination of the main contentious issues, a process that includes a series of direct talks between the parties, held under the auspices of the Secretary-General's Personal Envoy. In September of the same year, the Secretary-General reports that all the agreements reached during the talks have taken effect.

2000

MINURSO's lists of eligible voters are concluded. After eight years of delays, Morocco states it does not want a referendum after all.

2001
Morocco signs the first oil licences covering the occupied territories with the US energy company Kerr-McGee and the French oil company Groupe Total SA.

2002
UN legal counsel Hans Corell submits a legal opinion to the UN Security Council determining that oil exploration in disregard of the wishes and interests of the people of Western Sahara would violate principles of international law. Spain sells its 35 per cent ownership of Bou Craa.

2007
Negotiations start between Polisario and Morocco. Morocco submits a written proposal with a plan for autonomy but Polisario rejects any solution short of a referendum. The UN-mediated talks end inconclusively.

November 2014
The Spanish National High Court reiterates that Spain "remains the administering power of Western Sahara".

2015
The African Union (AU) issues a legal opinion agreeing that any exploration and exploitation of natural resources in Western Sahara by Morocco is illegal as it violates international law and resolutions of the United Nations and the African Union relating to the right to self-determination and permanent sovereignty of the people of Western Sahara over their natural resources.

2016
For the second year, Morocco rejects visits to Western Sahara by the UN Special Envoy. Morocco denies UN Secretary-General access to Western Sahara and unilaterally expels seventy-four of the UN staff.

April 2016
Five of the fifteen states in the UN Security Council abstain or vote against a resolution on Western Sahara – the least support a resolution has received for three decades, in any conflict. Any criticism directed towards Morocco is deflected by French support for the country. In August, Morocco violates the ceasefire by sending troops into as yet unoccupied territory.

November 2016
The UN Human Rights Committee expresses concern over the limited progress achieved on the question of the self-determination of the people of Western Sahara, and over the report that Morocco has failed to take the necessary measures to consult the people of Western Sahara on the exploitation of the natural resources of Western Sahara.

December 2016

The Court of Justice of the European Union (CJEU) rules that Western Sahara cannot be part of EU-Morocco trade agreements without the consent of the representative of the territory, referring to the UN resolutions defining Polisario as the representative.

2017

Morocco and the EU ignore the CJEU judgment from 2016, negotiating a new agreement of inclusion for Western Sahara.

June 2017

A court in South Africa makes a landmark decision, giving Polisario the ownership of a cargo of phosphate that Morocco was trying to export to New Zealand, and which had stopped over in South Africa.

2018

Morocco still occupies the larger part of the territory and refuses to take part in talks that could provide for the right to self-determination to be exercised. The UN calls for the two parties to meet to negotiate. The MINURSO operation remains one of very few UN missions internationally that has no mandate to report on human rights violations.

International Legal Framework – Key Quotes

. "The Court has not found legal ties of such a nature as might affect the application of General Assembly resolution 1514 (XV) in the decolonization of Western Sahara and, in particular, of the principle of self-determination through the free and genuine expression of the will of the peoples of the Territory."
Advisory Opinion, International Court of Justice, 1975[1]

. "The General Assembly [...] deeply deplores the aggravation of the situation resulting from the continued occupation of Western Sahara by Morocco and the extension of that occupation to the territory recently evacuated by Mauritania."
UN General Assembly, 1979[2]

. "If further exploration and exploitation activities were to proceed in disregard of the interests and wishes of the people of Western Sahara, they would be in violation of the principles of international law applicable to mineral resource activities in Non-Self-Governing Territories."
UN Legal Counsel Hans Corell, 2002[3]

. "Spain is still de jure, although not de facto, the Administering Power, and as such, until the end of the decolonization, has the obligations contained in articles 73 and 74 of the Charter of the United Nations. [...] Finally, it should be noted that, if in accordance with international legality, a territory cannot be considered Moroccan, nor can Morocco be accepted as the preferential jurisdiction of the place of commission of the offence."
The Spanish High Court, 2014[4]

. "We reiterate the fact that only the people of Western Sahara, as a Non-Self-Governing Territory, have the right to permanent sovereignty over their natural resources. [...] Member States of the UN and their companies are under obligation according to international law, UN Charter and other UN resolutions to refrain from helping in the perpetuation or legitimization of the colonial situation in Western Sahara by means of investments or explora-

tion and/or exploitation of renewable or non-renewable natural resources and other economic activities in the Non-Self-Governing Territory, and should therefore refrain from entering into agreements/contracts with Morocco as the occupying Power."
African Union, 2015[5]

· "The State Party should [...] enhance meaningful consultations with the people of Western Sahara with a view to securing their prior, free and informed consent for development projects and resource extraction operations; and [...] take the necessary steps to permit the people of Western Sahara to move about freely and safely on both sides of the berm, continue implementation of the demining programme along the berm and compensate victims."
UN Human Rights Committee, 2016[6]

· "The Committee recommends that the State party [...] strengthen its efforts, under the auspices of the United Nations, to find a solution to the issue of the right to self-determination for Western Sahara, as established in article 1 of the Covenant, which recognizes the right of all peoples to freely determine their political status and freely pursue their economic, social and cultural development."
UN Committee for Economic, Social and Cultural Rights, 2016[7]

· "It is contrary to the principle of international law of the relative effect of treaties to take the view that the territory of Western Sahara comes within the scope of the Association Agreement, which is applicable to relations between the European Union and the Kingdom of Morocco."
The Court of Justice of the European Union (CJEU), 2016[8]

· "In that regard, [the Court] notes first of all that, in view of the separate and distinct status guaranteed to the territory of Western Sahara under the Charter of the United Nations and the principle of self-determination of peoples, it cannot be held that the term 'territory of the Kingdom of Morocco', which defines the

territorial scope of the Association and Liberalisation Agreements, encompasses Western Sahara and, therefore, that those agreements are applicable to that territory. The General Court thus failed to draw the consequences of the status of Western Sahara under international law."

The Court of Justice of the European Union (CJEU), 2016[9]

. "The existence of a Moroccan occupation in Western Sahara is widely recognised."

The Advocate General of the CJEU, 2018[10]

. "[The EU fisheries in Western Sahara] breach the European Union's obligation to respect the right to self-determination of the people of that territory and its obligation not to recognise an illegal situation."

The Advocate General of the CJEU, 2018[11]

1 International Court of Justice, Advisory Opinion, "Western Sahara", 16 Oct. 1975, http://www.icj-cij.org/files/case-related/61/6197.pdf

2 UN General Assembly Resolution, "34/37: Question of Western Sahara", 21 Nov. 1979, http://www.un.org/documents/ga/res/34/a34res37.pdf

3 Legal Counsel Opinion, S/2002/161, 12 Feb. 2002, http://www.security councilreport.org/atf/cf/%7B65B FCF9B-6D27-4E9C-8CD3-CF6E4F F96FF9%7D/s_2002_161.pdf

4 Spanish High Court Judgment, 4 July 2014, http://wsrw.org/files/dat-ed/2016-04-19/audiencia_nacion al_4.7.2014_-_gdeim_izik.pdf

5 African Union Legal Opinion, 2015, https://au.int/en/newsevents/13174/legal-opinion-legality-context-interna tional-law-actions-allegedly-taken

6 Human Rights Committee, CCPR/C/MAR/CO/6, 1 Dec. 2016, http://tbinter net.ohchr.org/_layouts/treatybodyex ternal/Download.aspx?symbolno=C CPR%2fC%2fMAR%2fCO%2f6&Lang=en

7 Committee on Economic, Social and Cultural Rights E/C.12/MAR/CO/4, 22 Oct. 2015, http://tbinternet.ohchr.org/_layouts/treatybodyexternal/Download.aspx?symbolno=E%2fC.12%2fMAR%2f CO%2f4&Lang=en

8 Summary Judgment of the Court (Grand Chamber), Council v Front Polisario, "Case C-104/16 P", 21 Dec. 2016, http://curia.europa.eu/juris/docu-ment/document.jsf?text=&docid =191593&pageIndex=0&doclang= EN&mode=req&dir=&occfirst&part= 1&cid=257937

9 Court of Justice of the European Union, Press Release No. 146/16, 21 Dec. 2016, https://curia.europa.eu/jcms/upload/docs/application/pdf/2016-12/cp160146en.pdf

10 Advocate General of the Court of Justice of the European Union, Opinion, 10 Jan. 2018, http://eur-lex.europa.eu/legal-content/EN/TXT/?uri=CELEX: 62016CC0266

11 Ibid.

Declaration on the Granting of Independence to Colonial Countries and Peoples

Adopted by General Assembly resolution 1514 (XV) of 14 December 1960

The General Assembly,

Mindful of the determination proclaimed by the peoples of the world in the Charter of the United Nations to reaffirm faith in fundamental human rights, in the dignity and worth of the human person, in the equal rights of men and women and of nations large and small and to promote social progress and better standards of life in larger freedom,

Conscious of the need for the creation of conditions of stability and well-being and peaceful and friendly relations based on respect for the principles of equal rights and self-determination of all peoples, and of universal respect for, and observance of, human rights and fundamental freedoms for all without distinction as to race, sex, language or religion,

Recognizing the passionate yearning for freedom in all dependent peoples and the decisive role of such peoples in the attainment of their independence,

Aware of the increasing conflicts resulting from the denial of or impediments in the way of the freedom of such peoples, which constitute a serious threat to world peace,

Considering the important role of the United Nations in assisting the movement for independence in Trust and Non-Self-Governing Territories,

Recognizing that the peoples of the world ardently desire the end of colonialism in all its manifestations,

Convinced that the continued existence of colonialism prevents the development of international economic co-operation, impedes the social, cultural and economic development of dependent peoples and militates against the United Nations ideal of universal peace,

Affirming that peoples may, for their own ends, freely dispose of their natural wealth and resources without prejudice to any obligations arising out of international economic co-operation, based upon the principle of mutual benefit, and international law,

Believing that the process of liberation is irresistible and irreversible and that, in order to avoid serious crises, an end must be put to colonialism and all practices of segregation and discrimination associated therewith,

Welcoming the emergence in recent years of a large number of dependent territories into freedom and independence, and recognizing the increasingly powerful trends towards freedom in such territories which have not yet attained independence,

Convinced that all peoples have an inalienable right to complete freedom, the exercise of their sovereignty and the integrity of their national territory,

Solemnly proclaims the necessity of bringing to a speedy and unconditional end colonialism in all its forms and manifestations;

And to this end Declares that:

1. The subjection of peoples to alien subjugation, domination and exploitation constitutes a denial of fundamental human rights, is contrary to the Charter of the United Nations and is an impediment to the promotion of world peace and co-operation.

2. All peoples have the right to self-determination; by virtue of that right they freely determine their political status and freely pursue their economic, social and cultural development.

3. Inadequacy of political, economic, social or educational preparedness should never serve as a pretext for delaying independence.

4. All armed action or repressive measures of all kinds directed against dependent peoples shall cease in order to enable them to exercise peacefully and freely their right to complete independence, and the integrity of their national territory shall be respected.

5. Immediate steps shall be taken, in Trust and Non-Self-Governing Territories or all other territories which have not yet attained independence, to transfer all powers to the peoples of those territories,

without any conditions or reservations, in accordance with their freely expressed will and desire, without any distinction as to race, creed or colour, in order to enable them to enjoy complete independence and freedom.

6. Any attempt aimed at the partial or total disruption of the national unity and the territorial integrity of a country is incompatible with the purposes and principles of the Charter of the United Nations.

7. All States shall observe faithfully and strictly the provisions of the Charter of the United Nations, the Universal Declaration of Human Rights and the present Declaration on the basis of equality, non-interference in the internal affairs of all States, and respect for the sovereign rights of all peoples and their territorial integrity.

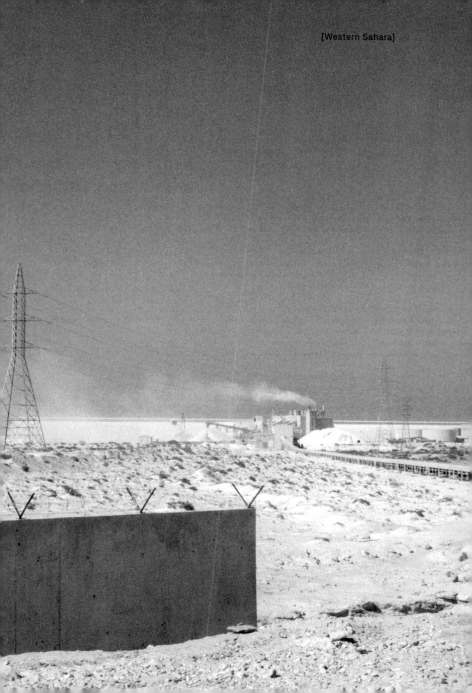
[Western Sahara]

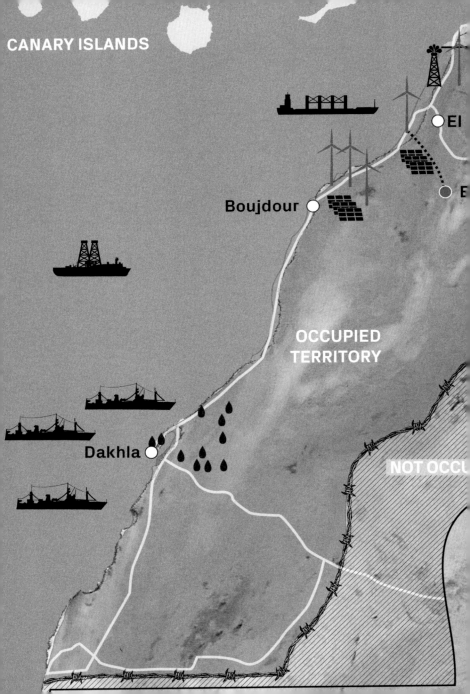

CANARY ISLANDS

EI

Boujdour

OCCUPIED
TERRITORY

NOT OCCU

Dakhla

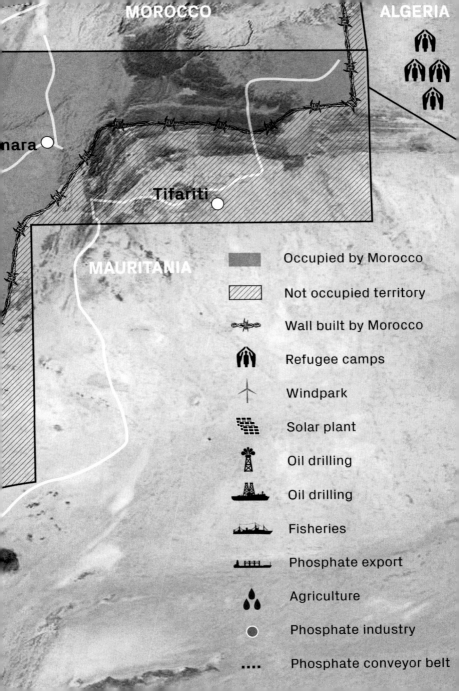

MOROCCO ALGERIA

nara

Tifariti

MAURITANIA

	Occupied by Morocco
	Not occupied territory
	Wall built by Morocco
	Refugee camps
	Windpark
	Solar plant
	Oil drilling
	Oil drilling
	Fisheries
	Phosphate export
	Agriculture
	Phosphate industry
....	Phosphate conveyor belt

Turning a Curse into a Blessing[1]

The plunder of Western Sahara's natural resources and the opportunities for the Sahrawi cause

Erik Hagen

"Morocco's foreign business partners are the kingdom's weakest link in the illegal occupation."

An unemployed youth from Western Sahara expresses the hope that her home country does not possess any more wealth.

She is a refugee, born and raised in refugee camps in the Algerian desert. Her parents fled across the border from Western Sahara at the time the territory – then still a Spanish colony – was invaded by Moroccan military forces.

Her wish illustrates the sad effects of the exploitation of natural resources in Western Sahara. Forty years after the invasion, Morocco is exploring for oil in partnership with a US oil company. The refugee knows all too well that if Morocco finds more resources in Western Sahara, it is less probable that it will give up on their baseless claims to the territory.

At the same time, her countrymen living under occupation speak of their agony. Leading activists observe the wealth being sold off, while all they get are beatings from the Moroccan police.

No wonder the Sahrawi people in general refer to the rich natural resources of Western Sahara as a problem. The country's resources are often referred to as a curse, putting obstacles in the way of the realization of their rights. In a way, they are correct. Over the last years Morocco has earned around 200 million dollars annually from the export of minerals from the territory alone. In addition, it benefits extensively from the sale of fishing licences to foreign governments and companies, with the EU one of the key players. Alongside its search for oil in the territory, Morocco also develops large renewable infrastructure programmes in the territory, which are controlled by the Moroccan king's company.

By attracting foreign businesses to occupied Western Sahara, Morocco manages to partly finance its costly military presence – it scores political points, while illegally increasing the presence of civilian Moroccan settlers. The operations prolong the sufferings of the unemployed and exiled. Had Morocco not occupied the territory and flooded it with settlers, there would have been plentiful job opportunities.

According to a 2013 interview with the Moroccan Minister of Communications, "there are more than twelve international agreements with Morocco that are almost unanimous in not excluding 'Sahara' from their scope of application":[2] a de facto confirmation that Western Sahara is part of Morocco. He elegantly summarized

the obvious trap that governments and companies can fall into when signing agreements with Morocco. The country is an occupying power. The Moroccan government has understood how the management of natural resources in Western Sahara can be key to slowly establishing visible signs of political support for its cause.

Other governments might not agree with the information minister's claim that the territory of Western Sahara is automatically included in trade deals with the Moroccan government. After all, no country in the world recognizes Moroccan claims to the territory. In 2016 the Court of Justice of the European Union ruled that Morocco and Western Sahara are "separate and distinct" territories and that trade agreements with Morocco do not cover the territory of Western Sahara.[3] Yet, the failure to expressly exclude Western Sahara from agreements with the Moroccan government is perceived in Rabat as support for their territorial claims.

The blessing

The equation can easily be turned around. The natural resources of Western Sahara, illegally plundered by Morocco, can in fact be a gold mine for the Sahrawi people in their campaign. By denouncing the companies involved, the Sahrawi people can massively increase support for their cause, directing to it the attention it deserves. The curse can, with some work, be turned into a blessing.

There are two aspects to this. The first has to do with highlighting Morocco's weak legal position. Campaigning on the issue of natural resources forces other states and parties to assess the legality of Morocco's controversial claims to the territory. The second is about attracting attention: campaigning against what amounts to underhand plunder causes international interest to focus upon the conflict. These two aspects are discussed below.

First, there is the blessing of international law: Morocco is on shaky ground in terms of international law. Its claim to Western Sahara – to territorial rights there – are groundless and rejected internationally. The resources can be usefully highlighted to expose Morocco's wrongful approach to the occupation.

It is important to commend the good work being done by civil society in highlighting Western Saharan human rights issues internationally. One can not only achieve visibility but also elicit strong

statements condemning Morocco's presence in Western Sahara by documenting the violations committed by Moroccan authorities. However, dealing with cases of human rights violations rarely leads to debate or legal analysis of the question of Morocco's illegitimate sovereignty claims over Western Sahara in the way that the natural resource question does.

The human rights situation in Western Sahara is today normally addressed by politicians, governments, and the UN without any mention of the context of the illegal occupation. Furthermore, the human rights issue is often raised using an "asymmetrically balanced" approach: even though one party evidently bears more of the responsibility for the cause of the conflict and for the violation of human rights than the other, both parties receive seemingly balanced recommendations for improvement. In fact, despite the poor human rights conditions in Western Sahara perpetuated by Moroccan occupying authorities, Morocco is routinely praised internationally by allies for the efforts it purportedly makes to improve the situation. And why is that a problem? Because as an illegal occupying power, it is not for Morocco to guarantee the human rights of the people of Western Sahara, whose right to freedom from occupation is already being violated. The question of Western Sahara's natural resources, however, cannot be analysed outside of the context of the legal status of the territory. It goes right to the core of the matter: Morocco has no legitimate basis for a territorial claim to Western Sahara in the first place.

As such, visible positive developments have taken place in the position of states and political parties during recent years, directly as a consequence of debates over the plunder of Western Sahara. Most remarkable are the Scandinavian countries. In 2002, Norway expressed more or less the same government policy on the Western Sahara question as any other country in the world. The Norwegian government said that it supported the people of Western Sahara's right to self-determination, but the policy was never elaborated much more than that. Western Sahara was not considered a high priority by the government.

In 2002, it was discovered that a Norwegian company was involved in the first seismic studies for Moroccan oil exploration in Western Sahara. From then onwards, Western Sahara became

an area in which Norway had a political and moral stake. A single question prompted the development of Norwegian policy on Western Sahara: "What is the opinion of the Minister of Foreign Affairs about a Norwegian company enabling oil companies to extract natural resources from an occupied territory?"[4] In the years that followed, Norway's policy was strengthened every time a new business link to the country was discovered. This peaked in 2005. The conservative Minister of Finance then stated that a US oil company's activities in Western Sahara constituted "a particularly serious violation of fundamental ethical norms because it may strengthen Morocco's sovereignty claims and thus contribute to undermining the UN peace process."[5]

In Sweden, after a similar question about a Swedish company's involvement in the oil industry in the territory, the Minister of Foreign Affairs said that "the Swedish government's position when it comes to understanding international law in this matter is clear. The area we today call Western Sahara, the former Spanish colony Spanish Sahara, is occupied by Morocco. [...] Morocco has no right to exploit the natural resources in Western Sahara for its own benefit."[6]

On its own initiative, as it was known that a New Zealand company was part-owner of fishing activities in Dakhla, the Maori Party in New Zealand stated, "We support the Sahrawi people's rights to self-determination in Western Sahara, and endorse the UN's calls for the illegal Moroccan occupation to end."[7] This was the first time a party in New Zealand had come out with such a strong statement.

Most importantly, perhaps, the increasing knowledge and debate over Western Sahara in the European institutions can mostly be attributed to the debates following the EU's unsavoury business deals in the territory.

In all similar cases, it is clear that the topic of natural resources triggers a debate over international law: Morocco has no legal claim to Western Sahara. If the debate is ignored, Morocco will score points, gaining – or believing it is gaining – political legitimacy. Once this is questioned, the Sahrawi side gains support. The natural resources issue is a gold mine for both the Sahrawis and for Morocco – as each party seeks to develop support for its respective position.

The second way in which the plundering is a prime opportunity for the Sahrawis is its appeal to the media and wider international public. In the media, the plundering of natural resources sparks an interest that is quite unlike most other aspects of the conflict. No matter where in the world they occur, it is rare for peaceful, legitimate liberation struggles, UN peace negotiations, or even human rights violations to catch anyone's interest. However, dirty business operations carried out by your neighbourhood company do.

The golden rule that any student of journalism would be taught is that the journalistic product needs to retain a degree of relevance. International affairs constitute a ridiculously small part of an average newspaper, and in the context of a few pages dedicated to international affairs, any conflict that is not "hot" will inevitably get limited treatment. In fact, most conflicts in the world could be categorized as "forgotten" by the media – while only a few receive any attention.

Even human rights are rarely addressed in the international media. In general, there are not many journalists in the world who write about human rights. If a human rights violation is committed in the journalist's or readership's own neighbourhood, it would fulfil the criterion of relevance. Sometimes a sympathetic journalist may be personally interested in writing about Western Sahara, but the degree of relevance is typically so minimal that it is impossible for the journalist to convince the editor that a story deserves to be written.

Imagine you are a foreign affairs journalist in a European country. You have three hours to write a story for tomorrow's newspaper. Why should you write about Western Sahara? Hardly any of your readership has heard of the occupation. It is light years away. No one died today. There are dozens of conflicts in the world that experienced far worse incidents in terms of immediate cruelty and casualties. It is much easier for you to write a story about serious human rights violations in Syria or DR Congo.

A demonstration of unemployed people in Boujdour or serious and credible accounts of torture from the prison cells in El Aaiún are, regrettably, not considered intrinsically interesting in the reality of today's media. The minimal media coverage of the grave and systematic violations in Western Sahara proves that point. Human rights demonstrations and torture are happening every day

in the world. What makes Western Sahara more relevant than other, apparently similar incidents?

That is where the resources come into play. Any incident of a local company from a journalist's own backyard involved in the unethical plundering of a foreign country would, by definition, fulfil the ground rule of journalism: relevance. The readers know the company, and it might even be a major employer or well-known local supermarket chain. It may even be located in the same street as the newspaper itself. The readers would surely appreciate knowing if such an enterprise is engaged in dirty business abroad.

The dirty business approach, combined with the growing number of industries on the ground in Western Sahara, means that the sufferings of the Sahrawi people have the potential to generate the national or even local interest that they truly deserve. And this can take place in basically any community in the entire world.

Over the last few years, the issue of local companies taking part in the increasing, wholesale plundering of the natural resources of Western Sahara has prompted thousands of articles in the Western media. The topic even receives regular television coverage in several countries, even at prime time. Not only is it perceived as relevant but it is also covered by different journalists in the newsroom from those focusing on foreign affairs: the business angle on the Western Sahara can just as easily be covered by journalists in the financial or domestic political sections. In other words, there is an increasing chance of catching the interest of media newsrooms.

Over recent years, some half of all Scandinavian news articles about Western Sahara are to be found in the business section of the newspapers, rather than the foreign affairs section. Most TV reports on the conflict broadcast on Northern European media channels over the last decade have had a business approach.

The news stories that treat the plundering of natural resources in Western Sahara are routinely composed in the same manner. They start with a revelation or critique of a business: that a local company is doing dirty business in an occupied country. Then, the journalist elaborates on the Moroccan occupation in 1975 and why doing such business is wrong. And at the end, they explain the human rights situation or the situation in the refugee camps: always the same structure. The business link is what is relevant

for the journalists – and thus also relevant for the readers: both politicians and civil society organizations.

Media attention and political pressure follow hard on each other's heels. The anti-apartheid campaigns in the 1980s would never have generated a sustained international outcry had it not been for the close trade between South Africa and Western countries. The dirty business ties to South Africa suddenly made human rights violations in the apartheid state relevant for local journalists all over the Western world. In other words, the same business ties that kept the apartheid regime in power were also the key to tearing it down.

The weakest link

For four decades, Sahrawis and activists have been demonstrating in front of Moroccan embassies around the world. Does it work? Does it create articles in international media? Does Morocco listen when Sahrawis shout? Maybe.

But surely Western companies do listen carefully to protests against them. Companies normally have an image to protect. When the protests get too intense, even the most unethical companies in Western Sahara have no other choice but to abandon their dirty operations.

Sahrawi campaigners normally give natural resources far lower priority than human rights abuses. Of course, human rights campaigns are very important. However, if the goal is attention, mobilization, and political results, targeting Morocco's business interests in Western Sahara clearly has more impact in terms of generating political momentum, legal opinions and visibility. Natural resources are the Sahrawis' way to make the grave human rights violations and their legitimate struggle visible to the outside world. Morocco's foreign business partners are the kingdom's weakest link in the illegal occupation.

Norway, the Netherlands, and, in part, Denmark are the only governments in the world who today urge their companies to stay away from Western Sahara. The three countries have had large industries involved in Western Sahara, be it fisheries, oil, shipping, or renewables. The governments' positions have a direct effect on companies leaving the territory. Why don't more governments follow this kind of approach? Not one of the governments in the forefront of provi-

ding support to the Sahrawi people – those who recognize the Western Saharan republic as a state – has such a policy today.

Nigeria, Ghana, and Angola are among the top five countries globally involved in the import of canned sardines from Morocco fished in Western Sahara. Key allies of the Sahrawi people and their government in Latin America are buying fish from occupied Western Sahara. Swedish companies are the main transporters of fuel oil into Western Sahara, and a Finnish concern is building infrastructure. Small towns in Spain that are deeply committed to supporting the Sahrawis, and who receive hundreds of children in solidarity programmes from the refugee camps every year, host businesses that are key to inflicting severe damage on the Sahrawis as a result of the pressure they exert on the Spanish government's fisheries deals.

Any government or community interested in working to increase respect for international law should consider the following: urge your companies to stay away; clarify the geographical limits of your trade agreements; instruct financial institutions and export credit agencies not to fund operations in the territory – or companies that operate there; make your public pension funds divest from international companies that take part in the plunder; break off cooperation with companies that chose to ignore basic human rights and international law in Western Sahara. Do all of this in public. These efforts will do a great deal to facilitate news coverage and civil society pressure.

Fighting the foreign companies that undermine the UN efforts to decolonize the territory constitutes a unique and golden opportunity for the Sahrawi cause, and if the Sahrawis and the rest of us take that opportunity, it will lead to increased media awareness and have far-reaching political consequences. It will not only stop Moroccan efforts to gain support for the Moroccan position but will in itself give support and much needed visibility to the legitimate rights for self-determination of the Sahrawi people.

Getting companies and governments to take note of the plundering and stop supporting the Moroccan occupation is actually not too difficult – the arguments for disengaging from trade and purchasing resources in an occupied Western Sahara are overwhelming. It merely requires a lot of thoughtful and targeted advocacy.

1 An earlier version of this chapter was presented as a paper at the "International Conference on the Decolonization of Western Sahara", Abuja, Nigeria, 2–4 June 2015.

2 "Kamā annā hunāka akhtar min 12 ittifāqiyya duwaliyya […], wa-alattī takādu tajma'u 'alā 'adam istithnā' al-sahrā' min majāl tatbīq al-ittifāqiyyāt bayna l-maghrib wa-hādhihi al-duwal." "Wazīr al-ittisāl al-maghribī li-'l-Hayāt': al-Jazā'ir wa-'Polisario' yamna'ānu ihsā' al-lāji'īn fī mukhayyamāt Tindouf", Al-Hayat, 14 Jan. 2013, http://alhayat.com/Details/472155

3 "Judgment of the Court (Grand Chamber) of 21 December 2016", Case C-104/16 P: Council v Front Polisario, Court of Justice of the European Union, 21 Dec. 2016, http://eur-lex.europa.eu/legal-content/EN/TXT/?uri=CELEX%3A62016CJ0104.
See also http://www.wsrw.org/a243×3695

4 "Hva synes utenriksministeren om at et norsk selskap tilrettelegger for at oljeselskaper skal kunne ta naturressurser ut av et okkupert område?" "Skriftlig spørsmål fra Hallgeir H. Langeland (SV) til utenriksministeren", Stortinget, 19 Nov. 2002, https://www.stortinget.no/no/Saker-og-publikasjoner/Sporsmal/Skriftlige-sporsmal-og-svar/Skriftlig-sporsmal/?qid=25729

5 "Company Excluded from the Government Petroleum Fund", press release, Norwegian Ministry of Finance, Regjeringen.no, 6 June 2005, https://www.regjeringen.no/no/aktuelt/company_excluded_from_the_government/id256359/

6 "Sweden underlines its position on Western Sahara", WSRW, 24 Sept. 2007, http://www.wsrw.org/a127×587

7 "Maori Party calls for ethical investment in fisheries", WSRW, 9 May 2008, http://www.wsrw.org/a128×715

The Commercial Controversies

Morocco's foreign business partners are the kingdom's weakest link in the illegal occupation

Erik Hagen

"We admit having made a mistake. It feels very uncomfortable having contributed to supporting an occupation power."

Morocco's business partners are well known. All the information about them is online. It is easy to find out the companies' addresses and the names of their leaders and owners. These companies are, each and every one, partially responsible for the continuation of the conflict. It is up to all of us to stop them.

The following essay provides an outline of the various commercial interests that are deeply involved in the occupied territory in partnership with the Moroccan government.

The oil

On 29 January 2002, the UN Under-Secretary-General for Legal Affairs wrote to the Security Council that "if further exploration and exploitation activities were to proceed in disregard of the interests and wishes of the people of Western Sahara, they would be in violation of the principles of international law". This document, the so-called "Corell Opinion", named after its author, continues to be a cornerstone of national governments' understanding of the legality and ethics of doing businesses in an occupied Western Sahara. Only a few months earlier, Morocco had signed the first ever oil licences covering the territory. The UN legal department now concluded that it would not be lawful to proceed in this fashion.

Morocco and its partners paid no heed to this. After twelve years of preparations, the first drilling began in December 2014. Further rounds of seismic studies in 2017 suggest that the company could be planning new drilling in 2018. So far, no oil has been found but the development is worrisome.

The operation – on a seabed licence "block" now known as "Boujdour Maritime" – is being conducted by US company Kosmos Energy together with its Scottish partner Cairn Energy. The licence was given to the companies by the Moroccan state oil company ONHYM. The contract was published online, and makes no reference to Western Sahara at all. No mention is made of the Sahrawi people.

Even though Kosmos Energy has come the furthest, it is not the only company searching for oil in Western Sahara. Over the last few years, Morocco has signed deals with several other partners for onshore and offshore exploration of oil in the territory, most prominently Glencore from Switzerland.

None of these oil companies have ever tried to seek the consent of the people of the territory.

Dirty green energy

At a time of global dependency on fossil fuels, any government's green energy projects would normally be commendable. However, an increasing number of projects initiated by the Moroccan government are not. Morocco does not produce oil and gas itself, and its government hungers not only for hydrocarbon finds but also for green energy. What better location for wind and sun installations than on the shores of occupied Western Sahara?

The large projects for solar and wind energy that are now being built will have severe consequences for the people of the territory. Yes, the energy production itself is green. However, the energy will be used to further capitalize on the resources already being exploited in Western Sahara. Moreover, by exporting the energy to Morocco proper, the occupying power anchors the territory to its own and Europe's energy grid. Morocco plans to build over one thousand megawatts of wind energy plants in Western Sahara. By 2020, more than 40 per cent of Morocco's wind energy is to be produced in the territory it holds under occupation. As recently as 2013, there was essentially no such production.[1]

The main partner of the Moroccan government is the German company Siemens, which is setting up windmills in partnership with a company owned by the Moroccan king himself – on the land that the king's father occupied in violation of international law and contrary to the opinion given at the time by the International Court of Justice. We will consider this company below.

The rock

Only weeks after the 1975 invasion of what was then Spanish Sahara by Morocco, the phosphate rock of the Bou Craa mine in Western Sahara was being exported to fertilizer companies overseas. The handling of the mine has ever since been controlled by Morocco's national phosphate company, OCP SA, which estimates the capacity of the mine at around 2.6 million tonnes annually. Though OCP claims that the Bou Craa mine represents only 1 per cent of all phosphate reserves existing within Morocco itself, no less than

a quarter of the kingdom's exported phosphate rock is from the mine, located inland from the capital city, El Aaiún.[2] The exceptionally high quality of Western Sahara's phosphate ore makes it a much-coveted commodity for producers of fertilizers overseas.

It seems, however, that the former high production levels could be coming to an end. The Bou Craa phosphate deposit consists of two layers. Until recently, only the first, top layer had been mined. This particular layer contained phosphate rock of the highest quality across all of the reserves controlled by OCP. In 2014, Bou Craa phosphate mining moved on to the second layer, which is of lower quality. Morocco has now sold all of the high-quality phosphate that ought to have been available to the Sahrawi people upon realizing their right to self-determination. At some point, there will be no more phosphate rock to excavate.

The illegally exploited rock is the Moroccan government's main source of income from Western Sahara, which it continues to occupy contrary to international law. Representatives of the Sahrawi people have consistently spoken out against the trade, both in the UN and to specific companies. The refugees from Western Sahara, representing half of the Sahrawi people, do not see any benefits from the trade. Many of the Sahrawis who were employed at the phosphate production unit at the time of the invasion, were forced to flee with their fellow citizens. OCP filled the positions they had vacated with Moroccan settlers.

Furthermore, Morocco specifically uses the Bou Craa phosphates for its political lobbying to gain the informal acceptance of other countries for its illegal occupation. An official Moroccan document leaked in 2014 explicitly states that Western Sahara's resources, including phosphate, should be used "to implicate Russia in activities in the Sahara". The document goes on to say that "in return, Russia could guarantee a freeze on the Sahara file within the UN".[3] With control over not only its own but also Western Sahara's phosphorus reserves, Morocco has placed itself in a very important position geopolitically. Approximately 71 per cent of global phosphate reserves are now controlled by the Moroccan government.[4]

The Moroccan state earns massively from the mine it controls in the occupied territory. The maths is easy: multiply the volume

exported by the international phosphate price. The value of exported phosphate has been stable at around 200 million dollars a year over a number of years. In comparison, the value of the annual multilateral humanitarian aid to the Sahrawi refugee camps is approximately 30 million euros.

So where does the phosphate go, once it has left El Aaiún harbour? Or, in other words, who is it that is really financing the occupation?

WSRW tracks all shipping traffic in the waters of Western Sahara on a daily basis. By doing so, it can routinely publish reports on Moroccan exports from the occupied territory, identifying all shipments of phosphates taking place. The latest report, "P for Plunder 2016", was issued in April 2017.[5]

Through this daily monitoring, WSRW believes that it has detected, tracked, and accounted for all vessels departing from El Aaiún harbour since the second half of 2011. For 2017, the total exported volume from Western Sahara is estimated by WSRW at around 1.6 million tonnes.

The calculation of the volumes is precise. The amount of phosphate loaded into a ship is ordinarily calculated to be 95 per cent of the ship's overall cargo capacity. Ships are then tracked and confirmed to have arrived at stated destinations. Where possible, estimated loaded amounts were checked against shipping documents, including bills of lading and port arrival receipts.

There is but little change from year to year in the customer pattern. As of 2017 there have been only five main importers of the rock: two in New Zealand, one in Canada, one in the US, and one in India. The ones registered on international stock exchanges have been subject to blacklisting by ethically concerned investors on the basis of this trade.

The fisheries

Morocco is one of the biggest fisheries nations in the world, but has hardly any fish itself. With most of its own fish stocks depleted or threatened, nearly all the fish caught by the kingdom are from the waters along the coast of the occupied territory. The foreign fishing takes place on two main levels: firstly, through foreign private fleets that fish under Moroccan licences; and secondly,

through agreements between Morocco and foreign states, such as Russia and the EU.

The fleet in the first category lands some of the fish in Western Sahara, while almost all the fish in the second category is exported directly. The fish caught in Western Sahara in the first category is processed in part locally in Dakhla or El Aaiún, or otherwise transported to Morocco proper. A continuing source of controversy are the grotesque images of Moroccan/foreign industrial vessels dumping huge quantities of fish overboard – so-called discards. In 2013, it was known that one single vessel had discarded one thousand tonnes of sardines as they were an inch too short for the company's processing plant in Agadir.[6] For the catches that are actually landed, large volumes are turned into oil or exported in cans.

The government-to-government agreements, constituting the second category, are particularly problematic, as they give a false impression of Moroccan sovereignty over the territory. Both the EU and the Russian fisheries agreements claim to be functioning in waters under the "sovereignty and jurisdiction" of Morocco. But does Morocco have sovereignty or jurisdiction over Western Sahara?

No, it does not. The UN and international law is very clear on that point. The territory is what the UN labels a "non-self-governing territory", or "colony". In fact, it is the last unresolved territory to be decolonized in Africa and treated as a territory under decolonization by the UN General Assembly.[7] Each colony has an "administrative power" – or "colonial power" – associated with it, which in Western Sahara has been Spain. Under international law, it is up to the people of Western Sahara to choose the status of the territory themselves and the management of the territory's resources.

A single vessel can dump more fish as garbage overboard than the volume of all international canned-fish aid to the refugees.[8]

The conflict tomatoes
Open the online program Google Earth and fly over the region near Dakhla peninsula, along the central coast of Western Sahara. You will see rectangular constructions, similar to football fields, randomly spread around the desert. Their shining reflection of the sky might lead you to think they are swimming pools. They are plantations. There are now eleven of them, one owned by the Moroccan

king, while the rest are owned by large French or Moroccan companies. No plantations are owned by Sahrawis.[9]

This large fruit-and-vegetable industry has developed near Dakhla since around 2004. By 2010, the total number of workers in Dakhla's agribusiness had already reached 6,480.[10] Practically all the workers are settlers from Morocco, who are offered work and housing in the region. The water used on the farmland for irrigation is fossil, pumped up from underground. Once depleted, it cannot be replaced. The desert agriculture is non-renewable.

The main markets for these conflict tomatoes are the EU and North America. Most end up in supermarkets in Europe.

The success stories

When the companies involved are first confronted, their routine response in many cases is that they have no idea they are involved in a controversial business operation. It is not just something they say – many actually seem to mean it. After all, some multinationals have subsidiaries and contracts all over the world. Shipping companies with dozens of vessels call on all ports of the planet, every single day. Grocery chains receive tinned and fresh produce from traders and importers with contacts, fishing fleets, and plantations in all corners of the globe.

Several of the companies, once contacted, state their appreciation for the information and promise never to do it again. Others, meanwhile, require a bit more convincing.

"Now that we understand the issue we will not directly contract any more business out of there," said the Chinese shipping company Jinhui, after being caught red-handed shipping phosphates from Western Sahara to New Zealand.[11]

"We had chartered two vessels to a Japanese company, and we were not aware that they shipped phosphates from this territory. We were also not aware that this was such a controversial topic. When we were made aware of this, we did what we could to stop this business. We do not want to be in conflict with anyone," Norwegian shipping company R-Bulk stated to newspapers after a shipment to the Venezuelan government-owned phosphate plant in Colombia was discovered.[12] Some shipping companies have now even included a clause in their agreements stating that they will

not allow their chartering company to bring the vessel to ports in Western Sahara. In recent years, a total of some fifteen shipping companies have stated they do not wish to carry out further transports of this sort.

"We admit having made a mistake. It feels very uncomfortable having contributed to supporting an occupation power," the CEO of SeaBird Exploration stated after an offshore seismic study for Glencore and New Age in Western Sahara in 2015.[13] In total, seven companies in the oil industry have left Western Sahara after being confronted.[14]

"We hope the country will be liberated, then the population there will profit from us quickly receiving their phosphates," the communications officer of one of the world's biggest fertilizer traders stated in 2009.[15] Three other importers have also specifically said that they will not buy any more phosphates from Western Sahara.[16] Similar decisions have also been made by companies in the fishing industry.[17]

Banks and investors have sold off shares from companies operating in Western Sahara for some 600 million dollars – and that is only what is known from the banks that transparently announce their blacklistings. The actual amounts could be much larger. The EU institutions guaranteed in 2013 that they would not support Morocco's green energy plans in Western Sahara, as Morocco previously stated that they would.[18] The EU is only reluctantly issuing such clarifying statements, as the EU has a long history of partnering Morocco in the plunder of the territory's resources.

1 "Moroccan wind energy in occupied Western Sahara passing 40%", WSRW, 31 Oct. 2017, http://www.wsrw.org/a105x3994

2 "Prospectus", OCP SA, 17 Apr. 2014, http://www.ise.ie/debt_documents/Prospectus%20-%20Standalone_bfbf30ab-a103-478e-bc61-8649a4a3e942.PDF

3 "Morocco admits to using Saharawi resources for political gain", WSRW, 25 Nov. 2014, http://www.wsrw.org/a105x3070

4 "Phosphate Rock", Annual Publications, Mineral Commodity Summaries 2018, US Geological Survey, Jan. 2018, https://minerals.usgs.gov/minerals/pubs/commodity/phosphate_rock/

5 "New report on global phosphate trade from occupied Western Sahara", WSRW, 25 Apr. 2017, http://www.wsrw.org/a246×3825

6 "Saharawis: Check out your fish here", WSRW, 19 Nov. 2013, http://www.wsrw.org/a217×2712

7 "The United Nations and Decolonization: Non-Self-Governing Territories", United Nations, http://www.un.org/en/decolonization/nonselfgovterritories.shtml

8 One vessel can discard 1,000 tonnes of fish: see n. 6. In comparison, the refugees get approximately 0.5 kg of fish aid every month, a total of around 900 tonnes per year.

9 "Report: EU consumers unwittingly supporters of occupation", WSRW, 18 June 2012, http://www.wsrw.org/a214×2321

10 "Entretien: Nous avons instruit 94 projets pour un investissement de 3,05 Mds de DH", interview with Abdellah Bouhjar, director of Dakhla's Regional Investment Centre, Finance News, Maghress, 12 May 2011, https://www.maghress.com/fr/financesnews/16159

11 "A line in the sand", South China Morning Post, 11 May 2008, http://www.scmp.com/article/637220/line-sand

12 "Vi hadde leid ut to skip til et japansk rederi, og var ikke klar over at de fraktet fosfat fra dette området. Vi var heller ikke klar over at dette var en så betent sak. Da vi fikk påpekt dette, gjorde vi det vi kunne for at denne virksomheten skulle oppheve. Vi har ikke lyst til å komme i konflikt med noen." "Trosser norske myndigheter", Bergensavisen, 29 Jan. 2013. Translation quoted in "Gearbulk criticised for unethical shipments", Norwegian Support Committee for Western Sahara,

29 Mar. 2013, http://www.vest-sahara.no/a128×1893

13 "Vi legger oss flate […]. Det føles veldig ubehagelig å ha vært med på å støtte en okkupasjonsmakt." "Svart gull kan bli slutten for fredsprosessen", Ny Tid, 31 Mar. 2015, https://www.nytid.no/svart-gull-kan-bli-slutten-for-fredsprosessen/. See also http://www.wsrw.org/a105×3206

14 "The company is often involved in oil and gas exploitation in areas where the local population has not been consulted. For that reason, the company has for instance stopped its involvement in Western Sahara", CEO of Dutch company Fugro, in "Fugro stopped Western Sahara work for lack of consultation", WSRW, 19 June 2012, http://www.wsrw.org/a214×2328
 "I have no problem in stating, in retrospect, that it might have been a bad idea to take this assignment", CEO of seismic services firm Spectrum ASA, after analysing seismic data from the territory, in "Oil subcontractor pulls out of Western Sahara", WSRW, 22 Sept. 2011, http://wsrw.org/a105×2096

15 "The United Nations and Decolonization" (see n. 7).

16 "Yara-profitt på okkupasjon", Adresseavisen, 5 Feb. 2009. See also "Fertilizer company 'hopes for liberation of Western Sahara'", WSRW, 15 Feb. 2009, http://www.wsrw.org/a141×1067

17 A shipbuilding company stopped its activities in El Aaiún in 2005. See "Selfa Arctic drar fra Vest-Sahara", Harstad Tidende, 4 May 2005, http://www.ht.no/incoming/article19140.ece

18 "As Europe lenders shy Sahara controversy, Morocco looks to China", WSRW.org, 6 Feb. 2014, http://www.wsrw.org/a228×2793

[Western Sahara]

EU:
Fish before Peace

The saga of how the EU Parliament once
stopped the controversial fisheries in occupie
Western Sahara

Erik Hagen

*"At a moment in which Morocco
has begun a democratization pro-
cess, it would be a very negative
message from the EU to reject this
agreement."*

The history of EU fisheries in Western Sahara, 2006–2018

- 2006: A Fisheries Partnership Agreement (FPA) between the European Community and Morocco is approved by the European institutions.
- 28 February 2007: The FPA comes into effect.
- 27 February 2011: The FPA expires, after four years.
- 28 February 2011: A one-year extension of the FPA begins, as the EU and Morocco have not succeeded in concluding a new agreement. The extension is determined by the European Commission.
- 29 June 2011: The Council of the European Union approves the one-year extension.
- 10 December 2011: The European Parliament rejects the one-year extension.
- 14 December 2011: Morocco announces the expulsion of the EU fishing fleet.
- 16 February 2012: The European Parliament approves a trade agreement with Morocco to liberalize agriculture and fisheries products; the Commission pushes for it to be applicable in Western Sahara. The agreement is found to be inapplicable in Western Sahara by the Court of Justice of the European Union (CJEU) on 21 December 2016.
- 24 July 2013: After one and a half years of negotiations, the EU and Morocco conclude a new four-year FPA, while the EU institutions are on summer break.
- 10 December 2013: The European Parliament resolves that the new four-year FPA is operative in Western Sahara. Dozens of Sahrawis are injured by Moroccan police while protesting the decision.
- 14 March 2014: The Western Sahara liberation movement Frente Polisario takes the Council of the European Union to the CJEU over the fisheries practice.
- 15 July 2014: A new 2014–2018 protocol of the Fisheries Partnership Agreement comes into effect.
- 2018: The CJEU is expected to decide on the legal process started by Polisario in 2014.

"The financial aspect is not necessarily the most important aspect of this agreement. The political aspect is just as important."[1]

In one short statement, Morocco's fisheries minister summarized the entire problem of the EU's former fishing agreement with Morocco. The year was 2006, and the upcoming EU-Moroccan fisheries partnership had been hotly debated in the European institutions. A new pact, in which the EU would pay money to the Moroccan government to fish in Western Saharan waters, was on the point of being concluded after months of dispute.

The statement underlined the problem with the entire deal: Morocco was about to reel in a large and controversial political catch under the cover of what, at first glance, seems like a simple fisheries agreement. As a leading beneficiary of the EU's Neighbourhood Policy, Morocco has been advantaged with a number of trade deals with the EU; some of these deals directly affect the territory of Western Sahara. Morocco naturally has an important agenda in these kinds of agreements. And it has nothing to do with fish. By attracting foreign companies and governments to sign accords for the management of the territory's natural resources, Morocco normalizes its long-standing illegal occupation of Western Sahara and creates an impression of international support for its presence in Sahrawi territory.

However, on one occasion, this project of including Western Sahara as part of the kingdom through EU agreements crumbled. In a historical decision on 14 December 2011, the European Parliament rejected EU participation in the territory's fisheries sector. It was one of the unique occasions in the history of the EU that the lawmakers blocked a trade deal, and the only time it has happened to a fisheries agreement. Five years after winning a political victory by concluding a Fisheries Partnership Agreement with the EU for Western Sahara, Morocco suffered a bitter loss on the same deal.

The saga behind the blocking of the EU-Morocco fisheries agreement in 2011 provides a remarkable insight into how far EU institutions and politicians can go in putting obstacles in the way of the principles of peace, law, and solidarity that the EU is based on. For several years, those who defended EU fishing in Western Sahara argued that the fisheries accord was not a political act, nor did it constitute interference in the Western Sahara conflict, as

it merely concerned fisheries. They blamed opponents for taking advantage of a simple trade agreement to serve their own political agenda.

However, when the four-year EU-Morocco agreement (which had come into effect in 2007) was up for renewal in 2011, the core arguments in support of continued fishing had been undermined by the studies of EU institutions. The same supporters who had stressed the apolitical nature of fisheries had only political arguments left to defend the idea of continuing them. In the end, it seemed to be all about politics, just as the Moroccan government had admitted. Even the documented environmental destruction and multimillion euro losses for the EU turned out to be unimportant as long as its large Spanish fishing fleet was kept busy and the Moroccan government satisfied.

EU interest in Morocco
Morocco today has the closest ties to the EU of any African state. The strategic reasons why the EU needs to maintain the goodwill of the Moroccan government are numerous: migration and drug control across the Strait of Gibraltar, intelligence exchange on terrorism, and overlapping maritime and land claims with its member state Spain, to name but a few.

According to European Commission figures, the EU is Morocco's biggest trading partner by far, accounting for around 50 per cent of the country's total trade. The trade in goods between the EU and Morocco is ever increasing, and in 2016 stood at more than 34.6 billion euros.[2] Through the trade cooperation, the European Community has entered into several agreements with its neighbouring country in the south-west. The problem, of course, is that those trade deals in practice cover natural resources in Western Sahara.

It appears that two EU states in general have the power to define EU policy on the Western Sahara conflict: Morocco's neighbour Spain and the kingdom's long-term ally France. The remaining twenty-six states in the EU appear not to invest much political capital, if any, in the dispute, in order not to upset Madrid and Paris.

"We know what international law guides us to do, but in this matter we follow Spain," stated a representative of one of the

country delegations to Brussels regarding the EU fisheries in Western Sahara.[3] There are some noble exceptions, where governments stress the legitimate rights of the Sahrawi people, most of all governments in Northern Europe. However, they rarely do so in open confrontation with the Spanish-French duo.

As such, the approach of the EU to the occupation of Western Sahara is not at all coherent. As we shall see later, the difference lies not only in conflicting positions between states but also in contradictory positions between the EU institutions. The European Parliament and the Commission can take highly divergent views. The European Parliament, consisting of democratically elected representatives from the twenty-eight EU states, repeatedly issues statements about the grave human rights situation in Western Sahara. For example, it "expresses its concern at the continued violation of human rights in Western Sahara; calls for the protection of the fundamental rights of the people of Western Sahara, including freedom of association, freedom of expression and the right to demonstrate; demands the release of all Sahrawi political prisoners".[4]

The critical position of the European Parliament is supported by reports from the UN Secretariat and leading human rights organizations. The US organization Freedom House, for instance, places Western Sahara at the bottom of its international ratings on political freedom together with states such as North Korea. However, on the other end of the scale, one would find players within the EU system with a completely different view. At key moments in the Western Sahara conflict, EU ambassadors to Morocco have actively pursued the Moroccan position, diverting attention away from human rights abuses in Western Sahara to focus on spreading Moroccan versions of the turn of events.[5] At a seminar on media freedom in Rabat, a former ambassador was quoted as saying that "Morocco and the EU share the same values of democracy and freedom".[6]

Integrating into the European market
It is within this overall framework of political cooperation between Morocco and the EU that the European fleet in the fish-rich waters off Western Sahara must be viewed.

In December 2011, ironically on the same day the European Parliament wrote history by rejecting the fisheries agreement, the Council of Ministers mandated the Commission to negotiate a so-called Deep and Comprehensive Free Trade Agreement (DCFTA).[7] The DCFTA negotiations formally started sixteen months later. The main objective of this agreement is to facilitate Morocco's gradual alignment with the EU single market.

"These negotiations show the EU's strong commitment to further developing its trade and investment ties with Southern Mediterranean partners who are committed to political and economic reforms," stated the EU Trade Commissioner.[8]

But there was a catch. As always, the EU was reluctant to properly exclude the occupied parts of Western Sahara from its trade deals with Morocco. Through the DCFTA talks, Morocco would negotiate the agreement with the EU as if the Moroccan-controlled parts of Western Sahara were part of the kingdom.

Thirty-one Sahrawi civil society organizations from occupied Western Sahara and the Sahrawi refugee camps in Algeria appealed to the European Commission to exclude their country from the DCFTA talks. The European Commission failed to take their wishes into account and has yet to consult the Sahrawis or their governing organizations.[9]

The DCFTA talks were later put on hold, but they illustrate the EU's intention to pursue a close and favoured relationship with their southern neighbour. They also clearly show how Western Sahara is the elephant in the room during EU-Moroccan dialogues. Overall, the EU tends to follow a say-as-little-as-possible approach.

"The EU confirms its support to the UN Secretary General and his Personal Envoy in their efforts to reach a just, lasting, and mutually acceptable political solution", stated the EU's spokesperson on human rights as the situation in Western Sahara was at its most intense since the ceasefire in 2010.[10] The quote is not atypical of the EU's approach to the conflict. By way of comparison, a UN Security Council resolution would normally state the same but end with the formulation "which will provide for the self-determination of the people of Western Sahara."[11] The EU often omits to mention this last phrase. It illustrates how the Sahrawi people are not taken

into account by the EU. When dealing with Sahrawi natural resources, the EU has always negotiated with Rabat, turning a deaf ear to Sahrawi protests.

Overgrown fishing fleet

The EU struggles with massive overcapacity in its fishing fleet. In short, there are far too many fishermen and fishing vessels for the ever-decreasing fish stocks available in European waters. In 2011, 88 per cent of the EU's own waters were already overfished.[12] The main problem is Spain, which accounts for a quarter of the total employment of the EU fishing sector[13] and has the highest number of catches in the EU.[14] To cope with the problem of excess capacities in some national fleets and unemployed fishermen, the EU enters into so-called Fisheries Partnership Agreements, or FPAs, through which the EU pays African and Pacific governments to issue fishing licences for EU vessels in their waters. The model is not without controversy. The EU fleet often overexploits fish stocks where it operates and thus enters into conflict with the traditional small-scale, often poor fishing communities operating from the coast. Some of the governments that have signed fisheries deals with the EU are known to be undemocratic or corrupt, and with limited resources to monitor the visiting European fleet. In the case of Western Sahara, the problem was more serious in that the EU signed the agreement with the wrong government: its occupying power.

The presence of European fisheries in Western Sahara is centuries old, operated by fishing communities in Southern Spain and the Canaries. When the territory was to be decolonized by Spain in the second half of 1975, the weak and collapsing Franco regime signed the Madrid Accords with Morocco and Mauritania, allowing the two neighbour countries to invade the territory. The deal was in direct conflict with the obligation Spain had to decolonize the territory. In return, Spain would be guaranteed to maintain its fisheries traditions and part of its stake in the phosphate industry in Western Sahara. In this way, the massively overgrown fishing fleet that the Franco regime had built could maintain its unsustainable fisheries even after it unilaterally, and therefore illegally, renounced its colonial obligations.

The Spanish tradition of fishing in Western Sahara after 1975 is thus part of the explanation as to why Western Sahara is not yet decolonized in the first place. It is a benefit that Spain enjoyed from allowing Morocco to occupy the territory in violation of the rights of the people who had inhabited the former Spanish province. Forty years later, the victims of the deal still live in refugee camps in the Algerian desert or suffer oppression from Morocco, a foreign government.

In 1986, Spain joined the European Union. From then on, it would be the EU that negotiated foreign fisheries agreements with Morocco on Spain's behalf. In 1988, the EU signed such an agreement with Rabat for the first time, making provision for eight hundred licences annually for Spanish and Portuguese fishermen. No ceiling on catches was introduced, and Morocco was paid 282 million euros for the deal. A new agreement was signed in 1992, the same year as the UN-organized referendum on independence in Western Sahara was planned to take place. The agreement was even more lucrative for the Moroccan government, which was paid the equivalent of 310 million euros, for an activity taking place almost exclusively in Western Saharan waters. In 1995, the latter agreement was redefined and prolonged, for a payment of 500 million euros, and in turn terminated by Morocco in 1999. By then, the fish stocks in Western Sahara were about to collapse.[15]

The halt of fisheries off the coast of Western Sahara at the turn of the century hit the Spanish fishing communities hard. "In Andalusia, more than 200 vessels have been affected and a total of 151 vessels remain tied up pending an improvement in fishing relations between Morocco and the EU. As a result of this crisis, business has dropped by half in the markets of the ports of Almería, Barbate, Huelva, Malaga and Algeciras," stated a Spanish Member of the European Parliament (MEP) in the autumn of 2004. "Would the Commission be prepared to make a fresh attempt at rapprochement with Morocco with the aim of facilitating cooperation on fishing-related matters?" she asked.[16]

In 2005, the Commission responded to the pressure from Spain, and commenced talks on yet another agreement, which, as we shall see, entered into force in 2007.[17] This was the first time the EU was planning to enter into such an agreement after the UN legal office,

led by Swedish ambassador Hans Corell, had issued its important 2002 legal opinion on oil exploration in Western Sahara to the UN Security Council. How would the EU relate to that?

Selective reading of international law

When it comes to resource exploitation in a territory under decolonization – a non-self-governing territory – the principles of international law are rather clear.

The people from such a territory have the right to decide not only on the independence of that territory but also on what shall happen to its resources. The UN legal opinion from 2002 came to exactly that conclusion. Any further exploration or exploitation "in disregard of the interests and wishes of the people of Western Sahara" would be in violation of international law, the UN Legal Counsel concluded.[18]

So how would the EU and Morocco relate to those principles, so recently and clearly spelled out by the UN secretariat? Morocco would naturally not be very helpful in ensuring that such an agreement would be in line with the wishes of the Sahrawis and international law – Morocco has, after all, violated those principles since 1975 by its mere presence in the territory.

The people of Western Sahara, the Sahrawis, would be unable to express their consent to the agreement as long as the deal was made with Rabat. Those living in the refugee camps in Algeria have no line of communication to the Moroccan government, as Morocco refuses to negotiate with the representatives of the Sahrawis, the national liberation movement Polisario, which Morocco considers a state enemy. The same lack of interest from Morocco applies to the occupied territories. Morocco would, in fact, not even accept that there is "a people" in the first place to seek consent from, nor accept the premise that the question of Western Sahara is treated as a matter of decolonization in the UN. "The people" of Western Sahara was identified by the UN Mission for a Referendum in Western Sahara (MINURSO), which was deployed in the territory in 1991.

The European Commission's five solutions

First, in nearly all communications, the EU removed references to the "people" of the territory altogether. That term is generally

replaced by the EU with "population" or "local population". All debates from this point on regarding the legality of the fisheries would, from the EU's perspective, be to obtain documentation on the "benefits to the local population". The problem with this misrepresentation, of course, is that a majority of that population today consists of Moroccan settlers and security forces. The EU and Morocco would never make any efforts to give the refugees or the people living in the non-occupied parts of Western Sahara a part in the equation. By misrepresenting "the people of Western Sahara" as "the local population in Western Sahara", the EU would thus find it sufficient to ask Morocco how its illegal settlers are doing.

Secondly, all references to "consent" – the term the UN uses – are almost entirely removed from EU texts. At best, they are replaced with the word "consultation", which has a very different meaning.

Thirdly, the EU from the beginning misquoted the legal status of Morocco in the territory. The UN document from 2002 underlines that Western Sahara today has no "administering Power" – or "colonial power".[19] Yes, the Franco regime left Western Sahara in 1975, but no international body has given any mandate to any other government to administer it. The UN opinion in 2002 was clearly written by analogy, as if Western Sahara had an administering power. Morocco refuses to be the administering power in Western Sahara, is not recognized as such by the UN, and does not report to the UN on the well-being of the people of Western Sahara as an administering power. The EU reading of this is gravely misjudged and gives the impression that the UN document indeed considers Morocco to be an administering power.

"Regarding the compliance of the current Agreement with international law, and the legal opinion of the European Parliament [...], we would like to reiterate that in his letter of 2002, Mr. Corell, concluded that (economic) activities in a Non-Self-Governing Territory by an administering Power are illegal 'only if conducted in disregard of the needs and interests of the people of that Territory'."[20]

Top European Commission officials repeatedly stressed that Morocco is the de facto administering power in the territory, and that therefore "the Commission proposal is in conformity with the legal opinion of the United Nations issued in January 2002".[21] This is, in fact, the reverse of what the UN legal opinion stated. There is

absolutely nothing under international law asserting the "de facto administering power" of a colony. Either a state is recognized as such or it is not.

The combined effect of these three misinterpretations is massive. While international law and the UN require that the Sahrawi people of Western Sahara have full authority to decide on the management of the resources of the territory, the EU interpreted the UN legal opinion as if it is sufficient to ensure that some locals (read: "as Morocco chooses to define them") are employed, then making sure that Moroccan government officials have approved it.

All references to the final conclusion of the UN opinion have been entirely omitted from all EU references to the document. The EU has invariably selected random quotes from other paragraphs in the document instead.

A fourth way, the European Commission argued at this point, was to keep its own internal legal opinions confidential. The legal offices of both the European Commission and Council authored legal opinions which the EU institutions consistently referred to. But these opinions were kept confidential due to their "great political sensitivity".[22] The EU thus claimed that everything was legal but never explained why – apart from the false references to the UN.

A fifth approach adopted by the Commission, and perhaps the most frustrating during the debates prior to the approval of the agreement, was to dodge all questions on where the fishing was to take place.

The Commission and key governments went to great lengths to obfuscate the whereabouts of the future fishing grounds. The agreement did not make any efforts to specify that Western Sahara would be excluded. Actually, it did not mention Western Sahara at all. Instead, the agreement allowed for EU fisheries under Morocco's "sovereignty and jurisdiction". It was clear for everyone that the fisheries would happen in Western Sahara, but the EU institutions and the Spanish fishing industry went to extreme lengths to avoid saying it. So all the questions from parliamentarians or journalists about Western Sahara remained unanswered.

"According to the provisions of the agreement, it is up to the Moroccan authorities as the contracting party concerned to define the fishing zones on the basis of which fishing licences will be

issued", Commissioner Borg stated just before the vote in the European Parliament plenary session on 15 May 2006.[23]

In 2006 and again in 2009 the European Parliament also undertook a legal analysis.[24] But unlike the legal opinions of the European Commission and Council, those from Parliament ended up in the public domain. Both reports warned of the illegality of the agreement. However, it was hard for Parliament's legal staff to draw a final conclusion, since the proposed agreement did not actually specify that fishing would take place in Western Sahara. Would the fisheries actually take place in Western Sahara? If that were to happen, and if Morocco did not respect the rights of the Sahrawis, the agreement would be illegal. The Parliament legal service in 2006 stated:

> "The text of the Agreement is not sufficiently clear as to its territorial area of application […]. This does not mean that the agreement is, as such, contrary to the principles of international law. At this stage, it cannot be prejudged that Morocco will not comply with its obligations under international law vis-à-vis the people of Western Sahara. It depends on how the agreement will be implemented. […] In case the Moroccan authorities disregard manifestly their obligations under international law vis-à-vis the people of Western Sahara, the Community could eventually enter into bilateral consultations with a view to suspending the agreement."[25]

The debates in Parliament were contentious. While parliamentarians objected to the Commission's fact-blurring and probable inclusion of Western Sahara, and stressed that the agreement would violate international law, the Commission itself worked intensively to calm the opposition.

> "The Commission thoroughly evaluated the political, legal and economic implications of an eventual agreement. In this case, as in others, the Commission carefully avoided a situation where the conclusion of new agreements in the field of fisheries could become a factor in international disputes or conflicts", the Commissioner stated.[26]

The group that had pushed for the agreement, mostly Spanish parliamentarians, praised the Commissioner for negotiating the agreement.

"I would like to express my gratitude to a section of the population who I represent," stated a Spanish parliamentarian on the Commission's work. "I am talking about the population of the Canary Islands, which also neighbours these waters, which has always fished in these waters and not, despite what some people have said, in a colonialist fashion. My great-grandfather signed an agreement with the population of the coast in order to fish there, on the basis of the principle of mutual interest. We had been fishing in those waters, we shall go back to fishing there, and I would like to thank the Commission for the effort it has made.

"I hope that this Parliament will approve this Agreement by a large majority, since it is very fair and very correct from the point of view of international law."[27]

Other defenders said that the debate over the Sahrawi people had nothing to do with such a forum.

"We believe that the Committee on Fisheries is not the place to resolve extremely important and complex international political problems," said Spanish MEP Carmen Fraga Estévez on 15 May 2006.[28]

She thanked her Spanish compatriot who had prepared the dossier for the Parliament's plenary session and paid tribute to the "balance he has achieved in relation to the political issues that have arisen".

The debate preceding the vote in the plenary session of the European Parliament was also used by pro-Moroccan parliamentarians to score political points, promoting absurd political statements in support of the Moroccan claims to the territory, in which legal references were even more twisted.

"I welcome this agreement, which is reasonable on two grounds," stated a French MEP who in the past had served as fiscal advisor of the Moroccan monarch.

> Firstly, it is reasonable as far as the fishery resources in the Moroccan provinces of Western Sahara are concerned. It is not the opinion of Parliament's legal service that counts, but that of the International Court of Justice. For centuries, Morocco has exercised a certain form of sovereignty over that territory. If Algeria wants an outlet into the Atlantic, that is its problem, but that is not a good enough reason to invent laws.

It is also reasonable because it is good to retain the benefits
derived from these agreements and to transfer them to the Saharan
provinces of Morocco and to the people .[...]

[...] We must take delight in the fact that we have concluded this
reasonable and balanced agreement with Morocco. Let us not pick a
quarrel with the Moroccans."[29]

The International Court of Justice has naturally concluded the
opposite: that Morocco has no legitimate claim or sovereignty over
Western Sahara.[30]

Wrapping up

The deal was eventually approved on 15 May 2006 and entered
into force on 28 February 2007. The EU fleet as a whole would be
given 114 licences, divided across several member states, in return
for an annual payment of 36 million euros to the Moroccan govern-
ment. It meant a total package of 144 million euros to fish, mostly
in a territory that an occupying Morocco had never been concerned
to assert or claim as its maritime zone.

A third of the parliamentarians voted against the Council's
decision in the plenary vote. It was not enough for a majority to
defeat the agreement. Since the Parliament did not then have
decision-making power over EU treaties, it would still have been
of no importance. The Council's decision would in either case have
gone through.

The vagueness of the territorial scope had led Sweden to vote
against the agreement in the Council, stating that "Western Sahara
is not part of the territory of Morocco under international law."
"How can the EU on the one hand support the United Nations reso-
lution and not recognise the annexation of the Western Sahara and
on the other hand have a fisheries agreement with Morocco that
covers the occupied areas? We want to be a neutral part in solving
this conflict," a Swedish official stated while the deal was up for
vote.[31]

Finland, Ireland, and the Netherlands agreed with the Swedish
position but did not vote against the deal, opting instead to abstain,
issuing their own statements. The remaining states endorsed the
agreement in the Council. Several representatives of EU govern-
ments stated that, in either case, if fisheries were in fact to take

place in Western Sahara, Morocco would have to make sure that the benefits would go to the "local population" and could not prejudge whether Morocco would comply or not. However, no specific reference was made in the agreement to define who that local population was. Were they Moroccan settlers, now in the majority, or Sahrawi?

In the end, Morocco was required during the four years of the agreement to deliver proof that the "local population" would benefit. As we shall see later, what they eventually coughed up was, to put it mildly, not really what it had agreed to with the EU.

"Please, friends of the Sahrawi people, tell the EU that they [must] first help solve the Western Sahara conflict, then they can exploit our fish. The way they do it now will only make problems for us and for the UN peace process," stated Sahrawi human rights activists from the occupied territories in a letter to the Parliamentarians the day before the vote.[32]

However, the Commission still claimed it had everything covered. "I repeat that concerning Western Sahara the wording used in the agreement was formulated very carefully. I repeat that it neither defines nor prejudges the legal status of the waters concerned. Again, with regard to [...] the question as to whether Morocco can conclude agreements that concern the exploitation of the natural resources of Western Sahara, the United Nations legal adviser gives a clear answer," were Commissioner Borg's last words in the European Parliament before the plenary vote.[33]

After the deal was sealed, and the fishing activity started in 2007, the critique would come from a highly regarded figure in international law: Corell himself.

Corell concerned

"I am afraid that Commissioner Borg has been ill advised," ambassador Hans Corell, then retired from his UN position, stated during a conference on international law in 2008.

The EU Commission's continuous misuse of the UN text had not passed unnoticed by the author. Corell thought it peculiar that the Commission was reading his text as if Morocco was a de facto administering power, and that the agreement "therefore" would be in conformity with the legal opinion. What Corell thought about the EU's use of his UN document deserves to be quoted at length:

I must confess that I was quite taken aback when I learnt about this Agreement. Without doubt, good relations between Europe and Morocco are of greatest importance. [...] But I am sure that it would have been possible to find a formulation that would have satisfied both parties while at the same time respecting the legal regime applicable in the waters off Western Sahara. Any jurisdiction over those waters is subject to the limitations that flow from the rules on self-determination.

It has been suggested that the legal opinion I delivered in 2002 has been invoked by the European Commission in support of the Fisheries Partnership Agreement. I do not know if this is true. But if it is, I find it incomprehensible that the Commission could find any such support in the legal opinion, unless, of course, it has established that the people of Western Sahara had been consulted, had accepted the agreement, and the manner in which the profits from the activity were to benefit them. However, an examination of the agreement leads to a different conclusion.

[...] It is very difficult to identify the Saharawi in this enumeration [of how the financial contribution shall be allocated]. [...]

In all the pages of the Agreement, there is not one word about the fact that Morocco's "jurisdiction" is limited by the international rules of self-determination.

As a European, I feel embarrassed. Surely, one would expect Europe and the European Commission – most of all – to set an example by applying the highest possible international legal standards in matters of this nature.

Under all circumstances, I would have thought that it was obvious that an agreement of this kind that does not make a distinction between the waters adjacent to Western Sahara, and the waters adjacent to the territory of Morocco, would violate international law.[34]

Other legal scholars concluded on the illegality of the agreement, as did the government of Sweden.[35]

The Legal Service of the European Parliament arrived at the same conclusion as the former UN legal chief. In a new legal opinion from 2009, made public in 2010, the office did not find any proof that the Sahrawi had ever been consulted in relation to the fisheries agreement in Western Sahara, which had by then been in effect for more than two years.

It is not demonstrated that the EC financial contribution [to Morocco] is used for the benefit of the people of Western Sahara. Yet, compliance with international law requires that economic activities related to the natural resources of a Non-Self-Governing Territory are carried out for the benefits of the people of such Territory, and in accordance with their wishes.

It concludes:

In the event that it could not be demonstrated that the FPA was implemented in conformity with the principles of international law concerning the rights of the Saharawi people over their natural resource, principles which the Community is bound to respect, the Community should refrain from allowing vessels to fish in the waters off Western Sahara by requesting fishing licenses only for fishing zones that are situated in the waters off Morocco.[36]

During the period when this legal opinion from the Parliament was still confidential, the leader of the Fisheries Committee told Western Sahara Resource Watch that the Parliament's legal opinion "supported the legality" of continued fisheries in Western Sahara. When the document was made public, it was clear that this was not really the case.

Benefiting whom?

"I think each refugee should have one slice of bread with fish every day," researcher Ingrid Barikmo told her colleagues in the refugee camps in Algeria, at a time when the controversial four-year fisheries agreement was half way through its application. The level of chronic malnutrition in the refugee camps is worrisome. Studies have shown that in certain periods one in every five Sahrawi children is acutely malnourished.[37]

Ms Barikmo had been studying nutrition levels in the Sahrawi refugee camps in Algeria for the previous fifteen years. Her team often gathers to discuss how to respond to the malnutrition among a population completely dependent on aid. Their research has uncovered a worrisome situation for the Sahrawi people who fled their homeland in 1975, when Morocco ignored the opinion of the International Court of Justice and invaded Western Sahara in the face of UN condemnation.

Ninety-three per cent of the refugee children have an unacceptable diet, according to the team's research. Ms Barikmo's suggestion of introducing more fish into the diet was apt, but there is too little funding to allow this.

"My colleagues simply laughed at me. They thought I was joking," Barikmo said later.[38]

The European Union's humanitarian organization, ECHO, donates an average of 10 million euros in humanitarian aid to these camps annually.[39] However, by way of comparison, the EU paid 3.6 times as much to Morocco annually under the Fisheries Partnership Agreement for access to the fish stocks that are owned by the same refugees. The EU buys the Sahrawis' fish from Western Sahara's occupying power, while the children in the refugee camps suffer from lack of protein.

The paradox of refugees not benefiting from Morocco's use of Western Sahara's resources, and of the people not consenting to this, is underlined by the UN Secretary-General and the UN Committee on Economic, Social and Cultural Rights.[40]

The other half of the Sahrawis still living in the occupied territory contend that they have not benefited from the EU's fishing agreements with Morocco. When 799 international organizations in 2010 protested the EU's plunder in a letter to the European Commission, virtually all Sahrawi civil society groups were among the signatories.[41] Meanwhile, expressing opposition to the Moroccan management of the territory it occupies can lead to harsh punishments. Any person critical of the illegal Moroccan presence risks being subjected to human rights violations. This has been documented, year after year, by leading international human rights organizations.

Sahrawi unemployed and activists who helped organize the 2010 protest camp outside of El Aaiún, in which socio-economic rights were sought, were convicted and sentenced to severe punishment by a Moroccan military court. One such person, the secretary-general of the Committee for the Protection of Natural Resources, was sentenced to life imprisonment. He has been an outspoken critic of the EU's fisheries activities in Western Sahara – and was one of eight to receive such a sentence.[42]

The European Parliament has repeatedly expressed its concern over the abuses.[43] So has the UN Secretary-General, who in 2013

and 2014 requested from the Security Council permanent UN monitoring of human rights violations in the territory. The same two countries that lobby for EU trade deals covering Western Sahara – Spain and France – prevented such an inclusion in the mandate of the UN mission in Western Sahara, MINURSO, even after pressure from the US to allow the activity.

As the fisheries operations of the EU continued, Sahrawis would carry homemade banners or tag the walls of buildings in El Aaiún with the words "Where is our right in fishing treaty?"

"We never had a voice in this undertaking, and the only outcome of the fisheries agreement that our people have noticed, is that our voices are suppressed even more, as Morocco feels itself supported by the European Union in its illegal and unfounded claim over our homeland. Since the Saharawi people have not agreed to nor benefit from the agreement, as required under international law, we respectfully ask that all European fisheries in Saharawi waters be halted immediately," stated a group of Sahrawi political prisoners in a letter to the president of the European Parliament.[44]

Most importantly, however, the Western Sahara liberation movement Frente Polisario repeatedly objected to the agreement. On numerous occasions representatives of Polisario contacted the EU institutions to protest the agreement. They also called on the UN to intervene.[45]

Before the fisheries agreement was concluded in April 2006, the Fisheries Committee took the initiative to have the two parties to the conflict, Morocco and Polisario, come to the Parliament for joint consultation. However, because Morocco did not want to present its case in the same forum as Polisario, the entire joint consultation was cancelled, to the joy of the Spanish socialists on the committee, who had tried to prevent the initiative. The organizers stated that there would not be any such consultation if both parties were not present at the same time.[46] The consequence was that Polisario's view was never heard in meetings with the Fisheries Committee. In all future consultations, it would be Morocco alone that was invited by the EU institutions to discuss the management of the Western Sahara fish stocks.

At the time when the fisheries agreement was adopted in 2006, EU states, parliamentarians, and the EU legal service stated that it

was not possible to prejudge how Morocco would comply with its obligations. When the first four-year term of the agreement came to an end, Morocco had never presented any evidence on whether the people of Western Sahara benefited from the fisheries or if they had consented. One has every reason to wonder what was actually discussed at the annual meetings between the Commission and Morocco. They had had four years to find out how this affected the Sahrawis.

In the end, parliamentarians were compelled to take the matter into their own hands. A delegation from the European Parliament's Fisheries Committee was supposed to visit Western Sahara in 2010 to assess the consultation process and how the people were benefiting. After months went by without any official reply, Morocco officially rejected the Fisheries Committee's proposal to visit the territory, claiming the timing for such a visit was "not opportune".[47]

Five other known European delegations of journalists, civil society groups, and students that travelled to the territory under-cover to investigate the application of the agreement in 2010–11 were expelled from Morocco or Western Sahara.[48]

Morocco's lack of interest in sharing information about the benefits to the so-called "local population" was frustrating for those European interests that lobbied for the agreement. A Moroccan report on the matter that was promised to the EU institutions kept being postponed. "Morocco will not give it to us," the leader of the Fisheries Committee stated.[49]

Many also queried what purpose it had to ask Morocco to produce such a report to begin with. Who gave Morocco the right to speak on behalf of the Sahrawis?

Corell, the former UN legal chief whose analysis the EU claimed to have built its arguments on, was back in the spotlight. In 2010, in a new article on the fisheries agreement, Corell wrote,

> It has been suggested to me that the European Commission is of the opinion that it is for Morocco to see to it that the agreement is implemented in a manner that the interests of the Saharawi are taken into consideration. In view of the circumstances, in particular the political dispute over many years between Morocco and the Frente Polisario, this position is simply not acceptable. An honourable actor in the international arena must demonstrate a higher standard. This applies in

particular to Europe where actions by States should be based on the Charter of the UN and modern treaties on human rights, such as the International Covenant on Civil and Political Rights and the European Convention for the Protection of Human Rights and Fundamental Freedoms.[50]

Awkward arguments

The European Commission, pro-fishing parliamentarians, and Morocco itself worked actively on defending the agreement during the four years it was in effect. They had a lot to defend, as a successful implementation of the Fisheries Partnership Agreement would lay the ground for a new one later. These were some of the main arguments:

a) Don't ask us, ask Morocco. "The UN Corell opinion confirms that [...] exploitation activities should be carried out 'for the benefit of the peoples of those Territories, on their behalf or in consultation with their representatives'. The Commission is of the view that it is Morocco's responsibility to ensure that this is the case," stated the EU Fisheries Commissioner, as if the EU had no responsibilities at all.[51]

b) Data will show the agreement is good. "The information on the economic impact of this agreement in the regions would be good to have. It would only support the validity of this agreement,"[52] EU ambassador Landaburu stated. This was before any data had yet been presented by Morocco to the EU, and while all evidence pointed to the opposite. In the end, no data was ever presented to answer how the agreement affected the people of Western Sahara, information that the European Parliament's legal service had identified, in 2006, as a prerequisite for its legality.

c) Inventing legal support. In a press conference in Casablanca, the same EU ambassador to Morocco declared that "the legal service of the European Commission and all the opinions of independent institutions have shown that there is no problem with the international legality of the fisheries agreement with Morocco".[53] After a number of letters had been sent to the ambassador and the Commission, the ambassador's office finally replied that the "independent institutions" he referred to were in fact the European institutions themselves.[54]

d) Claiming support from Parliament. "The EU Fisheries Partnership Agreement with Morocco also covers Western Sahara. This was approved by the Commission and the European Parliament," the EU commissioner Joe Borg stated to a Swedish TV documentary in March 2010.[55] The fact of the matter, however, is that by the time the agreement was up for vote, the EU had stated it would be in "Moroccan waters". The same commissioner admitted before the vote, several times, that they had gone to great lengths to avoid mentioning that the agreement would extend to Western Sahara. The entire vagueness of the scope of the agreement made it impossible for the Parliament's legal service to conclude on its legality.

e) Misrepresenting the critique. "As for human rights, that's a horizontal problem. Why is this agreement the only pact where this is raised as an issue?" said parliamentarian Carmen Fraga Estévez.[56] The question was really never one of human rights, but of whether the EU should sign an agreement with the wrong government, in waters that Morocco had not even bothered to lay maritime claims to. On no other occasion would the EU sign an agreement with the occupying power for fishing in occupied waters.

f) If the EU doesn't, someone else will. "A refusal would not mean the end of the use of maritime resources in the exclusive economic zone of the Western Sahara territory. Morocco could also conclude an FPA-style agreement with any other country seeking additional fishing resources. As a result, the FPA ensures that the demand for fish in the EU can be covered without fully exploiting or over-fishing the EU waters," German law firm Alber & Geiger wrote in an email to a group of parliamentarians on 11 May 2011. The law firm was "representing Morocco's interest before the European Parliament".

g) Opponents misusing the agreement for political purposes. The agreement "could be used for political reasons, because that is the normal political game, but there is no problem," stated EU ambassador Landaburu.[57] The latter argument was repeatedly used. Is it or is it not the case that fishing in Western Sahara in partnership with the occupying power has a political dimension?

"Fishing in Former Sahara is apolitical"

The statement of the Moroccan government to the local media in Morocco, underlining that the fisheries agreement has a politi-

cal dimension and that this is more important than the financial aspect, should be enough to overturn the EU ambassador's claims that there are political implications to the deal. Yet, both the Commission and the pro-fisheries lobby, time and again, have argued that the agreement has no political significance.

"The Western Sahara issue will not be resolved here," stated a French, pro-Moroccan parliamentarian in one of the debates in the Fisheries Committee.

"It is a controversy that seeks to make political capital out of a moment when the media is interested in the agreement," said the EU's chief negotiator for the EU-Morocco fisheries agreement, César Deben, shortly after the signing ceremony in 2006.[58] Ironically, in the same speech, Deben stated that Western Saharan waters had been "under Moroccan administration" since the Madrid Accords – the same accords that the 2002 UN legal opinion had found invalid.[59]

Deben proceeded to misrepresent the content of the European Parliament's legal opinion by stating that "there has always been controversy over this, even in previous years. An agreement with Morocco includes all waters and fishing zones of the Moroccan Kingdom. [...] I can say that Morocco has agreements with Russia, Ukraine, and other countries, and there has never been this kind of controversy. The interest lies not in the fishing activity in the waters of the former Sahara [sic] but in the fact that it is the EU that is negotiating it. But we are very confident, as the legal opinions both from the European Commission and the Parliament, as well as from the Council of Ministers, have been unanimous – the agreement respects all the prerequisites of Community and international law."[60]

"Former Sahara"? The statement from the former chief negotiator gives the impression that Western Sahara has ceased to exist, as if it became an integral part of Morocco when the Franco regime sold it to Morocco in exchange for fishing licences. But it did not disappear. Ignoring the fact that the entire territory's existence is clearly at stake in the conflict, this is in stark contrast to the UN terminology and to the foreign policies of the EU member states. It does not get more political than that. Imagine, as a comparison, the word combination "former Palestine".

The claim that a fisheries accord covering the territory of occupied Western Sahara does not have political consequences is not only countered by the Moroccan Minister of Fisheries himself, as mentioned in the introduction to this essay, but also by Sahrawis, Polisario, NGOs, and scholars: everyone except the fishing industry lobby.

"In order to find a solution [to the conflict], it is imperative that other actors do not behave in a manner that in fact risks undermining the efforts by the UN to find a solution. A particular responsibility rests with the members of the European Commission and in particular Spain," Ambassador Corell said about the agreement.[61]

The Norwegian government, which is not part of the EU, has labelled similar natural resource exploitation in Western Sahara "'a particularly serious violation of fundamental ethical norms' [...] because it may strengthen Morocco's sovereignty claims and thus contribute to undermining the UN peace process", underlining that "Morocco has for a number of years occupied Western Sahara despite strong UN condemnation".[62]

"It is extremely clear that Morocco only wants to keep the fisheries agreement with the EU for one reason – to legitimise Morocco's illegal occupation of Western Sahara by making the EU an accomplice," stated one of the many critics in the European Parliament, Isabella Lövin of the Swedish Green Party.[63]

From 2011, a new document appeared that would totally change the game: an independent evaluation commissioned by the EU itself. From then onwards, as all other arguments crumbled, even the pro-fishing lobby took to political arguments to defend the continued catches.

EU evaluation: All-time worst

At the time when the EU's fisheries agreements with African or Pacific nations are about to expire, the Commission is obliged to contract an independent bureau to evaluate the implementation of the agreement. This was also the case with the 2007–11 EU-Morocco Fisheries Partnership Agreement. The evaluation of the EU-Morocco agreement, written by a consultancy firm in Paris, did not go into aspects of international law or the wishes of the Sahrawi. Nor did it address the political consequences that the

Commission stated had been duly taken into consideration. However, the highly technical report studied and discredited the implementation of the agreement along two new fronts not addressed until then: the ecological destruction of Western Saharan waters and the financial loss to the EU.[64]

The evaluation revealed that Morocco was unable to manage the fish stocks of Western Sahara in a sustainable manner. The 103-page report noted that the EU was jointly responsible for over-exploitation of the pelagic fish stocks and helping put endangered marine animals at risk.

Of eleven demersal stocks fished in those waters, five appear overexploited, four were considered fully exploited, while two stocks were not sufficiently analysed due to lack of data. One of the priorities of the EU under the partnership was to have Morocco reduce its unsustainable fisheries practices. In fact, during the term of the agreement the EU had requested that Morocco speed up the process of banning the use of driftnets, an unsustainable fisheries method not allowed by the EU. Morocco "is not doing enough" to stop the practice, stated EU fisheries commissioner Borg back in 2009.[65] The evaluation one year later revealed that the money earmarked for that purpose had not been touched by Morocco at all.

The most surprising element of the evaluation was that the EU-Morocco fisheries agreement literally meant throwing money out of the window. The study showed that "each euro spent by the EU only generated 83 cents turnover and 65 cents direct and indirect value added accruing to the EU. […] These are the lowest cost-benefit ratios of support to the European fleet across all on-going bilateral agreements."[66]

In other words, the evaluation showed it would have been cheaper to just give the EU taxpayers' money directly to the fishermen in Spain, and not send them to Western Sahara to fish. Even had there not been a financial recession in the EU after 2008, such a deal would be nothing less than a squandering of resources. Tens of millions of euros had been lost.

Finally, those that claimed that the agreement was important for job creation for the local "Moroccan" economy, and as such important for the development of "Morocco", lost that argument: only

170 jobs were created under the agreement.[67] That is a great deal of money for each job – not even taking into account whether they were Sahrawis or illegal Moroccan settlers.

The leader of the Fisheries Committee, Spaniard Carmen Fraga Estévez, who until then had defended the Fisheries Partnership Agreement, was shocked at the findings. "The report is the most negative I have seen in my life," she summarized once the cat was out of the bag.[68]

So what arguments were left to support continued fishing after that?

According to the EU institutions' own reports, the agreement was in violation of international law, it destroyed the environment, it hardly created any jobs, and it was a waste of EU money. Leading experts on the Western Sahara issue said it also undermined the UN peace efforts by allowing Morocco to score political points.

The 2011 extension

Halfway through the 2007–11 fisheries agreement, a large constitutional reform shook up the relations between the EU institutions. The so-called Lisbon Treaty gave increased power to the Parliament in certain areas, among them the ability to overrule the Council of Ministers in matters such as fisheries agreements. Gaining these privileges led to a new power dynamic between the three EU institutions: the Parliament, the Council, and the Commission. It is the Commission's role to answer to the development of the fisheries agreement. Observant parliamentarians were often frustrated that getting information from the Commission on the implementation of the EU-Morocco fisheries agreement was like talking to a brick wall. It seemed that the Lisbon Treaty, which gave the Parliament increased powers, did not inspire the Commission to share information, about fishy deals like the one with Morocco.

For a long time it was difficult even to get a clear answer from the Commission about whether fishing took place in Western Sahara at all. The revelation about the EU actually fishing in Western Sahara only came after Members of the European Parliament had asked seven separate written questions to the Commission, each with a different wording and approach. The breakthrough came when a highly technical question was asked regarding the EU catch

volumes under the current agreement reported from the UN Food and Agriculture Organization (FAO)'s so-called fishing area 34.1.3, which partially overlaps the Western Saharan waters.[69]

Until then, when the Commission had been asked if EU vessels fished in the Western Sahara zone, the reply was normally that it was up to Morocco to define the area of application of the agreement.

"The lack of inter-institutional cooperation has obstructed the rapporteur's work through the entire process of preparing this draft recommendation," the rapporteur and Finnish MEP Carl Haglund later stated as he was writing a report to the Fisheries Committee on the fisheries agreement.[70] That is harsh language – particularly from Haglund, a young but very diplomatic parliamentarian, later to become Finland's Minister of Defence.

The lack of response and information-sharing was not due to a lack of knowledge. The Commission maintained a constant dialogue with its Moroccan counterparts, and would have been fully informed as to the whereabouts of its fleet at all times. Modern tracking devices on the vessels give full traceability. Not only that, staff from the Commission made visits to the occupied territory.

"The original licences for both [...] vessels will be given in Dakhla on Monday morning by the Delegation of the European Commission and the Moroccan authorities to the vessel owner," stated a mail from the Commission to one of the member states in November 2007.

The Commission's lack of will to cooperate with the Parliament became even clearer as the evaluation report was completed. One would imagine that the Parliament would have access to all evaluations that analyse how EU taxpayers' money is spent, including the damning report on the EU-Morocco fisheries agreement. But not so. For many months, it seemed that no one in the Parliament even knew it had been written. When it first became clear that the report had been compiled, it was kept strictly confidential.

The evaluation report was only presented for a very limited circulation: it was only in French and only made available four months after it was completed. And "available" is an exaggeration. Only the members of the Parliament's Fisheries Committee could read it. The document was only accessible in a separate small room that was equipped with a table, a chair, and a light bulb. Laptops, mobile

phones and even the parliamentarian's assistants were not allowed near the text, which proved that the EU was wasting money. In the past, those same reports had been available to all MEPs simply upon request, but not after the Lisbon Treaty gave new powers to the Parliament.

As the news started to spread that the Commission was sitting on an evaluation that was truly damaging to the Fisheries Partnership Agreement, the mood in the Parliament started to change.

When the 2007 agreement came to an end on 27 February 2011, a new four-year agreement had not yet been put in place, despite intense pressure from Spain, which was then in a deep economic recession. In order to buy some time, a provisional one-year extension was initiated from the day after the four-year agreement had terminated, on 28 February. Such an extension would also give the Commission an additional year to study the benefits accruing from the agreement to the "local populations". An email from well-paid US lobbyist Ed Gabriel to the advisor of the Moroccan king, sent on 10 May 2011, reveals how the one-year extension was arrived at. The EU's Fisheries Commissioner, after all, had not wanted it: she was pushed to do so by the President of the Commission himself, José Manuel Barroso.[71]

In order to be approved, such an extension had to be first passed by the Council of Ministers and then formally agreed to by the Parliament in the autumn.

The debate in the European institutions throughout 2011 was then on whether or not they should accept a twelve-month continuation to a fishing practice that had simply carried on without interruption. As matters turned out, the lobby in favour of fishing Western Sahara's waters would fail.

Growing opposition

Central to the debate of the one-year extension in 2011 was whether the first four years from 2007 to 2011 had really benefited "the local population" or not. This was naturally not what the UN had stressed (it had requested benefits and respect for the wishes of "the people"), but the Commission had set the agenda for the debate. Under these terms, Morocco could, in theory, have reported

on the illegal settlers benefiting from the EU agreement. However, it did not even bother to report on that.

On 13 December 2010, Morocco had for the first time forwarded information to the European Commission about how the EU funds had been spent. The first impression was not good. In a memo sent out from the Commission to the Council and Parliament on 16 February 2011, the content of the Moroccan report was diplomatically labelled as "some information" and "a step in the right direction". The Commission noted that "the socio-economic impacts on this region are assessed specifically and information provided tends to demonstrate that this region is benefitting in terms of job creation and additional turnover". However, a closer study of Morocco's short, forty-four-slide PowerPoint presentation, would lead to a different conclusion.[72] The document neither mentions Western Sahara nor its population at all. As was to be expected from a report from Morocco, the report did not even consider the wishes or interests of the Sahrawis, either those from the occupied territories or the portion of the people (some 50 per cent) that live as refugees in Algeria as a consequence of Morocco's occupation.

One month later, on 15 March 2011, no further information had reached the Commission, when the PowerPoint was sent out to the Council of Ministers.

The so-called benefit report proved to be crucial for many of the member states when they formulated their positions. It constituted the main argument for most Northern European countries, all of them objecting to extending the fisheries on such a shallow basis. But many small states are not enough to win a vote in the Council. One or two large EU member states are always needed to reach a sufficient qualified blocking minority. As the UK had a negative attitude to the fisheries from the beginning, and Spain, France, and Poland were positive, it was clear that the matter would fall to the German government.

As German officials reviewed the file, they concluded that there was no evidence whatsoever to show that the "local population" benefited. Remarkably, it seemed that the prolongation would be stopped by the Council, only a few months after the twelve-month extension had begun. In the end, however, in the last minute before the final vote on 29 June 2011, Germany did a volte-face. Without

any new data having been placed on the table, Germany stated that there was "overwhelming" evidence that there was local benefit. It never explained why it had changed its position.

Some speculate that the German U-turn was due to a political crisis in relations with Madrid. Only four weeks previously, German authorities had falsely claimed that Spanish cucumbers were responsible for an outbreak of E. coli bacteria in Europe. Others point to German relations with Morocco's allies in France, relations that always needed to be carefully balanced. Some claim it was due to Germany's desire for green energy production in North-West Africa. In any case, with Berlin's last minute turnaround, the Council could give its approval with the necessary majority, and, while waiting for Parliament's final approval later in the autumn, fisheries could continue. No one appeared to challenge Germany as to what information – after four years of frustrating Moroccan silence - had appeared out of the blue in order to make it change its opinion. No new information was added to the pointless PowerPoint. Applying the loss ratio explained by the evaluation report, the decision to extend the four-year agreement yet another year constituted a financial loss to the EU of a minimum of 12.6 million euros.[73]

By the autumn of 2011, five months later, it was Parliament's turn to assess whether it would give a green light to what the Commission and the Council had already approved. Would they use their newly acquired Lisbon Treaty powers and stop an agreement that in any case was to end only two months later? Under the one-year extension, the fisheries had by then already been running for months. But there was discontent about the way it was extended despite the flaws. "I am not happy that we had this sudden extension after asking for the Commission's views for a year," stated one parliamentarian.[74]

The three committees – the Development Committee, the Budget Committee, and the Fisheries Committee – would each present its recommendations, but the Fisheries Committee would carry most weight. It was the Fisheries Committee's recommendation that would be presented to the plenary of Parliament. In each committee, most controversial aspects of the agreement were debated, including the international relations question of Western Sahara itself.

The Budget Committee was first out of the gate. Taking into account the evaluation report, the Committee had no choice but to recommend rejection of the one-year extension. As the budget rapporteur, French MEP François Alfonsi, remarked,

> this agreement presents a double problem: it is not regular in legal terms, nor is it in line with the sustainable objectives that Parliament upholds.
>
> Tax payers' money needs to be spent wisely and legally.[75]

According to the rapporteur, this one single agreement with Morocco ate up a sizeable percentage of the entire EU budget for these types of bilateral fisheries agreements. "25% of the fisheries budget line is spent on this agreement – that is a lot," Alfonsi noted.[76]

Surprisingly, even though it was documented as a significant financial loss for the EU, it ended up in a close vote. And the voting procedure for this particular decision was apparently so confusing that some parliamentarians ended up voting for the opposite of what they intended. When the result proved negative for the prolonged agreement, a handful of surprised Spanish socialists objected, but the chair of the meeting said that there would be no new vote.

Second up was the Development Committee – and they arrived at the same conclusion. "The right way to go is not in neglecting international law, principles of environmental sustainability or sound economics," the Development Committee's rapporteur, Swedish MEP Isabella Lövin, stated.

Presenting her report in the Development Committee on 10 October 2011, the rapporteur strongly urged the Parliament to turn down the proposed one-year extension of the agreement. She explained how the sectoral support given under the fisheries agreement had been "a failure". Under the agreement, an annual amount of 13.5 million euros was earmarked for the development of the local fisheries sector of "Morocco". Only 15 per cent of that money had been used. The rapporteur added that it was "unacceptable that Morocco has totally neglected the European Commission's questions on the benefits and the wishes of the Saharawi people".

At that point, neither Morocco nor the European Commission had provided any proof that the Sahrawi had been consulted or had benefited from the fish deal that the EU had signed with occupier Morocco. As mentioned earlier, these were the prerequisites for legality that the Parliament's legal service had set down in its 2009 legal opinion.

Morocco's reported refusal to receive a delegation of the Parliament's Fisheries Committee, which was to evaluate the implementation of the fisheries partnership, was not appreciated by the Development Committee. "Such tactics – not answering questions or allowing delegations – should not be [re]warded," stated Lövin.[77]

When the decision came up for a vote in the Development Committee, the negative report was passed with an overwhelming majority. There were only a few objectors.

French MEP Maurice Ponga was one of them. By way of illustration, Ponga deemed it important to support Morocco's profound reforms by approving the agreement. Morocco needed, according to this argument, to be rewarded for its alleged political achievements through the fisheries agreement. Furthermore, "the fish have been caught and sold: we can't put them back in the water," he said.[78] Ponga is himself from another non-self-governing territory, New Caledonia, and known as a fierce defender of French control over the Melanesian archipelago.

To wrap it all up, the preparatory work in the committees ended with a splash in the Fisheries Committee. The rapporteur for the case in that committee, Finnish liberal Haglund, issued a very critical report, diplomatically outlining the problematic aspects of the evaluation. The report was a draft recommendation written for the plenary to vote on after being dealt with in the Fisheries Committee.

The "Haglund report" underlined the main conclusions from the important, independent evaluation report: how the agreement had resulted in large financial loss for the European Union and destroyed the ecology of Western Sahara's and Morocco's ocean waters. The recommendation also noted that there were questions as to the legality of the agreement, since it was being applied to the waters off Western Sahara, and indicated that there was no information to clarify whether the Sahrawi people actually benefit from the agreement.

But the draft report was not passed as easily as in the other two committees. The main reason is to be found in the composition of the Parliament's Fisheries Committee. It only includes members of fishing nations, each member representing its own national interests. The debates in the Committee normally thus follow the logic of parliamentarians overbidding each other in offering themselves generous concessions on their own fishing grounds, while the parliamentarians of other nationalities withhold any objections, since their own interests will be up for debate later. This mechanism of horse-trading threatened fish stocks, which, in itself, is one of the main explanations of how the EU has managed to destroy its own marine environment. And, to make the EU-Morocco debate even more problematic, a disproportionate number of the committee's members are Spanish and French – representing the two states with the closest relations to Rabat. All this made it nearly impossible to get Haglund's report approved: in the vote in the Fisheries Committee, the pro-Moroccan members decided to amend the final sentence from a negative to a positive conclusion. The rest of his report remained unchanged.

Naturally, this was not how Haglund wanted his report. What was intended to be a very thorough and critical report looked like a bad joke when it was presented before the entire European Parliament plenary session.

To summarize a long argument in a few sentences, once the amendment to the conclusion had been adopted, the report stated something like this: "Because it is damaging to the environment, because it is a waste of taxpayers' money, because of the controversy over Western Sahara, because it has no development effect, the EU fisheries agreement should thus be continued." It was passed with a small majority: twelve for and eight against, with one abstention.[79]

"That went well," said a smiling Spanish parliamentarian to the Moroccan delegation sitting contentedly at the back of the room as the meeting closed. The final vote would take place in a full session of the Parliament three weeks later, and the recommendation was to continue the fisheries because it was damaging to the environment, the EU economy, and international law.

For the next weeks, Haglund's team worked intensively to mobilize the vote against the report he had himself authored.

Historic decision

"No fishing activity from the European fleet will be tolerated and all boats operating in the area of the fisheries agreement are asked to leave national territorial waters on Wednesday before midnight," the Moroccan foreign ministry said in a statement on 14 December 2011.[80] The Moroccan government underlined, half in threat, that it would also conduct a global reassessment of its partnership with the EU.

The final vote in the EU Parliament in Strasbourg a few hours earlier had come as a shock to most observers. It took the fisheries industry and the Moroccan government by complete surprise. The voting numbers on the display screen showed that 326 had voted in favour of ending the EU-Morocco fisheries. 296 had voted against, while 58 had abstained.[81] For a second, there was total silence in the large plenary room, as if no one understood what had just happened. Then – as Haglund from Finland raised his fist in the air to celebrate – spontaneous applause broke out. The fisheries would end. It was the second time in the history of the European Union that a trade agreement had been stopped by the European Parliament, and the first time that this had happened to a fisheries agreement.[82]

Looking back on that decision years later, and taking into account the strength of the arguments to stop the fisheries deal, it was perhaps not a total surprise that the vote ended the way it did. The peculiar thing, however, was that 296 MEPs actually voted for the agreement. They didn't need to explain why. Most were influenced by the French and Spanish members of the socialist and conservative blocks in the parliament.

There was, in the end, a lot at stake as the parliamentarians were requested to cast their vote that day. The pressure on the members of parliament to accept a continuation of the fisheries had come from three main different fronts.

One of these was the Moroccan government itself with its key allies in the European Parliament. The Moroccan embassy to the EU had a large delegation consisting of lobbyists, parliamentarians, and ambassadors, who could be seen strolling around the corridors of the parliament. Morocco also commissioned a German law firm to represent them; this firm repeatedly made contact with the parliamentarians.

The Moroccan ambassador several times met with his friends in a newly established EU-Morocco Friendship Group at the parliament. The committee, a small group of mostly southern European parliamentarians, gathered with the ambassador a few times prior to the fisheries vote, and the main agenda was to agree on how they could influence the mood in the European Parliament. The final touches to their arguments were developed and sent along by the embassy to allies in this committee only a few days before the vote.

Hard-copy documents written by the Moroccan government were put in the pigeonholes of parliamentarians the day before the vote. The leaflets basically claimed that the findings of the game-changing independent evaluation were erroneous, that "the political aspects of [the] Western Sahara dispute are not relevant to the EP's decision on the agreement,"[83] and that Western Sahara was anyway part of Morocco's "Southern regions".

The night before the vote, the president of the Friendship Group, French MEP Gilles Pargneaux, without any underlying data, argued against the evaluation report, emailing all the other parliamentarians to say that the agreement was economically profitable and ecologically responsible. "I appeal to your critical discernment to reject those amendments which clearly exploit the issue of Western Sahara for well understood political ends, thus jeopardizing any future agreement between the EU and Morocco."[84] The same Pargneaux would later "salute" the US for no longer demanding human rights monitoring in the mandate of the UN operation in Western Sahara, after the American suggestion had been blocked by the French government.[85] The pro-Moroccan parliamentary group consistently labels the territory "Moroccan Sahara" and has, unlike other European parliamentarians, travelled unimpeded to the occupied territory with their Moroccan hosts.

The second group lobbying the Parliament consisted of the Spanish and Moroccan fisheries sector, in partnership with parliamentarians representing them, mainly in the Fisheries Committee. "In the Arab Spring, at a moment in which Morocco has begun a democratisation process, it would be a very negative message from the EU to reject this agreement," the vice chairman of the Fisheries Committee, Alain Cadec, wrote to all the parliamentarians the night before the vote, at a time when dozens of mails were going back

and forth between the defenders and opponents of the agreement on the European Parliament's internal mailing lists.[86]

At a debate on the FPA, Cadec expressed the following: "Withholding our consent [...] would send a very negative signal to the whole region, at this time of democratic reform. Morocco is a vital partner for the European Union. EU support should consist of more than just declarations: we make plenty of those here. It should also consist of agreements, and practical action."[87]

Thirdly, there was the Commission itself, which had invested considerable effort into this particular agreement, the EU's largest fisheries agreement. The fisheries commissioner warned two days before the vote that the Parliament "will be judged" in the light of overall EU-Moroccan relations. "The winds of change that have affected the Southern Mediterranean and some countries beyond have touched Morocco too. So what is the Commission's assessment of this? The Commission's assessment is that, in Morocco, the authorities have launched a significant process of reform with the elaboration of a new constitution, increasing democratic accountability and respect for human rights [...]. The European Union, at all levels, has welcomed these changes. [...] That is the framework we have to bear in mind when making our decisions," said Commissioner Maria Damanaki.[88] Several parliamentarians felt the Commission's pressure. It was orchestrated and planned – an email sent to the Moroccan king by one of his lobbyists following an internal fish-vote-strategy meeting with the head of the Parliament's fisheries committee, Carmen Fraga Estévez, noted the following: "Mrs Fraga expects some pressure from the President of the Commission."[89]

Yet, despite the calls from supporters of the agreement, the European Parliament rejected it. While objecting to the extension, the Parliament at the same time invited the Commission to start a new round of fisheries talks with Morocco. It noted, however, that the environmental and financial aspects as well as the "benefits" to the local population in Western Sahara would have to be taken into account.

The Commissioner for Fisheries and Maritime Affairs, remarked that "the EC will fully respect the European Parliament's vote today. [...] We do not know if a new fisheries protocol with Morocco is possible. We will explore all the possible ways forward," she said once the result of the vote became clear.[90]

The leading members of the Fisheries Committee had always stated that the Sahrawi people's rights – or "politics", as they said – had nothing to do with the Fisheries Committee. Yet, suddenly the very same people had very strong opinions on the political importance of the fisheries agreements. It seemed it was the only argument that remained: Morocco is important to the EU.

Alain Cadec, vice president of the Parliament's Fisheries Committee was in shock over the vote. "This is a very negative signal we are giving Morocco at the time of the Arab Spring," he stated.[91] The French parliamentarian had already stressed the importance of the "the development of the Moroccan fisheries policy in all Moroccan territory".[92]

A French former minister of justice, of Moroccan origin, called the Parliament's rejection a "provocation" and said Morocco needed to be supported for the "courageous reforms" that its government had carried out.[93]

The Spanish government stated its regret at the Parliament's decision and said that they "don't agree" with the Parliament – without going into details on why they didn't. Both shipowner associations and fishermen associations regretted the decision.[94]

"It is now urgent to find all possible means, through a specific and immediate action of the EU, to compensate the serious consequences of the agreement disruption that will hit many enterprises and workers of the fishing industry," stated the president of the European association of national fisheries organizations. The group criticized Damanaki for not better defending the agreement in the European Parliament.[95]

The Spanish government followed the demand from the sector and urged compensation from the EU for lost fisheries opportunities. By January 2012, the Spanish compensation demand to Brussels stood at a minimum of 15 million euros.[96] That equals 1.6 times the amount of money that the EU aid organization ECHO proudly donates every year to the Sahrawi refugees – owners of the fish that the Spanish fishermen wanted to catch.

In addition, the EU's ambassador expressed regret: "I am sorry for our relations with Morocco," the diplomat said. "Against the opinion of the Member States of the European Commission [sic] and Mrs. Ashton, EU High Representative for Foreign Affairs and Se-

curity Policy, the European Parliament voted against the proposed extension of the Protocol of the EU-Morocco fisheries agreement," Landaburu was quoted as saying in the Moroccan state media.[97]

Tomato side-effect

The Parliament's rejection of the fisheries agreement, and the following tension with Rabat, had a peculiar consequence. For years, the Commission and Morocco had been discreetly negotiating another bilateral agreement, on the free trade of agriculture and fisheries products.

The deal, which was an extension of the so-called EU-Morocco Association Agreement first negotiated in 2000, had already gone through the Council and was up for vote in the Parliament on 16 February 2012, only two months after the European Parliament had given the thumbs down to the fisheries pact. The agreement meant trade liberalization of a wide range of agriculture and fisheries products between the Moroccan and EU markets.[98] No mention whatsoever was made of Western Sahara or the Sahrawis.

Under the agreement, the EU would risk giving trade preferences to products from Western Sahara. The problem was identical to the one of the fisheries. What right did Morocco have to strike deals on natural resources in Western Sahara without taking into account the wishes and interests of the Sahrawis? Could Moroccan companies claim that a tomato is exported from Morocco if it is actually from occupied Western Sahara?

The question would, in principle, be easy to answer: no European state recognizes Moroccan claims to the territory. Other non-EU countries, such as Norway, Switzerland, or the US have clearly stated that trade preferences cannot be granted to goods from Western Sahara under their respective free trade agreements with Morocco. In a recent case, a Norwegian importer had a 1.2 million euro customs fee imposed by the Norwegian government for importing goods from Western Sahara. The importer had falsely declared the goods to be of Moroccan origin under Norway's free trade agreement with Morocco and had thus incorrectly received a tariff reduction on imported goods.[99]

The EU tends, however, to go in the opposite direction: it even published lists of companies in Western Sahara that were qualified

to export to the EU under the deal. Would the EU not violate its duty of non-recognition through such practice?

The vague geographical definition sparked debates. As the Parliament's agriculture committee looked into the agreement, it asked the Commission to identify whether Western Saharan goods would be included in the agreement or not. The Commission, unable to give a clear answer, invited the Moroccan ambassador himself to a hearing with the agriculture committee behind closed doors. "Let's start with the basics. Define your borders," the ambassador was challenged by the parliamentarians. After some time, the angry ambassador was observed departing the meeting room, slamming the doors.

An intense lobby was carried out on the part of the Commission and by pro-Moroccan parliamentarians to avoid the same thing happening to the trade agreement as had happened to the FPA. In fact, the Parliament's rejection of the fisheries agreement in December 2011 was used as an argument to not vote against the new trade agreement as well. Enough political damage had been done to relations with Rabat. Yet, the problem was exactly the same.

A report from Western Sahara Resource Watch identified eleven agricultural plantations in the region around the city of Dakhla, owned either by the Moroccan king personally or by French or Moroccan agriculture companies.[100] Similarly, a range of fish-processing companies in Western Sahara and southern Morocco utilize fish caught or landed in Western Sahara. These two sectors together are an important part of Morocco's strategy to cement the occupation, by employing Moroccan settlers in Western Sahara. The agreement between the EU and Morocco could be to directly benefit Moroccan companies that export fish and agricultural products from Western Sahara.

When the new trade agreement was up for the vote, many questions were raised about why the EU left it to Morocco to determine the borders of its national territory. Two of the three parliamentary rapporteurs appointed to examine the proposed agreement – the rapporteur of the Committee on Agriculture and Rural Development, and the rapporteur on International Trade – both recommended that Parliament withhold its consent. The legal dilemmas resulting from the possible inclusion of Western Sahara in the territorial scope of the new agreement were part of their concern.[101]

On 16 February 2012, under intense pressure from the European Commission, the European Parliament consented to the new agreement: 369 MEPs voted in favour, 225 against, and 31 abstained. Many parliamentarians were in fact under the impression that agri-industry doesn't exist in Western Sahara and that the geographical definition debate was thus irrelevant. While there was a good deal of knowledge in the Parliament about the EU-Morocco fisheries agreement, the controversies surrounding the trade deal went under the radar of most parliamentarians.

It is therefore not surprising that the debate was never as heated as on the fisheries. "So far there is practically no agricultural activity in Western Sahara," wrote the Commissioner for Neighbourhood Policy in a "fact sheet" to the parliamentarians a few weeks before they voted.[102] The fact that Morocco had plans for a massive expansion of the sector in the occupied territory was not mentioned. Nor that the agreement also covers fisheries products, which are exported to Europe on a large scale.

The European Commission welcomed the vote of the European Parliament on the agreement with Morocco. As Commissioner for Agriculture and Rural Development Dacian Cioloș stated to EU lawmakers, "this is an important agreement, not only in economic terms, but also in political terms."[103]

"To the extent that exports of products from Western Sahara are de facto benefitting from the trade preferences, international law regards activities related to natural resources undertaken by an administering power in a non-self-governing territory as lawful as long as they are not undertaken in disregard of the needs, interests and benefits of the people of that territory. The de facto administration of Morocco in Western Sahara is under a legal obligation to comply with these principles," stated EU High Representative Catherine Ashton.[104] The fact that Morocco does not view itself as the administering power of Western Sahara, does not behave as such in the UN institutions, and that the UN does not view Morocco as such seems not to be part of the EU's analysis. As with the fisheries, the EU also proceeded in violation of the 2002 UN legal opinion. "The EU recognizes Morocco's commercial rights in Western Sahara" was how one Moroccan newspaper interpreted Ashton's statements.[105]

Alain Cadec, the same parliamentarian that had lamented the rejection of fisheries activities in Western Sahara because Morocco was apparently pursuing reforms in the context of the Arab Spring, said the new trade deal was important since Morocco was going through a series of economic reforms.

The Moroccan ambassador to the EU called it "a great relief". "It is evidence of MEPs' confidence in the development and reform process in Morocco," he told the press. His superior had said that the outcome was thanks to the work of the diplomatic service and Moroccan MPs.[106] EU-Moroccan relations were back on track.

The new trade agreement, in the end, entered into force on 1 October 2012. Since then, some states have raised concerns with regard to its application. Both Sweden and the Netherlands have so far stated that goods coming from Western Sahara cannot be given preferential tariffs to the EU under the agreement.[107] Once again the Commission chose to turn a blind eye to the Sahrawi people's rights. The EU was split yet again.

On 21 December 2016, the deal was stopped by the Court of Justice of the European Union.[108] It judged that the EU had no right to enter into trade deals covering the territory of Western Sahara. The court concluded that the territory is "separate and distinct" from Morocco, and that it was up to the representatives of "the people" of the territory to decide if any trade agreements were to cover Western Sahara. All politically founded arguments from the EU institutions were totally ignored by the court. No mention was made of the "benefits to the population" nor of Morocco being the "de facto administering power".

Four more years
But let us return to the fishery, a story that has not quite ended. On the contrary, as fishing is now taking place once again. Right after the extension to the fisheries agreement had been voted down and the EU fleet left Saharan waters, the debate on EU fisheries in Western Sahara started all over again. By the time of the historic December 2011 vote, the former Commissioner for Fisheries, Joe Borg from Malta, had already been replaced by a more critical voice, Maria Damanaki from Greece. Politically active against the former dictatorship in Greece, Damanaki was a keen defender of

human rights – principles generally not much discussed in the EU fisheries meetings.

Her first suggestion, supported by several states, was to completely exclude Western Sahara from the new agreement with Morocco. She proposed that this should be mentioned in her negotiation mandate.[109]

"Excluding Western Saharan waters would make it impossible for Morocco to reach an agreement," stressed the vice president of the Spanish fisheries confederation, CEPESCA. He stated that because Western Sahara had been included in the deals before, they must be so again.[110]

Together with its Moroccan partners, CEPESCA has carried out lobbying in the EU institutions for years. In CEPESCA's view, the suggestion to exclude Western Sahara would not be a "viable" option for Rabat. Instead, CEPESCA underlined, Morocco would have to ensure benefits accrued to the region – the same demand that the EU had raised half a decade earlier, but which Morocco never bothered to report on.

After intense pressure from Spain, the Commission's suggestion to exclude Western Sahara was dropped from the draft negotiation mandate. Instead, a new suggestion was that the draft text would state clearly that the fishing zones covered by the envisioned agreement would include those in the waters of the Non-Self-Governing Territory of Western Sahara, south of 27°40N. A second specific item was that the Commission expected Morocco to guarantee that it would fulfil its obligations under international law which result from the "de facto administration of Western Sahara". According to the Commission, Morocco should regularly report on the geographical distribution of the socio-economic impact stemming from the support given under the agreement.

These two references to Western Sahara, however, stirred debates at the Council level for weeks. Spain and France, backed up by the fishing nations of Portugal, Latvia, and Lithuania, demanded that any specific mention of Western Sahara be removed from the text, in order not to upset their Moroccan counterpart. On the other hand, countries like Sweden, the Netherlands, the UK, and Germany favoured a clear reference.[111]

The territory of "Western Sahara" was, in other words, considered

by several governments too political to mention. But apolitical if omitted. Obviously, the only party to take into account when assessing the political controversy of the EU fishing in Western Sahara is, for some actors, the occupying power Morocco. With that in mind, the previous explanations of the apolitical nature of the fisheries agreement are put in a completely new light. The Commissioner stressed back in 2006 that it respected international law and would not prejudice the Western Sahara issue. "He also noted that the agreement made no direct reference to the Western Sahara," reported the Financial Times.[112]

So, the negotiation mandate had to be changed: one could indeed fish in occupied Western Sahara waters, but without mentioning where, because that would be political. As the reference to Western Sahara was in the end forced from the negotiating mandate primarily because of Spanish pressure, Commissioner Damanaki instead introduced a clause on basic human rights as a precondition for a new agreement. But the insistence on a human rights paragraph infuriated the Moroccans and remained the main hindrance to further negotiations. Even critics of the plans for a new agreement in Western Sahara questioned the insistence on human rights. The European Parliament had repeatedly condemned the Moroccan human rights track record in Western Sahara, while the UN Secretary-General expressed his deep concern. If human rights were a precondition, would the terms not then already be broken the very same day the agreement was signed?

While the negotiations on a human rights clause took place, the European Parliament repeatedly stressed that human rights in Western Sahara were being violated. In February 2013 Parliament

> expresses its concern at the continued violation of human rights in Western Sahara; calls for the protection of the fundamental rights of the people of Western Sahara, including freedom of association, freedom of expression and the right to demonstrate; demands the release of all Sahrawi political prisoners; welcomes the establishment of a Special Envoy for the Sahel and stresses the need for international monitoring of the human rights situation in Western Sahara; supports a fair and lasting settlement of the conflict on the basis of the right to self-determination of the Sahrawi people, in accordance with the relevant United Nations resolutions.[113]

During the summer of 2013, while EU institutions were on summer break, a new fisheries agreement was reached between the Commission and the Government of Morocco.[114] No human rights clause was introduced, the first time this had happened in a European fisheries partnership agreement since 2010.[115] Instead, a vague reference to the human rights clause in the Association Agreement was made in a compromise with the Moroccans.

In parallel to this, during the negotiations, the two EU states that had lobbied most for the Commission to enter into the fisheries agreement, Spain and France, prevented permanent UN monitoring of human rights in the territory. The UN Secretary-General Ban Ki-Moon had repeatedly urged the Security Council to introduce a permanent mechanism for human rights monitoring, which the US government had suggested to the Security Council. The suggestion was shot down by the two states. Thus, it is unlikely that the gravity of the Moroccan violations will ever be documented well enough to have the deal blocked.

The parliament approved the new agreement, ironically, on Human Rights Day 2013. The EU community had achieved a less costly agreement, but the violation of international law in the new agreement was just as significant as in the past. However, it included sufficient amendments to give the Spanish fishing fleet – and the Moroccan government – its majority in the parliament.

Later that same day, dozens of Sahrawis were injured by Moroccan security forces in occupied Western Sahara as they protested the EU signing of an illegal deal for the plunder of their fish stocks.[116]

History made

The voting down of the EU fisheries in Western Sahara on 14 December 2011 was a historic decision. It was the second time in the history of the European Union that the Parliament used its powers to stop an international treaty agreement that had been adopted by EU ministers.

The EU's own institutions, as well as the independent reports that it had commissioned, documented that the EU fisheries agreement in Western Sahara was damaging the ecology, financially catastrophic for the EU, scarcely creating any jobs – and in violation

of international law. As the prevailing mood turned against the deal, its defenders had fiercely tried all strategies to support the continued fisheries. They misrepresented the EU reports, they claimed the reports were wrong, and, most importantly, they argued for the political importance of Morocco. The EU is an ally of Morocco – and therefore the EU fleet must fish in Western Sahara. That was the logic during these hectic last days before the final vote. The same forces that had argued so intensively for the apolitical nature of the EU fisheries practices in Western Sahara had switched to the other extreme. They now used geopolitical arguments to defend fisheries.

Do these political arguments survive in a court of law? Does the EU fisheries practice, a political deal originating from the Franco regime's dirty sell-out of the Sahrawi people to the Moroccan occupier in 1975, really respect international law? Is it legal for the EU to fish in the waters of the occupied Western Sahara by paying Morocco money to do so?

That is now for the Court of Justice of the European Union to decide. In 2018, it will conclude on the legality of EU fisheries once and for all, after Frente Polisario brought a legal case against the EU in 2014.[117]

Time will tell if the EU feels the need to respect EU law, or if it tries to find political arguments to thwart that too.

1 "Le volet financier n'était pas forcément le plus important aspect de cet accord. Le volet politique est non moins important." "Accord de pêche: Naufrage polisarien", Aujourd'hui Le Maroc, 24 May 2006, http://www.fishelsewhere.eu/files/dated/2009-10-25/laenser_2006_in_alm.pdf. For translation, see "EU Commission and Morocco sign extension of controversial fish pact", WSRW, 28 Feb. 2011, http://www.wsrw.org/a204×1880

2 "Countries and regions: Morocco", European Commission, 2 May 2017, http://ec.europa.eu/trade/policy/countries-and-regions/countries/morocco/

3 Conversation with the author, November 2010.

4 "European Parliament resolution", European Parliament, 7 Feb. 2013, http://www.europarl.europa.eu/sides/getDoc.do?type=TA&language=EN&reference=P7-TA-2013-55. See also "Report", European Parliament, 19 Nov. 2012, http://www.europarl.europa.eu/sides/getDoc.do?type=REPORT&language=EN&refeence=A7-0377/2012

5 "La UE prefiere evitar el conflicto con Marruecos", La Razón, 12 Nov. 2010, http://www.larazon.es/detalle_hemeroteca/noticias/LA_RAZON_341773/historico/769-la-ue-prefiere-evitar-el-conflito-con-marruecos#.UXjX7Mp7N7k

6 "Le Maroc et l'UE partagent les mêmes valeurs de démocratie et de liberté (Eneko Landarbu)", Maghress, 27 Sept. 2013, https://www.maghress.com/fr/mapfr/14494

7 "Deep and Comprehensive Free Trade Area: EU-Morocco; Questionnaire", http://trade.ec.europa.eu/doclib/docs/2013/february/tradoc_150521.pdf

8 "EU and Morocco start negotiations for closer trade ties", European Commission, 22 Apr. 2013, http://trade.ec.europa.eu/doclib/press/index.cfm?id=888

9 "31 Saharawi NGOs call for change in EU's trade policy", WSRW, 26 June 2012, http://www.wsrw.org/a214×2338

10 "Statement by the Spokesperson of EU HR Ashton on Western Sahara", European Union Delegation to the United Nations – New York, http://eu-un.europa.eu/statement-by-the-spokesperson-of-eu-hr-ashton-on-western-sahara/

11 "Security Council Extends Mandate of United Nations Mission in Western Sahara until 30 April 2013, Unanimously Adopting Resolution 2044 (2012)", United Nations, 24 Apr. 2012, http://www.un.org/News/Press/docs/2012/sc10621.doc.htm

12 "Responsible Fishing Practices Critical", Greenpeace, 20 July 2011, http://www.greenpeace.org/africa/en/News/news/Responsible-Fishing-Are-Practices-Critical/

13 European Commission, "Facts and Figures on the Common Fisheries Policy" (2016), 18, https://ec.europa.eu/fisheries/sites/fisheries/files/docs/body/pcp_en.pdf

14 Eurostat: Your key to European statistics on fisheries, http://epp.eurostat.ec.europa.eu/web/fisheries/statistics-illustrated

15 Toby Shelley, Endgame in the Western Sahara: What Future for Africa's Last Colony? (London, 2004), 75.

16 Parliamentary questions, European Parliament, 29 Oct. 2004, http://www.europarl.europa.eu/sides/getDoc.do?type=WQ&reference=E-2004-2679&format=XML&language=EN

17 "Council Regulation on the conclusion of the Fisheries Partnership Agreement between the European Community

and the Kingdom of Morocco", 28 Apr. 2006, http://www.vest-sahara.no/files/dated/2008-05-15/fisheries_partnership_agreement_eu-morocco.pdf

18 "Letter dated 29 January 2002 from the Under-Secretary-General for Legal Affairs, the Legal Counsel, addressed to the President of the Security Council", United Nations, 12 Feb. 2002, http://www.wsrw.org/files/dated/2008-10-22/un_report_on_legality_oil.pdf

19 This is also mentioned in "Legal Opinion, SJ-0085/06", European Parliament Legal Service, 20 Feb. 2006, http://www.wsrw.org/files/dated/2013-04-26/parliament_legal_opinion_fpa_20.02.2006.pdf

20 Letter from European Commission to Western Sahara Resource Watch (WSRW), 23 June 2010, http://www.wsrw.org/files/dated/2010-06-24/letter_commission-wsrw_23.06.2010.pdf

21 "Commission under fire over Morocco fisheries agreement", EUobserver, 9 Mar. 2006, http://euobserver.com/news/21092

22 "EU Council refuses to disclose 2006 legal opinion on Morocco fish deal", WSRW, 04 July 2013, http://www.wsrw.org/a105×2617

23 Commissioner Joe Borg, "Debates", European Parliament, 15 May 2006, http://www.europarl.europa.eu/sides/getDoc.do?type=CRE&reference=20060515&secondRef=ITEM-018&format=XML&language=EN

24 Legal Opinion, SJ-0085/06 (see n. 19); Legal Opinion, European Parliament Legal Service, 13 July 2009, http://www.wsrw.org/files/dated/2017-11-30/ep_legal_opinion_schoo_2009.pdf; http://www.wsrw.org/files/dated/2017-11-30/ep_legal_opinion_schoo_2009_summary.pdf

25 Legal Opinion, SJ-0085/06 (see n. 19).

26 Commissioner Joe Borg, "Debates", European Parliament, 4 Apr. 2006, http://www.europarl.europa.eu/sides/getDoc.do?type=CRE&reference=20060404&secondRef=ITEM-014&format=XML&language=EN

27 MEP Manuel Medina Ortega, "Debates", European Parliament, 15 May 2006, http://www.europarl.europa.eu/sides/getDoc.do?type=CRE&reference=20060515&secondRef=ITEM-018&format=XML&language=EN

28 MEP Carmen Fraga Estévez, ibid.

29 MEP Jean-Claude Martinez, ibid.

30 "Western Sahara", Advisory Opinion, International Court of Justice, 16 Oct. 1975, http://www.icj-cij.org/files/case-related/61/6197.pdf

31 "EU fishing deal set to proceed despite Sahara dispute", Financial Times, 14 May 2006, http://www.ft.com/cms/s/0/7d092668-e380-11da-a015-0000779e2340.html

32 "Saharawi prisoners denounce EU fisheries", letter dated 16 May 2006, WSRW, 12 June 2011, http://www.wsrw.org/a193×1999

33 Commissioner Joe Borg in "Debates" (see n. 27).

34 Ambassador Hans Corell, "The legality of exploring and exploiting natural resources in Western Sahara", accessed 17 Feb. 2018, http://www.havc.se/res/SelectedMaterial/20081205pretoriawesternsahara1.pdf

35 The same conclusion on the illegality of the EU fisheries agreement was reached by French NGO Sherpa (2006; http://www.fishelsewhere.eu/files/dated/2010-06-26/sherpa analyse_fpa_2006.pdf), by the Asso-

ciation of the Bar of the City of New York (2011; http://wsrw.org/files/dated/2011-04-24/new_yorkbar_2011.pdf), by a group of Swedish jurists from four universities (2011; http://www.wsrw.org/files/dated/2011-02-17/swedish_legal-opinion_16.02.2011.pdf), and by ELDH, European Association of Lawyers for Democracy & World Human Rights (2011; http://www.eldh.eu/fileadmin/user_upload/ejdm/publications/2011/Press_release_-_9th_February_2011_-_Western_Sahara.pdf)

36 "Here is the secret legal opinion from the EU Parliament", WSRW, 23 Feb. 2010, http://www.wsrw.org/a105×1346

37 Sahrawi Democratic Republic Ministry of Public Health, "Nutritional and Food Security Survey among the Saharawi refugees in Camps in Tindouf, Algeria", October 2008, http://www.vest-sahara.no/files/dated/2013-05-02/nutritional_survey_2008.pdf

38 Ingrid Barikmo, researcher at Oslo and Akershus University College, in discussion with the author, 2013.

39 "ECHO Factsheet: Sahrawi refugees", European Commission, April 2013, http://reliefweb.int/sites/reliefweb.int/files/resources/sahrawi_en_0.pdf

40 "The dire humanitarian situation, coupled with the absence of access to the natural wealth and resources in Western Sahara west of the Berm, prevented the Western Saharans in the refugee camps from enjoying their economic, social and cultural rights." Security Council, "Report of the Secretary-General on the situation concerning Western Sahara", United Nations, 19 Apr. 2016, http://www.un.org/ga/search/view_doc.asp?symbol=S/2016/355
"The Committee recommends that the State party [...] guarantee respect for the principle of the prior, free and informed consent of the Sahraouis, and thus that they are able to exercise their right to enjoy and utilize fully and freely their natural wealth and resources." Economic and Social Council, Committee on Economic, Social and Cultural Rights, "Concluding observations on the fourth periodic report of Morocco", 22 Oct. 2015, http://www.wsrw.org/files/dated/2015-12-09/cescr_moroc co_2015_eng.pdf

41 "799 organisations, and a refugee in Brussels, protest EU fisheries", WSRW, 29 Sept. 2010, http://www.wsrw.org/a159×1614

42 "Civilian court follows military court against Saharawi activists", WSRW, 19 July 2017, http://www.wsrw.org/a105×3975

43 See n. 4. See also "European Parliament resolution", 12 Sept. 2012, http://www.europarl.europa.eu/sides/getDoc.do?type=TA&reference=P7-TA-2012-0334&language=EN

44 "Saharawi political prisoners demand halt to EU fisheries", WSRW, 14 Sept. 2010, http://www.wsrw.org/a159×1591

45 See, for example, "Polisario expresses concern to Security Council over EU fisheries", WSRW, 28 Nov. 2012, http://www.wsrw.org/a214×2422

46 "Marruecos sopesa no acudir a la UE para opinar sobre el acuerdo pesquero", ABC, 2 Apr. 2006, http://www.abc.es/hemeroteca/historico-02-04-2006/abc/Economia/marruecos sopesa-no-acudir-a-la-ue-paraopinar-sobre-el-acuerdo-pesquero_142988 229026.html

47 "Morocco rejects visit from Euro pean Parliament", WSRW, 4 June 2010, http://www.wsrw.org/a105×1433

48 "Danish journalist deported from Morocco after covering EU fisheries",

WSRW, 29 Nov. 2010, http://www.wsrw.org/a159×1705

49 "Marruecos no nos la va a dar." "Carmen Fraga afirma que habrá problemas para renovar el acuerdo con Marruecos", ABC, 30 June 2010, http://www.abc.es/agencias/noticia.asp?noticia=438556

50 Hans Corell, "Western Sahara – status and resources", in "Protracted conflicts: A long way to go for peace", New Routes 15, no. 4 (2010): 13, https://www.scribd.com/document/49022209/New-Routes-4-2010

51 "Parliamentary questions", Answer given by Ms Damanaki, on behalf of the Commission, 21 June 2010, http://www.europarl.europa.eu/sides/getAllAnswers.do?reference=E-2010-2633&language=EN

52 "Les informations sur les retombées économiques de cet accord dans les régions seraient bonnes à avoir. Elles ne feraient qu'appuyer le bien-fondé de cet accord." "Maroc-UE: Le renouvellement de l'accord de pêche dans l'impasse", L'Économiste, 1 Oct. 2010, http://www.leconomiste.com/article/maroc-uebrle-renouvellement-de-l-accord-de-peche-dans-l-impasse

53 "El servicio jurídico de la Comisión Europea y todos los dictámenes de instituciones independientes han demostrado que no hay ningún problema de legalidad internacional en el acuerdo pesquero con Marruecos." "La UE defiende la legalidad del acuerdo pesquero con Marruecos", ABC, 27 May 2010, http://agencias.abc.es/agencias/noticia.asp?noticia=397879

54 "Swedish students object to EU play on words", WSRW, 14 June 2011, http://www.wsrw.org/a204×1896

55 Commissioner Joe Borg speaking to Sveriges Television, "Det gränslösa fisket", Uppdrag Granskning, 3 Mar. 2010.

56 "Fishing pact loses EU millions in Morocco: Report", Reuters, 8 June 2011, http://www.reuters.com/article/2011/06/08/ozabs-trade-morocco-fish-idAFJOE7570GI20110608

57 "La legalidad del acuerdo pesquero 'puede ser utilizada por razones políticas, porque es el juego político normal, pero no hay ningún problema'." "La UE defiende la legalidad del acuerdo pesquero con Marruecos" (see n. 53).

58 "Es una polémica que intenta aprovechar políticamente un momento de interés mediático sobre un acuerdo." "Entrevista: César Deben, negociador entre la UE y Rabat", Canarias Ahora, 15 May 2006. Reprinted as "Apolitical support", Fish Elsewhere: Stop the EU fisheries in occupied Western Sahara, http://www.fishelsewhere.eu/a170×971

59 In 2014 and 2015, the criminal appeals court in Spain also stated that Spain is still de jure the administrative power in Western Sahara.

60 "Siempre ha habido polémica en los años anteriores también. Un acuerdo con Marruecos incluye todas las aguas y todas las zonas de pesca del Reino de Marruecos. Es una polémica que intenta aprovechar políticamente un momento de interés mediático sobre un acuerdo. Puedo señalar que Marruecos tiene acuerdos con Rusia, con Ucrania y otros países y nunca ha habido ese tipo de polémicas. El interés no es que haya una actividad pesquera en aguas del antiguo Sáhara sino que es la Unión Europea la que negocia. Pero estamos muy tranquilos ya que las opiniones jurídicas tanto de la Comisión Europea como del Parlamento como del Consejo de Ministros han sido unánimes y el acuerdo reúne y respeta todos los requisitos de derecho comunitario y de derecho internacional." "Entrevista: César Deben" (see n. 58).

61 Corell, "Western Sahara" (see n. 50), 13.

62 Norwegian Ministry of Finance, "Company Excluded from the Government Petroleum Fund", Regjeringen.no, 6 June 2005, https://www.regjeringen. no/no/aktuelt/company_excluded_ from_the_government/id256359/

63 "Morocco's fish fight: High stakes over Western Sahara", BBC, 15 Dec. 2011, http://www.bbc.co.uk/news/ world-africa-16101666

64 "Here is the evaluation report of the Morocco fish deal", WSRW, 5 Mar. 2012, http://www.wsrw.org/a214×2261

65 "Marruecos no está 'haciendo los esfuerzos suficientes'." "CE pide a Marruecos más esfuerzo para prohibir la pescar con redes de deriva", Nuestro-Mar, 9 Sept. 2009, http://www.nuestro-mar.org/noticias/pesca_y_acuicultu-ra_092009_25789_ce_pide_a _marruecos_mas_esfuerzo_para _prohibir_l

66 "EU-Morroco [sic] fish deal a 'failure' for all concerned," EUobserver, 1 Apr. 2011, https://euobserver.com/ environment/32102

67 "Here is the evaluation report of the Morocco fish deal" (see n. 64).

68 "Es el informe más negativo que he visto en mi vida." "La Eurocámara critica los malos resultados del acuerdo con Marruecos", EFE, 2 Sept. 2011 http://www.pesca2.com/informacion/ desc_noticia.cfm?noticia=10686

69 "EU Commission admits fishing in occupied Western Sahara", WSRW, 3 July 2008, http://www.wsrw.org/ a128×770

70 "Recommendation", European Parliament, 29 Nov. 2011, http://www. europarl.europa.eu/sides/getDoc. do?type=REPORT&reference= A7-2011-0394&language=EN

71 "Maria Damanaki opposed continued EU fishing in Western Sahara",

WSRW, 2 Dec. 2014, http://www.wsrw. org/a105×3086

72 "Support for controversial Morocco fishing agreement", European Voice 7 June 2011, http://www.euro peanvoice.com/article/imported/ support-for-controversial-morocco-fishing-agreement-/71549.aspx

73 35 per cent of 36 million euros, the annual payment under the protocol.

74 "Morocco fishing deal 'poor value for money'", European Voice, 6 Aug. 2011, http://www.europeanvoice.com/ article/imported/morocco-fishing-deal-poor-value-for-money-/71280. aspx

75 "Budget rapporteur calls for rejec-tion of fish pact", WSRW, 21 Oct. 2010, http://www.wsrw.org/a204×2134

76 Ibid.

77 "Development rapporteur urges Parliament to thumb down fish deal", WSRW, 19 Oct. 2011, http://www.wsrw. org/a204×2123

78 Ibid.

79 "Recommendation", European Parliament, 29 Nov. 2011, http:// www.europarl.europa.eu/sides/ getDoc.do?type=REPORT&refer-ence=A7-2011-0394&language=EN&-mode=XML

80 "EU lawmakers block Morocco-Western Sahara fishing deal", AFP, 14 Dec. 2011, https://www.modern ghana.com/news/367033/eu-lawmakers-block-morocco-western-sahara-fishing-deal.html

81 "MEPs reject extension of the EU-Morocco fisheries agreement and call for a better deal", European Parliament, press release, 14 Dec. 2011, http://www.europarl.europa.eu/ news/en/pressroom/content/201112 13IPR34070/html/Extension-of-EU-

Morocco-fisheries-agreement-rejected-call-for-a-better-deal

82　The first time the Parliament stopped an agreement was the Swift Agreement with the US in February 2010. A third time was the Anti-Counterfeiting Trade Agreement (ACTA) in February 2012.

83　"Moroccan lobby arguments before the EP", Fish Elsewhere, 10 May 2013, http://fishelsewhere.eu/a202×1417

84　"Arguments sent to European Parliament FOR the fisheries", Fish Elsewhere, 10 May 2013, http://fishelsewhere.eu/a202×1418

85　"Réaction à la résolution 2099 des Nations Unies", Groupe d'amitié UE-Maroc, 26 Apr. 2013, https://groupedamitieuemaroc.wordpress.com/2013/04/26/reaction-a-la-resolution-2099-des-nations-unies/

86　"Arguments sent to European Parliament FOR the fisheries" (see n. 84).

87　"Debates", European Parliament, 12 Dec. 2011, www.europarl.europa.eu/sides/getDoc.do?pubRef=-//EP//TEX-T+CRE+20111212+ITEM-013+DOC+XM-L+V0//EN

88　Ibid.

89　"Maria Damanaki opposed continued EU fishing in Western Sahara" (see n. 71).

90　"EP rejects extension of fisheries agreement with Morocco", Fish Information & Services, 15 Dec. 2011, http://fis.com/fis/worldnews/worldnews.asp?monthyear=&day=15&id=48505&l=e&special=&ndb=1%20target=

91　"C'est un signal très négatif que nous donnons au Maroc en plein printemps arabe." "Le Parlement européen rejette un accord de pêche avec le Maroc", Regards citoyens, 15 Dec. 2011, http://regards-citoyens.over-blog.com/article-le-parlement-europeen-rejette-un-accord-de-peche-avec-le-maroc-92522613.html

92　"[Le] développement de la politique de la pêche marocaine sur tout le territoire marocain." "Accord de pêche Maroc-UE: 'Alain Cadec en faveur de la reconduction'", Le Matin, 26 Nov. 2011, https://lematin.ma/express/2011/Accord-de-peche-Maroc-UE_Alain-Cadec-en-faveur-de-la-reconduction/159333.html

93　"Rachida Dati critique le Parlement européen", Le Maroc Hebdomadaire, 17–23 May 2013. See http://www.fishelsewhere.eu/a142×1426

94　"El Gobierno rechaza el veto a la prórroga con Marruecos, negativo para pescadores y armadores", RTVE, 14 Dec. 2011, http://www.rtve.es/noticias/20111214/gobierno-rechaza-veto-prorroga-marruecos-muy-negativo-para-pescadores-armadores/481953.shtml

95　"Indignation of the EU fishing shipowners following the rejection of the present protocol EU/Morocco by the European Parliament", Morocco Tomorrow, 17 Dec. 2011, https://moroccotomorrow.wordpress.com/2011/12/17/uefisheries-indignation-of-the-eu-fishing-shipowners-following-the-rejection-of-the-present-protocol-eumorocco-by-the-european-parliament/#more-7032

96　"(Amp) Arias Cañete dice que un año sin acuerdo de pesca con Marruecos costaría al menos 15 millones en ayudas", EuropaPress, 10 Jan. 2012, http://www.europapress.es/economia/noticia-economia-amp-arias-canete-dice-ano-acuerdo-pesca-marruecos-costaria-menos-15-millones-ayudas-20120110164009.html

97　"Head of EU Delegation in Morocco Regrets EP Vote against Extension

of Fisheries Agreement", Morocco Tomorrow, Dec. 15 2011, http://www.moroccotomorrow.org/head-of-eu-delegation-in-morocco-regrets-ep-vote-against-extension-of-fisheries-agreement/

98 "Draft Opinion of the Committee on Agriculture and Rural Development", European Parliament, 23 Feb. 2011, http://www.wsrw.org/files/dated/2011-07-12/opinion_ep_agri_agriculture_agreement_morocco.pdf

99 "Producer in Morocco stops purchases from Western Sahara", WSRW, 27 Dec. 2010 http://www.wsrw.org/a159×1764

100 "Report: EU consumers unwittingly supporters of occupation", WSRW, 18 June 2012, http://www.wsrw.org/a214×2321

101 "Agreement between the EU and Morocco concerning liberalisation measures on agricultural products and fishery products (16 Feb. 2012)", Official Journal of the European Union, 30 Aug. 2013, http://eur-lex.europa.eu/legal-content/EN/TXT/?uri=uriserv:OJ.CE.2013.249.01.0120.01.ENG

102 "Parliamentary Questions", European Parliament, 2 Mar. 2012, http://www.europarl.europa.eu/sides/getDoc.do?type=WQ&reference=E-2012-002451&format=XML&language=EN

103 "EU-Morocco: Agricultural agreement sign of credibility", European Commission, press release, 17 Feb. 2012, http://europa.eu/rapid/press-release_IP-12-143_en.htm

104 "Parliamentary questions", European Parliament, 14 June 2011, http://www.europarl.europa.eu/sides/getAllAnswers.do?reference=E-2011-002315&language=SL

105 "L'UE reconnait les droits commerciaux du Maroc sur le Sahara Occidental", Yabiladi, 31 May 2011, http://www.yabiladi.com/articles/details/5677/l-ue-reconnait-droits-commeciaux-maroc.html

106 "Morocco, EU adopt agriculture pact", Morocco Tomorrow, 22 Feb. 2012, http://www.moroccotomorrow.org/morocco-eu-adopt-agriculture-pact/

107 "Dutch government repeats: Western Sahara products are not from Morocco", WSRW, 13 Mar. 2013, http://www.wsrw.org/a105×2541

108 "EU Court protects Western Sahara from EU-Morocco trade deal", WSRW, 21 Dec. 2016, http://www.wsrw.org/a243×3695

109 "EC proposes new fishing agreement with Morocco to exclude Saharan waters", Fish Information & Services, 17 Dec. 2010, http://www.fis.com/fis/worldnews/worldnews.asp?l=e&country=0&special=&monthyear=&day=&id=39784&ndb=1&df=0

110 "Excluir las aguas (del Sáhara occidental) iba a imposibilitar por parte de Marruecos de q se llegara a un acuerdo." "Pescadores marroquíes y españoles piden a la UE nuevo acuerdo de pesca con mismas condiciones pero mejoras técnicas", EuropaPress, 7 Dec. 2011, http://www.europapress.es/internacional/noticia-ue-pescadores-marroquies-espanoles-piden-ue-nuevo-acuerdo-pesca-mismas-condiciones-mejoras-tecnicas-20111207205307.html

111 "EU Council still split over reference to Western Sahara", Fish Elsewhere, 26 Jan. 2012, http://www.fishelsewhere.eu/a140×1367

112 "EU fishing deal set to proceed despite Sahara dispute" (see n. 31).

113 "Motion for a Resolution", European Parliament, 4 Feb. 2013, http://www.europarl.europa.eu/sides/

getDoc.do?type=MOTION&reference=
B7-2013-0055&language=EN

114 "New EU-Morocco Fisheries Proto-
col signed today", WSRW, 24 July 2013,
http://www.wsrw.org/a217×2631

115 "Commission failed Council and
Parliament instructions on human
rights", WSRW, 1 Oct. 2013, http://
www.wsrw.org/a217×2667

116 "Western Saharans protest EU-
Moroccan fishing accord", Associated
Press, 11 Dec. 2013, https://finance.
yahoo.com/news/western-saharans-
protest-eu-morocco-204809442.html

117 "Polisario asks for annulment of
EU-Morocco illegal fish pact", WSRW,
22 June 2014, http://www.wsrw.org/
a105×2923

[Western Sahara]

Siemens: A Case Study on Corporate Conversations

An unannotated exchange of letters

We were always afraid of the consequences of Morocco's oil exploration programme in Western Sahara. "If Morocco finds oil in Western Sahara, the king will have even less incentive to accept self-determination in Western Sahara," many argued. Morocco does not produce oil itself, and depends on energy imports. But after fifteen years of exploration, oil has yet to be found.

Instead, something even more problematic developed: massive energy projects by German multinational Siemens. Since 2012, WSRW has been in contact with Siemens to enquire why they are building windmills on illegally occupied land, in partnership with the king's own company.

We offer you an insight into this conversation without additional comment.[1]

1 This exchange of letters has been posted on www.wsrw.org since 2012.

Dr. Dipl.-Ing. Michael Suess
Mitglied des Vorstands der Siemens AG
CEO des Sektors Energy
Wittelsbacherplatz 2
80 333 München

Regarding: Western Sahara, Siemens and the UNFCCC-CDM Windfarm Project

Dear Mr. Suess:

We write to you out of our concern for your company's proposed supply of wind turbines, with associated technical support, to the El Oued Wind Power Plant in occupied Western Sahara. We note Siemens' adherence to the Global Compact initiative, and have a few questions as to how you perceive this engagement to be consistent with your company's commitments under Global Compact.

Western Sahara Resource Watch (WSRW) works in solidarity with the Saharawi people who are the original and rightful inhabitants of Western Sahara. A substantial part of the Saharawi people have lived in refugee camps in the Algerian desert since Morocco illegally invaded their homeland in 1975. Others remain in the occupied territories where they are subjected to serious human rights violations and excluded from the major economic activities of phosphate mining and fishing. More than 100 United Nations resolutions support the Saharawi people's right to self-determination, a right that Morocco is denying them.

WSRW consists of organisations and individuals from more than 40 countries, who together research the engagement of foreign companies in the resource rich country. We believe the occupation of Western Sahara will not stop as long as Morocco profits from it.

Western Sahara - Background

Western Sahara is known as Africa's last colony. Its people - the Saharawi - are ethnically, culturally and linguistically distinct from their neighbors. For more than 40 years, the people of the territory have been noted by the United Nations as having the right of decolonization (*i.e.* self-determination). When Western Sahara was abandoned by Spain in November 1975 the International Court of Justice had just upheld the right of the Saharawi people to self-determination. (We note the Court restated the right to self-determination in its 2010 Kosovo advisory opinion.) A United Nations mission has been present in Western Sahara for more than 20 years. This mission (MINURSO) is not a peacekeeping mission. It is one to ensure the Saharawi people will exercise of their right to self-determination as with South West Africa (Namibia) and East Timor (Timor-Leste) before.

After Spain left its colony, Mauritania and Morocco occupied Western Sahara. The occupation continues in violation of international law. UN resolutions called for the two states to leave the territory and for the Saharawi people to have their right to self-determination. On February 27, 1976, the representatives of the Saharawi people declared the independence of their state, now recognized by more than 75 countries including the African Union. In 1979 Mauritania left the territory after refusing to contribute any longer to what it called "an unjust war". Morocco then occupied a larger part of Western Sahara and carried on with settling the territory with its own citizens, who now outnumber the Saharawi people.

International humanitarian law

The facts of Morocco's occupation of Western Sahara are well known. The occupation fails to meet basic requirements of the *Fourth Geneva Convention* and the *International Covenant on Civil and Political Rights*, treaties that almost all countries, including Spain and Morocco, have entered into and support. (These treaties were the basis in 2011 for the organized international community's UN-sanctioned intervention in Libya.) Morocco's occupation of Western Sahara has been declared illegal under the United Nations *Charter*, the law of self-determination for colonized (non-self-governing) peoples and, importantly for those who would support or assist Morocco in its continuing occupation, international criminal law. Critically, the taking of natural resources from the territory has continued. These include the Atlantic Ocean fishery and mineral resources from the Bou Craa phosphate mine.

The UNFCC-CDM Project in Occupied Western Sahara

The "Clean Development Mechanism" (CDM) of the United Nations Framework Convention on Climate Change (the UNFCCC) recently decided to proceed with the financing of the "Foum El Oued Wind Farm Project". A Project Development Document (PDD) describes the construction and operation of "a 100 megawatt (MW) grid-connected wind farm in the municipality of Laayoune, 9 km east of the wharf in the south of Morocco [sic]" by NAREVA Holding (a Moroccan industrial and financial group). This location is inside the international recognized borders of the territory of Western Sahara. It is in that area of the territory occupied by Morocco. The location is not Moroccan territory.

We note that the PDD identifies Morocco as the "host country", while making no mention of the legal status of Western Sahara.

The Foum El Oued project is presented in the PDD as part of an ongoing intensification of the exploitation of resources in occupied Western Sahara, involving an increase in activity by Moroccan firms, supported by the Moroccan government. On page two the Wind Farm is said to supply electricity to both private and publicly owned companies.

The PDD states that the Foum El Oued project had been expected to start operating on 15 October 2011. However, according to the CDM update website (cdmpipeline.org) the project is still at "validation stage" and therefore has not yet been approved. According to the PDD (at page 12) CDM finance is necessary to make the project attractive to NAREVA by revenues from the sale of Certified Emissions Reductions (CERs). On page 31 the PDD states that "NAREVA stressed that a wind power project is only profitable with CDM revenues." The first crediting period for the sale of CERs is given as 7 years (at page 27). The PDD makes it clear that the CDM is facilitating the project, which would not take place without the support of the CDM via CERs. It is this financing which makes possible Siemens' material support for the project.

We have three general concerns about the Foum El Oued project. First, the project has not been consented to by the Saharawi people. It is an accepted principle of international law that development in a territory such as Western Sahara - occupied militarily and non-self-governing - cannot be done unless there has been the consent of the legitimate inhabitants of the territory and at least some benefit to them. We emphasize here that Moroccan nationals illegally settled in occupied Western Sahara do not qualify as "inhabitants" for purposes of the required consent for industrial and infrastructure development in the territory.

Second, building infrastructure in Western Sahara entrenches the occupation. Such activity gives the

appearance of normalcy and legitimacy to an occupation that is manifestly illegal and which, through building projects, the presence of a very large military force, and population resettlement continues to delay a self-determination referendum for the Saharawi people.

Third, the Saharawi people in exile at refugee camps inside Algeria will see virtually no benefit of the Foum El Oued Wind Farm Project. Most rely on very little electrical power that is not mains supplied. The irony of an occupying state benefitting from the provision of technology, while a displaced people remain without adequate electricity supplies should be lost on no one.

We take note of Siemens's adhesion to the Global Compact (GC) initiative. The GC asks companies to support the 10 well-known principles "within their sphere of influence".

In that context, we are surprised to read statements given by your company to the Danish news service *DanWatch* on March 5 of this year, saying "Siemens's attitude is that Siemens supplies windmills, and it is the customer who decides where they are to be placed" (www.wsrw.org/a131x2263). By such statement, one could get the impression that Siemens chooses not to view its business partners – nor the end-use of its products – as within Siemens's own sphere of influence or corporate social responsibility policy. In the light of the installation and maintenance of key infrastructure in occupied Western Sahara, such a limitation of its responsibilities is, as we see it, highly regretful.

In this regard, WSRW has three questions for your company, which we hope will shed light on how Siemens interprets its commitments under the UN Global Compact initiative:

1) Does Siemens consider the human rights compliance of its business partners to be relevant in the context of fulfilling the principles of UN Global Compact?
2) Does Siemens consider that the human rights impacts of sales agreements or of maintenance contracts are relevant in the context of assuring human rights within its sphere of influence?
3) Does Siemens consider it relevant to engage in talks with the local communities affected by the company's operations?

Finally, we would like to request that Siemens AG not supply technical assistance and material technology to any wind farm (or other energy) project that may be built inside occupied Western Sahara.

We are grateful that you have taken the time to consider this letter, and we look forward to hear from you.

Yours sincerely,

Sara Eyckmans Axel Goldau
International Coordinator WSRW WSRW Coordinator for Germany

Copy of this mail sent to:
Mr. Georg Kell, Executive Director, Global Compact
Business and human rights department, Office of the UN High Commissioner for Human Rights
Centre for Research on Multinational Corporations, the Netherlands

www.wsrw.org

Western Sahara Resource Watch is an international organisation working in solidarity with the Saharawi people. We advance their right to self-determination, protect their natural resources and promote their human rights.

Dr. Felix Ferlemann
Chief Executive Officer
Wind Power Division

Via eMail:

to: Ms. Sara Eyckmans
to: Mr. Axel Goldau
cc: Ms. Alice Cope

Hamburg, May 8th 2012

Siemens' involvement in the Foum El Oued wind park project in the West Sahara region

Ms. Eyckmans, Mr. Goldau,

Thank you for your letter to Dr. Michael Süß, which I am answering in my capacity as CEO of Siemens Wind Power.

We do take your concerns seriously and appreciate that you are sharing your doubts with us. However, we can assure you that Siemens is checking the framework conditions thoroughly before a project decision is made.

As a globally active company, we bear great responsibility for sustainable development throughout the world. Siemens is committed to providing sustainable energy solutions to customers around the world. Since large parts of the African population do not have access to power supply, Siemens can contribute to advance the sustainable power generation in Africa.

The "Foum El Oued" wind park project bears a number of very positive effects regarding sustainable power production as well as the development of the region of West Sahara and the situation of the local population:

- Wind energy is clean and helps reducing greenhouse gas emissions while providing new technology and infrastructure to the West Sahara region
- The "Foum El Oued" wind park project is in validation process to become registered as a project under the UN's Clean Development Mechanism
- The project contributes to the social and economic development of the region
- It also provides indirect employment benefits for the local population

Siemens AG Lindenplatz 2 Tel.: +49 (40) 28 89 83 00
Energy Sector; Leitung: Michael Süß 20099 Hamburg Fax: +49 (40) 28 89 83 99
Wind Power Division; Leitung: Felix Ferlemann Deutschland

Siemens Aktiengesellschaft: Vorsitzender des Aufsichtsrats: Gerhard Cromme; Vorstand: Peter Löscher, Vorsitzender;
Roland Busch, Brigitte Ederer, Klaus Helmrich, Joe Kaeser, Barbara Kux, Hermann Requardt, Siegfried Russwurm, Peter Y. Solmssen, Michael Süß
Sitz der Gesellschaft: Berlin und München, Deutschland; Registergericht: Berlin Charlottenburg, HRB 12300, München, HRB 6684
WEEE-Reg.-Nr. DE 23891322

DR. FELIX FERLEMANN
CHIEF EXECUTIVE OFFICER
WIND POWER DIVISION

The participation of Siemens in this project is permissible under the applicable laws and regulations and does not infringe the right of self-determination or any other human right in public international law.

With delivering technology to this project, Siemens does not intend to make a political statement on the status of the region. Regardless of political disputes, we believe that a working infrastructure will help to improve the economic conditions, and as a consequence the situation of the people in the West Sahara.

I hope that these explanations will help you to understand our engagement in North Africa.

Sincerely,

Dr. Felix Ferlemann

Siemens AG Lindenplatz 2 Tel.: +49 (40) 28 89 83 00
Energy Sector; Leitung: Michael Süß 20099 Hamburg Fax: +49 (40) 28 89 83 99
Wind Power Division; Leitung: Felix Ferlemann Deutschland

Siemens Aktiengesellschaft: Vorsitzender des Aufsichtsrats: Gerhard Cromme; Vorstand: Peter Löscher, Vorsitzender;
Roland Busch, Brigitte Ederer, Klaus Helmrich, Joe Kaeser, Barbara Kux, Hermann Requardt, Siegfried Russwurm, Peter Y. Solmssen, Michael Süß
Sitz der Gesellschaft: Berlin und München, Deutschland; Registergericht: Berlin Charlottenburg, HRB 12300, München, HRB 6684
WEEE-Reg.-Nr. DE 23691322

Dr. Michael Suess
CEO Energy Sector

19 June 2012
Brussels

Dr. Felix Ferlemann
CEO Wind Power Division

Siemens AG
Wittelsbacherplatz 2
80 333 München

Regarding: Western Sahara, Siemens and the UNFCCC-CDM Windfarm Project

Dear Doctors Suess and Ferlemann:

We are grateful for Doctor Ferlemann's letter of this May 8 in reply to ours of March 6.

We again request that Siemens AG not supply wind power turbines or technical support to Nareva Holding of Morocco for that company's construction of a wind power project at Foum el Oued in occupied Western Sahara.

The matter is one of grave importance. It goes to the question of corporate involvement that would entrench Morocco's presence in Western Sahara, perpetuating the conflict over the territory and further delaying the Saharawi people's right to exercise self-determination.

Before discussing your May 8 letter, we wish to emphasize that two bodies of international law govern the conduct of business in occupied Western Sahara. The first – the right of the Saharawi people to permanent sovereignty over their natural resources – has been much commented upon. It is not a right that is shared with settlers, here Moroccan nationals, which have been introduced to Western Sahara in increasing numbers since the occupation in 1975. It is exclusively that of the Saharawi people, including those refugees living inside Algeria. What Morocco is obligated to do as the occupying state (and administering power *de facto*) is ensure development of resources in the territory has the manifest consent of the Saharawi people, and that the benefits of such developments accrue to them. In the case of the proposed Foum el Oeud project, it is land as such that is to be used as a natural resource. Land, in other words, is to be the basis for an energy production site.

The Saharawi people have themselves requested Siemens AG to not supply turbines to nor be involved with the Foum el Oued project. By any measure the prohibition against your company being involved with the project is clear.

The second area of law which applies to the occupation of Western Sahara is international humanitarian law. The *Fourth Geneva Convention*, to which Germany and Morocco are both signatories, requires an occupier to have regard for the security of the civil population, here the Saharawi, and to expressly not settle its own population into the territory.[1] How does this relate to or causally engage Siemens AG's legal obligations? The answer is simple. The electrical power from the Foum el Oued project will go to the benefit of the occupying state, in two ways. First, some of the power is to flow to a national grid inside Morocco. Second, that electricity used directly (or by offset from the project) inside Western Sahara will be substantially to be benefit of an introduced settler population that outnumbers the Saharawi people, now, by two to one. (There are, we add, no assurances on record that electrical power from the project will not be used by Moroccan armed

Western Sahara Resource Watch is an international organisation working in solidarity with the Saharawi people. We advance their right to self-determination, protect their natural resources and promote their human rights.

forces, more than 100,000 strong, in Western Sahara). Should the point be lost, it is electrification in Western Sahara that will make it increasingly possible to sustain an occupation and to continue the settlement of Moroccan nationals. The reasoning of the International Court of Justice in its 2004 Palestine Wall opinion applies directly to those who would consider material support for the ongoing occupation of Western Sahara:

Given the character and the importance of the rights and obligations involved, the Court is of the view that all States are under an obligation not to recognize the illegal situation resulting from the construction of the wall in the Occupied Palestinian Territory, including in and around East Jerusalem. They are also under an obligation not to render aid or assistance in maintaining the situation created by such construction. It is also for all States, while respecting the United Nations Charter and international law, to see to it that any impediment, resulting from the construction of the wall, to the exercise by the Palestinian people of its right to self-determination is brought to an end. In addition, all the States parties to the Geneva Convention relative to the Protection of Civilian Persons in Time of War of 12 August 1949 are under an obligation, while respecting the United Nations Charter and international law, to ensure compliance by Israel with international humanitarian law as embodied in that Convention.[2]

Your May 8 letter outlined several reasons in support of supplying turbines (and *in situ* technical support) for the Foum el Oued project. It is useful to consider them. While we agree that wind generated electrical power is sustainable and, on its face, usefully provided to Western Sahara, that amenity is more than offset by the negative aspects of contributing to the infrastructure development of an area under military occupation and to supply increasing amounts of power than at present for a growing in-migration of illegal settlers, as we have discussed above.

We appreciate that the Foum el Oued project is not merely one in which Nareva Holding has contracted with Siemens AG for technology supply, but is to be enabled with Clean Development Mechanism (UNFCCC) funding. That in no way should be taken as validating or making the project more acceptable within the law or ethically. We have taken issue with the UNFCCC's consideration of an application for funding of the project.

As to the third point in your letter, we reject the premises of the assertion that the Foum el Oued project will contribute to the social and economic development of Western Sahara. The project will have the result of placing additional physical infrastructure into a territory over which Morocco has no right or title, and contrary to the express demand of the Saharawi people. In such circumstances, the project serves to exacerbate the problem of Western Sahara's occupation and the stalled right of its people to self-determination.

The fourth point of your letter suggests the project will provide indirect employment benefits for the local population. That may be true. However, such population is two to one Moroccan. And we submit that the economic marginalization of the Saharawi people, evident in the territory's natural resources industries, will result for them an even smaller share of any economic benefit that would result.

The conclusion that Siemens AG's participation in the Foum el Oued project "is permissible under the applicable laws and regulations and does not infringe the right of self-determination" of the Saharawi people is not correct. We have concluded that the supply of turbines and technical support is illegal as a matter of international law, and contrary to the domestic law of most European states which criminalizes the aiding and abetting of an illegal occupation in the circumstances of an international conflict. The supply of wind power turbines will result in a cascading effect: Additional infrastructure in Western Sahara, provided by a leading technology company in a developed state, secures the physical

www.wsrw.org

Western Sahara Resource Watch is an international organisation working in solidarity with the Saharawi people. We advance their right to self-determination, protect their natural resources and promote their human rights.

presence of Morocco and adds to the legitimacy it seeks to create about its claim over the territory. The resulting electrical power will go to allowing greater electrification of the territory and therefore the ease of bringing additional settlers into it. There will then be the problem of ownership of the Foum el Oued wind power facility when Saharawi sovereignty is restored over all of Western Sahara.

We contend that, in supplying wind power generation technology into Western Sahara, Siemens AG would make a political statement about the problem of Western Sahara. Your company would be voting in effect with an occupying state for which no country recognizes its claim to the territory and in circumstances where its people have expressly asked for your restraint. Your statement that Siemens "does not intend to make a political statement" is strange, considering that your webpages still claim that the project is located in Morocco:
http://www.siemens.com/press/en/pressrelease/?press=/en/pressrelease/2012/energy/wind-power/ewp201201025.htm

That is factually wrong, and constitutes a strong political statement in complete disregard of the opinion of both the UN and of the Government of Germany.

All this said, we find it surprising that Siemens wishes to be associated with a project, operated by the company owned by the Moroccan king, on occupied land. The investor community has over the last years reacted strongly against business activities in Western Sahara. The following statement was issued by the Norwegian government upon an exclusion of a petroleum company in Western Sahara from its Pension Fund:

"Morocco has for a number of years occupied Western Sahara despite strong UN condemnation. The [Government Pension Fund's] Council [of Ethics] found that Kerr-McGee through its exploration activities most likely will enable Morocco to exploit petroleum resources in the area. The Council regarded this as 'a particularly serious violation of fundamental ethical norms' e.g. because it may strengthen Morocco's sovereignty claims and thus contribute to undermining the UN peace process'".

See the opinion here:
http://www.vest-sahara.no/files/pdf/kmg_divestment_norw_min_finance_release_05.pdf

We regret that you did not address the three questions in our letter of this March 6, questions meant to illuminate Siemens' commitment to UN Global Compact principles. The questions relate to your understanding of responsibility for human rights compliance in your company's sphere of influence, and the consultation with the people in the region where your firm is operating.

We again ask that Siemens AG carefully consider its decision on ethical, moral and legal grounds, and withdraw from supplying turbines and related technical assistance in Western Sahara.

It is our hope that we will hear from you about the concerns expressed above, and suggest that a meeting may be a productive way of fully engaging the matter.

Yours sincerely,

Sara Eyckmans Axel Goldau
International Coordinator WSRW WSRW Coordinator for Germany

[1] We note the 1977 Protocol I to the Geneva Conventions. Article I (4) particularly engages the responsibility of Germany's corporations and citizens in the circumstances of Western Sahara's occupation:

Article 1. General principles and scope of application

1. The High Contracting Parties undertake to respect and to ensure respect for this Protocol in all circumstances.

2. In cases not covered by this Protocol or by other international agreements, civilians and combatants remain under the protection and authority of the principles of international law derived from established custom, from the principles of humanity and from dictates of public conscience.

3. This Protocol, which supplements the Geneva Conventions of 12 August 1949 for the protection of war victims, shall apply in the situations referred to in Article 2 common to those Conventions.

4. The situations referred to in the preceding paragraph include armed conflicts in which peoples are fighting against colonial domination and alien occupation and against racist regimes in the exercise of their right of self-determination, as enshrined in the Charter of the United Nations and the Declaration on Principles of International Law concerning Friendly Relations and Co-operation among States in accordance with the Charter of the United Nations.

[2] Legal Consequences of the Construction of a Wall in the Occupied Palestinian Territory, Advisory Opinion, ICJ Reports 2004, p. 136, para. 159.

Copy of this mail sent to:
- Global Compact
- Business and human rights department, Office of the UN High Commissioner for Human Rights
- Centre for Research on Multinational Corporations, the Netherlands
- Siemens Denmark

 Gmail

Sara Eyckmans

Re. Siemens' potential involvement in another project in occupied Western Sahara

3 messages

Sara Eyckmans

Dear Mr Ferlemann,

Please find attached a letter regarding Siemens's pre-qualification in a tender ran by ONEE (Morocco's National Office for Electricity and Water) for the construction of five wind farms in Morocco. However, two of those wind farms will be located in occupied Western Sahara, putting Siemens at risk of unwittingly becoming part of a protracted conflict.

The letter outlines our concerns and questions. A reply by Siemens would be much appreciated, and will be featured in an upcoming report and on our website.

Answers to previously raised questions on Siemens' participation in the Foum el Oued project in occupied Western Sahara, would still be appreciated. Our initial letter on the subject was sent on 6 March 2012, and several letters and mails repeating the unanswered questions have been sent since, also within the framework of the UN Global Compact mediated dialogue with civil society.

Please do not hesitate to contact us if you'd require any further information to study this matter more closely.

With our best regards,

Sara Eyckmans

International Coordinator

Western Sahara Resource Watch

2 attachments

📄 **2013.07.03 WSRW - Siemens.pdf**
454K

 WSRW - Western Sahara background.pdf
640K

Ursula Wynhoven
To: Sara Eyckmans
Cc: Anita Househam

Dear Sara,

Since you have sent this directly to Siemens, we won't forward it to them.
We will note in our log though that you have sent it.

We followed up with Siemens last week and they told us to expect something
soon. They were having an internal discussion about the matter.

Kind regards,

Ursula

Ursula Wynhoven
General Counsel
UN Global Compact Office
[Quoted text hidden]
\- 2013.07.03 WSRW - Siemens.pdf - WSRW - Western

Sahara background.pdf
> <2013.07.03 WSRW - Siemens.pdf>
> <WSRW - Western Sahara background.pdf>

Siemens AG
Energy Sector
Wind Power Division
Lindenplatz 2
20099 Hamburg, Germany

To the attention of Mr Markus Tacke,
CEO of Siemens AG – Energy Sector

Brussels
26 September 2016

Re.: Siemens' involvement in Morocco's renewable energy projects in Western Sahara

Dear Mr Tacke,

It is our privilege to write to you. Western Sahara Resource Watch is at present finalizing a report about Morocco's renewable energy projects in occupied Western Sahara. Given Siemens' connection to all of those contentious projects, your firm will be featured in the report. Accordingly, we would be grateful for your comments to the questions below, so that we may accurately reflect Siemens' views and position in the upcoming publication.

Siemens, in collaboration with Enel Green Energy and Nareva, has been constructed by Morocco's National Office for Electricity and Water (ONEE) to construct five wind farms with a combined capacity of 850 MW. Three of those wind plants will be located in Morocco proper (Tangiers, Midelt and Jbel Hadid). The two other plants, accounting for almost half of the planned capacity, are to be constructed outside of the internationally recognized border of Morocco; inside the part of Western Sahara that Morocco illegally occupies since 1975; in Tiskrad and Boujdour. Three years ago, Siemens also participated in the construction of the Foum El Oued wind park, also located in what is often referred to as Africa's last colony.

In our previous letters to your company, we outlined our concerns with regard to Siemens' involvement, and explained why we consider such a participation in Morocco's colonial project in Western Sahara to be morally unacceptable, politically dangerous and legally questionable. We will not reiterate those concerns here.

However, we cannot see having received an answer to any of the questions that we raised in writing, including through the UN Global Compact mediated dialogue that we had requested. Hence, we wish to repeat the most pertinent of those questions here, as the answers are still relevant.

1. How has Siemens assured itself of the consent of the Saharawi people, through their internationally recognized representative body, the Frente Polisario, for the construction of wind energy plants in Western Sahara?
2. How does Siemens evaluate the construction of infrastructure on occupied land in view of its position on socially responsible investments?

3. Does Siemens consider the human rights compliance of its business partners to be relevant in the context of fulfilling the principles of UN Global Compact?
4. Does Siemens consider that the human rights impacts of sales agreements or of maintenance contracts are relevant in the context of assuring human rights within its sphere of influence?
5. Does Siemens consider it relevant to engage in talks with the local communities affected by the company's operations?

In addition, it is worth noting that the General Court of the Court of Justice of the European Union (CJEU) on 10 December 2015 partially annulled the EU-Morocco agricultural agreement in so far as it applied to Western Sahara. The Court stated that Western Sahara "is not included in the recognised international frontiers of [Morocco]", and "that the Kingdom of Morocco does not have any mandate granted by the UN or by another international body for the administration of [Western Sahara]" (points 232-233, Case T-512/12). As such, the CJEU echoes the 4 July 2014 Decision of Spain's High Court, the *Audiencia Nacional* which confirms that Spain, not Morocco, is the administering power over Western Sahara, and that the "territory cannot be considered Moroccan"(Case-Law Registry N° AAN 256/2014). Earlier this month, the General Advocate of the CJEU stated in his Legal Opinion that Western Sahara is not part of Morocco, and that no EU agreement with Morocco could apply to the territory (Conclusions de M. Wathelet, C-104/16).

Following these developments, we would welcome your reply to these additional questions.

6. Does Siemens consider Western Sahara to be part of Morocco – given its referral to the location of its projects in the territory as "south Morocco"?
7. How does Siemens assess the Decision of the *Audiencia Nacional* that Spanish criminal law still applies in Western Sahara, as Spain has never formally decolonized?
8. How does Siemens assess the views of the CJEU, that Western Sahara is not part of Morocco?

We would be grateful for your response before 4 October 2016. A reference to your response will be made in the mentioned report.

As always, we welcome the opportunity to provide you with any additional information that you may require to study this matter more closely. We thank you for your consideration of our letter and look forward to your reply.

Sincerely,

Sara Eyckmans
International Coordinator
Western Sahara Resource Watch

SIEMENS

DR. MARKUS TACKE
CHIEF EXECUTIVE OFFICER
WIND POWER AND RENEWABLES

Via eMail:
Ms. Sara Eyckmans

Hamburg, October 10th, 2016

Re.: Siemens' involvement in Morocco's renewable energy projects in Western Sahara

Dear Ms. Eyckmans,

Thank you for your correspondence dated September 26, 2016, on the issue of Siemens Wind Power's engagement in Morocco and Western Sahara. As you correctly point out, this is one of the many areas worldwide where Siemens is active. Although no new contracts have yet been signed, Siemens Wind Power and Renewables Division has been asked to provide wind power products and technology.

We are of the view that helping regions to develop their renewable energy capacity is a constructive and worthwhile way to bring both short-term benefits (e.g. local jobs and infrastructure improvements) as well as long-term benefits (including greater energy security). Western Sahara is one of the world's poorest and most under-developed regions, and we believe that enhancements to roads, sanitation, educational facilities, and power infrastructure can all serve to improve the lives of people in this area.

We also believe that wind farms are fundamentally different from, say, mines, which extract finite resources in an irreversible way. The wind in Western Sahara, in contrast, is a renewable source of energy, and the operation of wind farms in no way diminishes it.

Siemens AG
Wind Power and Renewables Division
Leitung: Markus Tacke

Berliner-Tor-Center
Beim Strohhause 17-31
20097 Hamburg
Deutschland

Tel.: +49 (40) 2889 0

Siemens Aktiengesellschaft: Vorsitzender des Aufsichtsrats: Gerhard Cromme; Vorstand: Joe Kaeser, Vorsitzender;
Roland Busch, Lisa Davis, Klaus Helmrich, Janina Kugel, Siegfried Russwurm, Ralf P. Thomas
Sitz der Gesellschaft: Berlin und München, Deutschland; Registergericht: Berlin Charlottenburg, HRB 12300, München, HRB 6684
WEEE-Reg.-Nr. DE 23691322

SCF 02/2015 V13.06

Your questions that deal with the legal and political status of Western Sahara deal with matters of international public law. It is, therefore, the responsibility of the subjects of international public law (such as international bodies, states and others) to deal with these matters. The views of NGOs are, of course, also of great value. Companies like ours, on the other hand, refrain as a matter of policy from taking positions or making judgements on such issues.

Nonetheless, we do support the stated position of the German government which has expressed its hope for a peaceful and consensual resolution to the outstanding issues in Western Sahara, and its support for the United Nations plan for the self-determination of the Saharawi people.

During our previous involvement in Western Sahara, we worked with local organizations and groups to ensure that our involvement provided tangible community benefits. We will continue to act in compliance with all applicable laws, and with the commitment that human rights are respected in projects in which we are involved. We will also continue to seek ways to ensure that local populations benefits from our engagement in respective regions.

We would be pleased to remain in constructive dialogue with you on this matter.

With kind regards

Dr. Markus Tacke,
CEO Siemens Wind Power and Renewables

Siemens AG
Wind Power and Renewables Division
Leitung: Markus Tacke

Berliner-Tor-Center
Beim Strohhause 17-31
20097 Hamburg
Deutschland

Tel.: +49 (40) 2889 0

Siemens Aktiengesellschaft: Vorsitzender des Aufsichtsrats: Gerhard Cromme; Vorstand: Joe Kaeser, Vorsitzender;
Roland Busch, Lisa Davis, Klaus Helmrich, Janina Kugel, Siegfried Russwurm, Ralf P. Thomas
Sitz der Gesellschaft: Berlin und München, Deutschland; Registergericht: Berlin Charlottenburg, HRB 12300, München, HRB 6684
WEEE-Reg.-Nr. DE 23691322

SCF 02/2015 V13.06

Siemens AG
Energy Sector
Wind Power Division
Lindenplatz 2
20099 Hamburg
Germany

To the attention of Mr Markus Tacke,
CEO of Siemens AG – Energy Sector

7 December 2017
Brussels

Dear Mr Tacke,

WSRW is writing to you with regard to Siemens' continued involvement in Morocco's plans to generate renewable energy in occupied Western Sahara. In recent months, Siemens' name has emerged as one of the companies connected to the 200 MW Aftissat wind farm, at present being constructed south of Boujdour, Western Sahara.

In our previous correspondence, and at the Siemens AGM of January 2017, we've asked what steps Siemens has taken to assure itself of the consent of the people of Western Sahara to its engagement in the wind farm projects in the territory. To date, that question remains unanswered.

Siemens has defended its connection to Africa's last colony by stating that developing "the region" would be to the benefit of the people. There are several comments to be made: first, Western Sahara is not a region – it has the status of a Non-Self-Governing Territory without an administering power appointed to it by the United Nations. That is important, as it has repercussions in terms of the legality of and risks associated with business activities in the territory. Second, given the cornerstone legal principle that applies to the decolonization of Western Sahara - that of self-determination - the evaluation needs be made whether potential benefits of any given project trump the right of the people to state whether they agree to or want the project in the first place. The Court of Justice of the European Union disagrees: it is not necessary to determine whether there are benefits to the people of the territory, rather, it is a must to receive their consent (§106, C-104/16 P, 21 December 2016, Council v Front Polisario).

Does Siemens consider that international companies are to respect and adhere to international law? It is not clear from your previous letter to us. You there responded to our question regarding the obtaining the Saharawi people's consent with the following statement: "Your questions that deal with the legal and political status of Western Sahara deal with matters of international public law. It is, therefore, the responsibility of the subjects of international public law (such as international bodies, states and others) to deal with these matters. The views of NGOs are, of course, also of great value. Companies like ours, on the other hand, refrain as a matter of policy from taking positions or making judgements on such issues."

A remarkable contrast with Siemens' response to the surfacing of its turbines in Crimea. Siemens described this development as "a blatant breach of Siemens' delivery contracts, trust and EU regulations" (*Siemens Press Release, 21 July 2017, "Official statement regarding turbines to Crimea"*). Yet at the same time, it ignores EU case-law as laid out by the Highest Court of the European Union in

above-mentioned Judgment of 21 December 2016, stipulating that Western Sahara is a territory that is "separate and distinct" from Morocco. Where Siemens acts swiftly against Russia in relation to its gas turbines turning up in Crimea, it works with Morocco to install wind turbines in Western Sahara.

We'd be grateful if you could clarify the following issues:

1. Has Siemens sought the consent of the people of Western Sahara for its involvement in the construction of energy infrastructure on their occupied land? What steps has it taken to obtain their consent through the UN recognized political representative of the people of Western Sahara, the Polisario Front?
2. Does Siemens agree with the conclusion of the Court of Justice of the European Union in the Court's December 2016 appeal decision that Western Sahara is a territory that is "separate and distinct" from Morocco?
3. Does Siemens consider that it should take into consideration EU case-law and international law when it takes on a project in a conflict area? Is it only for "international bodies, states and others" to act in line with international law, and do multinational corporate entities operate outside of the legal order?
4. A 2016 policy paper by the European Parliament's policy department called for a coherent approach to situations which are comparable under international law, specifically in the cases of Palestine, Crimea and Western Sahara? What is the basis of Siemens' different position in respect of materials supplied into Crimea from that of Western Sahara?

Thank you for your consideration and we look forward to receiving your views.

Sincerely,

Sara Eyckmans
Coordinator
Western Sahara Resource Watch

Mrs. Sara Eyckmans
Coordinator
Western Sahara Resource Watch
Brussels

Bilbao, January 8th 2018

Dear Ms. Eyckmans

Thank you for your letter dated December 7, 2017, addressed to our CEO, Dr. Markus Tacke.

Dr. Tacke has shared his views with you previously. His statement that our company "refrains as a matter of policy from taking positions or making judgements" on questions of international law remains our position.

As you know, there are a range of opinions regarding the political and legal status of Western Sahara. Siemens Gamesa Renewable Energy is aware of these divergent opinions, including the views of your organization.

Your suggestion that our company may be acting in contravention of the law is an allegation we take very seriously. Please be aware that we vigorously reject this charge. We share the commitment to business activities complying with the highest ethical and legal standards, and our company is determined to apply these standards wherever we are active throughout the world. As one of the pioneers in the sector (back in the 1980s), Siemens Gamesa Renewable Energy is fully devoted and committed to fostering not only the deployment of clean energy around the world but also to "clean business" This sound track record and has enabled us develop a sustainable business and relationship with stakeholders, having installed 80GW of clean energy in more than 90 countries. We have gained trust from our customers to feel confident that, when acquiring Siemens Gamesa Renewable Energy wind turbines, they are buying truly clean energy and with respect to human and environmental rights, any and all applicable laws as well as best practices.

SIEMENS GAMESA RENEWABLE ENERGY

Parque Tecnológico
de Bizkaia - Ed. 222
48170 Zamudio (Vizcaya)
España

Tel: +34 94 431 76 00
Fax: +34 94 431 76 32
www.gamesacorp.com

SIEMENS GAMESA RENEWABLE ENERGY, S.A., compañía de nacionalidad española, debidamente inscrita en el registro Mercantil de Vizcaya al libro 5139, Volumen 60,hojaBI-56858, provista de NIF número (NIF) A-01011253 y con domicilio social en 48170 Zamudio (Vizcaya- España-). Parque Tecnológico de Bizkaia, Edificio 222.

Before engaging in any project, we do confirm that nothing related to the project may imply any actions performed contrary to human and environmental rights, contrary to any and all applicable laws as well as best practices. As addressed above, Siemens Gamesa Renewable Energy, as a matter of policy, does not take positions or make judgments on issues of international public law. A company like ours has neither the mandate nor the capacity to independently advocate on such questions. These matters are, in our view, best left to national governments, who possess the appropriate diplomatic and political capacity, and to other international organizations and bodies with the relevant expertise. The views of shareholders, investors and NGOs are, of course, also of great value. On the situation of Western Sahara, declared by United Nation as a "non-self-governing territory" since 1991, we support the stated position of the International Community and the United Nations, which have expressed its hope for a peaceful and consensual resolution to the outstanding issues. At the present time, Western Sahara lacks much of the institutional and administrative infrastructure present in other parts of the world.

Helping developing parts of the world to share in the benefits of clean, renewable energy is a central part of our mission. As wind power technology evolves, we will continue to work hard to ensure that it creates value to all stakeholders wherever the projects in which we may involve as may be.

We remain hopeful that a peaceful and consensual resolution to this issue can be achieved.

Kind regards

Jon Lezamiz Cortazar

Global Public Affairs Director

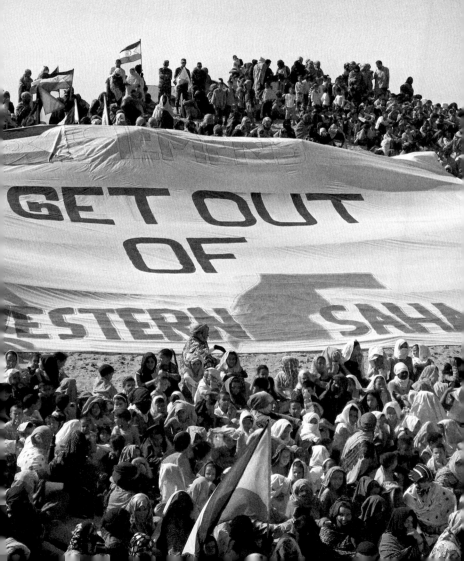

Plunder Intercepted

The legal case to seize globally traded phosphate from occupied Western Sahara

Jeffrey J. Smith

"Morocco has no claim to sovereignty over Western Sahara. Its claim to sovereignty as a result of its occupation of the territory is incompatible with the status of Western Sahara as a non-self-governing territory."

The surprise was complete. In the early afternoon of Monday, 1 May 2017, a long-planned legal drama would reach its denouement. A first in international law – the seizure under court order of a natural resource plundered from an occupied land – was about to be accomplished. A small harbour launch carrying an official of South Africa's High Court came alongside the bulk carrier anchored a kilometre off the beach at Port Elizabeth, and justice proceeded.

Introduction: Seizure and precedent

On 13 April 2017, a bulk carrier registered in the Pacific Ocean country of the Marshall Islands cast off its lines and departed a loading dock on the coast of occupied Western Sahara. On board were 55,000 tonnes of the world's best phosphate mineral rock, sought after by fertilizer manufacturers in Global North countries because of its high phosphorus content and absence of heavy metals. A few minutes later, the ship, named NM Cherry Blossom, revealed that it was sailing for Cape Town, a routine journey of two weeks. There was otherwise nothing remarkable about the ship. It was the fifth to depart occupied Western Sahara in 2017, bringing the year's exported phosphate to a total of 300,000 tonnes with a value of US$30 million.

On 1 May, after the NM Cherry Blossom sailed past Cape Town and anchored at Port Elizabeth in order to refuel, its cargo was seized under a court order. The government of the Sahrawi Arab Democratic Republic (the SADR) and the Sahrawi people's national liberation movement, the Frente Polisario, had succeeded in their legal action, a stunning intervention in the high-value trade in pillaged phosphate rock from Western Sahara.

Almost three weeks later, a similar intervention was made against a second ship, the MV Ultra Innovation, as it exited the Panama Canal for Canada. The combination of the cases would be a diplomatic and legal reverse for an occupying Morocco, as well as a substantial interruption of the phosphate trade. The aftermath saw the Panama Canal practically closed to transiting shipments of phosphate rock, and some of the companies involved dropping out of the trade. The NM Cherry Blossom would stay in Port Elizabeth for more than nine months, its cargo unable to move onward until a court order assured the SADR of ownership. And a legal precedent

in conflict minerals and the law of post-colonial self-determination was set.

This chapter tells the story of the Sahrawi campaign to seize cargos of phosphate rock. The historical circumstances leading to the events of May 2017 are considered. The extensive measures taken by the SADR government to seize the cargos under complete secrecy are recounted, and the implications for the phosphate trade and for future legal action are then considered.[1]

The seizure of phosphate cargos is something that must be understood in the context of the long history of Western Saharan decolonization. For years, it has been understood that the mining of phosphate rock is a pretext for Morocco to continue its occupation of the territory. Morocco does not profit from the mining and export of the commodity: its military occupation and the cost of supporting a population resettled from the kingdom into the territory is too costly. However, mining creates employment and related services for a settler population. It also gives legitimacy to the economic and physical infrastructure Morocco has built in Western Sahara.[2] Of course, there are other resources in Western Sahara that are exported. They are therefore vulnerable to legal action and include the coastal fishery and small amounts of sand and salt exported to European countries. But it is phosphate that is the most high-profile of resources because of the scale of the industry inside Western Sahara and the global need for phosphate as a fertilizer component. This can be seen in the value of exports from Western Sahara after 2014, which has been between US$210 million and 250 million annually.[3]

The SADR government and the Frente Polisario have recently looked at applying international law to the problem of Western Sahara's occupation. This was a response to a perceived deepening of the occupation, the inability to use law to remedy human rights violations (whether in Morocco or most other countries), and the sense that international law was developing in such a way that it could be applied in matters relating to natural resources.[4] The use of international law was also a response to the stalled promise of self-determination for the Sahrawi people. An example of the Sahrawi government's application of international law was the assertion of a claim to a 200-nautical-mile exclusive economic zone, declared

under national legislation in 2009. The claim was soon examined – and rejected – by the European Parliament's Legal Service, but it was successful all the same because it cast doubt over the legality of the European Union's renewed fisheries treaty with Morocco.[5]

A more consequential turn to using law in pursuit of self-determination was the decision to bring cases in the European Court of Justice in 2012. This was a risky choice. The first case was one to challenge the operation of the EU-Morocco free trade agreement in Western Sahara, while the second case was to set aside the EU-Morocco treaty for fishing in Saharan coastal waters. Both were brought only in the name of the Frente Polisario. To bring either case before the ECJ (now named the Court of Justice of the European Union, CJEU) as a state would have been to insist on recognition of the SADR, which was certain to be refused. Along the way, the cases inspired legal action by the Western Sahara Campaign UK (WSCUK) NGO in the United Kingdom's High Court as a challenge to government decision-making to allow the import of food imports from Western Sahara at European reduced tariffs. The initial decision of the CJEU in 2015 was favourable: the court allowed the case, reasoning that, in the circumstances, a national liberation movement could acceptably bring a complaint against the Council of the European Union's decision to extend free trade into Western Sahara. In its December 2015 judgment, the CJEU concluded that a meaningful inquiry about human rights when making trade arrangements applying to Western Sahara was required.[6] The Council of the European Union promptly appealed the result. The full court decided the matter in a straightforward decision the following December. The CJEU observed that Western Sahara was not part of Morocco and therefore trade arrangements could not be extended to it under the EU-Morocco trade agreement. The court also noted that any such extension would require the consent of the people of the territory.[7]

In pursuit of phosphate

For years, the SADR government had tracked the export of phosphate rock from Western Sahara. The first realization that it might be possible to intercept a shipment came in 2011. Ten companies were then purchasing some two million tonnes a year, sending

chartered ships to the coast of Western Sahara to be loaded. For years, these companies were from the Global North, including Europe. None of Western Sahara's phosphate rock was supplied to Africa's fertilizer manufacturers, and rarely to countries in the Global South. Only in 2016 did a company in India enter the field.[8] The cycle of shipments was well established, allowing certain cargos to individual companies to be accurately predicted. For example, Australia's remaining importer had been receiving shipments into the ports of Geelong and Portland at three-monthly intervals. Shipments to the Canadian importer – arriving in Vancouver on Canada's west coast – had been delivered on average every six weeks in 2015 and 2016.[9]

In addition to its analytical work, the SADR government sent letters of protest to the companies involved in buying the phosphate rock. Few companies responded. Among those which did were the operation in Australia and Europe's last purchaser in Lithuania.[10] Protest letters would be part of an eventual legal case to intercept shipments, because asserting Sahrawi sovereignty over the resource was a necessary step in claiming ownership rights. It was thought that the importing companies would respond to a claim of ownership by saying that they were "innocent purchasers", accepting the commodity on the simple basis that they thought it had been properly sold by Moroccan companies.

A next step in the campaign was to prepare for a possible interception. As a matter of Sahrawi policy, only legal means – the authorization of a court – would be employed. However much it was acceptable under international law, there would be no armed interception of a ship. Obtaining a court order in advance of a ship arriving at dock at El Aaiún was considered and rejected. This is because of uncertainty about the circumstances in which some ships are chartered to proceed to El Aaiún and load the phosphate rock. Not all can be confirmed as heading to El Aaiún until a week in advance, when their charter instructions are confirmed, or several days before, when they are observed on navigational tracks for El Aaiún. Taking legal action in the occupied territory itself was impossible. There are no legal avenues to do so, and action of any other kind given the extent of military and police forces present would be foolish.

Planning next turned to the question of the countries that have recognized the Sahrawi Republic. This meant that legal action – again, a Sahrawi claim of ownership – could be possible, but only if a shipment came into the territory of such countries. A cargo would have to arrive in or pass through their 12-nautical-mile territorial sea. The pattern of shipments revealed possible countries, among them Colombia, Panama, South Africa, and Venezuela. The Sahrawi authorities favoured Panama and South Africa. This was because many shipments heading for New Zealand and Canada go through the Panama Canal, and South Africa's courts are considered the most independent and most capable of applying international law in Africa. In addition, shipments to Colombia and Venezuela are less frequent and therefore less predictable. They are smaller shipments with relatively low value. Cargos bound for New Zealand's two importing companies, between them five or six a year, would sail west through the Panama Canal or around South America. Only three shipments annually were for Australia's importer, and not all would stop to refuel in South Africa. To complicate things, stops in South Africa could be at Cape Town, Port Elizabeth, or Durban and were usually no more than twelve hours in duration.

After 2011, the building blocks for lawsuits in the two countries were put in place. The Sahrawi government ensured it had local lawyers who understood the complexities of the cases. Australia's importing company had received the largest number of letters of protest over the years.[11] Shipments to that company were smaller than for other companies at only 35,000 tonnes each. (The Australian company claimed it needed high-grade phosphate, because converting its processing facilities to enable it to manufacture fertilizer from ordinary phosphate, which much of the world uses, would be too expensive.) These matters led the Sahrawi government to provisionally decide on a first interception in South Africa. If, as expected, there was a shipment for Australia in the May–June period, it would be seized first. There was also the question of the timing of both cases in the aftermath of the free trade case in the CJEU. It was accepted that a positive result here would be more helpful in Panama and South Africa than the other way around. Given how the court in South Africa – in its June 2017 decision, which is discussed below – responded to the December 2016

CJEU appeal judgment, this was a prudent decision by the Sahrawi government.

Preparing the trap

In January 2017 the case was ready.[12] The SADR and Frente Polisario would claim ownership rights through a civil lawsuit in South Africa's commercial trial court (the High Court) over a cargo aboard a ship that stopped to refuel. Later that month it seemed that a ship would leave El Aaiún for Australia. The timing was consistent with the annual cycle of shipments. But the ship didn't stop in South Africa, carrying on directly to the newly trading company in India.

In early April the NM Cherry Blossom anchored a short distance off the port at El Aaiún. The ship was one of the many bulk freighters that ply the world's oceans, a "Panamax" class vessel, 200 metres long and with capacity for 60,000 tonnes of cargo.[13] It loaded in less than four days. A debate among Sahrawi officials followed: the NM Cherry Blossom had taken aboard about 54,000 tonnes of phosphate rock. This had been estimated by reading the ship's draught marks before and after loading. Was the amount too much for the cargo to be for the Australian buyer? Only when ships depart El Aaiún can their destinations be accurately confirmed. It's then that they enter a port of call or transit point into their tracking systems, the automatic identification systems (AIS) which are mandatory under the rules of the International Maritime Organization. This allows the position of ships and identifying details to be read, sometimes in real time, on websites.

On 13 April, the NM Cherry Blossom cast off lines from the loading dock and displayed on its AIS that it was heading to Cape Town. That could mean a stop for fuel and therefore a cargo for Australia. As the ship sailed south into the Atlantic, its speed and course were monitored. Two weeks later, as the ship passed along the coast of Namibia, it showed arrival at Cape Town on 29 April. But on 28 April there was a change. The ship's AIS no longer showed a destination. Cape Town had only been a transit point. Sahrawi officials asked themselves, would the ship stop in South Africa? An anxious few hours passed. And then relief: later the same day, the ship displayed on its AIS that it was proceeding to Port Elizabeth, about thirty-six hours sailing time further to the east.

On Sunday, 30 April, Madam Justice Revelas accepted that an application to seize the cargo could be entertained by the High Court. As in many types of commercial shipping disputes, such as those about unpaid fuel supplied to a vessel and damage to a cargo, a claim and initial measures can be started without notice to the responsible parties. Such parties can include shipowners, charterers, managing enterprises, and those with an interest in a cargo. Indeed, maritime law allows a ship itself to be the subject of a civil claim where the ship has benefited from something supplied to it or work done aboard. Therefore, a bringing of the application to detain the cargo aboard the NM Cherry Blossom without notice to anyone was typical of maritime cases. This would allow surprise to be preserved. Justice Revelas was persuaded that the Sahrawi claim to ownership of the phosphate rock aboard the ship had some merit – in other words, that there was a possibility the claim could later be proven.

A court order could only take effect once the ship had entered South Africa itself. This meant the NM Cherry Blossom would have to sail into South Africa's 12-nautical-mile territorial sea for the cargo aboard to be detained. Passing ships do not go into Port Elizabeth's small inner harbour. Instead, shuttle tankers provide refuelling in a roadstead where ships anchor. Fortunately, South Africa's territorial sea is well publicized. It would be straightforward to calculate when the NM Cherry Blossom would enter the jurisdiction of the High Court and therefore when to obtain a court order. Just after 2 p.m. local time on 1 May, the ship having arrived at anchor, a court bailiff proceeded by launch and handed a copy of the court's order to the master. The NM Cherry Blossom would then remain at anchor, its cargo detained, for months.

The aftermath

Shipments from Western Sahara stopped several days later. Only one ship, which had already arrived, completed loading and sailed across the Atlantic for the American importer in Louisiana. Sahrawi officials were then surprised to learn that the NM Cherry Blossom had not been bound for Australia. Papers from the ship revealed it had been chartered by one of New Zealand's importing companies. Never before had a ship for New Zealand taken the longer route

from west to east around the Cape of Good Hope. The cargo had been seized, but it was for a different company. Could this put the case at risk?

As it turned out, it didn't. That is because the Sahrawi claim to ownership was without regard to the enterprise which had purchased the cargo. Both New Zealand companies had been given the protests of the Sahrawi government in recent years. A cargo for New Zealand explained the puzzle of the ship being loaded with 54,000 tonnes of phosphate rock. The reviews of shipments to New Zealand done by the Sahrawi government and WSRW determined such shipments to be between 50,000 and 60,000 tonnes. Shipments of this size are done with bulk carriers that are able to transit through the locks of the Panama Canal. We are left to speculate as to why the NM Cherry Blossom took the route it did. Two factors could be relevant. First, the ship's charterer or its master may have wanted to avoid the toll charges paid to pass through the Panama Canal. Second, if the Panama Canal was not to be used, then going around the tip of South America to New Zealand may have been considered risky in the early winter of the Southern Ocean. Bulk cargos are known to shift in heavy seas, threatening the stability of a ship.

As expected, the interception of the cargo created a problem for New Zealand's fertilizer industry, which was manufacturing fertilizer for the spring agriculture season that was to start a few months later. Aboard the NM Cherry Blossom was one-eighth of New Zealand's required imports of phosphate for the 2017–18 agricultural year. Only two companies produce fertilizer in New Zealand and they rely on receiving 400,000 tonnes of phosphate rock annually. And it is high grade that's needed, which explains why the majority of imports are from Western Sahara.[14]

As maritime law cases in many countries go, there would be a return to court to review the "correctness" of the 1 May order that had been granted to the Sahrawi government. This was expected. After all, the Sahrawi government had been granted the order without notice to the several defendants: the ship's owner, its charterer, the New Zealand buyer of the cargo, and the two Moroccan companies which had mined and exported the cargo. As for the government of South Africa, it took no interest in a matter that could

have had diplomatic implications. The case had been prepared as a commercial claim and South Africa has too independent a court system for the government to become involved. The judge who heard the application on 1 May ordered the parties to come back to court on 18 May to decide whether or not the order should continue to be in effect.

Morocco scores an own goal

In the days that followed, there was another surprise. In maritime commerce, when cargo or a ship is detained as a result of a court order, a payment or a form of security, such as a letter of credit or bank guarantee, is often put forward to substitute for the amount of the claim. This allows a ship to carry on with its trade. But this didn't happen with the NM Cherry Blossom. Could it be that the cargo was too valuable for security to be arranged? The cargo was 55,000 tonnes with an estimated market value, at US$100 per ton, of US$5.5 million. But there was another answer, and it proved to be the biggest surprise of the case and helped to defeat the two Moroccan companies' defence on 18 May.

It was revealed that Phosphates de Boucraa SA, a subsidiary of the Moroccan state-owned mining company OCP, owned the cargo in the NM Cherry Blossom. However, the global commodities market does not work this way. When the importer of a resource arranges for the shipping of a cargo, it pays for the commodity and takes ownership upon loading. The case in South Africa had been planned this way: as a dispute about ownership launched by the SADR and the Frente Polisario against the Australian (and then the New Zealand) importer. Was Phosphates de Boucraa (Phosboucraa, as it is known) honestly saying it owned the cargo even after it had left Western Sahara?

It seems the company may not have continued to own the cargo after 13 April. In mid-May a second shipment was dispatched from El Aaiún to the New Zealand company, arriving in late June. It is not clear if this was a substitute or make-up shipment, or whether Phosboucraa took back ownership of the cargo in the NM Cherry Blossom and sent the mid-May shipment at no cost. What the manoeuvre did was to leave only the Moroccan companies to defend the case at the 18 May hearing. No other party would participate,

including the charter operator of the ship (an Australian subsidiary of the German frozen pizza consortium Dr. Oetker), which was concerned about the ship being delayed. For every day of detention, the Dr. Oetker group would lose US$10,000. The legal contest, now more complicated, was a matter for the parties most directly concerned with Western Sahara's phosphate trade.

The problem the Moroccan companies created for themselves by claiming to own the cargo in the NM Cherry Blossom and their exclusive defence of the case was revealed weeks later. After the High Court had heard the case on 18 May and issued a judgment – discussed below – on 15 June, a senior official of OCP wrote to the court, denouncing it and seeking to justify Morocco's right to mine and export Western Sahara's phosphate rock. A part of the letter is useful reading to understand how Morocco views its claim to Western Sahara:

> By engaging with [the SADR and the Frente Polisario], the court did precisely what it ought not to have done; it sought to determine the legal rights of Morocco, a sovereign (and thus immune) state, in respect of the region of Western Sahara.[15]

This reasoning explains why Phosboucraa apparently took back ownership of the cargo aboard the NM Cherry Blossom, and why the two companies defended the case without the help of the New Zealand buyer of the phosphate.

Papers in Panama

On 17 May, the second ship was arrested under a civil court order. The Panamanian registered Ultra Innovation had only minutes earlier cleared the last of the Panama Canal locks into the Pacific Ocean when a launch came alongside with a court official and papers for the ship to be detained. This was a case under the particular requirements of Panama's maritime law that made the ship itself the object of claim, unlike the cargo in South Africa.

The shipment was the first of 2017 for the Canadian importer, and the sixth of the year to leave El Aaiún. The Ultra Innovation had arrived off Western Sahara on April 22 and completed loading 59,840 tonnes of phosphate rock on April 28. It departed the same day for a two week voyage to the Panama Canal.[16]

It is clear why the SADR acted against a second ship. A first reason was the momentum gained from the action in South Africa. A second may have been the prospect of shipments being stopped after that case. Aside from two ships which arrived on 5 May and 11 May at El Aaiún – which must have been chartered before 1 May – and the replacement shipment for New Zealand's importer (which also arrived on 11 May) – exports did not resume until a ship arrived on 16 July. A third reason to act in Panama could have been that doing so would effectively close the Canal, creating too much risk for ships to hazard whatever the outcome of the case. In the months following, that is what happened. In 2017, no more shipments to Canada or New Zealand passed through the Panama Canal. Ships for the Canadian importer were tracked as following the long route around South America.[17]

There may have been another reason to pursue a ship in Panama. Many shipping lines, for ease of regulation and tax planning purposes, are registered in that country. A quarter of all ships carrying Western Sahara's phosphate have a corporate connection to Panama. Pursuing legal action in the country is a signal to the global shipping trade to be aware of the risks involved.[18] It is worth noting that the SADR authorities acted against a ship operated by the Danish company Ultrabulk. The firm is reportedly one of the few ship management companies that the SADR had tried to engage.[19] Detaining an Ultrabulk ship would be a warning, of course, and could create the basis to act against other ships of the company under the concept of what is known in maritime law as sister ship liability.[20]

The Panama case is reported to have unfolded as planned. Two days later, on 19 May, the ship was free to sail onward to Canada, its owners, or perhaps the Canadian importer, putting forward financial security for the claim against it. Within days, Panama's maritime court reviewed the original application to detain the ship, and concluded it had to be set aside. The court reasoned that a Sahrawi claim to ownership had not been sufficiently established. The SADR appealed this result, and at the end of 2017, a decision in the case was anticipated. The basis for the appeal is reportedly that, because Panama has recognized the Sahrawi Republic, it must follow that a court will need to accept that there may be a

right to a commodity established as coming from Western Sahara, and it will therefore allow a trial on the merits of ownership rights.[21]

Denouement in South Africa

The 18 May hearing – and a decision that resulted from it by a three-judge panel of South Africa's High Court – would enter the annals of international law. Never before had a colonized people under military occupation taken legal action to claim ownership of a natural resource. After several weeks of waiting, and the High Court announcing it needed a little more time to finish writing a judgment, a decision was issued on 15 June. With the two Moroccan companies as the defendants to the case abandoning it a month later, the decision was the end of the line. The 55,000 tonnes of phosphate rock aboard the NM Cherry Blossom would fall to the Sahrawi side.[22]

The High Court decision addressed two issues.[23] The first was the basis of the Sahrawi claim to the phosphate rock. The second was the question of legal impediments to the case that could block it from proceeding to a full trial on the merits of the claim. It is worth noting that the court did not consider the question of standing, in other words, if the SADR and the Frente Polisario had the right to bring a civil lawsuit. Had OCP and Phosboucraa not abandoned the case in mid-July, either negotiations to resolve the Sahrawi claim would have taken place – which seems unlikely – or the case would have gone to trial, possibly sometime in 2018.

Many aspects of the occupation of Western Sahara are established facts. What makes the South Africa case unique is that particular aspects of the status of Western Sahara and the circumstances of the occupation would have to be considered by the High Court. The CJEU in its decisions about the Frente Polisario's free-trade case, and the International Court of Justice in its 1975 Western Sahara Advisory Opinion, did not have to deal with troubling "facts on the ground". The judges of the High Court understood such things when they made the following observations in their 15 June judgment:

> The essence of the case for the SADR and the PF is that the phosphate aboard the MV "NM Cherry Blossom" is part of the national resources of Western Sahara and belongs to its people; and that OCP

and Phosboucraa misappropriated the phosphate and sold it, having no right to do so. The SADR and the PF intend to institute a vindicatory action in respect of the cargo and the purpose of these proceedings is to ensure that it remains within the jurisdiction of this court (except if suitable security is furnished) until the vindicatory action is finalized.[24]

OCP and Phosboucraa, on the other hand, state that Phosboucraa was entitled to mine the phosphate and to sell it. Its rights to do both are derived from the law of Morocco. It also claimed to have mined and sold the phosphate in accordance with international law. Two further defences were raised. They are that in terms of the common law act of state doctrine, the dispute before us is not justiciable and secondly, that in terms of the Foreign State Immunity Act 87 of 1981, this court is precluded from deciding the matter because the laws of a sovereign state, Morocco, are implicated.[25]

The ICJ's [1975] judgment is clear: Morocco has no claim to sovereignty over Western Sahara. Its claim to sovereignty as a result of its occupation of the territory is incompatible with the status of Western Sahara as a non-self-governing territory. Furthermore, it acquired control of the territory by force. This, as a means of acquiring sovereignty, is contrary to customary international law.[26]

That Morocco has no legitimate claim to sovereignty over Western Sahara was recognized in R (on application of Western Sahara Campaign UK) v Revenue and Customs Commissioners & another,[24] a [2015] case concerned with the validity of preferential trade tariffs in respect of goods classified as being of Moroccan origin that in fact emanated from Western Sahara, and a European Union and Moroccan fisheries agreement insofar as it related to the waters of Western Sahara.[27]

We conclude that howsoever Morocco's presence in Western Sahara may be described, it does not exercise sovereignty over the territory.[28]

The High Court's reliance on earlier cases is noteworthy. The basic principles of international law expressed in those cases – which would be accepted by the High Court as being part of South African law through the country's constitution – are amplified because of this restatement of them.[29] What makes the High Court's decision

unique next to those of the ICJ, the UK High Court, and the CJEU is that, while the decision observed the people of the territory as having the right of self-determination, it stated that Western Sahara is occupied by armed force. This description has legal consequences, including the possible application of international humanitarian law. The criminal liability of individual persons involved in human rights abuses – including the export of phosphate rock – in a Western Sahara under occupation can thus be established.

If the two Moroccan companies could not succeed on the basic facts of sovereignty and the claim that they could lawfully mine and export the phosphate rock, they might yet have been successful in their defences of "act of state doctrine" and sovereign immunity. But when it comes to sovereign immunity, we must recall that the Kingdom of Morocco itself was not a participant in the lawsuit. Instead, it was simply companies – albeit state-owned – that claimed they owned the cargo and had the right to sell it. This could create problems for future cargos that transit through or arrive in other countries if the SADR government asserts them to be purportedly owned by OCP or Phosboucraa and not an importing company. On the question of judicial restraint under the act of state defence argued as a reason for the High Court to refuse to deal with a matter of international affairs, the Court concluded as follows:

> We are mindful of the complexity of the issues raised in this matter and the obvious fact that the issues to be addressed in achieving a resolution of the international disputes in relation to the territory of Western Sahara are matters that concern the international community at the highest level. Nevertheless, this court is faced not with the broader political question but with the rather more prosaic question as to the regulation of its procedure to enable litigating parties access to a judicial forum in which they can resolve a legal dispute. There is no reason of high policy engaged in this matter which would preclude the court from doing so.[30]

In the aftermath of such conclusions, OCP and Phosboucraa's withdrawal from any further defence of the case was not a surprise. There was little possibility that the two companies could claim an adequate or proper ownership of exported phosphate rock. On the

factual background recited by the High Court, it seemed unlikely that the mining and industrial activity associated with the phosphate trade could be shown to have been consented to and benefited the Sahrawi people.[31]

The road to justice

The implications of the cases in Panama and South Africa will take time to be fully understood. As 2017 came to a close, there was no question that the phosphate trade had changed because of the two cases. Fewer companies are involved at greater cost to transport the commodity. And the importing companies appear to be finding it more difficult to justify or explain their involvement. In the early going, however, this had not translated to the governments of importing countries becoming interested. The cases also revealed the imbalance of the global phosphate trade, the commodity from Western Sahara being available to only a few importing companies in Global North countries able to pay for it.

From a wider perspective, the cases mark the ongoing Sahrawi use of the law combined with the possibility that other resources could be the subject of legal actions. Fisheries are a resource vulnerable to legal challenge, because of the European Union's long history of treaties with Morocco for Western Sahara's waters, the value of the fishery, and its political importance to Morocco as a means of engaging Europe to create a legitimacy for its presence in Western Sahara. This will be the next chapter in the use of law when it comes to resources. The Panama and South Africa cases can also be expected to emphasize the usefulness of the Sahrawi government's application of the law as a whole in the pursuit of self-determination.

The Panama and South Africa cases also contribute to strengthening international law. This can be see on two levels. The first is the rule of law. The Sahrawi actions mark out a greater accessibility to the law by all peoples, including in places of occupation or colonial control, where an administering state that is primarily responsible will not or cannot act. Another aspect of the rule of law is that basic principles, those at the apex of the international system, can demonstrably be pursued. On a second level, the law which applies to the sovereignty over natural resources of non-self-governing

(and occupied) peoples has surely been strengthened. This is useful when it is recalled that the United Nations and those states primarily responsible for Western Sahara, Morocco and Spain, together with other countries which receive Sahrawi phosphate, have so clearly failed to apply the law over the decades.

The twentieth century American human rights leader Martin Luther King Jr. observed that "the arc of the moral universe is long, but it bends toward justice." Few people have waited longer than the Sahrawi for the basic right of self-determination to be made available. In the Panama and South Africa cases they continued to build for themselves a unique legal road to achieving such justice.

1 The information in this chapter was gathered from numerous sources, including media reports, interviews with senior Sahrawi government and diplomatic personnel, court records, and open source materials, including published works about the history and occupation of Western Sahara. All are cited in the following notes.

2 For an analysis of such matters and natural resource exports from Western Sahara, see Jeffrey J. Smith, "The taking of the Sahara: The role of natural resources in the continuing occupation of Western Sahara", Global Change, Peace & Security 27, no. 3 (2015): 263.

3 See the Western Sahara Resource Watch "P for Plunder" reports at www. wsrw.org.
 "The government of the Sahrawi Arab Democratic Republic [the SADR] independently calculates the market value of shipments for the purpose of a long-term reparations claim and to protest individual shipments to receiving companies." Emhamed Khadad, SADR minister-counsellor, in discussion with the author, 15 Nov. 2017.

4 Khadad, discussion (see n. 3)

5 See, respectively, Law No. 03/2009 Establishing the Maritime zones of the Saharawi Arab Democratic Republic (21 January 2009), and letter of the Jurisconsult to the European Parliament Fisheries Committee, "Here is the secret legal opinion from the EU Parliament" WSRW, 13 July 2009, http://www.wsrw.org/a159x1346

6 See "Judgment of the General Court (Eighth Chamber), 10 Dec. 2015, http://curia.europa.eu/juris/document/document.jsf?text=&docid=172870&pageIndex=0&doclang=EN&mode=lst&dir=&occ=first&part=1&cid=1099247

7 See "Judgment of the Court (Grand Chamber), 21 Dec. 2016, http://curia.europa.eu/juris/document/document.jsf?text=&docid=186489&pageIndex=0&doclang=EN&mode=lst&dir=&occ=first&part=1&cid=1099247. "In view of the separate and distinct status accorded to the territory of Western Sahara by the principle of self-determination [the application of the EU-Morocco free trade agreement] cannot […] be interpreted in such a way that Western Sahara is included within the territorial scope of that agreement." (para. 92) See also para. 106: "In the present case, however, the judgment under appeal does not show that the people of Western Sahara have expressed any such consent."

8 This company is in a long-term joint venture with the exporting company, Morocco's OCP SA (formerly Office Chérifien des Phosphates SA). Mining and export sale of the phosphate rock from Western Sahara is done by a subsidiary enterprise, Phosphates de Boucraa SA.

9 See "P for Plunder" reports for 2014–16 (see n. 3) and "Carriers of Conflict" (June 2017), http://wsrw.org/files/dated/2017-06-16/carriersofconflict_16.06.2017_web.pdf. Some shipments to Vancouver after 2014 did not go through the Panama Canal, instead sailing around South America, a journey of six weeks' duration.

10 Kamal Fadel, SADR Petroleum & Mining Authority, in discussion with the author, 8 Nov. 2017. The Lithuanian importer is said to have explained in letters to the SADR government that supply availability restrictions of phosphate from Russia had required the single 2016 shipment, after deciding to end imports in mid-2015.

11 In Australia, two other importers had withdrawn from buying phosphate rock from Western Sahara. The Australia Western Sahara Association is an active civil society group that has confronted importers and hosted a conference in Melbourne in 2015 on the subject of Western Sahara's resources.

12 Emhamed Khadad explained there had been an advance simulation of the cases in Panama and South Africa in the weeks following the December 2016 appeal judgment of the CJEU when ships bound for Canada and India passed by the two countries. Khadad, discussion (see n. 3).

13 Details of the NM Cherry Blossom can be found on the website of the ship's classification society, ClassNK, https://www.classnk.or.jp. Built in Japan and launched in December 2014, the ship is 198 metres long with a capacity of 60,960 deadweight tonnes, which is its capacity for loaded cargo as well as fuel and provisions. The ship

is owned by a Marshall Islands company, NM Shipping S.A. and is managed by the Greek firm A.M. Nomikos Transworld Maritime Agencies S.A. Photos of the ship are available on the website www.shipspotting.com.

14 See the website of the Fertiliser Association of New Zealand, www.fertiliser.org.nz. See also "NZ-bound phosphate shipment seized", The New Zealand Herald, 5 May 2017, http://www.nzherald.co.nz/business/news/article.cfm?c_id=3&objectid=11850638

15 Letter of Otmane Bennani Smires, OCP Executive Vice-President/General Counsel to the Registrar of the High Court at Port Elizabeth, 13 July 2017. The letter has not been published, but is available from the court's registry. The letter concludes "We were met at Port Elizabeth by a tribunal that has been used for political means. Given this, OCP SA and Phosboucraa have no other responsible choice but to withdraw from the proceedings and expose them as politically flawed."

16 Details of the Ultra Innovation can be found on the website of the Danish ship management company Ultrabulk A/S, www.ultrabulk.com. Owned by the Japanese firm Shoei Kisen Kaisha, the ship is 200 metres long and has a capacity of 61,188 deadweight tonnes. See photos of the ship at BC Chamber of Shipping, "June 23– Ultra Innovation", 23 June 2017, http://www.cosbc.ca/index.php/latest-news/item/3497-june-23-ultra-innovation

17 After the Ultra Innovation, there would be six more ships to Canada in 2017, two of them also managed by the Ultrabulk firm.

18 The SADR government issued a press release declaring the risks of trading into occupied Western Sahara. See "Policy Statement of the government of the Saharawi Republic on the risk and liability of ships carrying natural resources from occupied Western Sahara", media release.

19 Fadel, discussion (see n. 10).

20 Ultrabulk has been heavily involved in carrying Western Sahara's phosphate to Canada because the shipping line carries away potash from the port of Vancouver and is involved in a ship construction financing arrangement with Canada's potash marketing enterprise, Canpotex, of which the Canadian importer is a member. See Canadian Chamber of Commerce in Japan, "Canpotex increases fleet", CCCJ, 13 Jan. 2012, www.cccj.or.jp.

21 Khadad, discussion (see n. 3). The Maritime Courts of Panama do not routinely publish interim and procedural decisions. See the website of the Tribunales Maritimos, www.organojudicial. gob.pa.

22 A complicating feature of the case following the withdrawal of OCP and Phosboucraa was the insistence of the Australian time charterer that there be security posted for its claims to the demurrage of the ship – its delayed onward sailing and a resuming of trade – because of the detention of the cargo aboard. The Sahrawi government position was that such a claim could not be maintained because the charterer had notice of the risk of carrying Western Sahara's phosphate and that such a claim was to be made against the New Zealand importer chartering the NM Cherry Blossom for its voyage. Khadad, discussion (see n. 3).

23 See "Saharawi Arab Democratic Republic and Another v Owner and Charterers of the MV 'NM Cherry Blossom' and Others (15/6/2017) [2017] ZAECPEHC 31", Southern Africa Legal Information Institute, www.saflii.org/ za/cases/ZAECPEHC/2017/31.html.

24 Ibid., para. 13.

25 Ibid., para. 15.

26 Ibid., para. 40.

27 Ibid., para. 41. The 2015 decision of the United Kingdom court, R (Western Sahara Campaign UK) v The Commissioners for HMRC and the Secretary of State for the Environment, Food and Rural Affairs [2015] EWHC 2898 (Admin), can be found online: http:// www.bailii.org/ew/cases/EWHC/ Admin/2015/2898.html.

28 Ibid., para. 43.

29 Section 232 of South Africa's Constitution provides that "customary international law is law in the Republic unless it is inconsistent with the Constitution or an Act of Parliament".

30 "ZAECPEHC 31" (see n. 23), para. 100.

31 The requirement of international law for a non-self-governing people to consent to and benefit from the development and trade in natural resources, discussed elsewhere in this volume is well established. In a periodic review report for Morocco in 2016, the Committee on Economic, Social and Culture rights of the UN Human Rights Council urged Morocco to respect the Sahrawi people's right to "free, prior and informed consent" in the development of natural resources in the territory.
"OCP and Phosboucraa do not claim to have mined the phosphate in Western Sahara with the consent of the people of the territory. They do not and cannot claim to do so on behalf of its people. Their claim to mine phosphate for the benefit of the people is disputed by the SADR and the PF: as most of the Sahrawi people live to the east of the berm or in refugee camps in Algeria, those who may benefit from the mining of phosphate are not the 'people of the territory' but, more likely, Moroccan settlers." Ibid., para. 48.

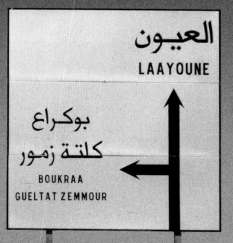

العيــون

LAAYOUNE

بوكـراع
كلتـة زمـور

BOUKRAA
GUELTAT ZEMMOUR

Colophon

Profit over Peace in Western Sahara
How commercial interests undermine
self-determination in the last colony in
Africa

Editors: Erik Hagen, Mario Pfeifer
Graphic Design: Markus Weisbeck
Research Assistance: Nina B. Anderson
Microtypography: Jonas Dahl
Authors: Erik Hagen, Jeffrey J. Smith
Copy-Editing: Simon Cowper, Juan
Majeed, Yvette Mutumba
Translation: Abed Azzam, Ina Görtz
Photography: Mario Pfeifer, WSWR,
[blackboardfilms]
Pre-press: ScanColor Reprostudio

Printed in Germany

ISBN 978-3-95679-405-6

The Arabic typeface that has been used
for this book is Traditional Arabic; the
English typeface is Px Grotesk.

All html links referred to in this publi-
cation were accessed on 15 January
2018.

NASA copyright policy states that
"NASA material is not protected by
copyright unless noted". (See Template:
PD-USGov, NASA copyright policy page
or JPL Image Use Policy.)

We would like to express our gratitude
for the opportunity to create this pub-
lication to our funders and supporters
– the Stiftung Kunstfonds Bonn, KOW,
and private supporters – as well as all
contributors and collaborators.

Special thanks to Nina Back Andersen,
Davide Contini, Sara Eyckmans, Sören
Lindh, Tone S. Moe, Asria Mohamed, Per
Kristian Cappelen Nielsen, Saleh Sid
Mustafa, Jeffrey J. Smith, and Sylvia
Valentin.

On a personal note, particular thanks
go to Abed Azzam, Max Bach, Simon
Cowper, Jonas Dahl, Tarje Gullaksen,
Ina Görtz, Tatjana Günthner, Alexander
Koch, Ralf Lenk, Yvette Mutumba,
Nikolaus and Raphael Oberhuber, the
Pfeifers, Simón Quiñones, Caroline
Schneider, and Markus Weisbeck.

Editors' Note: Major developments took
place in the days before this book went
to print. The multinational oil compa-
nies announced their departure, the
largest phosphate importer declared
that it is phasing down its imports, and
on 27 February 2018 the Court of Jus-
tice of the EU ruled on the EU fisheries'
practices in the territory. These large
developments are not described here
but can be followed on www.wsrw.org.

Since 2011 Mario Pfeifer has visited the
occupied and liberated territories of the
Western Sahara several times. In 2013
he also visited Sahrawi refugee camps
in the west of Algeria. The black-and-
white photographs in this publication
were taken on these research trips.

Sternberg Press
Caroline Schneider
Karl-Marx-Allee 78
D-10243 Berlin
www.sternberg-press.com

Sternberg Press

STIFTUNGKUNSTFONDS

KOW

الربح أهم من السلام في الصحراء الغربية –
كيف تقوّض المصالح التجارية تقرير المصير في آخر
مستعمرات إفريقيا
المحررون: إريك هاغن/ماريو بفايفر
التصميم الغرافيكي: ماركوس فايسبيك
مساعد البحث: نينا ب. أندرسون
المابكروغرافي: جوناس دال
المؤلفون: إريك هاغن، جيفري ج.سميث
تحرير النسخة: سيمون كوبر، جوان مجيد، إيفيت موتوما
الترجمات: عبد عزام، إينا كورتز
التصوير الفوتوغرافي: ماريو بفايفر،ديبيلو إس دبليو آر
(بلاك بورد فيلمز)
ما قبل الطباعة: سكانكالر ريبروستوديو
تمت الطباعة في ألمانيا

الترقيم الدولي للكتاب:978-3-95679-405-6

الخط العربي المستخدم لهذا الكتاب هو الخط العربي
التقليدي أما الخط اللاتيني فهو بي إكس كروتيسك
كل روابط الإنترنت المشار إليها في هذه الطبعة تم الولوج
إليها بتاريخ الخامس عشر من كانون الثاني عام ٢٠١٨.
سياسة حقوق الطبع والنشر لدى ناسا تصرح بأن "المواد
الصادرة من ناسا ليست محمية تحت حقوق الطبع والنشر
ما لم يذكر خلاف ذلك". (أنظر النموذج PD–
USGov صفحة حقوق الطبع والنشر لناسا أو سياسة
نشر الصور لموقع حي بي في إل).

نشكر جميع الداعمين والممولين لإتاحتهم الفرصة لنشر
هذا الكتاب وبالأخص مؤسسة كونستفوندز بون و
ك.و.دبليو كما ونشكر كل من ساهم وتعاون معنا كي
يخرج هذا العمل إلى النور.
شكر خاص لينا باك أندرسن ، دايفيد كونتيتي، سارا
آيكمانز ، سورين ليند، طوني سورمون مو، عصرية محمد،
بير كريستيان كابيلن نيلسن، صالح سيد مصطفى،
جيفري ح. سميث و سيلفيا فالنتين.
كما ونخص بالشكر عبد عزام، ماكس باخ، سيمون
كوبر، جوناس دال، تاريبيه غولاكسن، إبنا غورتز، تاتيانا
غونتر، أليكساندر كوخ، رالف لينك، إيفيت موتوما،
نيكولاوس و رافاييل أوبيرهوبر، عائلة بفايفر، سيمون
كوينينس، كارولين شنايدر، ماركوس فايسباك.

كلمة المحرر: حصلت تطورات كبيرة في الأيام التي سقت
طباعة هذا الكتاب. أعلنت شركات النفط المتعددة
الجنسيات مغادرتها، كما وصرح أكبر مستورد للفوسفات
بتقليل مستورداته بشكل تدريجي. بتاريخ السابع
والعشرون من شباط ٢٠١٨ بتت محكمة العدل الأوربية
في الممارسات الأوربية بخصوص صيد الأسماك في المنطقة.
إن هذه التطورات المهمة غير مذكورة هنا لكن يمكن
الاطلاع عليها ومتابعتها على موقع:
www.wsrw.org
منذ ٢٠١١ قام ماريو بفايفر بعدة زيارات إلى المناطق
المحتلة والمحررة في الصحراء الغربية. في ٢٠١٣ قام أيضاً
بزيارة مخيمات اللاجئين الصحراويين في غرب الجزائر.
الصور الموجودة بالأبيض والأسود في هذا الكتاب تم
التقاطها خلال رحلات البحث تلك.

تم النشر من قبل دار شتين بيرغ للنشر
دار شتين بيرغ للنشر
كارولين شنايدر
كارل ماركس آلي ٧٨
د–١٠٢٤٣ برلين
www.sternberg-press.com

Sternberg Press STIFTUNG KUNSTFONDS KOW

إن متطلبات القانون الدولي التي تخص موافقة الشعوب على التمتع بالحكم الذاتي على تطوير والتجارة بالموارد الطبيعية والاستفادة منها، والتي تمت مناقشتها في موضع آخر من هذا الاصدار، واضحة جدا. حثت اللجنة المعنية بالحقوق الاقتصادية والاجتماعية والثقافية التابعة لمجلس الانسان بالأمم المتحدة في تقريرها الدوري عام 2016 المغرب على احترام حق الشعب الصحراوي بـ"موافقة حرة ومسبقة وموثقة" على تنمية الموارد الطبيعية في الاقليم. في SADR v. OCP and Fosbucraa، ملاحظة 23 أعلاه، الفقرة 48، استنتجت المحكمة العليا:"لا تدعي OCP and Phosboucraa قيامهما باستخراج الفوسفات في الصحراء الغربية بموافقة شعب الاقليم. ولا يمكنهما القيام بذلك بتكليف من الشعب. إن مطالبتهما باستخراج الفوسفات لصالح منفعة الشعب يلاقي اعتراضا من جانب الحكومة الصحراوية وجبهة البوليساريو: إذ يعيش معظم الشعب الصحراوي في المنطقة الشرقية من الجدار الرملي او في مخيمات اللاجئين في الجزائر. ويبدو أن "الشعب صاحب الاقليم" ليس المستفيد من استخراج الفوسفات، بل وعلى الارجح، المستوطنون المغاربة". xxxi.

رسالة من عثمان بناي سمويس، نائب الرئيس التنفيذي/المستشار القانوني لـ OCP، إلى سجل المحكمة العليا في بورت اليزابيث، 13 تموز/يوليو 2017. لم يتم نشر الرسالة إلا أفا موجودة في سجل المحكمة. وتلخص الرسالة إلى القول "لقد وجدنا في بورت اليزابيث محكمة تم استخدامها لأغراض سياسية. وعلى ضوء ذلك، لا يوجد أمام OCP SA و Phosboucraa أي خيار مسؤول غير الانسحاب من القضية والاشارة الهادكذات عيب سياسي." xv

يمكن الحصول على تفاصيل عن السفينة Ultra-Innovation على موقع شركة ادارة السفن الدانماركية: www.ultrabulk.com. تملك السفينة الشركة اليابانية Shoei Kisen Kaisha. يبلغ طول السفينة 200 متر ويصل مقدار أحمال حمولتها 61188 طن. شاهدوا صورا للسفينة على الموقع "June" ,BC Chamber of Shipping (23 – Ultra Innovation" (حزيران/يونيو 2017): Www.cosbc.ca. xvi

بعد Ultra Innovation انطلقت ست سفن اخرى الى كندا في عام 2017 وادارت شركة Ultrabulk التين من بينها ايضا. xvii

اصدرت الحكومة الصحراوية بيانا صحفيا اعلنت فيه عن مخاطر التجارة في الصحراء الغربية المحتلة. انظروا "اعلان سياسة حكومة الجمهورية العربية الديموقراطية الصحراوية بصدد المخاطر ومـــــــــــؤولية الـــــــــق الــــــــــق تقـــــــــل لـــــــوارد الطبيعيـــــــــة مـــــــن الصـــــحراء الغربيـــــة المحتلـــــة" (حزيـــــــران/يونيو 2017): http://www.usc.es/export9/sites/webinstitucional/gl/institutos/ceso/descargas/SADR_Press-Release_Risk-Liability-of-Vessels_21–June-2017.pdf. "تود الحكومة الصحراوية تحذير دوي الشأن في تجارة السفن بما في ذلك المستأجرين للناي بأنفسهم وبسفهم عن امكانية تحمل مسؤولية واجراءات تعويض مستقبلية". xviii

مقابلة مع محمد حداد، ملاحظة 10 اعلاه.xix

ان السبب الذي يقف من وراء تورط Ultrabulk العميق بشحن الفوسفات من الصحراء الغربية الى كندا هو أن الخط البحري يشحن البوتاس من ميناء فانكوفر، بالإضافة إلى مشاركتها في اتفاقية لتمويل بناء السفن مع شركة تسويق البوتاس Canpotex والتي يعتبر المستورد الكندي عضوا فيها. انظروا غرفة التجارة الكندية في اليابان "اسطول Canpotex يكبر" (13 كانون الثاني/يناير 2012)، على: xx. www.cccj.or.jp.

مقابلة مع محمد حداد، ملاحظة 3 اعلاه. وفي العادة لا تنشر محاكم بنما البحرية قراراتها المؤقتة والاجرائية. انظر موقع Tribunales Maritimos، على: www.organojudicial.gob.pa xxi

وكانت الميزة التي أدت إلى تعقيد القضية بعد انسحاب Fosbucraa و OCP، هي اصرار المستأجر الاسترالي على توفير ضمان مالي على غرامة تأخير السفينة—أي تأخير تجارها من جديد لاستئناف التجارة——بسبب احتجاز الشحنة على متنها. واشار موقف الحكومة الصحراوية الى انه لا يمكن قبول هذا الادعاء لان المستأجر كان على علم بالمخاطر التي يحملها شحن الفوسفات من الصحراء الغربية، والى انه يجب توجيه هذا الادعاء ضد المستورد النيوزيلندي الذي استأجر NM Cherry Blossom للقيام بهذه الرحلة. مقابلة مع محمد حداد، ملاحظة 3 اعلاه. xxii

يمككم قراءة القرار على الانترنت. انظروا: Saharawi Arab Democratic Republic and Another v Owner and Charterers of the MV 'NM Cherry Blossom' and Others [2017] ZAECPEHC 31 (SADR v. OCP and Fosbucraa)، على: Southern Africa Legal Information Institute: www.saflii.org/za/cases/ZAECPEHC/2017/.

المرجع نفسه، الفقرة 13.xxiv

المرجع نفسه، الفقرة 15. xxv

المرجع نفسه، الفقرة 40 اقباس من رأي محكمة العدل الدولية بخصوص الصحراء الغربية (Western Sahara Advisory Opinion) عام 1975. xxvi

المرجع نفسه، الفقرة 41، تم حذف الاقتباس. يمككم قراءة قرار محكمة المملكة المتحدة (Western Sahara Campaign UK) v The Commissioners for HMRC and the Secretary of State for the Environment, Food and Rural Affairs [2015] EWHC 2898 (Admin، على الموقع التالي: EWHC http://www.bailii.org/ew/cases/2015/2898/Admin/10.html.
xxvii
المرجع نفسه، الفقرة 43.xxviii

تنص المادة 232 من دستور جنوب افريقيا على ما يلي: "القانون الدولي العرفي ساري المفعول في الجمهورية ما لم يكن متناقضا مع الدستور أو القوانين البرلمانية".xxix

SADR v. OCP and Fosbucraa، ملاحظة 23 اعلاه، الفقرة 100. xxx

تم جمع المعلومات الواردة في هذا الفصل من العديد من المصادر، بما في ذلك تقارير صحفية ومقابلات مع كبار موظفي الحكومة الصحراوية ودبلوماسيها وسجلات المحكمة ومواد من مصادر مفتوحة بما في ذلك أعمال عن تاريخ واحتلال الصحراء الغربية. تم اقتباس كل المصادر في الملاحظات التالية. I

للاطلاع على تحليل لصادرات هذه المواد والموارد الطبيعية من الصحراء الغربية، انظروا: Jeffrey J. Smith, "The taking of the Sahara: The role of natural resources in the continuing occupation of Western Sahara" (2015) 27 Global Change, Peace & Security 263 ii

انظروا التقرير: Western Sahara Resource Watch "P for Plunder" www.wsrw.org. تقوم حكومة الجمهورية العربية الصحراوية الديمقراطية بحساب مستقل للقيمة السوقية للشحنات بغرض التحضير لمطالبة طويلة الامد بتعويضات ومن أجل الاحتجاج أمام الشركات المتلقية بخصوص الشحنات الفردية. (مقابلة مع محمد الخداد، وزير -مستشار في حكومة الجمهورية العربية الصحراوية الديمقراطية، 15 نوفمبر/تشرين الثاني 2017) (مقابلة مع خداد). iii

مقابلة مع محمد خداد، المرجع نفسه. iv

انظروا تباعا، القانون رقم 03/2009 الذي يحدد المناطق البحرية للجمهورية العربية الديمقراطية الصحراوية (21 كانون الثاني/يناير 2009)، ورسالة المستشار القانوني الى لجنة صيد الاسماك في البرلمان الأوروبي (13 تموز/يوليو 2009): www.wsrw.org v

انظروا التقرير الخاص بالقضية: -T ،(10 December 2015) Frente Polisario c. European Council, Judgment of the General Court http://curia.europa.eu/juris/document/document.jsf? ـــــــ :ع 512-12، text-&docid-172870&pageIndex-0&doclang-EN&mode-lst&dir-&occ-first&part-1&cid-1099247 vi

انظـــــــــــــــــــروا التقريـــــــــــــــــــر الخـــــــــــــــــــاص بالقضـــــــــــــــــــية: http://curia.europa.eu/juris/document/document.jsf? .text-&docid-186489&pageIndex-0&doclang-EN&m ode-lst&dir-&occ-first&part-1&cid-1099247 بـــالنظر الى المكانـــة المختلفة والمتميزة التي مُنحت للصحراء الغربية استنادا إلى مبدأ تقرير المصير، لا يمكن ... تفسير [تطبيق اتفاقية التجارة الحرة بين المغرب والاتحاد الأوروبي] بطريقة تجعل الصحراء الغربية جزءا من النطاق الإقليمي لهذا الاتفاق". المرجع نفسه، الفقرة 92. وانظروا الفقرة 106: "إلا أنه في هذه الحالة، فإن القرار الواقع تحت الاستئناف لا يثبت بأن شعب الصحراء الغربية كان قد ابدى أي موافقة من هذا القبيل". vii

لهذه الشركة علاقة مشتركة طويلة الامد مع شركة التصدير OCP SA المغربية (والمعروفة سابقا باسم Office Chérifien des Phosphates SA). تقوم الشركة الفرعية Boucraa SA باستخراج وتصدير الفوسفات من الصحراء الغربية. viii

انظروا تقارير Plunder for P: "WSRW للأعوام 16-2014، وكذلك "Carriers of Conflict" (حزيران/يونيو 2017) على: www.wsrw.org. بعد عام 2014 لم تمر بعض الشحنات ام فانكوفر عبر قناة بنما، بل انحرت بدلا عن ذلك حول امريكا الجنوبية في رحلة تستغرق مدها ستة اسابيع. ix

مقابلة مع كمال فضل، سلطة البترول والتنقيب في الحكومة الصحراوية، 8 تشرين الثاني/نوفمبر 2017 (مقابلة مع فضل). نص رد المستورد اليتواني في رسالته إلى حكومة الصحراء الغربية أن القيود على توفير امدادات الفوسفات من روسيا تطلبت طلب شحنة واحدة فقط في العام 2016، وذلك بعد اتخاذه قرار بوقف الايرادات في منتصف عام 2015. س x انسحبت شركة استيراد أستراليين من شراء الفوسفات من الصحراء الغربية. ان جمعية الصحراء الغربية الأسترالية عبارة عن منظمة مجتمع مدني نشطة واجهت المستوردين وعقدت مؤتمرا بشأن موضوع الصحراء الغربية في ملبورن في عام 2015. ي xi

صرح محمد خداد بأنه قد تم مسبقا محاكاة القضايا في بنما وجنوب افريقيا في الاسابيع التي تلت حكم الاستئناف الصادر عن محكمة العدل للاتحاد الأوروبي. في كانون الاول/ديسمبر 2016 بعدما مرت السفن المتجهة الى كندا والهند عبر البلدين. مقابلة مع محمد خداد، ملاحظة 3 أعلاه. xii

يمكن الحصول على تفاصيل على موقع شركة تصنيف السفينة: NM Cherry Blossom شركة تصنيف السفينة: ClassNK: https://www.classnk.or.jp. بنيت السفينة في اليابان في كانون الاول/ديسمبر 2014. يبلغ طولها 198 مترا. تتسع السفينة إلى 60,960 طن من البضاعة بالإضافة الى الوقود والمؤن. تجدر الاشارة الى ان ملكية السفينة تعود لشركة مسجلة في حزر مارشال، NM Shipping S.A، كما وتديرها شركة يونانية (A.M. Nomikos Transworld Maritime Agencies S.A). ويمكن الحصول على صور للسفينة على الموقع التالي: xiii www.shipspotting.com

انظروا موقع رابطة الأسمدة النيوزيلندية: www.fertiliser.org.nz. انظروا ايضا "NZ-bound phosphate shipment seized" New Zealand Herald (2017) أيـــــــــــار/مايو http://www.nzherald.co.nz/business/news/article.cfm?c_id-3&objectid-11850638 5) xiv http://www.nzherald.co.nz/business/news/article.cfm?8c_id-3&objectid-11850638

وكشفت القضيتان عن عدم التوازن في تجارة الفوسفات العالمية، وكون فوسفات الصحراء الغربية سلعة لا تتوفر الا لعدد قليل من الشركات المستوردة في عالم الشمال والتي تملك القدرة على دفع ثمنه. ومن منظور اوسع، تشير القضيتان الى استخدام الصحراويين المستمر للقانون مقرونا بإمكانية احضاع موارد اخرى للإجراءات القانونية. فصيد الاسماك عبارة عن مورد معرض للطعن القانوني نظرا الى تاريخ المعاهدات الطويل بين الاتحاد الأوروبي والمغرب بخصوص الصحراء الغربية، وقيمة صيد الاسماك واهميته السياسية بالنسبة للمغرب كوسيلة لإشراك أوروبا لخلق شرعية لوجودها في الصحراء الغربية. وسيكون هذا موضوع الفصل التالي الذي يتناول اللجوء الى القانون بصدد مسألة الموارد. كما ونتوقع أن تؤكد القضايا في جنوب افريقيا وبنما على جدوى استخدام الحكومة الصحراوية للقانون ككل في سبيل تحقيق تقرير المصير.

من جهة أخرى، تساهم قضايا جنوب افريقيا وبنما في تعزيز القانون الدولي. ويمكن رؤية ذلك على مستويين. الاول هو حكم القانون. إذ تشير الاجراءات الصحراوية الى زيادة امكانية وصول القانون الى جميع الشعوب، بما في ذلك اماكن الاحتلال او السيطرة الاستعمارية، حيث لا تستجيب الدولة المديرة والمسؤولة الرئيسية. وثمة جانب اخر لسيادة القانون وهو ان المبادئ الاساسية، في حال تواجدها على قمة هرم النظام الدولي، قد اثبت امكانية تطبيقها. وعلى صعيد ثان، لا شك أن القانون المتعلق بالسيادة على الموارد الطبيعية في المناطق التي لا تتمتع بالحكم الذاتي (والمحتلة) قد تتعزز. وهذا أمر مفيد خصوصا إذا ما تذكرنا بأن الامم المتحدة والدول المسؤولة مباشرة عن الصحراء الغربية، أي المغرب واسبانيا، وكذلك سائر الدول التي تحصل على الفوسفات الصحراوي قد فشلت بشكل واضح في تطبيق القانون على مر العقود الفائتة.

لقد نبه رائد حقوق الانسان في القرن العشرين الأمريكي مارتن لوثر كينج على أن "قوس العالم الاخلاقي طويل إلا أنه ينحني أمام العدالة". ينتظر عدد من شعوب العالم إلى جانب الشعب الصحراوي تحقيق حق تقرير المصير. ومن خلال قضايا بنما وجنوب افريقيا يمكنهم أن يستمروا ببناء طريق قانوني فريد لتحقيق هذه العدالة.

البلاد——على تأثير أكبر بسبب اعادة تأكيدها.xxix إن الأمر الذي يجعل قرار المحكمة العليا فريد مقارنة بقرارات محكمة العدل الدولية والمحكمة البريطانية العليا ومحكمة العدل التابعة للاتحاد الاوروبي هو أنه في حين يعتبر القرار أن الشعب القاطن في الاقليم يتمتع بحق تقرير المصير، فإنه يذكر أيضا أن قوة عسكرية تحتل الصحراء الغربية. وتترتب على هذا الوصف نتائج قانونية، ومن بينها امكانية تطبيق القانون الدولي الانساني. وقد يعني هذا امكانية تحميل أفراد معينين من المتورطين في انتهاكات حقوق الانسان مسؤولية جنائية——وبما في ذلك تصدير الفوسفات الخام——في الصحراء الغربية الواقعة تحت الاحتلال.

وفيما لم تفز الشركتان المغربيتان في القضية لاعتمادهما على حقائق السيادة الاساسية وعلى ما يبدو كونه حق باستخراج الفوسفات وتصديره، فربما كانت لديهما إمكانية بالفوز لو أنهما كانتا قد استخدمتا دفاعات تعتمد على "مبدأ تصرف الدولة" والحصانة السيادية. ولكن، إذا ما نظرنا الى الحصانة السيادية فعلينا ان نتذكر ان المملكة المغربية لم تكن شريكة في الدعوى. فبدلا عن ذلك، كان المطلب بملكية الشحنة مجرد شركات——حتى لو كانت شركات تملكها الدولة. وقد يسبب ذلك مشاكلا للشحنات المستقبلية التي تمر عبر دول أخرى، أو تصل اليها، إذا ما أكدت الحكومية الصحراوية كونها في ملكية Fosbucraa أو OCP وليس في ملكية الشركة المستوردة. وكان رد المحكمة على مسألة الموانع القضائية الصادرة عن مبدأ تصرف الدولة التي عرضتها Fosbucraa و OCP بصفتها سبب يجعل المحكمة العليا ترفض التعامل مع مسألة تخص الشؤون الدولية، كما يلي:

ندرك تعقيد القضايا التي تم عرضها في هذا الشأن، وندرك كذلك الحقيقة الواضحة بأن المسائل التي يجب التعرض اليها للتوصل الى حل في النزاعات الدولية فيما يتعلق بالصحراء الغربية هي مسائل تعني المجتمع الدولي على أعلى المستويات. وعلى الرغم من ذلك، فإن القضية القائمة أمام هذه المحكمة ليست القضية السياسية الأعم وانما مسالة أكثر واقعية، وهي تخص تنظيم اجراءات لتمكين الاطراف المتقاضية من الوصول الى محفل قضائي يمكنهم من الوصول الى حل لنزاع قانوني. لا يوجد هناك أي سبب مرتبط بالسياسة العليا في هذا الامر والذي من شأنه ان يحول دون قيام المحكمة بذلك.xxx

وفي اعقاب هذه الاستنتاجات، لم يشكل انسحاب Fosbucraa و OCP من الدفاع عن هذه القضية أية مفاجأة. كان هناك احتمالا ضئيلا بأن تقوم الشركتين بطلب مقبول أو ملائم بملكية الفوسفات الخام المصدر. فعلى خلفية الوقائع التي أثليت امام المحكمة العليا، كان من المستبعد اثبات أن عمليات الاستخراج والتصنيع المرتبطة بتجارة الفوسفات يمكن ان تكون قد قُبلت قد قُبلت قد قُبلت من طرف الشعب الصحراوي أو أنه قد انتفع بها.xxxi

درب العدالة

سيستغرق فهم الآثار المترتبة على قضايا بنما وجنوب افريقيا فهمها كاملا وقتا طويلا. ومع نهاية عام 2017، لا شك في ان تجارة الفوسفات قد تغيرت بسبب هاتين القضيتين. غذ يشارك اليوم عدد أقل من الشركات في هذه التجارة، ويرافق ذلك ارتفاع في تكاليف نقل الفوسفات. ويبدو ان الشركات المستوردة تجد صعوبة أكبر في تبرير او تعليل مشاركتها في هذه التجارة. وخلال هذا المدى القصير، لم يتم بعد ترجمة ذلك الى جعل حكومات الدول المستوردة تبدي اهتمامها بالأمر. كما

لكانت هناك مفاوضات لإيجاد حل للادعاء الصحراوي – الامر الذي كان بعيد الاحتمال– او لاستمرت القضية لتصبح محاكمة في وقت ما من عام 2018.

إن جوانبا كثيرة من احتلال الصحراء الغربية عبارة عن حقائق ثابتة. وما يجعل الدعوى في جنوب افريقيا حالة فريدة من نوعها هو ضرورة التفات المحكمة العليا إلى الجوانب التي تخص مكانة الصحراء الغربية وظروف الاحتلال. فلم تكن محكمة العدل التابعة للاتحاد الاوروبي لدى اتخاذها قرارتها بشأن دعوى التجارة الحرة التي رفعتها جبهة البوليساريو، وكذلك محكمة العدل في رأيها الاستشاري حول الصحراء الغربية عام 1975 (Western Sahara Advisory Opinion) بحاجة الى التعامل مع "حقائق على الارض" تثير القلق. لقد ابدى قضاة المحكمة العليا تفهمهم لمثل هذه الامور من خلال الملاحظات التالية الواردة في الحكم الصادر في 15 حزيران/يونيو:

إن جوهر القضية من وجهة نظر الحكومة الصحراوية وجبهة البوليساريو هو أن الفوسفات على متن السفينة جزء من موارد الصحراء الغربية الوطنية وهو ملك لشعبها، وأن Phosboucraa و OCP اساءتا استخدام الفوسفات وقامتا ببيعه بدون أن يكون لهما حق في فعل ذلك. وتعتزم الحكومة الصحراوية وجبهة البوليساريو القيام بإجراءات دفاعية بخصوص الشحن، وتهدف هذه الاجراءات الى ضمان بقاء القضية في نطاق اختصاص هذه المحكمة (الا إذا تم توفير ضمان ملائم) الى حين اتمام الخطوات الاستشارية.[xxiv]

ومن ناحية اخرى، تدعي Phosboucraa و OCP بأن لدى Phosboucraa حق استخراج الفوسفات وبيعه. وهذه الحقوق مستمدة من القانون المغربي. كما انها تدعي بقيامها باستخراج وبيع الفوسفات وفقا للقانون الدولي. كما وقدمت دفاعيين اخريين. أولا، أنه ومن وجهة نظر القانون العام للدولة، لا توجد شرعية لعرض النزاع المقدم لنا؛ وثانيا، انه بحسب قانون حصانة الدولة الاجنبية رقم 87 من عام 1981، لا يجوز لهذه المحكمة اصدار قرارات بهذا الامر لتشابك قوانين دولة ذات سيادة، اي المغرب، به...[xxv]

قرار محكمة العدل الدولية [1975] واضح: لا يمتلك المغرب حق السيادة على الصحراء الغربية. فادعائه الحق بالسيادة نتيجة لاحتلاله الصحراء الغربية لا يتوافق مع مكانة الصحراء الغربية كاقليم لا يتمتع بالحكم الذاتي. وبالإضافة الى ذلك، سيطر المغرب على هذه الأراضي بالقوة. وهذا الأمر، بصفته وسيلة لاكتساب السيادة، مخالف للقوانين الدولية المتعارف عليها....[xxvi]

تم اعتماد عدم شرعية مطلب المغرب بحق السيادة على الصحراء الغربية في القضية (on R application of Western Sahara Campaign UK) v Revenue and Customs Commissioners & another, a [2015] case) [2015]، التي تعرضت إلى صحة التعريفات التجارية التفضيلية المتعلقة بالسلع المصنفة على انها من أصل مغربي ولكنها في الحقيقة آتية من الصحراء الغربية، وكذلك في اتفاق الصيد البحري المبرم بين الاتحاد الأوروبي والمغرب فيما يتعلق بمياه الصحراء الغربية...[xxvii]

وخلاصة ذلك أنه مهما كان الوصف الملائم لوجود المغرب في الصحراء الغربية فإن المغرب لا يتمتع بالسيادة على الاقليم.[xxviii]

إن اعتماد المحكمة العليا على القضايا السابقة لهو امر جدير بالملاحظة. تحصل مبادئ القانون الدولي في هذه القضايا——التي تتداولها المحكمة العليا كجزء من قانون جنوب افريقيا استنادا على دستور

تصل أي شحنة إلى كندا ونيوزيلندا عبر قناة بنما في عام 2017. وبالفعل، تم تعقب السفن المعدة للمستورد الكندي على الطريق الطويل حول امريكا الجنوبية.[xvii]

ويبدو ان هناك سببا اخرا من وراء ملاحقة السفينة في بنما. فالعديد من خطوط الملاحة مسجلة في هذه الدولة، ويعود ذلك إلى أسباب تتعلق بتنظيم وتخطيط الضرائب. كما أن لأربع مجمل السفن التي تنقل فوسفات الصحراء الغربية علاقات تجارية مع شركات بنمية. إن اتخاذ اجراءات قانونية في هذه الدولة عبارة عن إنذار لتجارة الشحن العالمية بالمخاطر المنطوية على ذلك.[xviii] ومن الجدير ذكره أن السلطات الصحراوية اتخذت خطوات ضد سفينة تشغلها الشركة الدانمركية Ultrabulk. وتشهد المصادر ان هذه الشركة واحدة من عدد قليل من شركات ادارة السفن التي حاولت الحكومة الصحراوية توريطها.[xix] فاحتجاز احدى بواخر Ultrabulk يشكل بالطبع تحذيرا يمكنه تشكيل اساس للعمل ضد سفن الشركة الاخرى بموجب مفهوم ما يسمى في القانون البحري "مسؤولية السفينة الشقيقة".[xx]

تطورت قضية بنما على ارض الواقع كما خُطط لها. وبعد ذلك بيومين، أي في 19 ايار/مايو، كان بإمكان السفينة الابحار الى كندا بعدما قام مالكها، أو ربما المستورد الكندي، بتوفير ضمان مالي مقابل الادعاء ضدها. وفي غضون ايام، تداولت محكمة بنما البحرية طلب احتجاز السفينة الاصلي وصلت الى نتيجة مفادها وضعها جانبا. وعللت المحكمة ذلك بأن الادعاء الصحراوي الذي يطالب بملكية الشحنة لا يمتلك اسسا كافية. قامت الحكومة الصحراوية بالاستئناف على القرار وتوقعت صدور قرار في القضية في نهاية 2017. وتأسس الاستئناف على الادعاء بأن اعتراف بنما بالجمهورية الصحراوية يوجب المحكمة بقبول امكانية ان يكون هناك حق للجمهورية بسلعة ثبت أن مصدرها الصحراء الغربية، ومن ثم أن تسمح المحكمة بمحاكمة يمكن البت من خلالها بمسالة حقوق الملكية.[xxi]

انفراج في جنوب افريقيا

دخلت جلسة الاستماع المنعقدة في 18 أيار/مايو —— وكذلك القرار الذي اتخذه القضاة الثلاثة في المحكمة العليا في جنوب افريقيا——إلى حوليات القانون الدولي. لقد كانت هذه المرة الاولى التي يقوم بها شعب مستعمَر وواقع تحت الاحتلال العسكري باتخاذ خطوات قانونية للمطالبة بملكية موارد طبيعية. فبعد عدة اسابيع من الانتظار، أعلنت المحكمة العليا حاجتها إلى بعض الوقت للانتهاء من صياغة الحكم الذي صدر في 15 حزيران/يونيو. فبعدما تخلّت الشركتان المغربيتان عن القضية بعد شهر، أصبح القرار بمثابة السطر الأخير. واصبحت الشحنة البالغ حجمها 55 ألف طن من الفوسفات الخام على متن NM Cherry Blossom في ملكية الصحراويين.[xxii]

تناول قرار المحكمة العليا قضيتين.[xxiii] كانت القضية الاولى أسس المطالبة الصحراوية بالفوسفات الخام. أما القضية الثانية فكانت مسألة العقبات القانونية امام القضية والتي يمكن ان تمنع تقدمها نحو التحول الى قضية مكتملة على موضوع الدعوى. وتجدر الاشارة الى ان المحكمة لم تنظر في مسألة الاحقية في التظلم، اي إذا ما كان للحكومة الصحراوية ولجبهة البوليساريو الحق في رفع دعوى مدنية. وفيما لو لم يتخل كل من Fosbucraa و OCP عن الدعوى في منتصف تموز/يوليو،

امريكي مقابل كل يوم تحتجز فيه السفينة. وهكذا تحول الصراع القانوني الذي أصبح أكثر تعقيدا إلى واحد بين الاطراف المعنية مباشرة بتجارة فوسفات الصحراء الغربية.

توضحت المشاكل التي سببتها الشركات المغربية لنفسها عندما ادعت أنها تمتلك الشحنة على متن السفينة وأنها الطرف الوحيد في الدفاع عن القضية بعد بضعة اسابيع. فبعدما نظرت المحكمة في القضية في 18 ايــار/مايو، واصـدرت حكمـا – ادنـاه – قـام مسـؤول كبـير في OCP في 15 حزيران/يونيو بتوجيه رسالة استنكار الى المحكمة سعى فيها الى تبرير حق المغرب باستخراج وتصدير فوسفات الصحراء الغربية. من المفيد قراءة جزء من الرسالة لفهم طريقة تفكير المغرب بصدد مطالبته بالصحراء الغربية:

من خلال التعاون مع الحكومة الصحراوية وجبهة البوليساريو أقدمت المحكمة على القيام بماكان عليها الاحجام عنه بالضبط، إذ أنها حاولت تحديد الحقوق القانونية للمغرب، وهي دولة ذات سيادة (وبالتالي محصنة) فيما يتعلق بمنطقة الصحراء الغربية. xv

يفسر هـذا المنطق سبب قيـام الشركتين، كمـا يبـدو، باسترجاع ملكية البضائع على متن السفينة المحتجزة وقيام الشركتين بالدفاع عن القضية دون مساعدة من طرف مشتري الفوسفات النيوزيلندي.

أوراق في بنما

في 17أيار/مايو تم احتجاز سفينة اخرى تبعا لقرار لمحكمة مدنية. فبضعة دقائق قبل خروج السفينة Ultra Innovation، المسجلة في بنما، من قناة بنما إلى المحيط الهادي، اقترب منها قارب وعلى متنه مسؤول بالمحكمة يحمل اوراقا تأمر باحتجاز السفينة. خضعت هذه القضية الى متطلبات خاصة في قانون بنما البحري، والذي حول السفينة نفسها إلى موضع المطالبة، وذلك خلافا للشحنة في جنوب افريقيا.

كانت تلك الشحنة الاولى المخصصة لكندا وسادسة الشحنات الخارجة من العيون في العام 2017. كانت السفينة قد وصلت الى الصحراء الغربية في 22 نيسان/ابريل، واستكملت تحميل 59,840 طن من الفوسفات الخام في 28 نيسان/ابريل. وغادرت في اليوم ذاته في رحلة تستغرق اسبوعين الى قناة بنما. xvi يعتبر مسار الفوسفات الصحراوي الى كندا اطول المسارات. فبعد وصول الفوسفات إلى ميناء فانكوفر يتم نقله على سكة الحديد إلى ألبرتا. بدأت هذه التجارة في عام 2013 وشكلت منذ ذلك الحين ما نسبته 30% من أجمالي الشحنات من الصحراء الغربية.

إن أسباب رفع الحكومة الصحراوية دعوى قضائية ضد السفينة الثانية واضحة. يعود السبب الاول إلى قوة الدفع المكتسبة من الدعوى الاولى في جنوب افريقيا. وقد يكون السبب الثاني توقع توقف الشحنات بعد القضية في جنوب افريقيا. وبالفعل، فغدا السفينتين اللتين وصلتا إلى العيون في 5 أيار/مايو و 11 أيار/مايو—والتي لا بد أنها حُمّلت قبل الاول من أيار/مايو—وكذلك السفينة التي استبدلت الشحنة التي كانت معدة للمستورد في نيوزيلندا (والتي وصلت في 11 أيار/مايو) لم يتـم استئناف الصادرات حتى وصول السفينة العاشرة للعام 2017 في 16تموز/يوليو. اما السبب الثالث من وراء التحرك في بنما فقد يكون أن القيام بذلك قد يؤدي الى اغلاق القناة مما سيجعل ارسال سفن اخرى الى هناك مخاطرة مهماكانت نتيجة القضية. وهذا ما حدث في الأشهر اللاحقة. لم

وبحسب ما هو متبع في القضايا البحرية في الكثير من الدول، يجب الرجوع إلى المحكمة من أجل فحص "صحة" الأمر الصادر في 1 أيار/مايو الذي مُنح للحكومة الصحراوية. كان هذا الأمر متوقعا. إذ تم استصدار هذا الأمر في صالح الحكومة الصحراوية بدون اشعار عدد من المدعى عليهم: مالك سفينة ومستأجرها ومشتري الشحنة النيوزيلندي وشركتين مغربيتين قامتا باستخراج الفوسفات وتصدير الحمولة. اما حكومة جنوب افريقيا، فلم تكن لديها أية مصلحة في هذه المسالة، الأمر الذي كان من الممكن ان تترتب عليه اسقاطات دبلوماسية. لقد تم الاعداد للقضية بصفتها دعوى قضائية، فيما يتمتع النظام القضائي في جنوب افريقيا بالكثير من الاستقلالية التي تمنع الحكومة من التدخل. طلبت القاضية التي استمعت إلى القضية في الأول من أيار/مايو من جميع الاطراف العودة الى المحكمة في 18 ايار/مايو للنظر فيما يجب التقرير بتمديد سريان مفعول القرار.

المغرب يحرز هدفا ذاتيا

في الايام التالية، تبدت مفاجأة اخرى. في التجارة البحرية، وعندما يتم احتجاز الحمولة او السفينة نتيجة امر من المحكمة، يجب في اغلب الاحيان طرح بديل عن قيمة الادعاء على شكل دفعة او وثيقة ضمان مثل رسالة اعتماد أو ضمان مصرفي. وهذا يسمح للسفينة استئناف رحلتها مع الحمولة. إلا أن هذا لم يحدث للسفينة. هل يمكن أن يكون سبب ذلك أن قيمة الشحنة كانت عالية لدرجة لم تسمح بترتيب الضمان المطلوب؟ كان وزن الشحنة 55 ألف طن (كما تثبت سندات التحميل)، وتقدر قيمتها في السوق بـ 5.5 مليون دولار امريكي. لكن الاجابة على سؤالنا كانت مختلفة تماما، وكانت تلك أكبر المفاجئات في القضية، كما أنها ساعدت على هزيمة الشركتين المغربيتين في 18 ايار/مايو.

اتضح ان Phosphates de Boucraa SA، وهي شركة فرعية تابعة لشركة التعدين OCP التي تمتلكها الدولة المغربية، قد كانت هي مالكة الحمولة الموجودة على السفينة المحتجزة. غير ان سوق السلع العالمية لا يعمل بهذه الطريقة. فعندما ينظم المستورد شحن بضاعة ما، فعليه دفع ثمنها ليصبح هو مالكها لدى تحميلها. تم التخطيط للقضية في جنوب افريقيا على النحو التالي: نزاع حول الملكية بين الحكومة الصحراوية وجبهة البوليساريو من جهة وبين الشركة الأسترالية، ومن ثم الشركة النيوزيلندية، المستوردة من جهة اخرى. هل كانت Phosphates de Boucraa (أو Fosbucraa) دقيقة أو صريحة بادعائها أنها هي من يتملك الحمولة حتى بعد انطلاقها من الصحراء الغربية؟

يبدو ان الشركة لم تكن تمتلك الحمولة بعد 13نيسان/ابريل. في منتصف ايار/مايو خرجت شحنة ثانية من العيون قاصدة الشركة النيوزيلندية لتصلها في أواخر حزيران/يونيو. من غير الواضح فيما إذا كانت تلك الشحنة بديلا (او تعويضا)، أو أن Fosbucraa استرجعت ملكية الشحنة الموجودة على متن السفينة وبعثت بالشحنة التي أُرسلت في منتصف أيار/مايو مجانا. لكن من الواضح أن مجال المناورة المتبقي قد ترك الشركتين المغربيتين تدافعان عن القضية في جلسة الاستماع التي انعقدت في 18 أيار/مايو وحدهما. لم يشارك في الجلسة أي طرف آخر، وبما في ذلك الشركة المستأجرة التي تشغل السفينة (شركة أسترالية وهي شركة فرعية تابعة لشركة البيتزا المحمدة الالمانية .Dr Oetker) والتي عبّرت عن قلقها ازاء تأخر السفينة. فقد كانت خسارة .Dr Oetker عشرة آلاف دولار

المياه الاقليمية لجنوب افريقيا ليصبح بالإمكان احتجاز الشحنة المتواجدة على متنها بحسب امر المحكمة. لا تدخل السفن العابرة إلى قلب ميناء بورت اليزابيث الصغير. وبدلا من ذلك، تزود قوارب لنقل الوقود هذه السفن بالوقود في مكلأ ترسو عنده السفن. ولحسن الحظ، فإن المعلومات عن البحار الجنوب افريقية متوفرة جيدا. ويمكن حساب الوقت الذي ستدخل فيه السفينة إلى المياه الإقليمية، وعلى ذلك معرفة الوقت الذي يجب فيه استصدار أمر قضائي. وتماما بعد الساعة الثانية بالتوقيت المحلي من بعد ظهر الاول من أيار/مايو رست السفينة، فعمد وكيل المحكمة الى استصدار الامر وتسليم نسخة منه للمسؤول. وإذ ذاك، ظلت السفينة راسية مكانها، وتم احتجاز شحنتها لمدة أشهر.

التداعيات

تم ايقاف الشحنات من الصحراء الغربية اياما عديدة. وكانت السفينة Louisiana من قبل ذلك قد استكملت تحميلها، فانطلقت مبحرة عبر الاطلسي تقصد مستوردا امريكيا. إلا أن مفاجأة غير متوقعة قد كانت تنتظر المسؤولين الصحراويين ومحاميهم في جنوب افريقيا. إذ لم تكن الحمولة معدة للتوجه الى استراليا. فقد كشفت اوراق السفينة انها كانت مكلفة من قبل احدى شركات الاستيراد النيوزيلندية. لم يسبق لسفينة وجهتها نيوزيلندا اتباع المسار الغربي الطويل نحو الشرق حول راس الرجاء الصالح. إذا، تم احتجاز الحمولة إلا أنها كانت معدة لشركة أخرى. أيمكن لهذا الامر تعريض القضية للخطر؟

كلا. ويرجع ذلك الى ان مطالبة الصحراويين بحق الملكية لم تقم حسابا للجهة التي اشترت الشحنة. لقد وصلت رسائل الاحتجاج التي ارسلتها الحكومة الصحراوية في السنوات الاخيرة إلى كلا الشركتين النيوزيلنديتين. كما وحلّت حقيقة كون نيوزيلندا وجهة الشحن لغز تحميل السفينة بـ 45 ألف طن من الفوسفات الخام. لقد اثبتت مراجعات الشحنات التي قصدت نيوزيلندا التي قامت بها الحكومة الصحراوية ومنظمة المرصد الدولي لمراقبة الثروات في الصحراء الغربية (WSRW)، أن حجم هذه الشحنات يتراوح ما بين 50 و 60 ألف طن. يتم شحن شحنات بهذا الحجم في بواخر عملاقة يمكنها عبور قناة بنما. لمعرفة السبب من وراء اتخاذ السفينة NM Cherry Blossom المسار الذي اتخذته فذاك أمر علينا تخمينه. وكما يبدو، هناك عاملين قد يكونا ذي صلة بالأمر. اولا، ربما قصد مالكو السفينة أو مستأجروها تجنب دفع رسوم الابحار عبر قناة بنما. ثانيا، إذا كان القصد تفادي العبور عبر قناة بنما، فقد يكون باعتبار الابحار عن طريق الطرف الجنوبي لأمريكا الجنوبية نحو نيوزيلندا خطيرا في اوائل فصل الشتاء في المحيط الجنوبي. فمن المعروف بأن البواخر العملاقة تتقلب في البحار الهائجة، الامر الذي يهدد ثبات السفينة.

وكما كان متوقعا، ولّد اعتراض الشحنة أزمة في مجال تصنيع الاسمدة النيوزيلندي، ولمزيد من الدقة، فيما يتعلق بتصنيع السماد لموسم الزراعة في فصل الربيع الذي كان على وشك أن يبدأ بعد بضعة أشهر. إذ كان على متن NM Cherry Blossom ما مقداره تُمّن حاجات نيوزيلندا من الفوسفات المستورد للسنة الزراعية 2017-18. وهناك شركتان لإنتاج الاسمدة في نيوزيلندا فقط وهما تعتمدان على الحصول على 400 ألف طن من الفوسفات سنويا. كما أنهما بحاجة إلى الفوسفات الممتاز وهذا ما يفسر حقيقة كون معظم الواردات من الصحراء الغربية.[xiv]

استراليا. وبدا التوقيت متوائما مع دورة الشحن السنوية. إلا أن السفينة لم تتوقف في جنوب افريقيا وإنما أبحرت مباشرة الى الشركة المستقبلة وحديثة العهد في الهند.

وفي اوائل نيسان/ابريل رست السفينة NM Cherry Blossom على بعد مسافة قصيرة من ميناء العيون. وكانت هذه السفينة احدى الناقلات العملاقة التي تعب في محيطات العالم، وهي من طراز باناماكس، ويبلغ طولها 200 متر وتتسع لحمولة مقدارها 60 ألف طن.[xiii] ويمكن تحميل السفينة في غضون فترة تقل عن اربعة ايام. وهكذا جرى النقاش التالي بين المسؤولين الصحراويين: تم تحميل حوالي 54 ألف طن من الفوسفات الخام على متن السفينة. وقد بُني هذا التقدير بعد قراءة علامات التحميل على السفينة قبل التحميل وبعده. هل كانت هذه الكمية أكبر من الشحنة المخصصة للمستورد الاسترالي؟ في الواقع، لا يمكن تحديد وجهة السفن التي تغادر ميناء العيون بدقة قبل إبحارها. فالسفن مزودة بأجهزة التعقب—نظم التتبع الآلية (AIS) وهي غير الزامية بموجب قواعد المنظمة البحرية الدولية—باسم الميناء الذي تقصده أو الميناء الذي تنوي التوقف عنده بعد إبحارها فقط. ويتيح هذا الأمر قراءة موقع السفن وتفاصيل التعرف عليها، أحيانا في الوقت الحقيقي، على مواقع للإنترنت.

وفي 13 نيسان/أبريل، أبحرت السفينة من رصيف الميناء وأعلنت من خلال نظام التتبع الآلي (AIS) نيتها التوجه إلى مدينة كيب تاون. الأمر الذي قد يعني أنها ستتوقف للتزود بالوقود قبل استكمال رحلتها إلى استراليا. وبما أن السفينة قد ابحرت جنوبا في المحيط الاطلنطي فيمكن رصد سرعتها ومسارها. وبعد اسبوعين، لدى مرور السفينة مقابل سواحل ناميبيا، أعلنت السفينة عن نيتها الإبحار إلى كيب تاون في 29 نيسان/ابريل. إلا أن تغييرا كان قد حصل في 28 نيسان/ابريل. إذ تم تغيير نظام التتبع الآلي (AIS) للسفينة. لم تعد لدى الصحراويين أية تفاصيل حول وجهة السفينة. لم تكن كيب تاون الا نقطة عبور. وتساءل الصحراويون فيما بينهم، أين يمكن للسفينة أن ترسو في جنوب افريقيا؟ مرّت ساعات من القلق. ومن ثم أتى الفرج: أعلنت السفينة في وقت لاحق من نفس اليوم على نظام التتبع الآلي (AIS) مواصلتها إلى الابحار إلى بورت اليزابيث، أي ما مقداره 36 ساعة إبحار باتجاه الشرق.

وفي يوم الاحد الموافق 30 نيسان/ابريل، قبلت السيدة جاستيس ريفيلس امكانية تكليف المحكمة العليا بطلب وضع اليد على الشحنة. وكما هو متبع في العديد من قضايا السفن التجارية، مثل الخلافات بشأن الوقود والبضائع ودفوعات أجور الطاقم وتلف البضاعة، فإنه من الممكن دفع مثل هذه بدون اشعار المدعى عليه. ويمكن ان يشمل ذلك مالكي السفن والمستأجرين وشركات الادارة وكل من له مصلحة في البضاعة المشحونة. وفي الواقع، يسمح القانون بإخضاع السفينة نفسها لمطالبة مدنية في حال كانت السفينة قد استفادت من بضاعة تزودت بها أو من عمل على متنها. ولذلك، فإن تقديم طلب حجز الشحنة على متن NM Cherry Blossom بدون اشعار أي طرف عبارة عن حالة عادية في القضايا البحرية، ومن شأن هذا الأمر أن يؤدي إلى الحفاظ على عنصر المفاجأة. كانت جاستيس ريفيلس مقتنعة بأن مطالبة الصحراويين بحق ملكية الفوسفات الخام على متن السفينة جديرة بالفحص، وبعبارة اخرى، بأن هناك امكانية لإثبات هذا الحق لاحقا.

ويمكن للقرار المحكمة أن يصبح ساري المفعول في حال دخول السفينة جنوب افريقيا فقط. وهذا يعني أنه على NM Cherry Blossom أن تبحر داخل مساحة الاثني عشر ميلا بحريا التي تشكل

بـذلك. كما أن أي عمـل مـن نـوع اخـر كـان بمثابـة عمـل أحمـق بـالنظر إلى ضخامة القوات العسكرية وقوات الشرطة المتواجدة في المكان.

وبالتالي انتقل التخطيط الى قضية الدول التي اعترفت بالجمهورية الصحراوية. الأمر الذي يعني انه بالإمكان القيام بإجراءات قانونية——أي ومن جديد، المطالبة الصحراوية بحق الملكية——فقط في حالة وصول احدى الشحنات الى اراضي هذه الدول. معنى هذا، أنه على سفينة الشحن الوصول إلى، أو المرور عبر، المياه الاقليمية التابعة لهذه الدول. كشف نمط الشحن عن عدة دولة ممكنة، ومن بينها كولومبيا وبنما وجنوب افريقيا وفنزويلا. فضّلت السلطات الصحراء الغربية بنما وجنوب افريقيا. ويرجع ذلك الى مرور الكثير من الشحنات الى نيوزيلندا وكندا عبر قناة بنما، والى اعتبار المحاكم في جنوب افريقيا الاكثر استقلالا وقدرة على تطبيق القانون الدولي في افريقيا. وبالإضافة الى ذلك، فإن الشحنات الى كولومبيا وفنزويلا اقل تواترا، وبالتالي من الصعب التنبؤ بها. كما انها شحنات صغيرة وقيمتها منخفضة نسبيا. كما أن الشحنات التي تبحر غربا إلى الشركتين المهمتين في نيوزيلندا، بعضها خمسة او ستة شحنات سنويا، فتمر عبر قناة بنما أو مـن حـول امريكـا الجنوبية. وهنـاك ثلاث شحنات سنوية مخصصة للمستورد الاسترالي ولكنها لا تتوقف جميعها في جنوب افريقيا للتزود بالوقود. أمور معقدة وتوقفات للسفن في جنوب افريقيا، بعضها في كيب تاون وأخرى في بورت اليزابيث أو دربان، لمدة لا تتجاوز في العادة 12 ساعة.

بعد عام 2011، تم بناء لبنات الدعوتين القضائيتين في كلا البلدين. وتأكدت حكومة الصحراء الغربية مـن توفير محامين محليين يفهمون تعقيدات القضايا. كما وقد وصل الى الشركة الأسترالية المستوردة أكثر عدد من رسائل الاحتجاج على مر السنين.[xi] كانت الشحنات الى هذه الشركة، التي كانت كل واحدة منها تصل إلى 35 ألف طن، صغيرة نسبيا. (زعمت الشركة الأسترالية انها بحاجة الى "فوسفات ممتاز" لأن تحويل مرافق التجهيز لتصنيع الاسمدة التي تستخدمها لملائمة الفوسفات العادي، بالنظر إلى لى الطلب العالمي، سيكون مكلفا جدا). حدثت هذه الامور بحكومة الصحراء الغربية الى اتخاذ قرار تحديد جنوب افريقيا كمكان الاعتراض الاول. ففي حال كانت هناك شحنة لأستراليا في حزيران/يونيو كما هو متوقع، فستكون تلك أول شحنة سيُعمل على استردادها. كما وكانت مسألة التوقيت في كلتا الحالتين حاضرة وذلك في أعقاب قضية التجارة الحرة في محكمة العدل للاتحاد الأوروبي. وكانت الفكرة الرائجة بأن قرارا ايجابيا في محكمة العدل للاتحاد الأوروبي سيكون أكثر فائدة في بنما وجنوب افريقيا بدلا من العكس. وبالنظر على قرار المحكمة الجنوب افريقية في حزيران/يونيو 2017، والذي سنعكف على مناقشته ادناه، ردا على قرار الاستئناف لمحكمة العدل للاتحاد الأوروبي الصادر في كانون الاول/ديسمبر 2016، فقد كان قرار الحكومة الصحراوية قرارا حكيما.

إعداد الفخ

تم استكمال تحضير القضية في كانون الثاني/يناير 2017.[xii] قامت حكومة الصحراء الغربية وجبهة البوليساريو فيها بالمطالبة بحقوق الملكية مـن خـلال دعوى مدنية في المحكمة التجارية الجنوب افريقية (المحكمة العليا) ضد الشحنات المتواجدة على متن السفن التي تتوقف للتزود بالوقود. في وقت لاحق مـن ذلـك الشهر، تم الاستنتاج مبدئيا على أن هنـاك سفينة على وشـك مغـادرة ميناء العيون إلى

وفي كانون الاول/ديسمبر 2015، خلصت المحكمة الى القرار القائل بوجوب إجراء تحقيق جاد بشأن تأثر حقوق الانسان باتفاقيات التجارة التي تخص الصحراء الغربية.[vi] وقام المجلس الأوروبي بالاعتراض على القرار على الفور. وقامت المحكمة بكامل هيئتها بإعطاء قرار صريح في كانون الاول/ديسمبر التالي. أكدت المحكمة بأن الصحراء الغربية ليست جزءا من المغرب، ولهذا فهي ليست منطقة يمكن ضمها إلى الترتيبات التجارية الخاضعة لاتفاقية التجارة بين المغرب والاتحاد الأوروبي. كما واشارت المحكمة الى حاجة مثل هذا الضم الى موافقة سكان الاقليم.[vii]

سعيا وراء الفوسفات

تتبعت حكومة الصحراء الغربية تصدير الفوسفات من الصحراء الغربية على مدار سنوات. وفي عام 2011، بدأت تتكون لديها الفكرة القائلة على انه من الممكن اعتراض احدى الشحنات. كانت هناك عشر شركات تشتري حوالي مليوني طن سنويا، وترسل سفنا مستأجرة الى ساحل الصحراء الغربية لتحميلها. وتواجدت هذه الشركات منذ سنوات عديدة في دول عالم الشمال، ومن ضمن ذلك، في اوروبا أيضا. لم يتم تصدير الفوسفات الخام من الصحراء الغربية إلى أي من مصانع الاسمدة في افريقيا، وفي الغالب لم يصل الفوسفات إلى بلدان عالم الجنوب (Global South) أيضا. وفقط في عام 2016، انضمت شركة هندية إلى التجارة.[viii] كانت دورة الشحنات منظمة بشكل جيد، الأمر الذي اتاح التنبؤ بشكل دقيق بتوقيت بعض الشحنات المخصصة للشركات المنفردة. على سبيل المثال، كان المستورد الاسترالي المتبقي الوحيد يتلقى شحنات مرسلة الى موانئ جيلونج كل ثلاثة أشهر. أما الشحنات التي كانت تصدر إلى كندا —أي إلى الساحل الغربي للبلاد في فانكوفر —فقد كانت تُرسل بالمعدل كل ستة اسابيع في العامين 2015 و 2016.[ix]

وبالإضافة الى عملها التحليلي، كانت حكومة الصحراء الغربية ترسل رسائل احتجاجية إلى الشركات المتورطة بشراء الفوسفات الخام. وقد أرسل عدد قليل من الشركات بردودها. ومن بين هؤلاء، المستورد الاسترالي وكذلك المشتري الأوروبي الأخير المتبقي في ليتوانيا.[x] شكّلت رسائل الاحتجاج جزءا من حالة اعتراض الشحنات، لأن المطالبة المستمرة بالسيادة على الصحراء الغربية كانت ضرورية للمطالبة بحقوق الملكية. وساد الاعتقاد بأن جواب شركات التصدير على المطالبة بالملكية سينص على أنهم "مشترون ابرياء" وأنهم اشتروا الفوسفات بدون سابق معرفة بالنزاع حول حقوق الملكية بين الشعب الصحراوي والمملكة المغربية.

أما الخطوة التالية في هذه الحملة فكانت عملية التحضير لإمكانية اعتراض الشحنات. ومن وجهة نظر السياسة التي تتبعها حكومة الصحراء الغربية، تعتبر الوسائل القانونية —اذن من محكمة— وسيلتها الوحيدة. ومهما كانت المسوغات التي يمنحها إياها القانون الدولي (والقانون المحلي)، فهي لا ترغب بالقيام بأي اعتراض مسلح للسفن. أما عن إمكانية الحصول على امر قضائي مسبق عن البواخر التي تصل إلى رصيف التحميل في العيون فقد تم رفضها بعد مناقشتها. ويرجع ذلك الى عدم الالمام بظروف تأجير السفن المكلفة بالإبحار الى العيون وتحميل الفوسفات الخام. إذ لا يمكن التأكد من توجه هذه السفن الى العيون قبل اسبوع على الأكثر لدى المصادقة على تعليمات التأجير، أو قبل أيام معدودة لدى التعرّف عليها على المسارات الملاحية المتوجهة الى العيون. كما وكان من المستحيل اتخاذ اجراءات قانونية على الأراضي المحتلة نفسها. إذ لا توجد مسارات قانونية للقيام

يجب فهم استرداد شحنات الفوسفات في سياق التاريخ الطويل لإنهاء استعمار الصحراء الغربية. وقد كان الاعتقاد السائد على مدى سنوات طويلة أن استخراج الفوسفات يشكل الذريعة التي تجعل المغرب يواصل احتلال اراضي الصحراء الغربية. وفي الحقيقة، لا يستفيد المغرب من استخراج وتصدير هذا الفوسفات: فكلفة الاحتلال العسكري وتكاليف دعم السكان الآتين من المملكة والذين أعيد توطينهم في الصحراء الغربية عالية جدا. ومع ذلك، فإن عملية استخراج الفوسفات تخلق عملا وخدمات للمستوطنين. كما أنها تضفي شرعية على البنية التحتية الاقتصادية والمادية المغاربية التي بنيت في الصحراء الغربية.[ii] كما توجد هناك مصادر طبيعية اخرى للتصدير في الصحراء الغربية. ولذلك فهي عرضة للمقاضاة القانونية. وتشتمل هذه على صيد الاسماك على الساحل وكميات صغيرة من الرمال والملح يتم تصديرها الى دول اوروبية. لكننا نجد الفوسفات في مركز الصورة مقارنة مع باقي الموارد نظرا إلى حجم هذه الصناعة داخل الصحراء الغربية والى الحاجة العالمية الفوسفات كمركب في الأسمدة، وكذلك نظرا إلى قيمة الصادرات بعد عام 2014 والتي تتراوح بين 210 و 250 مليون دولار أمريكي.[iii]

نجحت حكومة الصحراء الغربية وجبهة البوليساريو مؤخرا نحو التوجه إلى القانون الدولي بخصوص مسألة احتلال الصحراء الغربية. وكان ذلك ردا على تعميق الاحتلال وعلى عدم القدرة على استخدام القانون لمعالجة انتهاكات حقوق الانسان (في المغرب أو في معظم الدول الأخرى)، وبسبب ملاحظة تطوّر القانون الدولي بشكل يسمح بتطبيقه على قضايا ترتبط بالموارد الطبيعية.[iv] كما وكان استخدام القانون الدولي ردا على المماطلة بالوعد بتقرير مصير الشعب الصحراوي. ومثالا على ذلك، تقديم الحكومة الصحراوية دعوى أمام القانون الدولي في عام 2009 مطالبة بالاعتراف بـ 200 ميل بحري كجزء من المنطقة الاقتصادية الخاصة التي أعلن عنها بموجب التشريع الوطني. وفي وقت قصير تم فحص الطلب ورفضه من قبل الدائرة القانونية في البرلمان الأوروبي. الا انه وفي الوقت ذاته، يمكننا القول إن الطلب قد نجح لأنه القى بظلال من الشك حول قانونية تجديد معاهدة صيد الاسماك بين الاتحاد الأوروبي والمغرب.[v]

أما الانعطاف الذي يترابط منطقيا مع مجال استخدام الدعوى القانونية لتحقيق تقرير المصير، فقد كان قرار رفع دعاوى في محكمة العدل الاوروبية في عام 2012. كان ذلك القرار محفوفا بالمخاطر. فقد تم رفع القضية لتحدي اتفاقية التجارة الحرة بين الاتحاد الأوروبي والمغرب في الصحراء الغربية، ومن بعد ذلك، رفع القضية التي تخص معاهدة الصيد بين الاتحاد الأوروبي والمغرب للصيد في المياه الساحلية للصحراء الغربية باسم جبهة البوليساريو وحدها. إذ قد كان سيتم اعتبار طلب مكانة دولة امام محكمة العدل الاوربية ECJ (والتي أصبح اسمها فيما بعد محكمة العدل التابعة للاتحاد الأوروبي CJEU) بمثابة اصرار على الاعتراف بحكومة الصحراء الغربية، الأمر الذي كان سيرفض قطعا. وخلال ذلك، الهمت الدعاوى حراكا قضائيا قامت به المنظمة الغير حكومية "حملة الصحراء الغربية في المملكة المتحدة" (WSCUK) لدى المحكمة العليا في المملكة المتحدة لتحدي عملية اتخاذ القرارات الحكومية بخصوص السماح باستيراد الاغذية من الصحراء الغربية والذي يشمل تخفيضا للعمولات الجمركية. وكان قرار محكمة العدل التابعة للاتحاد الاوروبي في عام 2015 ايجابيا: قبلت المحكمة الدعوى معللة ذلك بأن حركات التحرر الوطني تمتلك في مثل هذه الظروف الاهلية لتقديم دعاوى ضد قرار المجلس الأوروبي بخصوص توسيع التجارة الحرة بحيث تشمل تلك الصحراء الغربية.

كانت المفاجأة مكتملة: في وقت مبكر من بعد ظهر يوم الاثنين الموافق 1 مايو/أيار 2017 وصلت دراما قضائية خُطط لها منذ أمد طويل إلى لحظة انفراجها. ففي سابقة قضائية في القانون الدولي، كان استرداد مورد طبيعي بموجب امر قضائي مصدره ارض محتلة على وشك ان يتحقق. إذ وصل زورق صغير يحمل على متنه موظف من المحكمة العليا في جنوب افريقيا إلى ناقلة ضخمة ترسو على بعد كيلومتر واحد من شاطئ بورت اليزابيث لتتقدم العدالة.

مقدمة: مصادرة وسابقة

في 13 نيسان/ابريل 2017 أرخت سفينة شحن عملاقة مسجلة في جزر مارشال الكائنة في المحيط الهادئ حبالها لتنطلق من رصيف للتحميل على ساحل الصحراء الغربية المحتلة. كانت السفينة تحمل 55 ألف طن من أفضل أنواع الفوسفات الخام في العالم، والتي تسعى وراء الحصول عليها مصانع الأسمدة في دول عالم الشمال (Global North) نظرا إلى نسبة الفوسفور العالية فيها وإلى عدم احتوائها على المعادن الثقيلة. وبعد بضع دقائق، أعلنت السفينة، والتي كانت تحمل الاسم NM Cherry Blossom، أنها تبحر متجهة نحو كيب تاون في رحلة روتينية تستغرق اسبوعين. وفيما عدا ذلك، لم تكن السفينة تستحق الملاحظة. وكانت تلك السفينة الخامسة من نوعها التي انطلقت من الصحراء الغربية عام 2017، محملة بالفوسفات الذي يُصدّر منه 300 ألف طن وتقدر قيمته بنحو 30 مليون دولار أمريكي.

وفي الأول من مايو/أيار، وبعدما أبحرت السفينة المذكورة إلى ما بعد كيب تاون، نحو بورت اليزابيث للتزود بالوقود، تم ضبط حمولة السفينة بموجب امر قضائي ومن ثم احتجازها. إذ نجحت حكومة الجمهورية العربية الصحراوية الديموقراطية وحركة التحرير الوطني-جبهة البوليساريو في دعواهم القضائية، الأمر الذي يشكل تدخلا مذهلا في التجارة القيمة بالفوسفات الخام الذي يتم نهبه من الصحراء الغربية.

وبعد ثلاثة اسابيع تقريبا، تم، وعلى نحو مماثل، اعتراض سفينة أخرى (Ultra Innovation) لدى خروجها من قناة بنما باتجاه كندا. تشكل الحالتين معا تقهقرا دبلوماسيا وقانونيا للمغرب الذي يحتل الصحراء الغربية، وتعطيلا مؤثرا لتجارة الفوسفات. أعقب ذلك عمليا اغلاقا لقناة بنما امام عبور شحنات الفوسفات الخام وكذلك عزوف عدد من الشركات المتورطة عن التجارة بها. أما NM Cherry Blossom فقد ظلت راسية في بورت اليزابيث لمدة تزيد على ستة أشهر بدون أن تتزحزح شحنتها من مكانها، وذلك إلى حين اصدار امر من المحكمة يؤكد على أن ملكيتها تعود إلى حكومة الجمهورية العربية الصحراوية الديموقراطية. وبهذا تم تحقيق سابقة قانونية في مجالي النزاع حول المعادن وقانون تقرير حق المصير الما-بعد استعماري. المعادن محل النزاع و قانون حق تقرير المصير مابعد‏الكولونيالي.

يسرد هذا الفصل قصة الحملة التي قام بها الشعب الصحراوي لاسترداد شحنات الفوسفات الخام. سنفصل فيما يلي الظروف التاريخية التي أدت الى تسلسل الأحداث في ايار/ مايو 2017. كما وستتابع الخطوات المكثفة التي قامت بها الحكومة الصحراوية تحت غطاء من السرية التامة لاسترداد الشحنات، لنسرد بعد ذلك تبعات هذا الأمر على تجارة الفوسفات وعلى مستقبل الاجراءات القانونية.[i]

اعتراض النهب

الدعوى القضائية لاسترداد فوسفات الصحراء الغربية المحتلة في التجارة العالمية

ج. ج. ب. سميث

لا يمتلك المغرب حق السيادة على الصحراء الغربية. فادعاؤه الحق بالسيادة نتيجة لاحتلاله الصحراء الغربية لا يتوافق مع مكانة الصحراء الغربية كـإقليم لا يتمتع بـالحكم الذاتي

cxiv WSRW.org، 24.07.2013، التوقيع على بروتوكول جديد لصيد الأسماك بين الاتحاد الاوروبي والمغرب اليوم، http://www.wsrw.org/a217x2631

cxv WSRW.org، 01.10.2013، المفوضية تسقط تعليمات اهلس والبرلمان بشأن حقوق الانسان، http://www.wsrw.org/a217x2667

cxvi الصحراويون العربيون يحتجون على اتفاقية الصيد بين المغرب والاتحاد الاوروبي، اسوشيتد برس، 10.12.2013، https://finance.yahoo.com/news/western-saharans-protest-eu-morocco-204809442.html

cxvii البوليساريو تطلب الغاء صفقة السمك الغير قانونية بين المغرب والاتحاد الاوروبي، http://www.wsrw.org/a105x2923، WSRW.org، 22.06.2014

xciv Arn Digital، 11.01.2012، البرلمان الاوروبي والمغرب من تعليق الاتفاقية بين الاتحاد الاوروبي والمغرب. الحكومة تخفض التعويضات المخصصة للصيادين المتضررين

xcv MAP، 14.12.2011، الاحتلال صيد الاتفاقية ضد الاوروبي البرلمان تصويت على بأسف المغرب في الأوروبي الاتحاد وفد ورئيس» http://www.moroccotomorrow.org/head-of-eu-delegation-in-morocco-regrets-ep-vote-against-extension-of-fisheries-agreement/

xcvi WSRW.org، 12.07.2011، البرلمان الأوروبي .13 تموز/يوليو 2011، رأى لجنة التنمية الزراعية والريفية لجنة الزراعة في البرلمان الاوروبي تهاجم الاتفاق الزراعي مع للمغرب، http://www.wsrw.org/a204x2053

xcvii WSRW.org، 27.12.2010، http://www.wsrw.org/a159x1764 منتج من المغرب يوقف عمليات شراء من الصحراء الغربية،

xcviii WSRW.org، 18.06.2012، http://www.wsrw.org/a214x2321 تقرير: المستهلكون في الاتحاد الاوروبي يدعمون الاحتلال عن غير قصد،

xcix 01.02.2012 البرلمان الاوروبي، A7 0023/2012، توصية بشأن مسودة قرار المجلس إبرام الاتفاقية بصيغة تبادل للرسائل بين الاتحاد الاوروبي والمملكة المغربية بصدد تدابير تجارة حرة متبادلة للمنتجات الزراعية والزراعية المصنعة والسمك والمنتجات السمكية واستبدال البروتوكولات 1 و 2 و 3 وملحقاتها وتعديلات على اتفاقية الشراكة الاوروبية-المتوسطية لإنشاء رابطة بين المجتمعات الاوروبية ((NLE)/2010/0248/2010 C7-0432 والدول الاعضاء فيها من ناحية والمملكة المغربية من ناحية اخرى 15975/2010)

c المرجع نفسه.

ci البرلمان الاوروبي، «سؤال برلماني E-002451/2012، 02.03.2012، http://www.europarl.europa.eu/sides/getDoc.do?type=WQ&reference=E-2012-002451&format=XML&language=EN

cii Europa.eu، 17.02.2012، علامة على مصداقية الاتفاقية الزراعية بين الاتحاد الاوروبي والمغرب، http://europa.eu/rapid/press-release_IP-12-143_en.htm

ciii 14.06.2011 المملكة العليا / نائبة الرئيس أشتون نيابة عن المفوضية الاوروبية، http://www.europarl.europa.eu/sides/getAllAnswers.do?reference=E-2011-002315&language=SL

civ Yabiladi.com، 31.05.2011، http://www.yabiladi.com/articles/details/5677/l-ue-reconnait-droits-commerciaux-maroc.html

cv Maghrebia، 21.02.2012، المغرب والاتحاد الاوروبي يجددان الاتفاقية الزراعة،

cvi المرجع نفسه.

cvii WSRW.org، 13.03.2013، المغرب من ليست الغربية الصحراء منتجات تكرر: المولندية الحكومة www.wsrw.org/a105x2541

cviii WSRW.org، 21.12.2016، http://www.wsrw.org/a243x3695 محكمة الاتحاد الاوروبي تحمي الصحراء الغربية من اتفاقية التجارة بين المغرب والاتحاد الاوروبي،

cix FIS.com،17.12.2010 المفوضية الاوروبية تقترح اتفاقية صيد جديدة مع المغرب تستثني المياه الصحراوية ، http://www.fis.com/fis/worldnews/worldnews.asp?l=e&country=0&special=&monthyear=&day=&id=39784&ndb=1&df=0

cx EuropaPress، 07.12.2011، الصيادون المغاربة والاسبان يطالبون بأن تكون الاتفاقية الاتحاد الاوروبي بنفس الشروط ولكن مع تقنيات افضل، http://www.europapress.es/internacional/noticia-ue-pescadores-marroquies-espanoles-piden-ue-nuevo-acuerdo-pesca-mismas-condiciones-mejoras-tecnicas-20111207205307.html

cxi Fishelsewhere.eu، 26.01.2012، http://www.fishelsewhere.eu/a140x1367 لا يزال مجلس الاتحاد الأوروبي منقسماً بشأن الاشارة الى الصحراء الغربية،

cxii 14.06.2006 ـ تايكر، http://www.ft.com/cms/s/0/7d092668-e380-11da-a015-0000779e2340.html فاينانشال، صفقة الصيد التابع للاتحاد الاوروبي تتقدم على الرغم من نزاع الصحراء الغربية

cxiii البرلمان الاوروبي، «مذكرة بصدد قرار الدورة الثانية والعشرين لمجلس حقوق الانسان التابع للأمم المتحدة http://www.europarl.europa.eu/sides/getDoc.do?type=MOTION&reference=B7-2013-0055&language=EN

lxxiv المرجع نفسه.

lxxv WSRW.org، 19.10.2011، معدة تقرير التنمية تحت البرلمان على التصويت ضد صفقة السمك، http://www.wsrw.org/a204x2123

lxxvi WSRW.org، 19.10.2011، معدة تقرير التنمية تحت البرلمان على التصويت ضد صفقة السمك، http://www.wsrw.org/a204x2123

lxxvii Fishelsewhere.eu، 07.11.2011، لجنتان تابعتان للبرلمان الاوروبي ترفضان اتفاقية صيد الاسماك بين المغرب والاتحاد الأوروبي، http://www.fishelsewhere.eu/a141x1344

lxxviii 29.11.2011 توصية من لجنة صيد الاسماك، http://www.europarl.europa.eu/sides/getDoc.do?type=REPORT&reference=A7-2011-0394&language=EN&mode=XML

lxxix AFP، 14.12.2011، مشرعو الاتحاد الاوروبي يوقفون صفقة صيد الأسماك المغربية-الصحراء غربية.

lxxx البرلمان الأوروبي، بيان صحفي، 14.12.2011، اعضاء البرلمان الأوروبي يرفضون تجديد اتفاقية صيد الاسماك بين الاتحاد الأوروبي والمغرب ويطالبون بصفقة أفضل، http://www.europarl.europa.eu/news/en/pressroom/content/20111213IPR34070/html/Extension-of-EU-Morocco-fisheries-agreement-rejected-call-for-a-better-deal

lxxxi في (ACTA) إذكانت الاتفاقية الاولى التي يوقفها البرلمان "اتفاقية سويفت" مع الولايات المتحدة في شباط/فبراير 2010. أما المرة الثالثة فكانت من نصيب اتفاقية مكافحة التزوير التجارية شباط/فبراير 2012.

lxxxii Fishelsewhere.eu، 10.05.2013، الحجج التي عرضها اللوبي المغربي أمام البرلمان الأوروبي، http://fishelsewhere.eu/a202x1417

lxxxiii Fishelsewhere.eu، 10.05.2013، الحجج التي أرسلت الى البرلمان الأوروبي دفاعا عن صيد الاسماك، http://fishelsewhere.eu/a202x1418

lxxxiv Groupe d'amitié UE-Maroc، 26.04.2013، Réaction à la résolution 2099 des Nations Unies، http://groupedamitieuemaroc.wordpress.com/

lxxxv عضو البرلمان كادبك في البرلمان الاوروبي، 12.12.2011، المفوضية تدافع عن اتفاقية صيد الاسماك بين المغرب والاتحاد الاوروبي، http://news.bbc.co.uk/democracylive/hi/europe/newsid_9656000/9656559.stm

lxxxvi المفوضة ماريا داماناكا في البرلمان الاوروبي، 12.12.2011، المفوضة تدافع عن اتفاقية صيد الاسماك بين المغرب والاتحاد الاوروبي، http://news.bbc.co.uk/democracylive/hi/europe/newsid_9656000/9656559.stm

lxxxvii WSRW.org، 01.12.2014، عارضت ماريا داماناكي استمرار صيد الاتحاد الأوروبي في الصحراء الغربية، http://www.wsrw.org/a105x3086

lxxxviii Fis.net، 15.11.2011، البرلمان الاوروبي يرفض تجديد اتفاقية صيد الاسماك مع المغرب، http://fis.com/fis/worldnews/worldnews.asp?monthyear=&day=15&id=48505&l=e&special=&ndb=1%20target=

lxxxix Les Echos، 15.12.2011، البرلمان الأوروبي يرفض اتفاقية صيد الاسماك مع المغرب، http://www.lesechos.fr/investisseurs/actualites-boursieres/reuters_00408556-le-parlement-europeen-rejette-un-accord-de-peche-avec-le-maroc-263143.php

xc Map.ma، 26.11.2011 ، «Il est du devoir du PE de soutenir notre partenaire dans cette période de démocratisation dans le Monde arabe»، estime Alain Cadec http://mobile.lematin.ma/content/132230035214517500/MatinActualite

xci Le Maroc Hebdomadaire، 17-23.05.2013، رشيدة داني تنتقد البرلمان الأوروبي، http://www.fishelsewhere.eu/a142x1426

xcii RTVE، 14.12.2011، الحكومة ترفض تصويت البرلمان على التمديد مع المغرب: سيء بالنسبة لصيادي الاسماك ومالكي السفن، http://www.rtve.es/noticias/20111214/gobierno-rechaza-veto-prorroga-marruecos-muy-negativo-para-pescadores-armadores/481953.shtml

xciii FISHupdate، 16.12.2011، البرلمان الاوروبي، المغرب/المغرب الحالي في اعقاب رفض البروتوكول الاتحاد الأوروبي/الاتحاد للاتحاد التابعة الصيد سفن مالكي سحط.

li المفوضية باسم ،مايا داماناكي، 21.06.2010، http://www.europarl.europa.eu/sides/getAllAnswers.do?reference=E-2010-2633&language=EN.

lii L'Economiste، أعيد نشرها في FisPros، 03.10.2010، Maroc/UE: l'accord dans l'impasse، http://fishpros.purforum.com/t197-maroc-ue-l-accord-dans-l-impasse

liii ABC، 25.05.2010، الاتحاد الاوروبي يدافع عن قانونية اتفاقية الصيد مع المغرب، http://agencias.abc.es/agencias/noticia.asp?noticia=397879

liv " قام مع متفقة الجميع اختبرها الاستماك صيد اتفاقية ارمت الذي الوقت في مستقلة. اوروبية مؤسسات وهي الأوروبي، والبرلمان المجلس الى وكذلك الاوروبية، المفوضية لينداوير، السفير اشار طلاب من السويد بعترضون علي تلاعب الاتحاد الاوروبي بالألفاظ، 14.06.2011، http://www.wsrw.org/a204x1896 القانون الدولي " WSRW.org.

lv المفوض حو بورع لتفريدن سفوغيس، Uppdrag Granskning، 03.03.2010، 'Det gränslösa fisket'.

lvi رويترز، 08.06.2011 http://www.reuters.com/article/2011/06/08/ozabs-trade-morocco-fish-idAFJOE7570GI20110608

lvii ABC، 27.05.2010، الاتحاد الاوروبي يدافع عن قانونية اتفاقية الصيد مع المغرب، http://agencias.abc.es/agencias/noticia.asp?noticia=397879

lviii الصحراء الغربية مياه تشمل الاوروبي والاتحاد المغرب بين الجديدة الصيد اتفاقية، 28.07.2005، اوروبا برس، http://www.fishelsewhere.eu/files/dated/2009-01-31/cesar_deben_statement_28.07.2005.pdf

lix وعلاوة علي ذلك، أقرت محكمة الاستئناف الجنائية الاسبانية في العامين 2014 و 2015 أن اسبانيا لا تزال قانونا السلطة الادارية في الصحراء الغربية.

lx كانارياس اوبزا، 15.05.2006، مقابلة مع سيزار ديبين، http://www.fishelsewhere.eu/a170x971

lxi يمكن الوصول عليه عبر. والموارد، المكانة – الغربية الصحراء مسارات: 4/2010، كويل، هانس السفور: http://www.wsrw.org/a159x1747

lxii وزارة المالية البرويجية، 06.06.2005، استثناء شركة في صندوق البترول الحكومي، https://www.regjeringen.no/no/aktuelt/company_excluded_from_the_government/id256359/

lxiii الصحراء الغربية الاسماك معركة المغربية: الاستماك معركة، 15.12.2011، بي بي سي، http://www.bbc.co.uk/news/world-africa-16101666

lxiv WSRW.org، 05.03.2012، تجدون هنا تقرير تقييم اتفاقية الصيد المغربة، http://www.wsrw.org/a214x2261

lxv ديستكا الدباء، 09.09.2009، المفوضية الاوروبية تطلب من المغرب زيادة التشديد علي منع استخدام الشباك العائمة لصيد الاسماك http://www.nuestromar.org/noticias/pesca_y_acuicultura_092009_25789_ce_pide_a_marruecos_mas_esfuerzo_para_prohibir_l

lxvi WSRW.org، 05.03.2012، تجدون هنا تقرير تقييم اتفاقية الصيد المغربة، http://www.wsrw.org/a214x2261

lxvii EFE، 02.09.2011، البرلمان الاوروبي ينتقد نتائج السيئة للاتفاقية مع المغرب، http://www.pesca2.com/informacion/desc_noticia.cfm?noticia=10686

lxviii WSRW.org، 03.07.2008، المفوضية الاوروبية تعترف بصيد السمك في الصحراء الغربية المختلة، http://www.wsrw.org/a128x770

lxix WSRW.org، 01.12.2014، عارضت مايا داماناكي استمرار. صيد الاتحاد الاوروبي في الصحراء الغربية، http://www.wsrw.org/a105x3086

lxx EuropeanVoice.com، 07.07.2011، دعم لاتفاقية صيد الاسماك المغربية المثيرة للجدل، http://www.europeanvoice.com/article/imported/support-for-controversial-morocco-fishing-agreement-/71549.aspx

lxxi خسارة 35% من 36 مليون يورو، الدفعة السنوية بموجب البروتوكول.

lxxiii WSRW.org، 21.10.2010، معد تقرير الميزانية يدعو. الى رفض اتفاقية السمك، http://www.wsrw.org/a204x2134



http://www.eldh.eu/declarations/publication/press-release-fishery-agreement-between-european-union-and-morocco-illegal-61/)

xxxvi Fishelsewhere.eu، 23.02.2010، هذا الرأي القانوني السري للبرلمان الأوروبي، http://www.fishelsewhere.eu/a140x1077

xxxvii World Food Programme, Medicos Del Mundo, Norwegian Church Aid, Akershus University College, Nutritional and Food Security Survey among the Saharawi refugees in Camps in Tindouf, Algeria (تشرين الاول/اكتوبر. 2008). http://www.vest-sahara.no/files/dated/2013-05-02/nutritional_survey_2008.pdf

xxxviii مقابلة، 2013، الباحثة انغريد باريكسو، معهد جامعة اوسلو واكرسوش.

xxxix ECHO، 2013 نيسان/ابريل، المفوضية الاوروبية، بيان حقائق اللاجئون الصحراويون، http://reliefweb.int/sites/reliefweb.int/files/resources/sahrawi_en_0.pdf

xl تمنع الحالة الانسانية المزرية وإلى حدما انعدام امكانية الوصول الى الموارد والثروات الطبيعية في الصحراء غربي الجدار الرملي، الصحراويون في مخيمات اللاجئين من التمتع بحقوقهم الاقتصادية والاجتماعية والثقافية. الامين العام للأمم المتحدة، 19.04.2016. تقرير الامين العام عن الحالة المتعلقة بالصحراء الغربية، http://www.un.org/ga/search/view_doc.asp? توصي اللجنة بان تقوم الدولة الطرف بما يلي: [...] ضمان احترام مبدأ موافقة الصحراويين المسبقة والحرة والموثقة، وبالتالي تمكينهم من ممارسة حقهم في التمتع " symbol=S/2016/355. والاستفادة على نحو كامل وحر ثرواتهم ومواردهم الطبيعية". مجلس حقوق الانسان التابع للأمم المتحدة، اللجنة الاقتصادي، والاجتماعي، لجنة الحقوق الاقتصادية والاجتماعية والثقافية 22.10.2015 http://www.wsrw.org/files/dated/2015-12-09/cescr_morocco_2015_eng.pdf

xli WSRW.org، 29.09.2010، 799 منظمة ولاجي في بروكسل يحتجون على صيد الاتحاد الاوروبي، http://www.wsrw.org/a159x1614.

xlii WSRW.org، 19.7.2017، في أعقاب محكمة عسكرية، محكمة مدنية تلاحق الناشطين الصحراويين http://www.wsrw.org/a105x3975

xliii 07.02.2013، http://www.europarl.europa.eu/sides/getDoc.do?type=TA&language=EN&reference=P7-TA-2013-55. 13.12.2012, http://www.europarl.europa.eu/sides/getDoc.do?type=REPORT&language=EN&reference=A7-0377/2012. 12.09.2012,

http://www.europarl.europa.eu/sides/getDoc.do?type=TA&reference=P7-TA-2012-0334&language=EN

xliv WSRW.org، 14.9.2010، السجناء السياسيون الصحراويون يطالبون الاتحاد الاوروبي بوقف الصيد، http://www.wsrw.org/a159x1591.

xlv على سبيل المثال، Fishelsewhere.eu، 28.11.2012، جبهة البوليساريو تعرب عن قلقها ازاء صيد الاتحاد الأوروبي أمام مجلس الامن، http://www.fishelsewhere.eu/a140x1388

xlvi ABC، 04.04.2006، 72/5000، المغرب يرفض الذهاب إلى الاتحاد الأوروبي للتعليق على اتفاقية صيد الأسماك، http://www.abc.es/hemeroteca/historico-02-04-2006/abc/Economia/marruecos-sopesa-no-acudir-a-la-ue-para-opinar-sobre-el-acuerdo-pesquero_142988229026.html

xlvii Fishelsewhere.eu، 04.06.2010، المغرب يرفض زيارة من البرلمان الاوروبي، http://www.fishelsewhere.eu/a140x1143

xlviii WSRW.org، 29.11.2010، ترحيل صحفي دانماركي من المغرب بعد تغطية صيد الاتحاد الأوروبي للأسماك، http://www.wsrw.org/a159x1705. طرد بعد مقابلة WSRW.org، 11.01.2011، من الصحراء الغربية WSRW طرد عضو في http://www.wsrw.org/a204x1813. WSRW.org، 01.02.2011، على مغادرة الصحراء الغربية WSRW إجبار http://www.wsrw.org/a204x1844. WSRW.org، 29.5.2011، الصحراويون يهددون بصدد صيد الاتحاد الاوروبي للأسماك http://www.wsrw.org/a204x1933. WSRW.org، 6.11.2012، سافر الى مقابلة بصدد صيد الاتحاد الاوروبي للأسماك – طرد من الصحراء الغربية، http://www.wsrw.org/a214x2409

xlix EFE (ABC.es)، 30 حزيران/يونيو، 2010 كارمن فراخا تؤكد وجود مشاكل لمنع تجديد الاتفاقية مع المغرب، http://www.abc.es/agencias/noticia.asp?noticia=438556

l السفير، هانس كوري، مسارات 4/2010، الصحراء الغربية – المكانة والموارد، يمكن الحصول عليه عبر: http://www.wsrw.org/a159x1747

xix رأي قانون. الأوروبي البرلمان في القانونية الدائرة في ايضا مذكور مذكور وهكذا، SJ, 20.02.2006-0085/06،http://www.wsrw.org/files/dated/2013-04-26/parliament_legal_opinion_fpa_20.02.2006.pdf

xx http://www.fishelsewhere.eu/index.php? الغربية الصحراء موارد مراقبة منظمة إلى الاوروبية المفوضية من رسالة (WSRW 27.06.2010،في parse_news-single&cat=140&art=1151

xxi EU Observer, 09.03.2006, Commission under fire over Morocco fisheries agreement, http://euobserver.com/news/21092

xxii WSRW.org، 04.07.2013، المغرب مع الصيد اتفاقية بصدد 2006 عام من قانون رأي عن الكشف يرفض الأوروبي الاتحاد بمجلس، http://www.wsrw.org/a105x2617

xxiii http://www.europarl.europa.eu/sides/getDoc.do? الأوروبي، البرلمان في بورغ جو حول المفوض، 15.05.2006 type=CRE&reference=20060515&secondRef=ITEM-018&format=XML&language=EN

xxiv رأي قانون. الأوروبي البرلمان في القانونية الدائرة، SJ-0085/06, 20.02.2006, http://www.wsrw.org/files/dated/2013-04-26/parliament_legal_opinion_fpa_20.02.2006.pdf قانون. رأي القانونية والدائرة الأوروبي البرلمان http://www.wsrw.org/files/dated/2017-11-30/ep_legal_opinion_schoo_2009.pdf 13.07.2009, 13.07.2009 موجز قانون، رأي القانونية والدائرة الأوروبي البرلمان http://www.wsrw.org/files/dated/2017-11-30/ep_legal_opinion_schoo_2009_summary.pdf

xxv قانون رأي القانونية الدائرة، الاوروبي البرلمان، SJ-0085/06, 20.02.2006، http://www.wsrw.org/files/dated/2013-04-26/parliament_legal_opinion_fpa_20.02.2006.pdf

xxvi http://www.europarl.europa.eu/sides/getDoc.do? الأوروبي، البرلمان مناقشات، 30.10.2006 type=CRE&reference=20060404&secondRef=ITEM-014&format=XML&language=EN

xxvii http://www.europarl.europa.eu/sides/getDoc.do? الاوروبي، البرلمان في اورتيجا ميدينا مانويل البرلمان عضو، 15.06.2006 type=CRE&reference=20060515&secondRef=ITEM-018&format=XML&language=EN

xxviii http://www.europarl.europa.eu/sides/getDoc.do?الأوروبي، البرلمان في كارمن البرلمان عضو، 15.05.2006 type=CRE&reference=20060515&secondRef=ITEM-018&format=XML&language=EN

xxix http://www.europarl.europa.eu/sides/getDoc.do? الأوروبي، البرلمان في مارتينيس كلود-جين البرلمان عضو، 15.05.2006 type=CRE&reference=20060515&secondRef=ITEM-018&format=XML&language=EN

xxx استشاري. رأي، 1975، الدولية، العدل محكمة،http://www.icj-cij.org/en/case/61

xxxi الغربية الصحراء من النزاع من الرغم على تتقدم الاوروبي للاتحاد التابعة الصيد صفقة، 14/6/2006، ناثر فاينانشال، http://www.ft.com/cms/s/0/7d092668-e380-11da-a015-0000779e2340.html

xxxii WSRW.org، 16.05.2006، رسالة، http://www.wsrw.org/a193x1999

xxxiii http://www.europarl.europa.eu/sides/getDoc.do? الأوروبي، البرلمان في بورغ جو حول المفوض، 15.06.2006 type=CRE&reference=20060515&secondRef=ITEM-018&format=XML&language=EN

xxxiv الغربية الصحراء في الطبيعية الموارد واستغلال استكشاف، قانونية 05.12.2008، كويل، هاتر السفير، http://www.havc.se/res/SelectedMaterial/20081205pretoriawesternsahara1.pdf

xxxv http://www.wsrw.org/index.php? حكومية الغير الفرنسيين المحامين منظمة وصلت (Sherpa 2006) الاتفاقية شرعية بعدم القائلة النتيجة نفس إلى، cat=193&art=1479) نيويورك، بار جمعية (Association of the Bar of the City of New York) 2011, http://www.wsrw.org/index.php? parse_news-single&cat=105&art=1894، 2011) جامعات اربع من السويدين القانون أصحابي وجموعة، http://www.wsrw.org/files/dated/2011-02-17/swedish_legal-opinion_16.02.2011.pdf)، العالمية الانسان وحقوق للديمقراطية الاوروبيين المحامين وجمعية، ELDH (2011،

i Aujourd'hui le Maroc, 24.05.2006, Accord de pêche: naufrage polisarien, http://www.fishelsewhere.eu/files/dated/2009-10-25/laenser_2006_in_alm.pdf

ii المغرب: الدول والمناطق، 21.04.2017، المفوضية الاوروبية، http://ec.europa.eu/trade/policy/countries-and-regions/countries/morocco/

iii 2010 محادثة مع المؤلف، تشرين الثاني/نوفمبر.

iv البرلمان الأوروبي، 07.02.2013 http://www.europarl.europa.eu/sides/getDoc.do?type=TA&language=EN&reference=P7-TA-2013- انظروا ايضا: 13.12.2012 – التقرير السنوي لحقوق الانسان والديقراطية في العالم 2011، وسياسة الاتحاد الأوروبي بهذا الشأن .55 http://www.europarl.europa.eu/sides/getDoc.do?type=REPORT&language=EN&reference=A7-0377/2012

v La Razón، 12-11.2010، http://www.larazon.es/detalle_hemeroteca/noticias/LA_RAZON_341773/historico/769-la-ue-prefiere-evitar-el-conflicto-con-marruecos#.UXjX7Mp7N7k

vi الخريطة، 2013 27/9، Eneko Landaburu: "Le Maroc et l'UE partagent les mêmes valeurs de démocratie et de liberté", http://www.aufaitmaroc.com/actualites/maroc/2010/9/27/eneko-landaburu-le-maroc-et-lue-partagent-les-memes-valeurs-de-democratie-et-de-liberte#.UXjarcp7N7l

vii المجلس الاوروبي، DCFTA، 2013 استطلاع، الاتحاد الأوروبي والمغرب، http://trade.ec.europa.eu/doclib/docs/2013/february/tradoc_150521.pdf الاستبيان، 2013

viii المفوضية الاوروبية، 22.04.2013، الاتحاد الأوروبي والمغرب يبدأن مفاوضات لإقامة علاقات تجارية أوثق، http://trade.ec.europa.eu/doclib/press/index.cfm?id=888

ix نداء منظمات المجتمع المدني الصحراوية لتغيير سياسة الاتحاد الأوروبي التجارية 31، 26.06.2012، http://www.wsrw.org/a214x2338

x بيان الناطق الرسمي باسم الاتحاد الأوروبي أثنون بشان الصحراء الغربية، http://www.eu-un.europa.eu/articles/en/article_10352_en.htm ،11/10/2010

xi قرار مجلس الامن 2044 (2012)، مجلس الامن يمدد تفويض بعثة الامم المتحدة في الصحراء الغربية، http://www.un.org/News/Press/docs/2012/sc10621.doc.htm

xii غرينبيس، 20.07.2011، Responsible Fishing Practices Critical,http://www.greenpeace.org/africa/en/News/news/Responsible-Fishing-Are-Practices-Critical/

xiii المفوضية الاوروبية، (2016)، ص 16، الحقائق والارقام حول شراكة صيد الاسماك المشتركة، https://ec.europa.eu/fisheries/sites/fisheries/files/docs/body/pcp_en.pdf

xiv المكتب الاحصائي، للمجموعة خصوص صيد الأسماك http://epp.eurostat.ec.europa.eu/web/fisheries/statistics-illustrated

xv Endgame in the Western Sahara (2004)، Toby Shelley، 75 ص.

xvi سؤال مدون وجهته ماريا ساليناس غارسيا إلى المفوضية الاوروبية في 29.12.2004، http://www.europarl.europa.eu/sides/getDoc.do?type=WQ&reference=E-2004-2679&format=XML&language=EN 29.12.2004

xvii اتفاقية شراكة صيد الاسماك بين الاتحاد الأوروبي والمغرب، http://www.vest-sahara.no/files/dated/2008-05-15/fisheries_partnership_agreement_eu-morocco.pdf http://www.vest-sahara.no/files/dated/2008-05-15/fisheries_partnership_agreement_eu-morocco.pdf

xviii الامم المتحدة، 12.02.2002، رسالة بتاريخ 29 كانون الاول/ديسمبر، 2002، موجهة من وكيل الامين العام للشؤون القانونية مكتب المستشار، القانوني، إلى رئيس مجلس الامن http://www.wsrw.org/files/dated/2008-10-22/un_report_on_legality_oil.pdf

الذي قام به نظام فرانكو عام 1975——القانون الدولي حقا؟ هل يمكن اعتبار قيام الاتحاد الأوروبي بالصيد في مياه الصحراء الغربية المحتلة مقابل دفع الأموال للمغرب أمرًا مشروعا من ناحية قانونية؟ لقد حان الان دور محكمة العدل الأوروبية لاتخاذ قرارها في هذا الشأن. ستقرر محكمة العدل التابعة للاتحاد الأوروبي في العام 2018 شرعية صيد الاتحاد الاوروبي نهائيا، بعد رفع جبهة البوليساريو قضية أمامها ضد الاتحاد الاوروبي عام 2014. cxvi

سيثبت المستقبل إذاكان الاتحاد الاوروبي سيشعر بالحاجة الى احترام قوانين الاتحاد الاوروبي، أو إذا ماكان سيحاول ايجاد حججا سياسية ضد ذلك ايضا.

مجلس الامن. اسقطت الـدولتان الاقتراح. ولـهذا، أصبح مـن غير المرجح أن يتـم توثيق خطورة الانتهاكات المغربية اطلاقا، وهو الأمر الذي يمكن أن يكون كافيا لتعليق الصفقة.

ومما يدعو للسخرية، أن البرلمان أقر بالموافقة على الاتفاقية الجديدة في يوم حقوق الانسان عـام 2013. أبرم الاتحاد الاوروبي اتفاقية بتكلفة أقل، إلا أن انتهاك الاتفاقية الجديدة للقانون الدولي مساو لما كان في الاتفاقية القديمة تماما. ومع ذلك، فقد تضمنت ما يكفي مـن التعديلات لمنح اسطول الصيد الإسباني——والحكومة المغربية——الأغلبية البرلمانية.

وفي وقت لاحق مـن نفس اليـوم، اصيب عشرات الصحراويين علـى يـد قـوات الامن المغربية في الصحراء الغربية المحتلة أبان احتجاجهم علـى توقيع الاتحاد الاوروبي علـى اتفاقية غير قانونية لنهب ثروتهم السمكية. [cxv]

صنع التاريخ

كان التصويت ضد صيد الاتحاد الأوروبي في الصحراء الغربية في 14 كانون الاول/ديسمبر 2011 قرارا تاريخيا. لقد كانت تلك المرة الثانية في تاريخ الاتحاد الاوروبي التي يقوم البرلمان فيها باستخدام سلطته لتعطيل معاهدة دولية كان وزراء خارجية الاتحاد الاوروبي قد اعتمدوها من قبل.

ونّقت مؤسسات الاتحاد الاوروبي، بالإضافة إلى تقارير مستقلة طلبتها، كون اتفاقية صيد الاسماك في الصحراء الغربية تدمر البيئة وأنها كارثة مالية بالنسبة للاتحاد الاوروبي وأنها لم تخلق فرص عمل إلا بالكـاد، وأنها تنتهك القانون الـدولي. وحينما رجحت كفة نزوع البرلمان ضد الصفقة، استخدم المدافعون عنها وبشراسة كل الاستراتيجيات لدعم استمرار صيد الاسماك. لقد أساؤوا تفسير تقارير الاتحاد الاوروبي، وزعموا أنها تقارير خاطئة، والاهم من هذا كله، أنهم حاججوا دعما لأهمية المغرب السياسية: الاتحاد الاوروبي حليف للمغرب——ولذلك علـى اسطول الصيد التابع للاتحاد الأوروبي الصيد في الصحراء الغربية. لقد كان ذلك المنطق الحاكم خلال هذه الايام المحمومة التي سبقت التصويت النهائي. لقد انتقلت نفس القوى التي كانت تحاجج بشكل مكثف في صالح الطابع اللا–سياسي لصيد الاسماك الذي يقوم به الاتحاد الاوروبي في الصحراء الغربية إلى الطرف الاخر. لقد استخدموا حججا جيو-سياسية للدفاع عن صيد الاسماك.

هل ستصمد هذه الحجج السياسية أمام المحكمة؟ هل تحترم ممارسات الصيد التي يقوم بها الاتحاد الأوروبي——وهي عبارة عن صفقة سياسية نشأت عن البيع القذر للشعب الصحراوي للمحتل المغربي

الصحراء الغربية كانت قد أُسقطت في نهاية الأمر من التكليف التفاوضي، وذلك بالأساس بسبب الضغط الاسباني، أدخلت المفوضة داماناكي بدلا عنها، بندا يجعل من احترام حقوق الانسان الاساسية شرطا مسبقا للتوصل الى اتفاقية جديدة. إلا أن الاصرار على بند حقوق الانسان قد أثار هو الآخر غضب المغاربة وظل العائق الأساسي امام إجراء المزيد من المفاوضات. وقد عبّر حتى منتقدو التخطيط لاتفاقية جديدة في الصحراء الغربية عن تساؤلاتهم بصدد الاصرار على حقوق الانسان. وكان البرلمان الأوروبي قد ادان سجل حقوق الانسان المغربي في الصحراء الغربية مرارا، فيما أعرب الأمين العام للأمم المتحدة عن قلقه الشديد. فإذا ما تم اعتماد حقوق الانسان كشرط اساسي، أليس صحيحا أنه سيتم اختراق الاتفاقية في نفس يوم التوقيع عليها؟

ففي الوقت الذي كانت تجري فيه المفاوضات بشأن حقوق الانسان، كان البرلمان الاوروبي يؤكد مرارا وتكرارا على انتهاك حقوق الانسان في الصحراء الغربية. وأعرب البرلمان في شباط/فبراير 2013 عن "قلقه ازاء استمرار انتهاك حقوق الانسان في الصحراء الغربية، وأنه يدعو الى حماية الحقوق الاساسية لشعب الصحراء الغربية، بما في ذلك حرية التنظيم وحرية التعبير والحق في التظاهر؛ ويطالب بالإفراج عن جميع السجناء السياسيين الصحراويين؛ ويرحب بإنشاء البعثة الخاصة لمنطقة الساحل، ويشدد على الحاجة إلى مراقبة دولية لحالة حقوق الانسان في الصحراء الغربية؛ ويؤيد التوصل الى تسوية عادلة ودائمة للنزاع على اساس حق تقرير المصير للشعب الصحراوي وفقا لقرارات الامم المتحدة ذات الصلة". cxii

وخلال صيف عام 2013، وفيما كانت مؤسسات الاتحاد الأوروبي في اجازة صيفية، تم التوصل إلى اتفاقية لصيد الاسماك بين المفوضية والحكومة المغربية. cxiii ولم يُضاف إليها أي بند حول حقوق الانسان، وذلك لأول مرة في إطار شراكات صيد السمك الاوربية منذ عام 2010. cxiv وبدلا عن ذلك، تمت إضافة إشارة مبهمة إلى بند حقوق الانسان في اتفاقية التعاون وذلك كحل وسط مع المغاربة.

وموازاة لذلك، وفي خلال المفاوضات، منعت دولتا الاتحاد الاوروبي، اسبانيا وفرنسا، اللتان كانتا في مقدمة الضاغطين على المفوضية لإبرام معاهدة صيد الاسماك، مراقبة الامم المتحدة الدائمة لحقوق الانسان في الاقليم. لقد حث الامين العام للأمم المتحدة بان كي مون مجلس الامن مرارا وتكرارا على اعتماد آلية دائمة لمراقبة حقوق الانسان، وهي الآلية التي كانت الحكومة الاميركية قد اقترحتها على

قامت CEPESCA مع شركائها المغاربة بالضغط على مؤسسات الاتحاد الأوروبي على مدى سنوات. وفي رأي CEPESCA، لن يكون اقتراح استثناء الصحراء الغربية خيارا "قابلا للحياة" بالنسبة للرباط. وبدلا من ذلك، وكما أكدت CEPESCA، سيقوم المغرب بدلا عن ذلك بضمان استفادة المنطقة——وهذا هو نفس الطلب الذي طالب به الاتحاد الأوروبي قبل نصف عقد من الزمن، إلا أن المغرب لم يعن مطلقا بالإبلاغ عنه.

وبعد ضغوط مكثفة من طرف اسبانيا تم اسقاط اقتراح المفوضة الداعي الى استثناء الصحراء الغربية من مسودة التوكيل التفاوضي. وبدلا عن ذلك، ظهر اقتراح جديد ينص على التصريح بوضوح في المسودة أن مناطق صيد الاسماك المشمولة في الاتفاقية المتوخاة تشمل المناطق الواقعة "قبالة مياه اقليم الصحراء الغربية الذي لا يتمتع بالحكم الذاتي جنوب 27°N40". ونص بند آخر على أن المفوضية تتوقع ان يضمن المغرب الايفاء بالتزاماته بموجب القانون الدولي الصادرة عن "الادارة الفعلية للصحراء الغربية". وبحسب المفوضية، على المغرب اصدار تقارير متتابعة وبانتظام بصدد التوزيع الجغرافي للآثار الاجتماعية-الاقتصادية الناجمة عن الدعم الحاصل بموجب الاتفاقية.

أثارت هاتان الاشارتان إلى الصحراء الغربية نقاشات دامت اسابيعا في المجلس. وطالبت كل من اسبانيا وفرنسا، وبدعم من الدول التي تعتمد على صيد الاسماك (البرتغال ولاتفيا وليتوانيا)، بإزالة أية إشارة مباشرة إلى الصحراء الغربية من النص كيلا يتسبب ذلك بإغضاب نظيرتها المغربية. ومن جهة اخرى، طالبت دول مثل السويد وهولندا والمملكة المتحدة والمانيا بإشارة مباشرة وواضحة.[cx]

وبعبارة اخرى، يعتبر عدد من الحكومات أن تعبير "الصحراء الغربية" ذو طابع سياسي قوي إذا ما تم ذكره. إلا أنه لا-سياسي إذا ما حُذف. ومن الواضح أن الطرف الوحيد الذي يجب أخذه بعين الاعتبار لدى تقييم الخلاف السياسي بصدد صيد الاتحاد الاوروبي في الصحراء الغربية هو، بالنسبة لبعض الجهات الفاعلة، السلطة المحتلة المغربية. ومن هذا المنطلق، تقع التفسيرات السابقة القائلة بالطابع الحيادي واللا-سياسي لاتفاقية صيد الاسماك داخل منظور جديد تماما. أكد المفوض في عام 2006 انه يحترم القانون الدولي وأنه لن يحكم مسبقا على قضية الصحراء الغربية. ووفقا لما ذكرته صحيفة فاينانشيال تايمز، فقد " أشار الى ان الاتفاقية لم تشر إلى الصحراء الغربية مباشرة".[cxi]

لهذا، كان يجب تغيير التكليف التفاوضي: يمكن فعلا الصيد في مياه الصحراء الغربية المحتلة، ولكن من الضروري عدم ذكر ذلك لأن من شأن ذلك أن يصبح شأنا سياسيا. وبما أن الاشارة الى

وهكذا عادت العلاقات بين المغرب والاتحاد الاوروبي الى مسارها الأول.

وفي نهاية المطاف، دخلت الاتفاقية التجارية الجديدة إلى حيز التنفيذ في الأول من تشرين الاول/اكتوبر 2012. ومنذ ذلك الحين، عبّرت بعض الدول عن قلقها فيما يتعلق بتطبيقها. وكانت كل من السويد وهولندا قد صرحتا بعدم امكانية اعطاء البضائع القادمة من الصحراء الغربية تعريفات تفضيلية في الاتحاد الاوروبي بموجب الاتفاقية.[cvi] وللمرة الثانية، قررت المفوضية عدم الالتفات إلى حقوق الشعب الصحراوي. وانقسم الاتحاد الأوروبي من جديد.

وفي 21 كانون الاول/ديسمبر 2016، علّقت محكمة العدل التابعة للاتحاد الاوروبي الاتفاقية.[cvii] ورأت المحكمة أن الاتحاد الاوروبي لا يملك حق الدخول في صفقات تجارية تشمل اراضي الصحراء الغربية. وخلصت المحكمة الى ان هذه الاراضي "منفصلة ومستقلة" عن المغرب، وأن قرار شمل اراضي الصحراء الغربية في أية اتفاقية تجارية يعود الى ممثلي "شعب" تلك الاراضي. وقد تجاهلت المحكمة جميع الحجج السياسية التي أتى بها الاتحاد الاوروبي. ولم ترد اشارة الى "استفادة السكان" ولا إلى كون المغرب السلطة الادارية الفعلية".

أربعة أعوام أخرى

ولكن دعونا نعود الى قصة صيد الاسماك التي لم تنته تماما. أو، وعلى العكس من ذلك تماما، إذ أن نشاطات صيد الاسماك قائمة اليوم مجددا. فمباشرة بعد التصويت ضد تمديد اتفاقية صيد الاسماك، وبعدما غادر اسطول الاتحاد الاوروبي المياه الصحراوية، ابتدأ النقاش حول صيد الاتحاد الأوروبي في الصحراء الغربية من جديد. لدى التصويت التاريخي في كانون الاول/ديسمبر 2011، كان المفوض السابق لشؤون صيد الاسماك المالطي جو بورغ قد أخلى مكانه ليحل محله صوتا أكثر نقدا، هو صوت اليونانية ماريا داماناكي. كانت داماناكي ناشطة سياسيا ضد النظام الديكتاتوري السابق في اليونان ومدافعة قوية عن حقوق الانسان——وهي مبادئ لا تتم مناقشتها عامة في اجتماعات صيد الاسماك في الاتحاد الاوروبي.

وكان اقتراحها الأول، والذي أيده عدد من الدول، الاستبعاد الكامل للصحراء الغربية من اتفاقية جديدة مع المغرب، كأمر ينبغي ذكره في توكيلها التفاوضي.[cviii]

وبدوره، أكد رئيس اتحاد صيد الاسماك الاسباني (CEPESCA) أن "استثناء مياه الصحراء الغربية سيجعل الوصول إلى اتفاقية مع المغرب أمرا مستحيلا". وأضاف أنه نظرا إلى إدراج الصحراء الغربية في الصفقات السابقة فيجب العود على ذلك من جديد.[cix]

وبالتالي، ليس من المستغرب ان المناقشة لم تكن ساخنة كما كانت المناقشة حول صيد الاسماك. إذ أرسل المفوض المسؤول عن سياسات الجوار في "بيان حقائق" إلى اعضاء البرلمان عدة اسابيع قبل التصويت: "عمليا، لا يوجد حتى الآن أي نشاط زراعي في الصحراء الغربية".[c] لم تأت هذه الرسالة على ذكر حقيقة أن المغرب كان يحضر خطط إنعاش للقطاع في الأراضي المحتلة. كما لم تذكر أن الاتفاقية تشتمل على منتجات سمكية يُصدّر قسم كبير منها إلى أوروبا.

رحبت المفوضية الاوروبية بتصويت البرلمان الأوروبي على الاتفاقية مع المغرب.

وأعلن مفوض التنمية الزراعية والريفية داسيان سيلوس أمام اعضاء البرلمان: "هذه الاتفاقية هامة، ليس من الناحية الاقتصادية فقط بل ومن الناحية السياسية أيضا".[ci]

أما الممثلة العليا للاتحاد الاوروبي كاثرين اشتون فقد صرحت بدورها: "مادامت صادرات المنتجات من الصحراء الغربية تستفيد فعليا من التفضيلات التجارية، يعتبر القانون الدولي الأنشطة المتصلة بالموارد الطبيعية والتي تضطلع بها الدولة القائمة بإدارة إقليم لا يتمتع بالحكم الذاتي أنشطة مشروعة، ما دامت لا تتجاهل احتياجات ومصالح الناس في ذلك الاقليم. على الادارة المغربية الفعلية للصحراء الغربية الالتزام قانونيا بالامتثال إلى هذه المبادئ".[cii]

وهكذا يبدو أن تحليل الاتحاد الأوروبي لا يشتمل على حقيقة أن المغرب لا يرى نفسه السلطة الادارية للصحراء الغربية، ولا يتصرف كما لو كان يحمل هذه الصفة في مؤسسات الأمم المتحدة، وأن الامم المتحدة لا ترى المغرب على هذا النحو. في الواقع، يناقض الاتحاد الأوروبي رأي الامم المتحدة القانوني من عام 2002 كما فعل من قبل بصدد صيد الأسماك، ولهذا فسرت احدى الصحف المغربية تصريحات أشتون على النحو التالي: "الاتحاد الاوروبي يعترف بحقوق المغرب التجارية في الصحراء الغربية".[ciii]

أما ألان كاديك، وهو عضو البرلمان الذي تحسّر على تعليق أنشطة صيد الاسماك في الصحراء الغربية بداعي أن المغرب يبدو كمن يسعى وراء الاصلاح في سياق الربيع العربي، فقد صرّح أن الاتفاقية التجارية الجديدة هامة لأن المغرب يمر بسلسلة من الاصلاحات الاقتصادية.[civ] أما سفير المغرب لدى الاتحاد الاوروبي فقد سمّاها "ارتياحا كبيرا". وصرح للصحافة: "أنها دليل على ثقة أعضاء البرلمان في عملية التنمية والاصلاح في المغرب". وقال رئيسه ان النتيجة كانت بفضل عمل السلك الدبلوماسي ونواب البرلمان المغربي.[cv]

الزراعة خلف ابواب مغلقة. وتحدى أعضاء البرلمان السفير: فلنبدأ بالأمور الأساسية: هلا عرّفت لنا حدودكم؟". وبعد مرور وقت قصير، لوحظ السفير الغاضب يغادر قاعة الاجتماع طارقا الابواب.

أجرت المفوضية بالإضافة إلى أعضاء البرلمان المؤيدين للمغرب ضغوطا مكثفة لتجنب النتيجة التي آلت إليها اتفاقية صيد الاسماك. وفي الواقع، تم استخدام رفض البرلمان لاتفاقية صيد الاسماك في كانون الاول/ديسمبر 2011، كحجة ضد التصويت ضد إقرار الاتفاقية التجارية أيضا. وكان لسان الحجة أن العلاقة مع الرباط قد تضررت بما يكفي سياسيا. ولكن، ظلت المشكلة نفسها قائمة: حدد تقرير أصدرته منظمة المرصد الدولي لمراقبة الثروات في الصحراء الغربية (WSRW) احدى عشرة مزرعة في المناطق المحيطة بمدينة الدخلة يملكها العاهل المغربي شخصيا أو شركات زراعية فرنسية أو مغربية.xcvii وبشكل مماثل، تستخدم مجموعة من شركات تصنيع الاسماك في الصحراء الغربية وجنوب المغرب أسماكا يتم صيدها في الصحراء الغربية أو تلك التي تصل إلى شواطئ الصحراء الغربية. يشكل هذان القطاعان معا جزءً مهما من استراتيجية المغرب لترسيخ الاحتلال عن طريق تشغيل المستوطنين المغاربة في الصحراء الغربية. ويمكن للاتفاقية بين الاتحاد الأوروبي والمغرب أن تفيد الشركات المغربية التي تصدر الاسماك والمنتجات الزراعية من الصحراء الغربية بشكل مباشر.

وقبيل التصويت على اتفاقية التجارة، تعالت الكثير من التساؤلات: لماذا ترك الاتحاد الاوروبي للمغرب مسألة تحديد حدوده الاقليمية. ودعا اثنان من ثلاثة معدي التقارير البرلمانية إلى فحص الاتفاقية المقترحة——الأول من لجنة التنمية الزراعية والريفية والآخر من لجنة التجارة الدولية——كما أوصيا البرلمان بحجب موافقته.xcviii وكانت المعضلات القانونية الناشئة عن احتمال ادراج الصحراء الغربية في النطاق الاقليمي للاتفاقية الجديدة جزءا من مخاوفهم.xcix

وفي 16 شباط/فبراير 2012، وتحت ضغط شديد من المفوضية الاوروبية، وافق البرلمان الاوروبي على الاتفاقية الجديدة: صوت 369 عضوا لصالحها و 225 ضدها فيما امتنع 31 عضوا عن التصويت. وكان العديد من اعضاء البرلمان على قناعة بأن الصناعة الزراعية منعدمة في الصحراء الغربية، ولذلك فإن التعريف الجغرافي للنقاش لا يمت للموضوع بصلة. وفي الحين الذي كانت تتوفر فيه الكثير من المعلومات عن اتفاقية صيد الاسماك بين المغرب والاتحاد الاوروبي في البرلمان، غفل معظم اعضاء البرلمان عن الخلافات حول الصفقة التجارية.

وكانت الاتفاقية، والتي تعتبر امتدادا لما يسمى اتفاق الشراكة بين الاتحاد الاوروبي والمغرب التي ابتدأ التفاوض بشأنها عام 2000، قد أُقرّت في المجلس وكانت على وشك التصويت عليها في البرلمان في 16 شباط/فبراير 2012، أي بعد شهرين فقط من تصويت البرلمان الاوروبي ضد صفقة السمك. وتعني هذه الاتفاقية، السماح بالتجارة الحرة لمجموعة واسعة من المنتجات الزراعية والسمكية في اسواق المغرب ودول الاتحاد الاوروبي.xcv ولم تحو الاتفاقية على أية اشارة إلى الصحراء الغربية او الصحراويين على الاطلاق.

وبموجب الاتفاقية، يخاطر الاتحاد الاوروبي بإعطاء افضليات تجارية لمنتجات من الصحراء الغربية. كانت تلك مشكلة مماثلة لمشكلة اتفاقية صيد الاسماك. فهل يملك المغرب الحق في عقد صفقات تخص الموارد الطبيعية في الصحراء الغربية دون مراعاة رغبات ومصالح الصحراويين؟ هل يمكن للشركات المغربية الادعاء بأن الطماطم المستوردة قادمة من المغرب إذا ما كانت في حقيقة الأمر قادمة من الصحراء الغربية المحتلة؟

من ناحية مبدئية، الإجابة سهلة: لا تعترف أية دولة اوروبية بحق المغرب في الصحراء الغربية. وقد أعلنت دول أخرى خارج الاتحاد الاوروبي، مثل النرويج أو سويسرا أو الولايات المتحدة بشكل واضح أنه لا يمكن منح منتجات الصحراء الغربية أفضليات تجارية بموجب اتفاقات التجارة الحرة مع المغرب. وفي قضية حديثة العهد، توجّب على أحد المستوردين النرويجيين دفع رسوم جمركية بلغت 1.2 مليون يورو فرضتها الحكومة النرويجية على استيراد سلع من الصحراء الغربية. أبلغ مستورد البضائع زورا أنها مستوردة من المغرب في إطار اتفاقية التجارة الحرة بين النرويج والمغرب وحصل تبعا لذلك بالخطأ على تخفيض جمركي على السلع المستوردة.xcvi

وعلى الرغم من ذلك، نحى الاتحاد الاوروبي إلى المضي قدما في الاتجاه المعاكس. وزيادة على ذلك، نشر الاتحاد الاوروبي قوائم بأسماء الشركات المتواجدة في الصحراء الغربية والتي كانت مؤهلة للتصدير الى الاتحاد الأوروبي بموجب الصفقة. ألا ينتهك الاتحاد الاوروبي بذلك واجب عدم الاعتراف من خلال هذه الممارسة؟

أثار غموض التعريف الجغرافي الجدال. ولدى بحث اللجنة الزراعية التابعة للبرلمان الاتفاقية، طلبت من المفوضية أن تحدد فيما إذا كانت سلع الصحراء الغربية ستُدرج في الاتفاقية ام لا. وقامت المفوضية، التي لم تتمكن من اعطاء اجابة واضحة، بدعوة السفير المغربي نفسه إلى جلسة استماع مع لجنة

أما وزيرة العدل الفرنسية السابقة، المغربية الاصل، فقد صرحت أن رفض البرلمان "استفزاز"، وأضافت أنه كان يجب بدلا عن ذلك دعم المغرب على إثر "الاصلاحات الجريئة" التي قامت بها الحكومة المغربية.[xc]

وأعربت الحكومة الاسبانية عن أسفها على قرار البرلمان، وعبرت عن "عدم اتفاقها" مع البرلمان—— بدون أن تعطي تفاصيل بصدد أسباب ذلك. كما وأعربت كل من اتحادات مالكي السفن واتحادات الصيادين عن اسفها على القرار.[xci]

وصرح رئيس الرابطة الاوروبية لمنظمات صيد الاسماك الوطنية: "من الملح الآن توفير كل الوسائل الممكنة، من خلال اجراءات محددة وفورية للاتحاد الاوروبي، للتعويض عن الاسقاطات الخطيرة المترتبة على تعطيل الاتفاقية، والتي ستطال العديد من شركات صناعة صيد الاسماك والعمال. كما وانتقدت الرابطة داماناكي بسبب سوء دفاعها عن الاتفاقية امام البرلمان الأوروبي.[xcii]

وتبعت الحكومة الاسبانية طلب القطاع، فقامت بمطالبة الاتحاد الأوروبي بتعويض خسائر صيد الاسماك. وبحلول كانون الثاني/يناير 2012، بلغ مبلغ طلب التعويض الاسباني من بروكسل 16 مليون يورو.[xciii] ويعادل هذا المبلغ 1,6 اضعاف المبلغ الذي تفخر منظمة المساعدات التابعة للاتحاد الاوروبي (ECHO) بالتبرع به سنويا الى اللاجئين الصحراويين——أي إلى مالكي الاسماك التي اعتزم الصيادون الاسبان اصطيادها.

وبالإضافة الى ذلك، أعرب سفير الاتحاد الاوروبي عن اسفه قائلا: "انني آسف على علاقاتنا مع المغرب". واقتبست وسائل الاعلام المغربية الرسمية لاندابورو قوله "خلافا لرأي الدول الاعضاء في المفوضية الاوروبية (كذا)، والسيدة اشتون ممثلة الاتحاد الاوروبي العليا للشئون الخارجية والسياسة الامنية، صوت البرلمان ضد التمديد المقترح لبروتوكول اتفاقية صيد الاسماك بين المغرب والاتحاد الاوروبي.[xciv]"

الاثار الجانبية للطماطم

كان لرفض البرلمان اتفاقية صيد الاسماك والتوتر الذي أعقبه مع الرباط، نتيجة مميزة. تفاوض المغرب والمفوضية لسنوات وبهدوء بشأن ابرام اتفاقية ثنائية أخرى تخص التجارة الحرة لمنتجات الزراعة وصيد الاسماك.

ماريا داناماكي: "لقد أثرت رياح التغيير التي أثّرت على جنوب البحر الابيض المتوسّط وبعض الدول الاخرى على المغرب ايضا. فما هو تقييم المفوضية بهذا الخصوص؟ يشير تقييم المفوضية إلى أن السلطات المغربية قد بدأت اصلاحا كبيرا يشتمل على وضع دستور جديد وزيادة المساءلة الديمقراطية واحترام حقوق الانسان. [...] لقد رحّب الاتحاد الاوروبي على جميع مستوياته بهذه التغييرات. [...] علينا أن نضع هذا الإطار نصب اعيننا قبل اتخاذ قرارتنا."lxxxv شعر العديد من أعضاء البرلمان بضغوطات المفوضية. تم تخطيط كل شيء: وجاء في نص رسالة بريد الكتروني أرسلها أحد أعضاء اللوبي إلى العاهل المغربي بعد اجتماع داخلي حول استراتيجية–تصويت السمك مع رئيسة اللجنة البرلمانية لصيد الاسماك كارمن فراجا "تتوقع السيدة فراجا بعض الضغط من طرف رئيس المفوضية."lxxxvi

ولكن، وعلى الرغم من دعوات مؤيدي الاتفاقية قام البرلمان الاوروبي برفض التمديد. وفيما رفض البرلمان التمديد، فقد قام في الوقت نفسه بدعوة المفوضية إلى البدء بجولة جديدة من المحادثات مع المغرب حول صيد الاسماك شريطة أن تأخذ بالحسبان الجوانب البيئية والمالية وكذلك "استفادة" السكان المحليين في الصحراء الغربية منها.

واشار مفوض شؤون صيد الأسماك والبحرية بعدما توضحت نتيجة التصويت أن "المفوضية الاوروبية سوف تحترم تصويت البرلمان الاوروبي اليوم. [...] لا نعرف إذا ما كان بروتوكول جديد لصيد الاسماك مع المغرب لا يزال ممكنا. سوف نستكشف جميع الطرق الممكنة للمضي قدما."lxxxvii وصرح الاعضاء البارزين في لجنة الصيد البحري مرارا وتكرارا بعد وجود علاقة بين حقوق الشعب الصحراوي——أو "السياسة" بحسب تعبيرهم——ولجنة صيد الاسماك. وعلى الرغم من ذلك، أصبح لنفس الاشخاص فجأة آراء قوية جدا بخصوص الاهمية السياسية لاتفاقيات صيد الاسماك. وكما يبدو، كانت تلك حجتهم الوحيدة المتبقية: المغرب مهم جدا بالنسبة للاتحاد الأوروبي. أُصيب ألان كاكيك، نائب رئيس لجنة الصيد البحري التابعة للبرلمان، بصدمة أزاء التصويت. وصرح: "اننا نعطي اشارة سلبية جدا للمغرب في أوان [الـ] ربيع العربي."lxxxviii كما وكان عضو البرلمان الفرنسي قد سبق وشدد على اهمية "صيد الاسماك المغربي في جميع انحاء الاراضي المغربية."lxxxix

كما وتم توزيع منشورات مطبوعة من تأليف الحكومة المغربية على صناديق بريد أعضاء البرلمان قبل يوم من التصويت. وادّعت المنشورات بشكل أساسي أن نتائج التقييم المستقل الذي غيّر قواعد اللعبة كانت خاطئة، وأنه "لا علاقة بين الجوانب السياسية للصحراء الغربية وبين قرار البرلمان الاوروبي بشأن الاتفاق"، [lxxxi] وأن بالصحراء الغربية جزء من "المناطق الجنوبية للمغرب على أية حال".

وفي الليلة التي سبقت التصويت، بعث رئيس لجنة الصداقة عضو البرلمان الفرنسي جيل بارغني رسالة بريد الكتروني إلى جميع أعضاء البرلمان يحاجج فيها ضد تقرير التقييم، ولكن بدون توفير أية بيانات، مدعيا أن الاتفاقية "مربحة ماليا ومسؤولة بيئيا. [...] اناشد بصيرتكم النقدية أن ترفضوا تشخيص هذه التعديلات، التي تستغل بشكل واضح قضية الصحراء الغربية لتحقيق اغراض سياسية معروفة، وتعرّض بذلك أي اتفاق مستقبلي بين الاتحاد الأوروبي والمغرب للخطر". [lxxxii] وقد قام نفس هذا الشخص لاحقا بـ "تحية" الولايات المتحدة على وقف مطالبتها بقيام بعثة الامم المتحدة برصد حقوق الانسان في الصحراء الغربية، وذلك بعد قيام الحكومة الفرنسية بالاعتراض على الاقتراح [lxxxiii]. وتسمي المجموعة البرلمانية الموالية للمغرب المنطقة "الصحراء المغربية"، وسافر أعضاؤها برفقة مضيفيهم المغربيين بدون أي عائق إلى الأراضي المحتلة خلافا لزملائهم أعضاء البرلمان الاوروبي الآخرين.

أما المجموعة الثانية فتتألف من قطاعي الصيد الإسباني والمغربي وشركائهم أعضاء البرلمان الذين يمثلونهم، وخصوصا في لجنة صيد الاسماك. وفي الليلة التي سبقت التصويت، كتب نائب رئيس لجنة صيد الاسماك إلى جميع أعضاء البرلمان: "في الربيع العربي، في الوقت الذي بدأ فيه المغرب بدمقرطة البلاد، سيكون رفض هذه الاتفاقية رسالة سلبية جدا من الاتحاد الاوروبي"؛ حصل ذلك خلال الوقت الذي كانت تُرسل فيه عشرات الرسائل، ذهابا وايابا بين المدافعين والمعارضين للاتفاقية عبر البريد الالكتروني الداخلي للبرلمان. واضاف، "إذا ما رفضنا الاتفاقية فسنرسل اشارة سلبية الى المنطقة في وقت تمر فيه بعملية تجدد ديمقراطي. إن المغرب شريك هام للاتحاد الاوروبي، ويجب على دعمنا للمغرب أن يتجاوز التصريحات والبيانات —التي نكثر منها— إذ علينا تقديم الدعم العملي". [lxxxiv]

أما الجهة الثالثة فهي المفوضية ذاتها، والتي كانت قد استثمرت جهدا كبيرا في هذه الاتفاقية التي تعتبر أكبر اتفاقية صيد الاسماك في الاتحاد الاوروبي. وحذر مفوّض صيد السمك قبل يومين من التصويت بأن البرلمان "سيُحاكَم" على ضوء مجمل العلاقات بين المغرب والاتحاد الاوروبي. صرحت المفوضة

شاشة العرض أن 326 عضوا قد صوتوا لصالح انهاء اتفاقية صيد الاسماك بين المغرب والاتحاد الأوروبي، كما وصوت 296 ضد، فيما امتنع 58.[lxxix] وللحظة، ساد صمت مطبق في قاعة الهيئة العامة الكبيرة، وكأن أحدا لم يستوعب ما الذي حدث للتو. وعندها——بعدما رفع هاغلوند الفنلندي بقبضته في الهواء احتفالا——تفجّر التصفيق العفوي. سيتوقف صيد الاسماك. كانت تلك المرة الثانية في تاريخ الاتحاد الاوروبي التي يقوم فيها البرلمان الاوروبي بتعطيل اتفاقية تجارية، والمرة الاولى التي يعطل فيها اتفاقية لصيد الاسماك. [lxxx]

وإذا نظرنا بعد هذه السنوات وراءً الى هذا القرار، وأخذنا بعين الاعتبار الحجج الضخمة الداعية لوقف صيد الاسماك، فربما لم تكن نتيجة التصويت مفاجئة إلى هذا الحد. وإن ما يبعث على الغرابة فعلا هو تصويت 296 من أعضاء البرلمان الاوروبي لصالح الاتفاقية. لكنهم ليسوا بحاجة لتفسير ذلك. فقد قام معظمهم بذلك تحت تأثير زملائهم الفرنسيين والاسبان من الاشتراكيين والمحافظين في البرلمان.

في نهاية الأمر، كان هناك الكثير من عدم الوضوح، إذ أنه قد طُلب من أعضاء البرلمان الادلاء بأصواتهم في ذلك اليوم. فيما كانت مصادر الضغط على اعضاء البرلمان للموافقة على استمرار صيد الاسماك قادمة من ثلاث جهات أساسية مختلفة.

كانت الجبهة الأولى مكونة من الحكومة المغربية وحلفائها الرئيسيين في البرلمان الأوروبي. وكان وفد السفارة المغربية الى الاتحاد الأوروبي كبيرا ويضم اعضاء اللوبي والبرلمانيين والسفراء الذين شوهدوا يتجولون في اروقة البرلمان. كما وكلف المغرب شركة المانية لتمثيله، وكان ذاك مكتب محاماة الذي تواصل مع اعضاء البرلمان مرارا.

كما وقابل السفير المغربي اصدقائه عدة مرات في مقر لجنة صداقة المغرب والاتحاد الأوروبي التي كانت قد أُفتتحت حديثا في البرلمان. اجتمعت اللجنة المكونة من مجموعة صغيرة من اعضاء البرلماني من الدول الاوروبية الجنوبية مع السفير عدة مرات قبل التصويت على اتفاقية صيد الاسماك، وكان أهم بند على جدول أعمالها التوافق حول كيفية التأثير على مزاج البرلمان الاوروبي. وتم وضع اللمسات الاخيرة على حججها وارسالها عن طريق السفارة إلى حلفائها في هذه اللجنة قبل بضعة ايام من التصويت فقط.

بالإضافة إلى ذلك، فقد جعل وجود عدد غير متناسب من الاعضاء الاسبان والفرنسيين، وهما الدولتان اللتان تتمتعان بأوثق العلاقات مع الرباط، نقاش المغرب–الاتحاد الأوروبي أكثر تعقيدا. وأدى هذاكله الى جعل المصادقة على تقرير هاغلوند مهمة شبه مستحيلة. ولدى تصويت لجنة صيد الاسماك، قرر الأعضاء الموالون للمغرب تعديل الجملة الختامية من استنتاج سلبي الى استنتاج إيجابي، فيما ظلّ باقي التقرير على حاله.

بطبيعة الحال، لم يرغب هاغلوند بذلك. فالتقرير الذي قصد به يكون تقريرا شاملا ونقديا أصبح بمثابة مزحة سيئة لدى عرضه في جلسة الهيئة العامة للبرلمان الاوروبي.

ولتلخيص مناقشة طويلة في بضعة جمل، نص التقرير بعد ادخال التعديل عليه على شيء من هذا القبيل: "علينا ضمان استمرارية اتفاقية صيد الاسماك للاتحاد الاوروبي بسبب الحاقها ضررا بالبيئة ولأنها تبدد اموال دافعي الضرائب وبسبب الخلاف حول الصحراء الغربية ولأنها بدون أثر تنموي". وتمت المصادقة على القرار بأغلبية صغيرة: 12 مع القرار و 8 ضده مع امتناع عضو واحد عن التصويت. lxxvii

وعلّق عضو برلمان اسباني في نهاية الاجتماع مبتسما: "نجحنا". وهو الأمر الذي أسعد الوفد المغربي الذي تواجد وقتها في الجزء الخلفي من قاعة الاجتماع. وبهذاكان على التصويت النهائي في هيئة البرلمان أن يتم بعد ثلاثة اسابيع، وذلك في الوقت الذي كان فيه لسان التوصية يدعو الى مواصلة صيد الاسماك لأنه يلحق ضررا بالبيئة واقتصاد الاتحاد الأوروبي والقانون الدولي.

وخلال الاسابيع المقبلة، عمل طاقم هاغلوند بشكل مكثف للتحرك سياسيا نحو التصويت ضد التقرير الذي كتبه هو بنفسه.

قرار تاريخي

صرحت وزارة الخارجية المغربية في بيان لها في 14 كانون الاول/ديسمبر 2011: "لن نقبل أي نشاط صيد للأسطول صيد للأسطول الأوروبي، ونطلب من زوارق الصيد العاملة في مناطق اتفاقية صيد الاسماك مغادرة مياهنا الاقليمية الوطنية قبل منتصف ليل يوم الاربعاء ". كما وأكدت الحكومة المغربية في لهجة تميل إلى التهديد بأنها ستقوم بـ"إعادة تقييم شاملة لشراكتها مع الاتحاد الأوروبي." lxxviii

وكان التصويت النهائي في البرلمان الأوروبي في ستراسبورغ قبل ذلك بساعات قليلة بمثابة صدمة لمعظم المراقبين. فقد فاجأ القرار صناعة صيد الاسماك والحكومة المغربية تماما. ودلّت ارقام التصويت على

الصيد البحري. وأضافت لويفين "يجب عدم منح الهبات مقابل اساليب مثل عدم الرد على الأسئلة او الاحجام عن استقبال الوفود".

ولدى التصويت في لجنة التنمية، تمت المصادقة على التقرير السلبي بأغلبية ساحقة، فيما اعترض البعض فقط.

وكان عضو البرلمان الفرنسي موريس بونغا أحد هؤلاء. على سبيل التوضيح، اعتبر بونغا انه من المهم دعم "الاصلاحات العميقة" المغربية من خلال المصادقة على الاتفاقية. وبحسبه، يجب مكافأة المغرب على الانجازات السياسية المزعومة من خلال اتفاق صيد الاسماك.[lxxvi] وعلاوة على ذلك، "لقد تم صيد الاسماك وبيعها: لا يمكننا إعادتها إلى البحر". ومن الجدير ذكره، أن بونغا نفسه يتحدر من اقليم كاليدونيا الجديدة الذي لا يتمتع بالحكم الذاتي، وهو معروف كأحد المدافعين الشرسين عن السيطرة الفرنسية على الأرخبيل الميلانيزي.

وباختصار، فشلت هذه الاعمال التحضيرية التي اضطلعت بها اللجنتان لدى وصولها إلى لجنة صيد الاسماك. أصدر معد التقارير في تلك اللجنة الليبرالي الفنلندي هاغلوند تقريرا نقديا شديد اللهجة والذي يوجز بلغة دبلوماسية جوانب التقييم الاشكالية. وكان التقرير عبارة عن مسودة توصية تم اعدادها لرفعها الى الهيئة العامة لتصوت عليها بعد مناقشتها في لجنة صيد الاسماك.

أوجز "تقرير هاغلوند" الاستنتاجات الرئيسية في تقرير التقييم المستقل والمهم: كيف أفضت الاتفاقية الى خسارة مالية كبيرة للاتحاد الأوروبي ودمرت البيئة في مياه الصحراء الغربية والمغرب. كما واشارت التوصية إلى مسألة قانونية الاتفاقية، بسبب تطبيقها في مياه الصحراء الغربية في ظل غياب أية معلومات توضح فيما إذا كان الشعب الصحراوي يستفيد من الاتفاقية.

إلا أن تمرير مسودة القرار لم يكن سهلا كما في اللجنتين الأخرتين. ويرجع ذلك خصوصا على تركيبة لجنة صيد الاسماك التابعة للبرلمان الاوروبي. فقد كانت تلك اللجنة مكونة من دول تعتاش على صيد الاسماك فقط وتمثل مصالحها. ولهذا فمن الطبيعي أن تتبع المناقشات التي دارت في اللجنة منطق المزاودة بين أعضاء البرلمان ليقدموا من خلالها تنازلات سخية على صيد السمك لأنفسهم، في حين يحجم أعضاء البرلمان من الدول الأخرى عن الاعتراض وذلك لمعرفتهم بأن مصالح دولهم ستناقش لاحقا. هددت آلية المساومات هذه احتياطي الثروة السمكية المهددة اصلا، الأمر الذي يشكل في حد ذاته، أحد أهم الأمور التي تفسر الكيفية التي أدت بالاتحاد الاوروبي إلى تخريب بيئته البحرية.

وكتب معد تقرير الميزانية عضو البرلمان فرنسيس الفونسي: "تحمل هذه الاتفاقية مشكلة مزدوجة: فهي ليست سوية من الناحية القانونية، كما أنها لا تتماشى مع اهداف البرلمان [...] بضرورة التصرف بأموال دافعي الضرائب بحكمة وقانونية". lxxii

وبحسبه، فقد أتت اتفاقية واحدة مع المغرب على نسبة كبيرة من ميزانية الاتحاد الأوروبي المخصصة لهذا النوع من الاتفاقات الثنائية لصيد الأسماك بأسرها. وأضاف الفونسي: "تم صرف 25% من الميزانية المخصصة لصيد الاسماك على هذه الاتفاقية--وهذا كثير". lxxiii

ومما يثير الدهشة، أنه على الرغم من توثيق خسارة مالية كبيرة للاتحاد الاوروبي، أوشكت أعداد المؤيدين والمعارضين على التعادل. وقد كانت اجراءات التصويت على هذا القرار مربكة لدرجة جعلت بعض اعضاء البرلمان يصوتون خلافا لنيتهم الأولى. ولدى ظهور نتيجة التصويت السلبية الرافضة للتمديد، اعترضت حفنة من الاشتراكيين الاسبان المتفاجئين، إلا أن رئيس الجلسة رفض إعادة التصويت.

أما اللجنة الثانية فكانت لجنة التنمية والتي توصلت إلى نفس النتيجة. إذ صرحت معدة تقرير اللجنة عضوة البرلمان السويدي إيزابيلا لوفين: "إن الطريق الصحيح الذي يجب اتخاذه لا يجب أن يتجاهل القانون الدولي ومبادئ المحافظة على البيئة أو الاقتصاد السليم".

ولدى تسليمها التقرير في لجنة التنمية في 10 تشرين الاول/اكتوبر 2011، حثت معدّة التقرير البرلمان بشدة على رفض مقترح تمديد الاتفاق سنة إضافية. lxxiv

وتذكر معدّة التقرير أن الدعم القطاعي بموجب اتفاقية صيد الاسماك قد "فشل". وبموجب الاتفاق، تم تخصيص 13.5 مليون يورو سنويا لتطوير قطاع صيد الاسماك المحلي في "المغرب". لقد تم استخدام 15% فقط من هذه الاموال. واضافت معدّة التقرير أنه "من غير المقبول تجاهل المغرب التام لأسئلة المفوضية الاوروبية بصدد الاستفادة العائدة على الشعب الصحراوي ورغباته". lxxv

وعندها، لم يقدم المغرب ولا المفوضية الاوروبية أي دليل على استشارة الصحراويين أو استفادتهم من صفقة الاسماك التي وقعها الاتحاد الاوروبي مع المحتل المغربي. وكما ذكرنا، كانت تلك الشروط المسبقة التي ذكرتها الدائرة القانونية التابعة للبرلمان في رأيها القانوني في عام 2009. لم يرق للجنة التنمية رفض المغرب استقبال وفد لجنة صيد الاسماك التابع للبرلمان لتقييم تنفيذ اتفاق الشراكة في ميدان

يتكهن البعض بان التحول الألماني يرجع الى ازمة سياسية في العلاقات مع مدريد. فقبل اربعة اسابيع فقط زعمت السلطات الالمانية كذبا ان الخيار الاسباني مسؤول عن تفشى بكتيريا الاشريكية القولونية في اوروبا. ويشير آخرون الى العلاقات الالمانية مع حلفاء المغرب في فرنسا والتي تعنى ألمانيا بالحفاظ على توازنها. ويزعم البعض انه السبب هو رغبة المانيا في انتاج الطاقة الخضراء في شمال غرب افريقيا. وعلى اية حال، تمكن المجلس بمساعدة تحوّل برلين في اللحظات الاخيرة المصادقة بالأغلبية اللازمة. وفي انتظار موافقة البرلمان النهائية في وقت لاحق في الخريف، أمكن لصيد الاسماك الاستمرار. ولم يكن هناك أحد ليتحدى المانيا ويطالبها بالمعلومات التي ظهرت من العدم ——بعد أربع سنوات من الصمت المغربي المحبط——والتي جعلتها تغيّر رأيها بهذه الصورة. لم ترد اية معلومات جديدة لتضاف إلى العرض العبثي لشرائح برنامج PowerPoint. إذا ما أخذنا بعين الاعتبار نسبة الخسارة التي ظهرت في تقرير التقييم، فقد شكّل قرار تمديد الاتفاقية سنة اضافية خسارة مالية إضافية للاتحاد الاوروبي مقدارها 12.6 مليون يورو على الأقل.[lxx]

وبحلول خريف 2011، أي بعد خمسة أشهر، كان على البرلمان التقرير فيما إذاكان سيعطي ضوء اخضرا لقرارات المفوضية والمجلس السابقة. فهل سيستخدم البرلمان السلطة التي منحته اياها معاهدة لشبونة مؤخرا ويوقف الاتفاقية التي كانت على أي حال على وشك الانتهاء بعد شهرين؟ فقدكان صيد الاسماك الخاضع لتمديد السنة الاضافية مستمرا منذ أشهر. إلا أن حالة من الاستياء قدكانت تسود الأجواء بسبب الطريقة التي تم اتباعها لتمديدها على الرغم من عيوبها. وصرح أحد أعضاء البرلمان: "لست سعيدا بهذا التمديد المفاجئ بعدما طلبنا آراء من المفوضية لمدة عام".[lxxi]

وفي الوقت الذي تقدم فيه ثلاث لجان——لجنة التنمية ولجنة الميزانية ولجنة صيد الاسماك——توصياتها، يبقى الوزن الاكبر لتوصيات لجنة الصيد. فمن المفروض أن تكون توصية لجنة صيد الاسماك هي التي يجب عرضها أمام الهيئة العامة للبرلمان. كما وتم مناقشة جوانب الاتفاقية الأكثر اثارة للجدل، وبضمنها مسألة العلاقات الدولية المرتبطة بالصحراء الغربية في جميع اللجان.

كانت لجنة الميزانية هي اللجنة الأولى التي رفضت الاتفاقية. فبالنظر إلى تقرير التقييم، لم يكن بوسع اللجنة غير التوصية برفض تمديد الاتفاقية سنة اضافية.

وفي 13 كانون الاول/ديسمبر 2010، قدم المغرب وللمرة الاولى معلومات الى المفوضية الاوروبية تتعرض إلى كيفية إنفاق أموال الاتحاد الأوروبي. لم يكن الانطباع الاول جيدا. ففي مذكرة موجهة من المفوضية إلى المجلس والبرلمان في 16 شباط/فبراير 2011، تم تعريف مضمون التقرير المغربي دبلوماسيا "بعض المعلومات" و"خطوة في الاتجاه الصحيح". وعلّقت المفوضية: "تم تقييم الاثار الاجتماعية والاقتصادية على هذه المنطقة تحديدا، وتميل المعلومات التي تم تقديمها إلى البرهنة على استفادة المنطقة من ناحية خلق فرص عمل ودوران اضافيين". إلا أن دراسة قصيرة ومعمقة أكثر للمغرب كانت قد عُرضت من خلال 44 شريحة لبرنامج PowerPoint فقد أوصلت إلى نتيجة مختلفة.lxix لا تذكر الوثيقة الصحراء الغربية او سكانها أبدا. وكما كان متوقعا من التقرير الذي قدمه المغرب، لم يُعر التقرير رغبات او مصالح الصحراويين اهتماما، ويصح هذا الأمر على صحراويي الأراضي المحتلة وكذلك على نصفهم الآخر من الذين يعيشون كلاجئين في الجزائر نتيجة الاحتلال المغربي.

وبعد ذلك بشهر واحد، أي في 15 اذار/مارس 2011، لم ترد اية معلومات إلى المفوضية، إذ أن عرض الشرائح كان قد أُرسل إلى مجلس الوزراء.

وثبت أن التقرير الذي اصطلح على تسميته "تقرير الإفادة" الضئيلة قدكان في غاية من الاهمية لدى صياغة الكثير من الدول الاعضاء لمواقفها. إذ شكّل ذلك التقرير الحجة الرئيسية التي استخدمتها معظم بلدان اوروبا الشمالية والتي جميعها عارضت تمديد الصيد استنادا إلى مثل هذه الاسس الضحلة. إلا أن الكثير من الدول الصغيرة لا يكفي للفوز بتصويت في المجلس الأوروبي. فلذلك، هناك دائما حاجة إلى دولة كبيرة أو دولتين كبيرتين من الدول الاعضاء في الاتحاد الأوروبي من أجل تكوين أقلية مانعة كافية. وبما أن المملكة المتحدة نظرت إلى الصيد بسلبية منذ البداية، فيما نظرت اسبانيا وفرنسا وبولندا إليها بإيجابية، أصبح من الواضح انه يجب توجيه الأنظار نحو الحكومة الالمانية. راجع المسؤولون الألمان الملف، وخلصوا إلى نتيجة مفادها أنه لا يوجد هناك أي دليل على الاطلاق على استفادة "السكان المحليين". وبالتالي بدا بأن المجلس سيوقف التمديد بعد عدة أشهر من بدء التمديد البالغ قدره 12 شهرا. ولكن، وفي اللحظة الاخيرة قبل التصويت النهائي في 29 حزيران/يونيو 2011، انقلبت المانيا. وبدون طرح أية معطيات جديدة، صرحت المانيا أن هناك أدلة "دامغة" على استفادة المحليين. لم توضح المانيا أبدا السبب من وراء تغيير موقفها.

الذي اثبت أن الاتحاد الاوروبي يبدد الأموال. وفي الماضي، كان بإمكان جميع أعضاء البرلمان الاطلاع على هذه التقارير نفسها بعد طلب بسيط. أم بعدما منحت معاهدة لشبونة صلاحيات جديدة للبرلمان فقد تغير الأمر.

وعندما شاع خبر احتفاظ المفوضية بتقييم يضر بمعاهدة الشراكة في مجال الصيد البحري بدأ مزاج أعضاء البرلمان يتغير.

ولدى انتهاء اتفاقية 2007 في 27 شباط/فبراير 2011، لم يتم ابرام اتفاقية جديدة للسنوات الاربع القادمة، وذلك على الرغم من الضغط الشديد الذي مارسته اسبانيا التي كانت تعاني وقتها من ركود اقتصادي عميق. ولشراء بعض الوقت، تم تمديد الاتفاقية لمدة سنة واحدة، وذلك ابتداء من 28 شـباط/فبراير. ويمكن لمثل هـذا التمديد أن يمنح المفوضية سنة اضافية لدراسة الفوائد الناجمة عن الاتفاق لصالح "السكان المحليين". وتكشف رسالة بريد الكتروني من اللوبي الامريكي إد غابريل الى مستشار العاهل المغربي في 10 ايار/مايو 2011 كيفية التوصل إلى تمديد الاتفاقية سنة إضافية. إذ لم ترغب مفوضة الاتحاد الأوروبي لشؤون صيد الاسماك بذلك أبدا، إلا أن رئيس اللجنة خوسيه مانويل باروسو هو الذي دفعها إلى ذلك. lxviii

ولإقرار مثل هذا التمديد، يجب أولا اقراره في مجلس الوزراء، ومن ثم الحصول على موافقة البرلمان عليه رسميا في الخريف.

وعلى هذا تمحور الجدال في المؤسسات الاوروبية خلال عام 2011 حول إذا ماكان يجب الموافقة على استمرارية الصيد الذي كان وقتها وببساطة، مستمرا بدون انقطاع. وكما توضح، كان اللوبي الداعم للصيد في مياه الصحراء الغربية على وشك الفشل.

تزايد المعارضة

وتمحور الجدال حول تمديد الاتفاقية سنة اضافية حول إذا ماكانت السنوات الاربع الاولى من 2007 الى 2011 قد أفادت "السكان المحليين" فعلا. وبطبيعة الحال، لم يكن ذلك الأمر ذاته الذي كانت الأمم المتحدة قد أولته الأهمية فعلا (إذ طالبت الامم المتحدة بإفادة "الشعب" ورغباته)، إلا أن المفوضية هي التي كانت قد حددت جدول أعمال المناقشة. وفي ظل هذه الشروط، أصبح بإمكان المغرب، نظريا، تقديم تقرير يفيد باستفادة المستوطنين مـن الاتفاقية مـع الاتحاد الأوروبي. ولكن المغرب لم يلتفت الى تقديم تقرير عن ذلك بالمرة.

للاتفاقية بحسب تقرير لمنظمة الغذاء والزراعة التابعة للأمم المتحدة فيما يسمى منطقة الصيد 34.1.3، والتي تتداخل جزئيا مع مياه الصحراء الغربية.[lxvii]

وحتى ذلك الحين، إذا تم توجيه سؤال حول ما كانت زوارق الصيد الاوروبية تصيد في مناطق الصحراء الغربية إلى المفوضية، فقد كان ردها عادة أن للمغرب الحق في تحديد مجال تطبيق الاتفاق.

وكتب مُعد التقارير عضو البرلمان الفنلندي كارل هاغلوند خلال إعداده تقريرا للجنة الصيد عن اتفاقية صيد الاسماك: "لقد عرقل انعدام التعاون بين المؤسسات عمل معد التقارير خلال عملية اعداد مسودة التوصية هذه". كانت تلك التعابير قاسية—ولا سيما بسبب صدورها عن هاغلوند، وهو عضو برلمان صغير السن ولكنه دبلوماسي جدا، وأصبح لاحقا وزير دفاع فنلندا.

لم يكن نقص المعلومات السبب الكامن من وراء عدم الرد وعدم تقاسم المعلومات. لقد كانت المفوضية على اتصال دائم مع شركائها المغربيين، وكان لديها معلومات كاملة عن أماكن تواجد اسطولها طوال الوقت. إذ يمكن تعقب الزوارق بدقة من خلال معدات التعقب الحديثة المتواجدة على متنها. بالإضافة الى ذلك، قامت طواقم المفوضية بزيارة الأراضي المحتلة.

أفادت رسالة البريد الالكتروني التي بعثت بها المفوضية الى أحد الاعضاء في تشرين الثاني/نوفمبر 2007 بأنه "سيتم تسليم التراخيص [...] للزورقين في الدخلة صباح يوم الاثنين عن طريق وفد المفوضية الاوروبية والسلطات المغربية الى مالك السفينة".

وأصبح عدم رغبة المفوضية بالتعاون مع البرلمان أكثر وضوحا بعد الانتهاء من تقرير التقييم المذكور. ومن المتعارف عليه أن يكون اطلاع على جميع التقييمات التي تحلل كيفية إنفاق الاتحاد اموال دافعي الضرائب متاحا أمام البرلمان، بشكل يشمل التقرير السيء عن اتفاقية صيد الاسماك بين المغرب والاتحاد الاوروبي. ولكن لا. فقد مرت أشهر عديدة بدا فيها أنه لا يوجد في البرلمان أي شخص على علم به. وحين عُرف بوجود التقرير للمرة الأولى، تم إبقاؤه في طي السرية التامة.

تم عرض تقرير التقييم على دائرة ضيقة جدا: كان التقرير متوفرا باللغة الفرنسية فقط، وأصبح متاحا بعد اربعة أشهر من اعداده. وهناك مبالغة في استخدام التعبير "متاحا". فقد كان بإمكان اعضاء لجنة صيد الاسماك التابعة للبرلمان فقط الاطلاع عليه. كما وكان الاطلاع على هذه الوثيقة ممكنا في غرفة صغيرة منفصلة كانت مجهزة بطاولة وكرسي ومصباح كهربائي. إذ لم يكن بالإمكان الاقتراب من الوثيقة مع اجهزة الكمبيوتر والهواتف المحمولة. كذلك لم يُسمح للمساعدين البرلمانيين رؤية النص

وظيفة——حتى إذا لم نأخذ بعين الحسبان إذا ماكان هؤلاء من الصحراويين او المستوطنين المغاربة الغير شرعيين.

وصدمت النتائج رئيسة لجنة صيد الاسماك الاسبانية كارمن فراجا، والتي كانت حتى ذلك الحين تدافع عن اتفاقية شراكة صيد الاسماك. والتي لخّصت قائلة: "هذا أسوء تقرير رأيته في حياتي".[lxvi]

فما هي إذا الحجج المتبقية لدعم الاستمرار بصيد الاسماك بعد ذلك؟

فوفقا لتقارير مؤسسات الاتحاد الاوروبي نفسه، خرقت الاتفاقية القانون الدولى ودمرت البيئة ولم تخلق فرص عمل إلا بالكاد وأهدرت اموال الاتحاد الأوروبي. وبحسب خبراء بارزين في قضية الصحراء الغربية، فقد قوّضت الاتفاقية جهود السلام التي بذلتها الامم المتحدة إثر سماحها للمغرب بإحراز نقاط سياسية.

التمديد عام 2011

في منتصف الطريق أبان معاهدة الصيد البحري للسنوات 2007–2011، هزّت اصلاحات دستورية واسعة العلاقات بين مؤسسات الاتحاد الأوروبي. فقد منحت معاهدة لشبونة المزيد من القوة للبرلمان الاوروبي في مجالات معينة، ومن بينها القدرة على رفض قرارات مجلس الوزراء في مسائل مثل اتفاقيات صيد الاسماك. ومن خلال حصوله على هذه الامتيازات، تكونت ديناميكية جديدة لعلاقات القوة بين مؤسسات الاتحاد الأوروبي الثلاث: البرلمان والمجلس والمفوضية. وكان من مسؤولية المفوضية التجاوب مع التطورات في اتفاقية صيد الاسماك. وكثيرا ما أصيب أعضاء البرلمان المراقبين بالإحباط نظرا لأن الحصول على معلومات من المفوضية حول تنفيذ اتفاقية صيد الاسماك بين المغرب والاتحاد الأوروبي كان مثل التحدّث مع الحائط. وبداكما لو أن معاهدة لشبونة، التي منحت البرلمان المزيد من الصلاحيات، لم تشجع المفوضية على تبادل المعلومات حول صفقات مريبة كمثل الصفقة مع المغرب.

فحتى مجرد الحصول على اجابة واضحة من المفوضية على السؤال الذي يعنى بأنشطة الصيد في الصحراء الغربية أمرا صعبا لفترة طويلة. وجاء الكشف عن الاتحاد الأوروبي يقوم فعلا بصيد الأسماك في الصحراء الغربية بعدما قام اعضاء البرلمان الاوروبي بتوجيه سبعة اسئلة مكتوبة بصياغات مختلفة الى المفوضية. إذ حصل الانفراج بعد توجيه سؤال تقني خالص بشأن كميات صيد الاتحاد الأوروبي تبعا

المفوضية أنها قد أُخذت في عين الاعتبار. بيد ان التقرير الذي يغلب عليه الطابع التقني فقد درس الاتفاقية ورفع عنها مصداقيتها بالنظر إلى جانبين جديدين لم يتم التطرق اليهما حتى ذلك الحين: التدمير البيئي لمياه الصحراء الغربية والخسارة المالية للاتحاد الأوروبي.lxiii

يكشف التقييم عن ان المغرب لا يمتلك القدرة على ادارة الثروة السمكية في الصحراء الغربية بشكل مستدام. كما ويشير التقرير المكون من 103 صفحة إلى أن الاتحاد الاوروبي يشارك في تحمل مسؤولية الاستغلال الزائد عن حده لثروة البحر السمكية ويساهم في تعريض الحيوانات البحرية للتهديد. فبالنظر إلى ما مجموعه إحدى عشرة مجموعة من اسماك القاع، يبدو أن خمسة منها قد استغلت فوق طاقتها، وأربعة تم استغلالها تماما، فيما لم يكن من الممكن تحليل المجموعتين الباقيتين بسبب عدم توفر المعطيات اللازمة. هذا فيما كانت احدى اولويات الاتحاد الأوروبي في إطار الشراكة التقليل من أنشطة صيد الاسماك المغربية التي كان يجب ايقافها. وفي الواقع، طلب الاتحاد الأوروبي خلال مدة سريان الاتفاق من المغرب تسريع عملية حظر استخدام الشباك العائمة التي يمنع الاتحاد الاوروبي استخدامها. وكان المفوض بورغ قد صرح من قبل في عام 2009 أن المغرب "لا يقوم بما فيه الكفاية" لوقف طريقة الصيد هذه.lxiv وكشف التقرير الصادر بعد ذلك بعام واحد ان المغرب لم يستخدم الاموال المخصصة لهذا الغرض اطلاقا.

أما أكثر مركبات التقييم مفاجأة فقد كان تصريح التقرير بأن القصد من اتفاقية صيد الاسماك بين الاتحاد الاوروبي والمغرب قد كان فعليا القاء المال من النافذة. إذ أظهرت الدراسة ان "أن كل يورو أنفقه الاتحاد الاوروبي أدى إلى دوران 83 سنتا وإلى إيراد مباشر وغير مباشر للاتحاد الأوروبي مقداره 65 سنتا [...] وهذه أدنى نسبة ربح لدعم الاسطول الاوروبي مقارنة بجميع الاتفاقات الثنائية الجارية".

وبعبارة اخرى، أثبت التقييم أن التكلفة الناتجة عن مجرد اعطاء الصيادين الاسبان اموال دافعي الضرائب في الاتحاد الأوروبي مباشرة أقل من تكلفة ارسالهم للصيد في الصحراء الغربية. وحتى لو لم يكن هناك ركود اقتصادي في الاتحاد الاوروبي بعد عام 2008، لما كانت هذه الصفقة الا اهدارا لا أكثر ولا اقل. لقد فقدت عشرات الملايين من اليوروهات.

واخيرا، وردا على اولئك الذين صرحوا بان الاتفاق مهم لخلق فرص عمل في الاقتصاد المحلي "المغربي"، فقد تبين أن 170 وظيفة فقط قد خلقت في إطار الاتفاق.lxv وهذه تكلفة كبيرة لكل

السياسات الخارجية للدول الاعضاء في الاتحاد الأوروبي. هذه هي قمة التداخل مع السياسي. لو قارنا ذلك مع التعبير "فلسطين سابقا".

لا يتعارض الادعاء بأن اتفاقية الصيد التي تشمل أراضي الصحراء الغربية المحتلة لا تحمل ع... سياسية مع أقوال وزير الصيد المغربي نفسه فقط، والتي وردت في مقدمة هذا المقال، بـل تصريحات الصحراويين والمنظمات غير الحكومية والمختصين وجبهة البوليساريو جميعا، باستثناء الصناعة السمكية.

كما وصرح السفير كوريل بصدد الاتفاقية: "إذا ما أردنا ايجاد حل للصراع، يجب على الجه... الفاعلة المختلفة ألا تتصرف بطريقة تهدد بتقويض الجهود التي تبذلها الامم المتحدة من اجل ايجاد للقضية. وتقع مسؤولية خاصة على عاتق اعضاء المفوضية الاوروبية ولا سيما اسبانيا". [lx]

صنفت الحكومة النرويجية، الغير عضو في الاتحاد الاوربي، تعاملا مماثلا مع الموارد الطبيعية في الص... الغربية كـ "انتهاكات خطيرة جدا للقواعد الاخلاقية الاساسية لأن من شأنها تعزيز ادعاء المغ... بالسيادة، ومن ثم الاسهام في تقويض عملية السلام التي ترعاها الامم المتحدة"، كما وأكدت "المغرب يحتل الصحراء الغربية منذ سنين عديدة على الرغم من ادانة الامم المتحدة الشديدة". [lxi]

ومن جهتها، صرحت واحدة من المنتقدين الكثيرين في البرلمان الأوروبي، ايزابيلا لوفين من ح... الخضر السويدي: "من الواضح تماما ان هناك سبب واحد يدفع المغرب على الابقاء على اتف... صيد الاسماك مع الاتحاد الأوروبي——هو شرعنة الاحتلال المغربي الغير قانوني للصحراء الغربية طريق جعل الاتحاد الأوروبي شريكا". [lxii] واعتبارا من عام 2011، ظهرت وثيقة جديدة غيّرت ال... تماما: تقييم مستقل تم اجراؤه بطلب من الاتحاد الأوروبي نفسه. ومنذ ذلك الوقت وصاعدا، تقوض سائر الحجج الأخرى، إلى درجة انتقل فيها اللوبي الموالي للصيد الى استخدام حجج سياسية للد... عن الاستمرار بالصيد.

تقييم الاتحاد الأوروبي: الأسوء على مر التاريخ

في كل مرة توشك فيها اتفاقيات الصيد للاتحاد الأوروبي مع الدول الافريقية او دول المحيط الها... على الانتهاء، فإن المفوضية ملزمة بالتعاقد مع مكتب مستقل لتقييم تنفيذ الاتفاقية. وكان ذلك ح... اتفاق الشراكة في مجال الصيد البحري 2007-2011 بين الاتحاد الأوروبي والمغرب أيضا. لم يتط... تقييم الاتفاقية بين المغرب والاتحاد الأوروبي، والذي تم اعداده من قبل شركة استشارية في باريس، مسألة القانون الدولي أو رغبات الصحراويين. كما انه لم يتناول التداعيات السياسية التي قا...

الصيد البحري في الصحراء السابقة اتفاق غير سياسي

ينبغي أن يكون بيان الحكومة المغربية الى وسائط الاعلام المحلية في المغرب، الـذي يؤكد عـلى أن اتفاقية صيد الاسماك تحمل بعدا سياسيا أهم من البعد الاقتصادي، كافيا لدحر ادعاءات سفير الاتحاد الأوروبي القائلة بعدم وجود اسقاطات سياسية للاتفاقية. ومع ذلك، ادّعت المفوضية وكذلك اللوبي الداعم لصيد الاسماك، مرارا وتكرارا، أنه لا توجد اسقاطات سياسية للاتفاقية.

وخلال احدى المناقشات التي دارت في لجنة الصيد، صرح أحد أعضاء البرلمان الفرنسيين، والموالي للمغرب، أن "قضية الصحراء الغربية لن تحل هنا".

وبعد وقت قصير من مراسم التوقيع على الاتفاقية عام 2006، صرح سيزار ديبين، كبير المفاوضين على اتفاقية صيد الاسماك بين المغرب والاتحاد الأوروبي قائلا: "يسعى هذا الجدال لاستغلال الاهتمام الاعلامي بالاتفاقية سياسيا". lvii

ومما يدعو للسخرية تصريح ديبين في نفس خطاب الدفاع ان الصحراء الغربية "تخضع للإدارة المغربية" منذ اتفاقات مدريد – وهي نفس الاتفاقات التي اعتبرها الرأي القانوني للأمم المتحدة عام 2002 غير قانونية. lviii

وتابع ديبين تشويه مضمون الرأي القانوني للبرلمان قوله: "لقد كان هناك دائما الكثير من الجدال بشأن هذا الأمر، وذلك حتى في الاتفاقات السابقة. تشمل الاتفاقية مع المغرب جميع المياه ومناطق صيد الاسماك التابعة للمملكة المغربية. [...] يمكنني القول بان المغرب قد ابرم اتفاقيات مع روسيا واوكرانيا ودول اخرى، ولم يكن هناك جدلا كهذا. ولا يكمن الاهتمام هنا في انشطة صيد الاسماك في مياه الصحراء السابقة (كذا)، بل في أن الاتحاد الأوروبي هو الطرف المفاوض. ولكننا واثقون جدا بأن الاتفاقية تحترم جميع متطلبات القانون المحلي والدولي، نظرا الى اجماع الآراء القانونية التي أصدرتها المفوضية الاوروبية والبرلمان الأوروبي وكذلك مجلس الوزراء". lix

"الصحراء سابقا"؟ تعطي التصريحات الصادرة عن كبير المفاوضين السابق الانطباع بأن الصحراء الغربية لم تعد موجودة، وكأنها اصبحت جزءا لا يتجزأ من المغرب بعدما باعها فرانكو للمغرب مقابل تراخيص الصيد. لكنها لم تختف. من الواضح أن تجاهل الوجود الكلي لهذه الاراضي يعبر عن وجود تحيز لأحد أطراف الصراع، كما انه يتناقض بشكل صارخ مع مصطلحات الامم المتحدة ومع

د) *ادعاء دعم البرلمان*. صرح جو بورغ مفوض الاتحاد الأوروبي خلال فيلم وثائقي سويدي في اذار/مارس 2010: "تشمل اتفاقية شراكة الصيد مع المغرب الصحراء الغربية أيضا. وقد وافقت على ذلك المفوضية الاوروبية والبرلمان الأوروبي."[liv] أما حقيقة هذه القضية فقد كانت بالأحرى أن الاتحاد الأوروبي، قبل التصويت على الاتفاقية، كان قد صرح بأن الصيد سيكون في "المياه المغربية". واعترف المفوض نفسه عدة مرات قبل التصويت انهم بذلوا مساعي كثيرة لتجنب الاشارة الى ان الاتفاق يشمل الصحراء الغربية. ومنع الغموض الشامل الذي لف نطاق تنفيذ الاتفاقية من الدائرة القانونية التابعة للبرلمان الاقرار بشرعيتها.

هـ) *إساءة تمثيل النقد*. أما عضوة البرلمان كارمن فراجا فقد صرحت: "وفيما يتعلق بحقوق الانسان، فإن ذاك الأمر مشكلة أفقية. فلماذا هذه الاتفاقية الوحيدة التي تثير هذا الموضوع؟".[lv] وفي الحقيقة، لم يكن السؤال المطروح يعني بحقوق الانسان أبدا، وإنما إذا ما كان إذا ما كان يتعين على الاتحاد الأوروبي توقيع اتفاقية مع الحكومة الخطأ، وأنها تخص مياه لم يأبه المغرب مرة بالمطالبة بسيادته عليها. فلم يحدث أن وقع الاتحاد الأوروبي في أي وقت مضى على اتفاقية مع السلطة القائمة بفعل الاحتلال للصيد في المياه المحتلة.

و) *إذا لم يقم الاتحاد الأوروبي بذلك فسيفعل طرف آخر*. كتب مكتب المحاماة الالماني ألبير غايغر ——وهو مكتب المحاماة الذي "يمثل مصالح المغرب امام البرلمان الأوروبي"——في رسالة بريد الكتروني الى مجموعة من البرلمانيين في 11 ايار/مايو 2011: "لن يؤدي الرفض توقف استخدام الموارد البحرية في المنطقة الاقتصادية الخاصة في الصحراء الغربية. إذ أنه بإمكان المغرب ابرام اتفاقية صيد مماثلة مع أي دولة أخرى تبحث عن موارد إضافية لصيد الاسماك. ونتيجة لذلك، تضمن هذه الاتفاقية تغطية الطلب على الاسماك في الاتحاد الأوروبي بدون استغلال كامل أو زائد عن حده للثروة السمكية في مياه الاتحاد الأوروبي".

ز) *اساء المعارضون استخدام الاتفاقية لخدمة اغراض سياسية*. صرح سفير الاتحاد الأوروبي لاندابورو أنه "يمكن استخدام الاتفاقية لأسباب سياسية، لان ذلك سياسة عادية، ولكن لا توجد مشكلة".[lvi].. لقد تم استخدام هذه الحجة الاخيرة مرارا وتكرارا. هل هناك أبعاد سياسية للصيد في الصحراء الغربية من خلال شراكة مع السلطة المحتلة؟

فإن هذا الموقف غير مقبول بتاتا. على لاعب محترم في الساحة الدولية أن يمثل معايير أسمى من ذلك. وينطبق ذلك بوجه خاص على اوروبا حيث ينبغي على الاجراءات التي تتخذها الدول ان تستند على ميثاق الامم المتحدة وعلى معاهدات حقوق الانسان الحديثة، مثل المعاهدة الدولية الخاصة بالحقوق المدنية والسياسية والاتفاقية الاوروبية لحماية حقوق الانسان والحريات الاساسية".[xlix]

حجج غريبة

عملت كل من المفوضية الاوروبية واعضاء البرلمان المؤيدون لصيد الاسماك والمغرب بنشاط للدفاع عن الاتفاقية خلال السنوات التي كانت فيها سارية المفعول. فقد كان لديهم الكثير للدفاع عنه، إذ أن تنفيذا ناجحا لاتفاقية شراكة صيد الاسماك سيشكل أساسا لإبرام اتفاقية جديدة تلحق بها. وفي التالي بعض حججهم الرئيسة:

أ) لا تسألنا، بل اسأل المغرب. صرح مفوض الاتحاد لشؤون صيد الاسماك، كما لو كان الاتحاد الأوروبي بدون مسؤوليات على الاطلاق: "يؤكد رأي كوريل من الامم المتحدة أن [...] تنفيذ انشطة الاستغلال يجب ان تتم "لصالح شعوب تلك الاقاليم، أو نيابة عنهم، أو بالتشاور مع ممثليهم". وترى المفوضية ان المغرب هو المسؤول عن ضمان ذلك".[1]

ب) ستثبت المعطيات أن الاتفاقية جيدة. صرح سفير الاتحاد الاوروبي لاندابورو "سوف تثبت المعطيات عن التأثير الاقتصادي لهذه الاتفاقية على المناطق صحة هذه الاتفاقية".[li] صدر هذا التصريح قبل وصول أية معطيات من طرف المغرب للاتحاد الأوروبي، وفي الوقت الذي كانت فيه جميع الادلة تشير الى العكس. وفي النهاية، لم يتم تقديم أية معطيات يمكنها الاجابة على كيفية تأثير الاتفاق على شعب الصحراء الغربية، وهي المعطيات التي كانت قد صرحت الدائرة القانونية في البرلمان الأوروبي بصددها في عام 2006 كونها شرط مسبق لأثبات شرعيتها.

ج) اختراع الدعم القانوني. أعلن سفير الاتحاد الأوروبي لدى المغرب في مؤتمر صحفي في الدار البيضاء، "لقد أوضحت الدوائر القانونية التابعة للجنة الاوروبية وكذلك جميع المشورات التي قدمتها المؤسسات المستقلة عدم وجود اية مشكلة بصدد الشرعية الدولية لاتفاق صيد الاسماك مع المغرب".[lii] وبعد توجيه عدد من الرسائل الى السفير، رد مكتب السفير في النهاية موضحا أن "المؤسسات المستقلة" هي في الحقيقة المؤسسات الاوروبية نفسها.[liii]

هذه المبادرة. وصرح المنظمون انه لن تكون هناك اية مشاورات إذا ما لم يحضر الطرفان في الوقت ذاته. [xlv] وكانت نتيجة ذلك عدم تمكن جبهة البوليساريو من عرض موقفها أمام لجنة الصيد. وفي جميع المشاورات اللاحقة، دعت مؤسسات الاتحاد الأوروبي المغرب فقط لمناقشة ادارة الثروة السمكية في الصحراء الغربية.

وفي الوقت الذي أعتمدت فيه اتفاقية صيد الاسماك في عام 2006، صرحت دول اعضاء في الاتحاد الأوروبي واعضاء برلمان والدائرة القانونية للاتحاد الأوروبي انه من غير الممكن التكهن فيما إذا ما كان المغرب سيفي بالتزاماته. ولدى انتهاء فترة الاتفاقية بعد أربع سنوات، لم يكن المغرب قد قدم بعد أي دليل على ما إذا كان شعب الصحراء الغربية قد استفاد من عائدات صيد الاسماك او إذا ما كان قد وافق عليها. لذلك، لا بد من التساؤل هنا عن فحاوى الاجتماعات السنوية بين المفوضية والمغرب. فقد كانت لديهم أربع سنوات لمعرفة تأثيرها على الصحراويين.

وفي نهاية الأمر، كان على اعضاء البرلمان أخذ زمام الأمور. وكان من المفروض أن يصل وفد من لجنة الصيد التابعة للبرلمان الأوروبي إلى الصحراء الغربية عام 2010 من أجل تقييم كيفية استفادة واستشارة الشعب الصحراوي. ومرت شهور بدون أي رد رسمي، وقام المغرب برفض اقتراح لجنة صيد الاسماك زيارة الاقليم رسميا مدعيا ان توقيت الزيارة "غير مناسب". [xlvi] وطرد المغرب من الصحراء الغربية خمسة وفود اوروبية اخرى مكونة من صحفيين ومنظمات المجتمع المدني وطلاب، والتي سافرت الى الإقليم في 2010–2011 بسرية للتحقيق في امر تطبيق الاتفاقية السابقة. [xlvii]

لقد خذل عزوف المغرب عن تقاسم المعلومات حول استفادة ما يسمى "السكان المحليين" الأوروبيين الذين دفعوا نحو نجاح الاتفاقية. وتم تأجيل تقرير مغربي عن الموضوع وُعِدت مؤسسات الاتحاد الأوروبي به مرة تلو المرة. وصرح رئيس لجنة صيد الاسماك "لا يقدم المغرب التقرير لنا". [xlviii]

أثار العديدون السؤال المبدئي حول الجدوى المرتجاة من الطلب من المغرب تقديم التقرير كهذا. فمن اعطى المغرب حق التحدث باسم الصحراويين؟

وعاد كوريل، المسؤول القانوني للأمم المتحدة الذي ادعى الاتحاد الأوروبي تأسيس حججه على تحليله، إلى الساحة.

كتب كوريل عن اتفاقية الصيد في مقال جديد صدر عام 2010: "لقد قيل لى ان المفوضية الاوروبية ترى ان المغرب هو المسؤول عن تنفيذ الاتفاق بشكل يأخذ مصالح الصحراويين في عين الاعتبار. وفي ضوء الظروف، ولا سيما النزاع السياسي طويل الأمد بين المغرب وجبهة البوليساريو،

فقد قامت محكمة عسكرية مغربية بإدانة الصحراويين من العاطلين عن العمل والناشطين الذين شاركوا في تنظيم مخيم احتجاجي عام 2010 خارج العيون، الذي طالب بالحقوق الاجتماعية والاقتصادية، ومعاقبتهم معاقبة شديدة. وقد حُكم على أحدهم، وهو الامين العام للجنة حماية الموارد الطبيعية، بالسجن مدى الحياة. كما أنه قد كان واحد من أنشط منتقدي نشاطات صيد الاتحاد الأوروبي في الصحراء الغربية، وواحدا من ثمانية أشخاص نالوا هذه العقوبة. [xli]

وكان البرلمان الأوروبي قد أعرب مرارا عن قلقه ازاء هذه التجاوزات. [xlii] وقد فعل الامين العام للأمم المتحدة الشيء ذاته وطلب، في الأعوام 2013 و 2014، من مجلس الامن رصد انتهاكات حقوق الانسان في الإقليم بشكل متواصل. وقد منع نفس البلدين اللذان جعلا ضغطا نحو جعل اتفاقيات تجارة الاتحاد الأوروبي تشمل الصحراء الغربية، اسبانيا وفرنسا، هذا الادراج في تفويض بعثة الامم المتحدة في الصحراء الغربية، MINURSO، حتى بعدما ضغطت الولايات المتحدة للسماح لهذا النشاط.

مع تواصل نشاطات الصيد الاوروبية، علّق الصحراويون على جدران الابنية في مدينة العيون أو أنهم حملوا لافتات صنعوها في بيوتهم: "اين حقنا في صيد السمك؟".

وصرحت مجموعة من السجناء السياسيين الصحراويين في رسالة وجهوها الى رئيس البرلمان الاوروبي: "لم يكن لنا رأي في هذا المسعى، وكانت النتيجة الوحيدة التي وجدها شعبنا تخرج عن اتفاقية صيد الاسماك هي المزيد من القمع لأصواتنا، لأن المغرب يشعر أن الاتحاد الاوروبي يدعم مطالبته الغير قانونية والغير مشروعة بوطننا. وبما ان الشعب الصحراوي لم يبد موافقته على الاتفاقية ولا يستفيد منها، كما يطالب القانون الدولي، فإننا نطالب بوقف الصيد في المياه الصحراوية على الفور". [xliii]

غير ان الاهم من ذلك هو ان جبهة البوليساريو اعترضت على الاتفاق مرارا وتكرارا. وقد تواصل ممثلو جبهة البوليساريو مع مؤسسات الاتحاد الاوروبي للاحتجاج على الاتفاقية. كما أنهم قد دعوا الامم المتحدة الى التدخل. [xliv]

وقبل ابرام اتفاقية الصيد البحري في نيسان/ابريل 2006، بادرت لجنة صيد الاسماك الى دعوة طرفي النزاع، المغرب وجبهة البوليساريو، إلى البرلمان للمشاركة في مشاورات مشتركة. ولكن نظرا لعدم رغبة المغرب في عرض قضيته في نفس المنتدى الذي تشارك فيه جبهة البوليساريو، تم الغاء المشاورات المشتركة، الأمر الذي بعث البهجة في قلوب الاشتراكيين الاسبان أعضاء اللجنة الذين حاولوا منع

من المستفيد؟

تقوم السيدة باريكمو بدراسة مستويات التغذية في مخيمات اللاجئين الصحراويين في الجزائر منذ 15 عاما. وكثيرا ما يجتمع فريقها لبحث كيفية الرد على سوء التغذية لدى السكان الذين يعتمدون على المعونات بشكل مطلق. كشف البحث عن الوضع المقلق لأبناء الشعب الصحراوي الذين فروا من وطنهم في عام 1975 ، بعد أن تجاهل المغرب رأي محكمة العدل الدولية وغزى الصحراء الغربية، الأمر الذي ادانته الامم المتحدة. وبحسب ابحاث الفريق، فإن تغذية 93% من الاطفال اللاجئين غير مرضية.xxxvii وتم أخذ اقتراح السيدة باريكمو بإضافة المزيد من السمك في النظام الغذائي بعين الاعتبار، ولكن التمويل لم يكن كافيا.

وقالت باريكمو فيما بعد، "لقد ضحك زملائي مني واعتقدوا أنني أمزح".

وتتبرع منظمة المساعدة الانسانية التابعة للاتحاد الأوروبي، ECHO، بما معدله 10 ملايين يورو سنويا من المساعدات الانسانية الى هذه المخيمات.xxxviii بيد ان الاتحاد الأوروبي، وللمقارنة، يدفع للمغرب 3.6 اضعاف هذا المبلغ سنويا بموجب اتفاقية شراكة صيد الاسماك من اجل الوصول الى الثروة السمكية التي يمتلكها نفس اللاجئين. وهكذا يشتري الاتحاد سمك الصحراويين من القوة التي تحتل الصحراء الغربية، فيما يعاني الاطفال في مخيمات اللاجئين من نقص في البروتين.

لقد أكد الامين العام للأمم المتحدة ومجلس حقوق الانسان التابع للأمم المتحدة على المفارقة الكامنة في عدم وصول عائدات المغرب من الصحراء الغربية الى اللاجئين أو من عدم موافقتهم على ذلك.xxxix

ويفيد النصف الاخر من الصحراويين الذين لا يزالون يعيشون في الأراضي المحتلة انهم لم يستفيدوا من اتفاقية الصيد البحري بين الاتحاد الأوروبي والمغرب. كما ;كانت كل منظمات المجتمع المدني الصحراوية من ضمن الـ 799 منظمة دولية التي ارسلت رسالة احتجاج على نهب الاتحاد الأوروبي في عام 2010. xl وفي هذه الاثناء، يؤدي التعبير عن معارضة الادارة المغربية للمنطقة التي تحتلها إلى عقوبات قاسية. فقد يتعرض كل شخص يجرؤ على انتقاد التواجد المغربي الغير قانوني إلى إجراءات تنتهك حقوق الانسان. وقد وثَّقت منظمات حقوق الانسان الدولية الرائدة هذا الامر سنة بعد سنة.

السرد. [...] ولا توجد كلمة واحدة في الاتفاقية بمجملها تتحدث عن ان "السلطة القانونية" المغربية تخضع للقواعد الدولية لحق تقرير المصير.

وبصفتي اوروبيا، اشعر بالحرج. وبالتأكيد، يتوقع المرء من اوروبا، ومن المفوضية الاوروبية بشكل خاص، أن تكون مثالا على تطبيق اعلى المعايير القانونية الدولية الممكنة في قضايا من هذا النوع. وفي جميع الأحوال، اعتقد انه من الواضح ان اتفاقية من هذا النوع من حيث أنها لا تفرق بين المياه المتاخمة للصحراء الغربية والمياه المتاخمة للمغرب تنتهك القانون الدولي".

وخلص متخصصون قانونيون آخرون إلى عدم شرعية الاتفاقية،[xxxv] وهي نفس النتيجة التي وصلت اليها حكومة السويد.

وتوصلت الدائرة القانونية في البرلمان الأوروبي إلى ذات الاستنتاج الذي توصل اليه الرئيس السابق للدائرة القانونية في الامم المتحدة. وفي رأي قانوني جديد عام 2009، نُشر في عام 2010، لم تجد الدائرة اي دليل يشير الى استشارة الصحراويين فيما يتعلق باتفاقية الصيد البحري في الصحراء الغربية، التي كانت آنذاك قد دخلت الى حيز التنفيذ منذ أكثر من عامين. "لا توجد أدلة على استخدام [...] الدفعات المالية [للمغرب] لصالح شعب الصحراء الغربية. ولكن الامتثال للقانون الدولي يتطلب ان يكون القيام بالأنشطة الاقتصادية المتعلقة بالموارد الطبيعية في اقليم لا يتمتع بالحكم الذاتي في صالح سكان هذا الاقليم ووفقا لرغباتهم".[xxxvi]

واستنتاجا:

"وإذا لم يثبت ان تنفيذ الاتفاقية لم يتماشى مع مبادئ القانون الدولي المتعلقة بحقوق الشعب الصحراوي بموارده الطبيعية، وهي مبادئ تلتزم المجموعة الاوروبية باحترامها، فعلى المجموعة الامتناع عن السماح للسفن بالصيد في المياه الواقعة قبالة الصحراء الغربية عن طريق طلب تراخيص صيد في مناطق الصيد التي تقع قبالة سواحل المغرب".

وخلال هذه الفترة، ظل هذا الرأي القانوني للبرلمان سريا، فيما أبلغ رئيس لجنة الصيد البحري منظمة المرصد الدولي لمراقبة الثروات الطبيعية في الصحراء الغربية (WSRW) أن الرأي القانوني للبرلمان "يؤيد شرعية" استئناف الصيد في الصحراء الغربية. وحين نشر الوثيقة اتضح أن الحقيقة كانت غير ذلك.

إلا أن المفوضية واصلت ادعائها بأنها اهتمت بتغطية كل الجوانب. وهكذا كانت كلمات المفوض بورغ الاخيرة في البرلمان الأوروبي قبل التصويت عليها كما يلي: "اكرر اننا قمنا فيما يتعلق بالصحراء الغربية بصياغة الاتفاقية بعناية فائقة. وأكرر بأن الاتفاقية لا تعرّف، ولا تحكم مسبقا على، مكانة مياه الصحراء الغربية القانونية. ومرة اخرى، ففيما يتعلق [...] بالسؤال فيما إذا كان بإمكان المغرب عقد اتفاقيات تتعلق باستغلال الموارد الطبيعية للصحراء الغربية فإن اجابة المستشار القانوني للأمم المتحدة واضحة".[xxxiii] وبعد إبرام الصفقة نهائيا والبدء بالصيد في عام 2007، جاء النقد من احدى الشخصيات المرموقة في القانون الدولي، من السيد كوريل بنفسه.

هانس كوريل يعبر عن قلقه

خلال مؤتمر عن القانون الدولي عام 2008، صرح سفير الامم المتحدة المتقاعد هانس كوريل: "أخشى ان معلومات المفوض بورغ خاطئة".[xxxiv]

لم تفت مؤلف نص الامم المتحدة اساءة استخدام مفوضية الاتحاد الأوروبي للنص باستمرار. لقد استغرب كوريل من قراءة المفوضية للوثيقة كما لو كانت تنص على كون المغرب السلطة الإدارية الفعلية، وان الاتفاقية، بحسب ذلك، لا تتعارض مع الرأي القانوني. ويستحق رأي كوريل في استخدام الاتحاد الأوروبي لوثيقة الامم المتحدة التي كتبها بنفسه اقتباسا لائقا:

"يتعين عليّ ان اعترف انني فوجئت تماما عندما علمت بهذا الاتفاق. ومما لا شك فيه ان العلاقات الطيبة بين اوروبا والمغرب تكتسي اهمية كبرى. [...] ولكنني متأكد انه قد كان من الممكن التوصل الى صيغة مرضية للطرفين، مع الحرص في نفس الوقت على احترام النظام القانوني الذي ينطبق على المياه قبالة الصحراء الغربية. فعلى أي سلطة قضائية على تلك المياه أن تخضع للقيود النابعة من القواعد المختصة بحق تقرير المصير.

لقد تمت الاشارة الى ان المفوضية الاوروبية قد استخدمت الراي القانوني الذي قمت بتحضيره في عام 2002 لدعم اتفاق الشراكة في مجال الصيد البحري. لا اعرف إذا كان ذلك صحيحا. لكن إذا ثبت ذلك بالفعل، فإني لا استوعب كيف كان بإمكان المفوضية أن تعثر على دعم من هذا القبيل في الرأي القانوني. وهذا بالطبع باستثناء التأكد من استشارة شعب الصحراء الغربية، وكذلك التأكد من أنه قد قبل الاتفاقية والتأكد كذلك من الطريقة التي سيستفيد من خلالها من ارباح النشاط. إلا أن معاينة الاتفاقية تؤدى الى استنتاجات مختلفة. [...] ومن الصعب جدا تحديد الصحراويين في هذا

انهاء الاتفاق

تمت المصادقة على الاتفاقية في 15 ايار/مايو 2006، ودخلت حيز التنفيذ في 28 شباط/فبراير 2007. تم بموجبها منح اسطول الصيد التابع للاتحاد الاوروبي ككل، 114 ترخيصا مقسمة بين عدد من الدول الاعضاء مقابل دفعة سنوية قيمتها 36 مليون يورو الى الحكومة المغربية. هذا يعني تكلفة اجمالية مقدارها 144 مليون يورو للصيد في منطقة معظمها منطقة لم يعن المغرب المحتل من قبل بالمطالبة بها كمنطقة بحرية تعود له أو التعبير عن ذلك.

صوّت ثلث أعضاء البرلمان ضد قرار المجلس في الجلسة العامة. ولم يكن احراز غالبية كافيا لدحر الاتفاقية. إذ لم يكن لدى البرلمان سلطة لاتخاذ قرار بشأن معاهدات الاتحاد الأوروبي، إلا أن غالبية كهذه تبقى ذات اهمية. فقرار المجلس كان سيدخل إلى حيز التنفيذ في كلتا الحالتين.

وأدى غموض النطاق الإقليمي للاتفاقية إلى تصويت السويد ضد الاتفاق في المجلس الأوروبي، لأن "الصحراء الغربية ليست جزءا من أراضي المغرب بموجب القانون الدولي". وصرح مسؤول سويدي قبيل التصويت على الصفقة: "كيف يمكن للاتحاد الأوروبي دعم قرار الامم المتحدة والاحجام عن الاعتراف بضم الصحراء الغربية من جهة، وابرام اتفاقية صيد الاسماك مع المغرب والتي تغطي المناطق المحتلة من جهة اخرى؟ نحن نريد ان نكون محايدين في حل هذا الصراع".[xxxi] وأيدت كل من فنلندا وايرلندا وهولندا الموقف السويدي، إلا أنها اختارت الامتناع عن التصويت ضد الصفقة، وقامت بإصدار بياناتها الخاصة. وصادقت باقي الدول على الاتفاقية في المجلس. وصرح عدد من ممثلي حكومات الاتحاد الأوروبي أنه إذا ما كانت الصحراء الغربية موقعا فعلى المغرب في كل الأحوال التأكد من ان عوائد الصيد ستخصص لصالح "السكان المحليين"، إلا أنهم لم يتمكنوا من التنبؤ مسبقا بكيفية التزام أو عدم التزام المغرب بذلك. ولكن، لم ترد في الاتفاقية أية اشارة إلى هوية السكان المحليين. فهل هم المستوطنون المغاربة الذين أصبحوا اغلبية ام الصحراويون؟

وفي نهاية الأمر، كان على المغرب توفير أدلة على استفادة "السكان المحليين" خلال سنوات الاتفاقية الاربع. وكما سنرى لاحقا، فإن ما حصلوا عليه يختلف تماما عما جرى الاتفاق عليه مع الاتحاد الأوروبي. وجاء في نص رسالة بعثها نشطاء حقوق الانسان الصحراويين من المناطق المحتلة الى أعضاء البرلمان قبل يوم من التصويت: "نرجو اصدقاء الشعب الصحراوي إبلاغ الاتحاد الأوروبي بضرورة حل النزاع حول الصحراء الغربية أولا ومن ثم يمكنهم استغلال ثرواتنا السمكية. فالطريق التي يتم اتباعها الان ستسبب لنا ولعملية السلام التي ترعاها الامم المتحدة المشاكل فقط".[xxxii]

قام القطاع، الذي كان بمعظمه من أعضاء البرلمان الاسبان، والذي ضغط من اجل ابرام الاتفاقية بالإشادة بالمفوض على خلفية التفاوض بشأن الاتفاقية.

وصرح أحد أعضاء البرلمان الاسبان تعليقا على عمل المفوضية: "اود ان أعرب عن امتناني لقطاع السكان الذين أمثلهم". "اتحدث عن سكان جزر الكناري ايضا، جيران هذه المياه، الذين طالما اصطادوا في هذه المياه، ولكن ليس في سياق استعماري كما يدّعي البعض. لقد وقع أحد أجدادي الأوائل مع سكان الساحل على اتفاقية للصيد، وذلك على اساس مبدأ المصلحة المتبادلة. لقد كنا نصطاد في تلك المياه، وسنعود الى الصيد فيها، وأود أن أشكر المفوضية على الجهود التي بذلتها. وآمل أن يصادق البرلمان على هذه الاتفاقية بأغلبية كبيرة، لأنها اتفاقية عادلة وصائبة للغاية من وجهة نظر القانون الدولي".xxvii

وادعى مدافعون آخرون بأن النقاش حول الشعب الصحراوي لا علاقة له بهذا المنتدى. وفي 15 ايار/مايو 2006، صرحت عضوة البرلمان كارمن فراجا "نعتقد بأن اللجنة المعنية بصيد الاسماك ليست المكان المناسب لحل مشاكل سياسية دولية بالغة الاهمية والتعقيد".xxviii

كما وشكرت ابن بلدها الإسباني الذي أعد ملف جلسة البرلمان، وكذلك "التوازن الذي حققه فيما يتعلق بالقضايا السياسية التي نشأت". كما واستغل المناقشة التي سبقت التصويت في جلسة البرلمان الأوروبي أعضاء برلمان من الموالين للمغرب من أجل احراز نقاط سياسية، وتعزيز مقولات سياسية عبثية لدعم مطالبة المغرب بالصحراء الغربية والتي زادت من تحريف المراجع القانونية.

فصرح عضو برلمان فرنسي الذي شغل في الماضي منصب المستشار المالي لملك المغرب: "إنني أرحب بهذا الاتفاقية الذي ألقاها منطقية لسببين"xxix

"فهي منطقية أولا، بالنظر إلى الثروة السمكية في الصحراء الغربية. وليس رأى الدائرة القانونية في البرلمان ما يجب أخذه بالحسبان، بل راي محكمة العدل الدولية. لقد مارس المغرب ومنذ قرون شكلا معينا من اشكال السيادة على الصحراء الغربية. وإذا ماكانت الجزائر بحاجة إلى منفذ على المحيط الاطلسى فتلك مشكلة تخصها، ولكن ذلك لا يشكل سببا كافيا لابتكار القوانين. وهى منطقية أيضا لأن جمع عوائد هذه الاتفاقات وتقديمها للصحراء المغربية وللشعب أمر جيد. [...] علينا أن نكون مسرورين من حقيقة ابرامنا هذه الاتفاقية المنطقية والمتوازنة مع المغرب. دعونا لا نختلق مشادة مع المغاربة". وبطبيعة الحال، كان استنتاج محكمة العدل الدولية عكس ذلك تماما: لا يمتلك المغرب مطلبا مشروعا او سيادة على الصحراء الغربية.xxx

الأوروبي وصناعة الصيد الاسبانية بذلت كل جهد لتجنب الافصاح عن ذلك مباشرة. وهكذا ظلت جميع الاسئلة التي وجهها اعضاء البرلمان والصحفيون دون جواب.

وكما صرح المفوض بورغ قبيل التصويت في جلسة البرلمان الأوروبي في 15 ايار/مايو 2006: "ووفقا لأحكام الاتفاقية، تمتلك السلطات المغربية بصفتها الطرف المتعاقد حق تحديد مناطق صيد الاسماك واصدار تراخيص الصيد بحسب ذلك". xxiii.

في عام 2006، ومرة اخرى في عام 2009، حضّر البرلمان الأوروبي كذلك تحليلا قانونيا. xxiv ولكن، وعلى عكس آراء المفوضية الاوروبية والمجلس الاوروبي القانونية، كان بإمكان الجمهور هذه المرة الاطلاع على هذا التحليل. لقد حذر كلا التقريرين من عدم قانونية هذه الاتفاقية. ومع ذلك، فقد كان من الصعب على الطاقم القانوني التابع للبرلمان الخروج باستنتاج نهائي، لأن الاتفاقية المقترحة لا تحدد فيما إذا كانت مواقع الصيد تضم الصحراء الغربية. هل سيتم صيد الاسماك في الصحراء الغربية؟ إذا ما كان أمر كهذا سيحدث، وإذا ما كان المغرب ينوي عدم احترام حقوق الصحراويين، فستكون الاتفاقية غير قانونية. تنص الوثيقة الصادرة عن الدائرة القانونية التابعة للبرلمان الأوروبي عام 2006 على ما يلي:

"[...] نص الاتفاقية ليس واضحا بما فيه الكفاية بالنظر إلى مجال تطبيقها الجغرافي [...]. هذا لا يعني ان الاتفاقية، بهذا الشكل، تتعارض مع مبادئ القانون الدولي. وفي هذه المرحلة، لا يمكن الحكم مسبقا بأن المغرب لن يمتثل لالتزاماته بموجب القانون الدولي تجاه شعب الصحراء الغربية. وهذا يتوقف على كيفية تنفيذ الاتفاق. [...] وفي حالة تجاهل السلطات المغربية الواضح لالتزاماتها بموجب القانون الدولي تجاه شعب الصحراء الغربية، يمكن ان يجري الاتحاد مشاورات ثنائية بغية تعليق الاتفاقية". xxv كانت المداولات في البرلمان عنيفة. فبينما اعترض برلمانيون على قيام المفوضية بتشويش الحقائق وامكانية ادراج الصحراء الغربية، وكذلك تأكيدهم على أن الاتفاقية ستنتهك القانون الدولي، عملت المفوضية جاهدة على تهدئة المعارضة.

وصرح المفوض: "قامت المفوضية بتقييم شامل للأبعاد السياسية والقانونية والاقتصادية المترتبة على الاتفاقية المزمعة.. وفي هذه الحالة، كما في غيرها، حرصت المفوضية على تجنب وضع يمكن فيه أن يصبح فيه ابرام اتفاقيات جديدة في مجال صيد الاسماك عاملا في نزاعات او صراعات دولية". xxvi.

أكّد كبار مسؤولي المفوضية الاوروبية مرارا ان المغرب هو فعليا السلطة التي تدير الصحراء الغربية، ولهذا فإن "اقتراح المفوضية يتفق مع الراي القانوني للأمم المتحدة الصادر في كانون الثاني/يناير 2002". [xxi] وفي الواقع، يتعارض ذلك مع ما ورد في الراي القانوني للأمم المتحدة. وليس هناك أبدا، *أبدا*، شيء في القانون الدولي يسمى "السلطة الادارية الفعلية لمستعمرة ما. فإما أن يكون هناك اعتراف بدولة ما للقيام بما للقيام بهذا الأمر، أو لا.

إن وقع الجمع بين هذه الاساءات التفسيرية الثلاثة لهائل. ففيما يطالب القانون الدولي والامم المتحدة بمنح الشعب الصحراوي كامل السلطة للتقرير بشأن ادارة موارد بلادهم، يفسر الاتحاد الأوروبي رأي الأمم المتحدة القانوني كما لو كافيا للتأكد من أن لبعض السكان المحليين عملا (اقرؤوا: "بما أن المغرب قرر الدفاع عنهم")، ثم التأكد من أن مسؤولين في الحكومة المغربية قد وافقوا على ذلك.

كما أن جميع الاشارات الى الاستنتاجات النهائية الواردة في رأي الامم المتحدة القانوني لا تظهر في أية من اشارات الاتحاد الاوروبي الى هذه الوثيقة. وبدلا عن ذلك، عكف الاتحاد الأوروبي بشكل دائم على اختيار مقتطفات عشوائية من فقرات الوثيقة الاخرى.

أما الطريقة الرابعة التي استخدمتها المفوضية الاوروبية في هذه المرحلة فكانت إبقاء آرائها القانونية الداخلية سرية. لقد حضّرت كل من المكاتب القانونية للمفوضية الاوروبية والمجلس الأوروبي آراء قانونية تشير مؤسسات الاتحاد الأوروبي اليهما باستمرار. إلا أنهما ظلا طي الكتمان، بسبب "الحساسية السياسية الكبيرة". [xxii] ولهذا أمكن الادعاء بأن كل شيء قانوني، بدون توفير أي تفسير —باستثناء الاقتباسات الخاطئة للأمم المتحدة. أما الطريقة الخامسة التي استخدمتها المفوضية، وقد تكون تلك الاكثر احباطا اثناء المناقشات التي سبقت الموافقة على الاتفاق، فكانت تجنب الاتحاد الأوروبي لكل الاسئلة حول مواقع صيد الأسماك.

تفننت المفوضية والحكومات الرئيسية في تعتيم مواقع الصيد المستقبلية. ولم تكترث الاتفاقية بإضافة تصريح يستثني الصحراء الغربية. وفي الواقع، لم تشر الاتفاقية الى الصحراء الغربية بتاتا. وبدلا من ذلك، تفسح الاتفاقية المجال للاتحاد الأوروبي الصيد في المناطق الواقعة تحت "سيادة وسيطرة" المغرب. وكان من الواضح للجميع ان مواقع الصيد ستكون في الصحراء الغربية، إلا أن مؤسسات الاتحاد

أولا، أزال الاتحاد الأوروبي في كافة اتصالاته تقريبا أية اشارة الى "شعب" تماما. بشكل عام، استبدل الاتحاد الأوروبي المصطلح بعبارة "السكان" او "السكان المحليين". وانطلاقا من هذه النقطة، دارت كل الجدالات بخصوص قانونية الصيد من وجهة نظر الاتحاد الاوروبي للحصول على وثائق حول "فوائد في صالح السكان المحليين". والمشكلة الكامنة في هذا التزوير هي، بطبيعة الحال، أن مكونات اغلبية هؤلاء السكان اليوم هم المستوطنون المغاربة وقوات الامن. ولن يبذل الاتحاد الأوروبي والمغرب أي جهد ابدا لجعل اللاجئين او الذين يعيشون في الاجزاء الغير المحتلة من الصحراء الغربية جزءا من المعادلة. وبحسب اساءة تفسير "شعب الصحراء الغربية"، التي تجعله "سكان الصحراء الغربية المحليين"، فسيكون كافيا بالنسبة للاتحاد الأوروبي مسائلة المغرب عن احوال المستوطنين الغير شرعيين.

ثانيا، نزعت كل الاحالات الى "الموافقة" التي تستخدمها الامم المتحدة من كل نصوص الاتحاد الأوروبي تقريبا. ونجدها، في أفضل الاحوال، مستبدلة بالكلمة "تشاور"، والتي تحمل معنى مختلفا تماما.

ثالثا، لقد اساء الاتحاد الأوروبي اقتباس مكانة المغرب القانونية في الصحراء الغربية منذ البداية. تؤكد وثيقة الامم المتحدة من عام 2002 على عدم وجود "سلطة ادارية" أو "قوة استعمارية" تتحكم بالصحراء الغربية اليوم.[xix] صحيح أن نظام فرانكو قد ترك الصحراء الغربية في عام 1975، ولكن لم يتم اعطاء أي تخويل لأية حكومة اخرى بإدارتها. لقد تمت صياغة رأي الأمم المتحدة في عام 2002 قياسيا بشكل واضح كما لو كانت للصحراء سلطة إدارية. يرفض المغرب أن يكون الدولة القائمة على ادارة الصحراء الغربية، ولا تعترف الامم المتحدة بدور كهذا للمغرب، كما وأن المغرب لا يقدم تقارير حول رفاه شعب الصحراء الغربية كما لو كان يقوم بدور سلطتها الادارية. يسيء الاتحاد الأوروبي قراءة ذلك بشكل خطير. إذ يوفر الاتحاد الأوروبي الانطباع بأن وثيقة الامم المتحدة تعتبر المغرب السلطة الادارية بالفعل.

"وبالنظر إلى امتثال الاتفاقية الحالية للقانون الدولي، وإلى الرأي القانوني الصادر عن البرلمان الأوروبي [...]، نود ان نؤكد من جديد ان السيد كوريل قد خلص في رسالته في عام 2002 إلى أن النشاطات (الاقتصادية) في اقليم لا يتمتع بالحكم الذاتي من قبل سلطة ادارية غير قانونية "في حال جرى تجاهل احتياجات ومصالح شعب ذلك الاقليم فقط"".[xx]

التي يخطط الاتحاد الأوروبي لإبرام اتفاقية من هذا النوع بعد قيام المكتب القانوني للأمم المتحدة، والذي يترأسه السفير السويدي هانس كوربل، برفع رأي قانوني مهم في عام 2002 بصدد التنقيب عن النفط في الصحراء الغربية الى مجلس الامن الدولي. فماذا كان رد فعل الاتحاد الأوروبي حيال ذلك؟

قراءة انتقائية للقانون الدولي

إن مبادئ القانون الدولي التي تتعلق باستغلال الموارد أقاليم في مرحلة تصفية الاستعمار——إقليم لا يتمتع بالحكم الذاتي——واضحة.

فحق شعب هذا الاقليم في اتخاذ قرار بشأن استقلاله وكيفية التصرف بمصادره شأنان لا ينازعه عليهما أحد. ويصل الرأي القانوني للأمم المتحدة الصادر عام 2002 الى هذا الاستنتاج بالضبط. كما أن أي استكشاف او استغلال "يتجاهل مصالح ورغبات شعب الصحراء الغربية" سيكون انتهاكا للقانون الدولي، بحسب المستشار القانوني للأمم المتحدة.[xviii]

إذا، كيف تعرض الاتحاد الأوروبي والمغرب إلى تلك المبادئ التي عبرت عنها مؤخرا الامانة العامة للأمم المتحدة بوضوح شديد؟ من الطبيعي أنه لا جدوى من الاتكال على المغرب لضمان توافق مثل هذه الاتفاقية مع رغبات الصحراويين والقانون الدولي——ففي نهاية الامر، ينتهك المغرب هذه المبادئ منذ عام 1975 بمجرد تواجده في الاقليم.

ولن يتمكن شعب الصحراء الغربية، الصحراويون، من الاعراب عن موافقتهم على الاتفاقية طالما كانت الرباط طرفا فيها. فأولئك الذين يعيشون في مخيمات اللاجئين في الجزائر، لا يمتلكون وسائل للتواصل مع الحكومة المغربية، لأن المغرب يرفض التفاوض مع ممثلي الصحراويين، حركة التحرير الوطني–جبهة البوليساريو. فالمغرب يرى فيهم عدوا للدولة. وينطبق الأمر ذاته على عدم اهتمام المغرب بسكان الأراضي المحتلة. وفي الحقيقة، يرفض المغرب في المقام الاول قبول فكرة وجود "شعب" يجب الحصول على موافقته، كما أنه لا يقبل الفرضية القائلة بوجوب التعامل مع مسألة الصحراء الغربية بصفتها مسألة ما بعد استعمارية في الامم المتحدة. وفي الحقيقة، تم تحديد من هو "شعب" الصحراء الغربية من قبل بعثة الامم المتحدة للاستفتاء في الصحراء الغربية (MINURSO) خلال تواجدها هناك عام 1991.

حلت المفوضية الاوروبية هذه المعضلة من خلال خمس طرق رئيسية.

الصيد الضخم الذي بناه نظام فرانكو ان يستكمل صيد الأسماك، وإنما بشكل لا يمكن الاستمرار به، حتى بعد تنصل اسبانيا أحادي الجانب (وعلى ذلك، الغير قانوني) من التزاماتها الاستعمارية.

يعبر تقليد صيد الاسماك الإسباني بعد عام 1975 في الصحراء الغربية بشكل جزئي عن حقيقة بقاء الصحراء الغربية رازحة تحت الاستعمار. فهذا هو الربح الذي تجنيه اسبانيا من خلال السماح للمغرب باحتلال الصحراء الغربية، وبذلك انتهاك حقوق الشعب الذي كان يسكن المقاطعة الاسبانية السابقة. وبعد 40 سنة، لا يزال الضحايا يعيشون في مخيمات اللاجئين في الصحراء الجزائرية، أو أنهم يعانون من اضطهاد حكومة المغرب الاجنبية.

انضمت اسبانيا للاتحاد في عام 1986. ومنذ ذلك الحين، أصبح الاتحاد الأوروبي هو طرف المفاوضات بشأن اتفاقيات صيد الاسماك الاجنبية مع المغرب لتمثيله إسبانيا. ومنذ عام 1988، وقع الاتحاد الأوروبي للمرة الاولى على مثل هذا الاتفاق مع الرباط، والذي يسمح باستصدار 800 رخصة سنويا للصيادين الاسبان والبرتغاليين. لم يتم تثبيت حد أقصى لكمية الصيد في نص الاتفاقية، فيما حصل المغرب بحسبها على 282 مليون يورو في المقابل. وتم توقيع اتفاقية جديدة في عام 1992، وهو نفس العام الذي كان من المفروض أن يجري فيه الاستفتاء على الاستقلال في الصحراء الغربية بتنظيم من الامم المتحدة. وكان ربح المغرب من هذه الاتفاقية أكبر، إذ حصلت على 310 مليون يورو مقابل نشاط الصيد الذي كان جميعه تقريبا في مياه الصحراء الغربية. وفي عام 1995، أعيدت صياغة الاتفاقية الاخيرة وكذلك تمديدها مقابل دفع 500 مليون يورو، وهي الاتفاقية التي أنهاها المغرب في عام 1999. وفي ذلك الوقت، أوشكت الثروة السمكية في الصحراء الغربية على الانهيار.[xv]

ضرب وقف الصيد في مياه الصحراء الغربية في نهاية القرن الصيادين الاسبان بقوة. فكما صرحت عضوة اسبانية في البرلمان الأوروبي في خريف عام 2004: "في الاندلس، تضرر أكثر من 200 قارب صيد فيما ظل ما مجموعه 151 قاربا مقيدا إلى حين تتحسن فيه علاقات الصيد بين المغرب والاتحاد الأوروبي. ونتيجة لهذه الازمة، انخفضت التجارة بمقدار النصف في أسواق موانئ الميريا ومالقة والجزيرة الخضراء".[xvi] وأضافت متسائلة: "هل ستكون المفوضية على استعداد للقيام بمحاولة جديدة للتقرب من المغرب بهدف تيسير التعاون في المسائل المتصلة بالصيد البحري؟".

وفي عام 2005، استجابت المفوضية إلى الضغوط الاسبانية، وبدأت بمحادثات للتوصل إلى اتفاقية جديدة والتي، وكما سنرى، دخلت حيز التنفيذ في عام 2007.[xvii] لقد كانت تلك هي المرة الاولى

النزاع. وعلى سبيل المقارنة، فإن قرارات مجلس الامن عادة ما تكون مشابهة ولكنها تنتهي بالصياغة التالية"... الذي يكفل حق تقرير المصير لشعب الصحراء الغربية".[xi] غالبا ما يغفل الاتحاد الأوروبي عن ذكر العبارة الاخيرة. وهذا يوضّح لنا كيف لا يأخذ الاتحاد الأوروبي الشعب الصحراوي بعين الاعتبار. فلدى التعامل مع الموارد الطبيعية الصحراوية، قام الاتحاد الأوروبي دائما بالتفاوض مع الرباط، فيما هو يصم آذانه امام الاحتجاجات الصحراوية.

أسطول صيد عملاق

يعاني الاتحاد الأوروبي من الضخامة الزائدة لأسطول صيد الاسماك. وباختصار، يفوق عدد صيادي الاسماك وقوارب الصيد البحري الثروة السمكية التي تتناقص يوميا في المياه الاوروبية بكثير. فبحلول عام 2011، تجاوزت كمية الصيد في 88 بالمائة من مياه الاتحاد الأوروبي حدها الأعلى.[xii] وتتمثل المشكلة الرئيسية في اسبانيا، ولها ربع مجموع العمالة في قطاع الصيد التابع للاتحاد الاوروبي[xiii] واكبر عدد من قوارب الصيد في الاتحاد الأوروبي.[xiv] ولمواجهة مشكلة الطاقات الزائدة في بعض اساطيل دول الاتحاد ومشكلة الصيادين العاطلين عن العمل، يوقّع الاتحاد الأوروبي على ما يسمى اتفاقيات شراكة لصيد الاسماك، أو "FPAs"، يدفع من خلالها لحكومات دول افريقية واخرى في المحيط الهادئ اموالا من أجل استصدار تراخيص صيد مخصصة لسفن الاتحاد الأوروبي في مياهها. وهذا النموذج محط جدال. فعادة ما يتجاوز استغلال اسطول الصيد التابع للاتحاد الأوروبي الثروات السمكية في مناطق صيده طاقتها، ويدخل بذلك إلى نزاع مع جماعات الصيادين التقليدية والصغيرة، والفقيرة عموما، التي تصيد على الساحل. كما أن بعض الحكومات الموقعة على اتفاقيات الصيد مع الاتحاد الأوروبي معروفة بكونها فاسدة أو غير ديمقراطية، وأنها تمتلك موارد محدودة لا تسمح لها بمراقبة اسطول الاتحاد الأوروبي. أما في حالة الصحراء الغربية، فإن المشكلة أكثر خطورة لأن الاتحاد الأوروبي وقع على الاتفاقية مع الحكومة الخاطئة: القوة المحتلة.

يصل عمر ممارسة الصيد الأوروبي، والتي يقوم بها صيادون من جنوب اسبانيا وجزر الكناري، في الصحراء الغربية إلى قرون عدة. وعند انتهاء الاستعمار الاسباني للصحراء الغربية في النصف الثاني من عام 1975، وقّع نظام فرانكو الضعيف والمتهاوي على اتفاقات مدريد مع المغرب وموريتانيا والتي تسمح للدولتين الجارتين احتلال الاقليم. تعارضت الاتفاقية تعارضا مباشرا مع التزام اسبانيا بإنهاء استعمار الاقليم. وفي المقابل، ضمنت الاتفاقية لإسبانيا الحفاظ على تقليد صيد الأسماك، وكذلك على حصة في ملكية صناعة الفوسفات في الصحراء الغربية. وبهذه الطريقة، أصبح بإمكان اسطول

الاندماج في السوق الأوروبية

لـذلك، يجب النظر إلى تواجد الاسطول الأوروبي لصيد الـسـمـك في مياه الصحراء الغربية الغنية بالسمك ضمن هذا الإطار العام من التعاون السياسي بين المغرب والاتحاد الأوروبي.

ومن المثير للسخرية، أنه وفي نفس اليوم من كانون الاول/ديسمبر 2011، الذي سجل فيه البرلمان الأوروبي تاريخا من خلال رفضه لاتفاقية صيد الاسماك، كلف مجلس الوزراء المفوضية بالتفاوض على ما يسمى اتفاقية التجارة الحرة العميقة والشاملة (DCFTA). vii وبدأت المفاوضات الرسمية حول هذه الاتفاقية بعد مرور 16 شهرا. والهدف الرئيسي من هذه الاتفاقية هو تسهيل تواؤم المغرب التـدريجي مع السوق الموحدة للاتحاد الأوروبي. وصرح مفوض التجارة بالاتحاد الاوروبي أن "هذه المفاوضات تظهر التزام الاتحاد الأوروبي بتطوير علاقاته التجارية والاستثمارية مع شركاء في جنوب المتوسط الملتزمين بالإصلاحات السياسية والاقتصادية". viii

ولكن هناك مشكلة. فكما جرت العادة، كان الاتحاد الأوروبي مترددا في استبعاد صريح للأجزاء المحتلة من الصحراء الغربية من الصفقات التجارية مع المغرب. وخلال محادثات DCFTA، كان بإمكان المغرب التفاوض على الاتفاقية مع الاتحاد الأوروبي كما لو كانت المناطق التي يسيطر عليها في الصحراء الغربية جزءا من المملكة.

قدمت منظمات المجتمع المدني في الصحراء الغربية المحتلة وفي مخيمات اللاجئين الصحراويين في الجزائر التماسا إلى المفوضية الاوروبية تناشدها فيه باستثناء بلدهم من المحادثات حول اتفاقية DCFTA. لم تعر المفوضية الاوروبية هذه الرغبات اهتماما ولم تتشاور مع الصحراويين او مع منظماتهم المسؤولة عن إدارة حياتهم اليومية. ix

جُمدت المحادثات حول اتفاقية DCFTA في وقت لاحق. إلا أنها وعلى الرغم من ذلك تصوّر لنا عزم الاتحاد الأوروبي على إقامة علاقة وثيقة وتفضيلية مع جارته الجنوبية. كما أنها تبين بوضوح كيف تمثل الصحراء الغربية المشكلة التي لا يريد أحد الخوض فيها في اثناء الحوارات بين المغرب والاتحاد الأوروبي. وعموما، يميل الاتحاد الأوروبي الى اتباع سياسة القول-القليل بقدر الامكان.

وصرح المتحدث باسم الاتحاد الأوروبي بشأن حقوق الانسان في الوقت الذي كانت فيه شدة التوتر في الصحراء الغربية الأعلى منذ وقف إطلاق النار في عام 2010: "يؤكد الاتحاد الأوروبي دعمه مساعي الامين العام للأمم المتحدة ومبعوثه الشخصى من اجل التوصل الى حل عادل ودائم ومتفق عليه من قبل الطرفين" x لا يخرج هذا الاقتباس عن النهج المألوف الذي يتبعه الاتحاد الأوروبي تجاه

"اننا نعرف الجهة التي يرشدنا اليها القانون الدولي، لكننا وبهذا الخصوص نحذو حذو اسبانيا." كان هذا تصريح ممثل وفود الـدول في بروكسل بصدد مسألة صيد الاتحـاد الأوروبي في الصحراء الغربية.[iii] إلا أن هناك بعض الاستثناءات النبيلة، والتي تؤكد الحكومـات مـن خلالهـا على الحقوق المشروعة للشعب الصحراوي، وجميعها حكومـات في اوروبا الشمالية. ومع ذلك، فإنهم نادرا مـا يفعلون ذلك من خلال مواجهة مفتوحة مع الثنائي اسبانيا-فرنسا.

وعلى هذا النحو، يفتقر نهج الاتحاد الأوروبي نحو احتلال الصحراء الغربية الى الاتساق. وكما سنرى لاحقا، لا يكمن الاختلاف في تباين المواقف المتناقضة بين الدول فحسب، بل وايضا في المواقف المتناقضة بين مؤسسات الاتحاد الأوروبي. فمن الممكن أن يتخذ كل من البرلمان الأوروبي والمفوضية الاوروبية وجهات نظر تختلف عن بعضها الى حد كبير.

لقد أصدر البرلمان الأوروبي، والـذي يتـألف مـن ممثلين منتخبين بصـورة ديمقراطيـة مـن دول الاتحـاد الأوروبي الـ 28، مرارا بيانات تتعرض إلى خطورة حالة حقوق الانسان في الصحراء الغربية. فعلى سبيل المثال، "يعرب البرلمان عـن قلقه ازاء استمرار انتهاكات حقوق الانسان في الصحراء الغربية؛ ويدعو الى حماية الحقوق الاساسية لشعب الصحراء الغربية، وبما في ذلك حرية التنظيم وحرية التعبير والحق في التظاهر؛ كما ويطالب بالإفراج عن جميع السجناء السياسيين الصحراويين".[iv]

كما ويدعم موقف البرلمان الأوروبي النقدي هذا التقارير الواردة من الامانة العامة للأمم المتحدة ومن منظمات حقوق الانسان الرائدة. فمنظمة Freedom House الامريكية، على سبيل المثال، تضع الصحراء الغربية في أسفل التصنيف الدولي فيمـا يتعلق بمسألة الحرية السياسية، وذلك اسوة بدول مثل كوريا الشمالية. ومع ذلك، ومن ناحية اخرى، يمكن للمرء ان يجد أعضاء آخرين داخل الاتحاد الأوروبي يحملون وجهة نظر مختلفة تماما.

وفي اللحظات الحاسمة في النزاع على الصحراء الغربية، دعم سفراء دول الاتحاد الأوروبي في المغرب بشكل فعال الانتهاكات المغربية لحقوق الانسان في الصحراء الغربية مـن خلال المشـاركة في نشـر وجهة النظر المغربية للأحداث.[v] فيما نقل عن سفير سابق خلال ندوة حول حرية الاعلام في الرباط قوله "ان المغرب والاتحاد الأوروبي يتشاطران نفس قيم الديمقراطية والحرية".[vi]

فعلى مدى سنوات عديدة، ادعى اولئك الذين يدافعون عن صيد الاتحاد الأوروبي للأسماك في الصحراء الغربية ان اتفاقية الصيد ليست عملا سياسيا ولا تشكل تدخلا في النزاع حول الصحراء الغربية، بحكم كونها اتفاقية تعني بصيد الاسماك لا أكثر. كما واتهموا خصومهم باستغلال اتفاقية تجارة بسيطة لخدمة اهدافهم السياسية.

بيد انه ولدى العزم على تجديد الاتفاقية، ومدتها أربع سنوات، بين المغرب والاتحاد الأوروبي (والتي دخلت حيز التنفيذ في عام 2007) في 2011، تم نسف الحجج الاساسية التي تدعم استمرارية الصيد البحري من خلال التحقيقات التي قامت بها مؤسسات الاتحاد الأوروبي. وهكذا، لم تبق في جعبة هؤلاء الذين شددوا على الطابع اللاسياسي للصيد البحري إلا حججا سياسية يدافعون من خلالها عن استمرار صيد الاسماك. وفي النهاية تبدى لنا كيف كان الأمر برمته سياسيا، وهو الامر الذي اعترفت به الحكومة المغربية. فحتى تدمير البيئة الموثق والخسائر التي قدرت بملايين اليوروهات لم تكن مهمة في نظر الاتحاد الأوروبي، طالما ظل اسطول الصيد الإسباني الكبير يعمل وطالما ظلت الحكومة المغربية راضية.

المصالح الاوروبية في المغرب

يعتبر المغرب اليوم أقرب دولة افريقية الى الاتحاد الأوروبي. والاسباب الاستراتيجية التي تجعل الاتحاد الأوروبي بحاجة الى الحفاظ على علاقة طيبة مع الحكومة المغربية عديدة: ايقاف الهجرة ومكافحة المخدرات عبر مضيق جبل طارق وتبادل المعلومات الاستخبارية حول الارهاب ومطالبات بحرية وبرية متداخلة مع اسبانيا، عبارة عن امثلة على ذلك فقط.

ووفقا للأرقام الصادرة عن المفوضية الاوروبية، يعتبر الاتحاد الأوروبي أكبر شريك تجاري للمغرب بحيث تبلغ التجارة معه حتى الان 50 بالمئة من إجمالي التجارة المغربية. وبتجارة السلع بين الاتحاد الأوروبي والمغرب في ارتفاع متواصل، وقد وصلت الى أكثر من 34,6 مليار يورو في 2016.[ii] ومن خلال التعاون التجاري، وقعت المجموعة الاوروبية على عدة اتفاقات مع جارتها في الجنوب الغربي. والمشكلة، بالطبع، هي ان تلك الصفقات التجارية تشمل عمليا الموارد الطبيعية في الصحراء الغربية. ويبدو ان دولتي الاتحاد الأوروبي اللتين تتمتعان بالقدرة على تحديد سياسة الاتحاد الاوروبي حول النزاع في الصحراء الغربية عموما هما: اسبانيا جارة المغرب، وفرنسا وهي حليفته منذ أمد بعيد. أما باقي الدول الـ 26 في الاتحاد فلا يظهر أنها تبذل أية رأسمال سياسي يذكر في النزاع من اجل عدم ازعاج مدريد وباريس.

"ليس الجانب المالي اهم جوانب هذا الاتفاق بالضرورة. فالجانب السياسي على نفس القدر من الاهمية".[i] هكذا لخص وزير صيد الاسماك المغربي في بيان مقتضب المشكلة الكامنة في اتفاقية صيد الاسماك السابقة بين الاتحاد الأوروبي والمغرب برمتها. في العام 2006، بدأ يعلو لهب الجدل في المؤسسات الاوروبية حول شراكة الصيد المتوقعة قريبا بين المغرب والاتحاد الأوروبي. إذ أن اتفاقا جديدا يدفع بحسبه الاتحاد الأوروبي اموالا للحكومة مقابل حق صيد الاسماك في مياه الصحراء الغربية كان على وشك التوقيع بعد أشهر من الخلاف.

شدد البيان على المشكلة الكامنة في الاتفاقية بأكملها: لقد كان المغرب على وشك حبك خدعة سياسية كبيرة ومثيرة للجدل تحت غطاء ما قد يبدو للوهلة الاولى اتفاقية بسيطة لصيد الاسماك. فبصفته أحد أكبر المستفيدين من سياسة الجوار للاتحاد الأوروبي، حظي المغرب بأفضلية توقيع عدد من الصفقات التجارية مع الاتحاد الأوروبي؛ فيما تؤثر بعض هذه الصفقات تأثيرا مباشرا على منطقة الصحراء الغربية. وبالطبع، فإن لهذا النوع من الاتفاقيات أهمية خاصة على جدول اعمال المغرب. فالأمر لا علاقة له بموضوع السمك على الإطلاق: فمن خلال جذب الشركات والحكومات الاجنبية لتوقيع اتفاقيات لإدارة موارد الصحراء الغربية الطبيعية، يقوم المغرب بتطبيع احتلاله الغير شرعي طويل الأمد للصحراء الغربية، كما ويخلق انطباعا بوجود دعم دولي لتواجده في الصحراء الغربية.

وعلى اي حال، فقد تقوض مشروع ضم الصحراء الغربية هذا إلى المملكة من خلال الاتفاقات مع الاتحاد الأوروبي ذات مرة. ففي قرار تاريخي في 14 كانون الاول/ديسمبر 2011، رفض البرلمان الأوروبي مشاركة الاتحاد الأوروبي في صيد الاسماك في الاقليم. لقد كانت تلك إحدى المناسبات الفريدة من نوعها في تاريخ الاتحاد الأوروبي والتي يقوم بها المشرعون بمنع اتفاقية تجارية، وكذلك المرة الوحيدة التي يتم فيها منع اتفاقية لصيد الاسماك. فبعد انتصار سياسي للمغرب تلا المصادقة على اتفاقية *شراكة صيد الاسماك* مع الاتحاد الأوروبي في الصحراء الغربية في عام 2006، خسر المغرب خسارة مريرة بعد خمس سنوات منذ هذه الاتفاقية.

تعرض لنا القصة من وراء عرقلة اتفاقية الصيد البحري بين المغرب والاتحاد الأوروبي في عام 2011 اطلالة عن الدرجة التي قد تصل اليها مؤسسات الاتحاد الأوروبي والسياسيين الاوروبيين فيما هم يضعون العراقيل امام مبادئ السلم والقانون والتضامن التي تأسس عليها الاتحاد الأوروبي.

التسلسل الزمني

تاريخ صيد الاتحاد الاوروبي. للأسماك في الصحراء الغربية، ٢٠٠٦–٢٠١٨

٢٠٠٦: موافقة مؤسسات الاتحاد الأوروبي على اتفاقية الشراكة في مجال الصيد (FPA) بين الاتحاد الأوروبي والمغرب.

٢٨ شباط/فبراير ٢٠٠٧: دخول الاتفاقية حيز التنفيذ.

٢٧ شباط/فبراير. ٢٠١١: انتهاء الاتفاقية بعد اربع سنوات.

٢٨ شباط/فبراير. ٢٠١١: بدأ تمديد الاتفاقية لمدة سنة واحدة فقط، إثر فشل الاتحاد الأوروبي والمغرب في إبرام اتفاق جديد. تم تمديد الاتفاقية بقرار من المفوضية الأوروبية.

٢٩ حزيران/يونيو. ٢٠١١: المجلس الأوروبي. يصادق على تمديد مدته سنة واحدة.

١٠ كـانـون الاول/ديسـمـبـر ٢٠١١: البرلـمـان الأوروبي. يرفـض التمـديـد لمـدة سـنـة واحـدة.

١٤ كانون الاول/ديسمبر. ٢٠١١: المغرب يعلن طرد اسطول الصيد التابع للاتحاد الأوروبي.

١٦ شبـاط/فبراير ٢٠١٢: البرلمان الأوروبي يقر اتفاقية تجارية مع المغرب لخصخصة المنتوجـات الزراعيـة والسمكية، فيما تدفع المفوضية الأوروبية باتجاه تطبيقها على الصحراء الغربية أيضا. تبين أن الاتفاق لا يسري على الصحراء الغربية وفقا لمحكمة العدل التابعة للاتحاد الأوروبي في ٢١ كانون الاول/ديسمبر. ٢٠١٦.

٢٤ تموز/يوليو. ٢٠١٣: بعد سنة ونصف من المفاوضات، الاتحاد الأوروبي والمغرب يتوصلان إلى اتفاقية شراكة صيد (FPA) جديدةٍ مدتها أربع سنوات، وذلك خلال تواجد مؤسسات الاتحاد الأوروبي في عطلتها الصيفية.

١٠ كانون الاول/ديسمبر. ٢٠١٣: البرلمان الأوروبي يصادق على إخراج اتفاقية شراكة صيد ومدتها اربع سنوات إلى حيز التنفيذ في الصحراء الغربية. إصابة العشرات من الصحراويين بجروح على يد الشرطة المغربية خلال احتجاجهم على قرار البرلمان الأوروبي.

١٤ اذار/مارس ٢٠١٤: حركة تحرير الصحراء الغربية، جبهة البوليساريو، تقاضي المجلس الأوروبي في محكمة العدل الاوروبية بشأن صيد الاسماك.

١٥ تموز/يوليو. ٢٠١٤: بروتوكول جديد لـ ٢٠١٤–٢٠١٨ لاتفاقية شراكة صيد الاسماك يدخل حيز التنفيذ.

٢٠١٨: توقع صدور قرار محكمة العدل التابعة للاتحاد الأوروبي. بشأن القضية القانونية التي بادرت اليها جبهة البوليساريو في عام ٢٠١٤.

الاتحـاد الأوروبــي: الأسماك قبل السلام

قصـــة ايقــاف البرلمــان الأوروبي صيد الاسمـاك المثير للجـدل في الصحراء الغربية المحتلة.

في الوقت الذي بدأ فيه المغرب بعملية تحويل ديموقراطية، سيحمل هذا في طياته رسالة سلبية من الاتحاد الأوربي في حال رفضه لهذه الاتفاقية

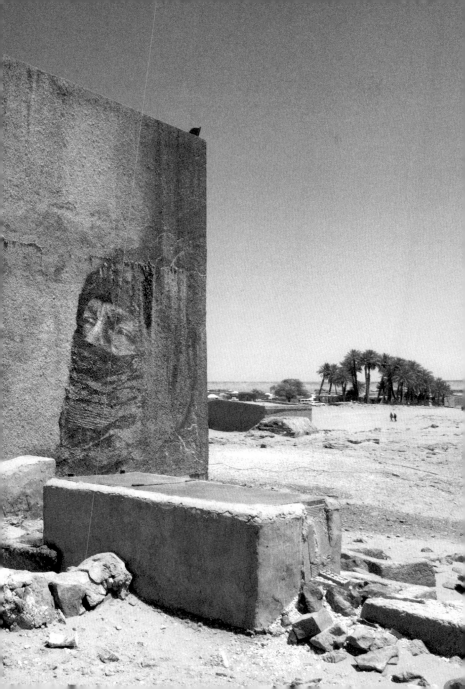

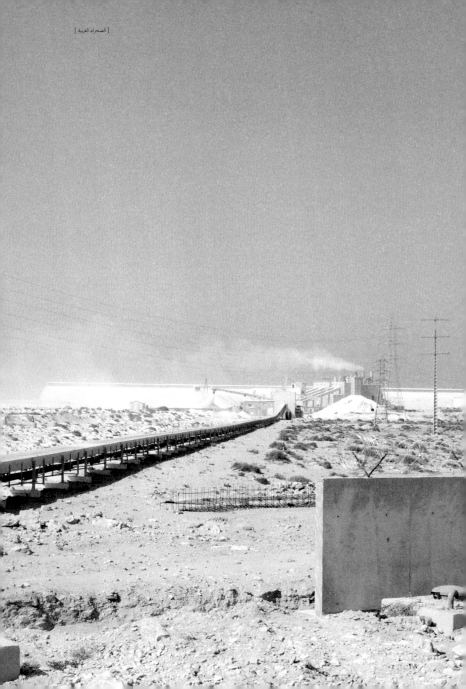

i http://www.wsrw.org/a105x3994 ،40%، طاقة الرياح المغربية في الصحراء الغربية المحتلة تتحاور. WSRW.org، 31.10.2017

ii http://www.ise.ie/debt_documents/Base%20Prospectus_b81be83f-8e8f-43ef85d9- ،2014، 17 نيسان/ابريل، نشرة إعلامية17 ، ii OCP SA
cc5a4ae0277a.PDF?v=402015

iii http://www.wsrw.Org/a105x3070 ،2014، 25 تشرين الثاني/نوفمبر، المغرب يعترف باستخدام الموارد الصحراوية للحصول على مكاسب سياسية. WSRW.org ،

iv https://minerals.usgs.gov/minerals/pubs/commodity/phosphate_rock، الخام، الموسمات، النشرة السنوية، المسح الجيولوجي الامريكي.

v http://www.wsrw.org/a246x3825 ، تقرير جديد عن تجارة فوسفات الصحراء الغربية المحتلة. WSRW.org، 25.04.2017

vi http://www.wsrw.org/a217x2712 أيها الصحراويون: إفحصوا أسماككم هنا. WSRW.org، 19.11.2013

vii http://www.un.org/en/decolonization/nonselfgovterritories.shtml الأمم المتحدة، الأمم المتحدة وإنهاء الاستعمار، الاقاليم التي لا تتمتع بالحكم الذاتي.

viii يمكن لسفينة واحدة إلغاء ألف طن من الاسماك: مثلا، 013 ،19.11.2013، WSRW.org، أيها الصحراويون: إفحصوا أسماككم هنا
http://www.wsrw.org/a217x2712 وللمقارنة، يحصل اللاجئون على معونة مقدارها حوالي نصف كيلو من الاسماك شهريا أي ما يعادل حوالي 900 طن سنويا.

ix http://www.wsrw.org/a214x2321 ، WSRW.org، 18.06.2012، تقرير: المستهلكون في الاتحاد الاوروبي يدعمون الاحتلال عن غير قصد.

x Finance News, 12.05.2011, Interview with Abdellah Bouhjar, Director of Dakhla's Regional Investment Centre "Nous avons
instruit 94 projets pour un investissement de 3,05 Mds de DH"

xi http://www.scmp.com/article/637220/line-sand ،11.05.2008، خط في الرمال. ساوث تشاينا مورنينغ بوست.

xii http://www.vest-sahara.no/a128x1893 تم العثور عليه عبر xii Bergensavisen 29.01.2013, Trosser norske myndigheter

xiii http://www.wsrw.org/a105x3206 انظروا ايضا Ny Tid, 01.04.2015, Svart gull kan bli slutten på fredsprosessen

xiv "قالها ما تقوم الشركة باستغلال النفط والغاز. في مناطق لم يستشر فيها السكان المحليين أحد. ولهذا السبب، فقد قامت الشركة على سبيل المثال بإيقاف عملها في الصحراء الغربية". المدير التنفيذ
للشركة الهولندية Fugro. WSRW.org، 19.06.2012، شركة Fugro توقف أعمالها في الصحراء الغربية لانعدام التشاور. http://www.wsrw.org/a214x2328
"ليس لدي اي مشكلة بالتصريح استرجاعيا أن قولنا هذه المهمة قد كان فكرة سيئة". المدير التنفيذي لشركة خدمات المسح الجيولوجي Spectrum ASA بعد تحليل البيانات الجيولوجية من
الاقليم.. WSRW.org، 19.06.2012، شركة Fugro توقف أعمالها في الصحراء الغربية لانعدام التشاور. http://www.wsrw.org/a214x2328

xv http://www.wsrw.org/a141x1067 انظروا ايضا Adresseavisen, 05.02.2009, Yara-profitt på okkupasjon

xvi WSRW, P for Plunder 2016, http://www.wsrw.org/a246x3825

xvii Harstad Tidende, 04.05.2005, Selfa Arctic drar fra Vest-Sahara, (2005 شركة لبناء السفن أوقفت نشاطاتها في العيون عام
(http://www.ht.no/incoming/article19140.ece
Norwatch, 22.12.2006, Norsk investering Vest- إيقاف حفظ لإقامة مصنع لإنتاج زيت السمك في مدينة العيون عام 2006. وبدلا عن ذلك أقيم المصنع جنوب المغرب-)
(http://www.vest-sahara.no/a80x330 انظروا ايضا [Sahara stanset [Norwegian Fishery Investment in Western Sahara Stopped

xviii http://www.wsrw.org/a228x2793 ، فيما يتحسب المقرضون الاوروبيون نزاع الصحراء الغربية للمغرب يتوجه للصين. WSRW.org، 06.02.2014

كما وصرحت شركة الشحن النرويجية R-Bulk للصحف بعد الكشف عن نقلها شحنة إلى مصنع للفوسفات في كولومبيا تديره الحكومة الفنزويلية: "لقد أجّرنا باخرتين لشركة يابانية، ولم نعلم أنها كانت معدة لنقل الفوسفات من هذا الاقليم. كما اننا لم نكن على علم بأن هذا الأمر يشكّل موضوعا ساخنا. أما الآن، وبعدما تم ابلاغنا بهذا، فقد قمنا بكل ما يمكننا فعله للتأكد من ايقاف هذه التجارة. لا نريد أن نكون في صراع مع أحد".[xii] وفضلا عن ذلك، بدأت بعض شركات الشحن بإدخال بند الى العقود التي تبرمها ينص على عدم سماحها لمستأجري السفينة بالإبحار بها إلى موانئ الصحراء الغربية. وفي السنوات الاخيرة، قامت حوالي 15 شركة شحن بالتصريح عن عدم رغبتها بالقيام بالمزيد من هذا النوع من عمليات الشحن.

كما وصرح المدير التنفيذي لشركة SeaBird Exploration بعد اجرائها مسح جيولوجي لصالح الشركتين Glencore و New Age في الصحراء الغربية عام 2015: "نعترف بأننا ارتكبنا خطأً. نشعر بعدم الارتياح الشديد لمساهمتنا في دعم سلطة محتلة".[xiii] وبالفعل، غادرت سبع شركات نفطية الصحراء الغربية بعد مواجهتها.[xiv]

وصرح أحد مسؤولي الاتصالات في إحدى كبريات شركات التجارة بالفوسفات عام 2009: "نأمل أن تتحرر الصحراء الغربية ليحصل السكان هناك منا على الفوسفات الذي يعود لهم".[xv] وكذلك، صرح ثلاثة مستوردين آخرين بوضوح أنهم لن يشتروا الفوسفات من الصحراء الغربية.[xvi] كما واتخذت شركات تعمل في مجال تصنيع الاسماك قرارات مماثلة.[xvii]

باع عدد من المصارف والمستثمرين أسهم تعود لشركات تعمل في الصحراء الغربية بمبلغ يرجح حجمه بحوالي 600 مليون دولار——وهذا ما نعرفه فقط من خلال البنوك التي تطبق مبدأ الشفافية على استعداداتها. ويمكن للمبلغ الفعلي أن يكون أكبر من ذلك بكثير. وفي عام 2013، تعهدت مؤسسات الاتحاد الاوروبي بأنها لن تدعم مخططات الطاقة الخضراء المغربية في الصحراء الغربية، خلافا لما أعلن عنه المغرب في وقت سابق.[xviii] يصدر الاتحاد الأوروبي هذه التوضيحات بتردد، فللاتحاد الأوروبي تاريخ طويل في مشاركة المغرب نهب موارد الاقليم.

طماطم الصراع

شغّل برنامج جوجل إيرث على الانترنت وحلّق فوق المنطقة القريبة من شبه جزيرة الداخلة على طول الساحل الأوسط للصحراء الغربية. ستشاهد مباني مستطيلة الشكل تشبه ملاعب كرة القدم متبعثرة عشوائيا في الصحراء. قد يجعلك انعكاسها المشع تعتقد انها مسابح. إلا أنها في الحقيقة مزارع. لقد أصبح عدد هذه المزارع اليوم ١١، وفيما يملك العاهل المغربي إحداها، تملك شركات فرنسية ومغربية الباقي. لا يملك الصحراويون أيا من المزارع.[ix]

لقد بدأ هذا الانتاج الضخم للفواكه والخضروات بالقرب من الداخلة بالنمو منذ عام ٢٠٠٤. ومنذ عام ٢٠١٠، وصل مجموع عدد العمال المشتغلين بالزراعة في الداخلة إلى ٦٤٨٠ عاملا.[x] ومن الناحية العملية، فإن جميع العمال هم مستوطنون مغاربة تم اعطائهم عمل وسكن في المنطقة. وتستخدم للري احفوريات يتم استخراجها من تحت الارض. ولا يمكن استبدال هذه في أوان نفاذها. ليست الزراعة الصحراوية قابلة للتجديد.

أما الاسواق الرئيسية لطماطم الصراع هذه فهي اسواق الاتحاد الأوروبي وامريكا الشمالية. إذ يصل معظمها إلى محلات السوبر ماركت في أوروبا.

قصص النجاح

عندما يتم مواجهة الشركات المتورطة للمرة الأولى، فإن ردها الروتيني عادة ما يكون أنها لم تكن على علم بأنهم دخلوا في عملية تجارية مثيرة للجدل. وهذا ليس مجرد شيء يقولونه——إذ يبدو أن الكثيرين منهم يعنون ما يقولون. ففي نهاية الأمر، لدى بعض الشركات العابرة للقارات شركات صغيرة تابعة وعقود في جميع انحاء العالم. فشركات الشحن البحرية تمتلك عشرات البواخر التي تسافر إلى كل الموانئ على وجه الأرض في كل يوم. وتحصل متاجر البقالة الكبيرة على المنتجات المعلبة والطازجة من التجار والمستوردين الذين يتواصلون مع اساطيل صيد الاسماك والمزارع في كل ركن من أركان المعمورة. وهناك بعض الشركات التي تعبر عن تقديرها للمعلومات لدى الاتصال معها، وتعد بعدم تكرار ذلك مرة اخرى. وفي حالات اخرى، تحتاج الشركات إلى المزيد من الاقناع.

صرحت شركة الشحن جينهوي الصينية بعد الامساك بها متلبسة بشحن الفوسفات من الصحراء الغربية الى نيوزيلندا: "اننا نفهم القضية الآن ولن نقوم بالتعاقد المباشر على أي عملية تجارية هناك".[xi]

الصيد البحري

يعتبر المغرب أحد أكبر الدول التي تعتاش على الصيد البحري. إلا أنه لا يكاد يكون لديه سمك. ففيما نجد معظم الثروة السمكية المغربية مستنزفة أو مهددة، وتأتي غالبية الاسماك التي يتم صيدها في المملكة من المياه على طول ساحل الارض المحتلة. ويتم الصيد الأجنبي على مستويين أساسيين: أولا، صيد أساطيل الصيد الأجنبية الخاصة التي تحصل على تراخيص من المغرب، وثانيا، الصيد من خلال اتفاقيات بين المغرب والدول الاجنبية مثل روسيا والاتحاد الاوروبي.

و إلى حد ما، توصل الاساطيل من الفئة الاولى من السمك إلى الصحراء الغربية، فيما يتم تصدير معظم الاسماك من الفئة الثانية مباشرة. ويتم تصنيع جزء من الاسماك التي يتم صيدها في الصحراء الغربية بحسب الفئة الأولى محليا في الداخلة أو العيون، أما الجزء الآخر فيتم نقله إلى المغرب لتصنيعه. وتشكل الصور البشعة للزوارق المغربية/الأجنبية وهي تلقي بكميات هائلة من الصيد في البحر محلا للجدل المستمر. ففي عام 2013، تم الكشف عن قيام سفينة واحدة بإلقاء ألف طن من السردين بإلقاء كان طوله أقصر بمقدار إنش واحد من الطول اللازم لتجهيزه في المصنع التابع للشركة في أغادير.[vi] أما بالنسبة للصيد الذي يصل إلى البر فيتم تحويله إلى زيت أو أن يتم تصديره معلبا.

أما الاتفاقيات المبرمة بين الحكومات، أي الصيد بحسب الفئة الثانية، فهي إشكالية بشكل خاص، لأنها تعطي انطباعا خاطئا بسيادة المغرب على الإقليم. إذ تدّعي اتفاقيتا صيد الاسماك مع الاتحاد الاوروبي ومع روسيا أن نهما تعملان في المياه الواقعه تحت "سيادة واختصاص" المغرب. ولكن، هل تقع الصحراء الغربية تحت سيادة المغرب أو اختصاصه؟

كلا. إن الامم المتحدة والقانون الدولي واضحان جدا بصدد هذه النقطة. تصنف الامم المتحدة الصحراء الغربية كـ "اقليم لا يتمتع بالحكم الذاتي" أو كـ"مستعمرة". وفي حقيقة الامر، تعتبر الصحراء الغربية حتى اليوم آخر المستعمرات في افريقيا، وترى الجمعية العامة للأمم المتحدة فيها اقليما في طريقه إلى إنهاء الاستعمار.[vii] ولكل مستعمرة "سلطة ادارية"——أو "سلطة استعمارية"——ترتبط بها، وقد كانت تلك بالنسبة للصحراء الغربية اسبانيا. وبموجب القانون الدولي، فإن لشعب الصحراء الغربية الحق في اختيار وضع الاقليم وادارة موارده بأنفسهم.

وبحسب البحوث في مجال التغذية، يحصل 93% من الأطفال في مخيمات اللاجئين الواقعة قرب مدينة تندوف، حيث يعيش نصف الشعب الصحراوي، على تغذية غير ملائمة. يحصل كل لاجئ مرة في الشهر على علبة أسماك تحمل عبارة "صنع في الصين" كهبة من الحكومة السويدية.

يمكن لباخرة واحدة إلقاء كمية من السمك في البحر كفائض للقمامة يفوق حجمها كل المساعدات السمكية المعلبة التي يتم منحها للاجئين.[viii]

ويجني المغرب أرباحا كبيرة من المناجم التي يسيطر عليها في الاراضي المحتلة. العملية الحسابية بسيطة: حجم الصادرات ضرب اسعار الفوسفات العالمية. تبلغ قيمة صادرات الفوسفات حوالي 200 مليون دولار سنويا على مدى عدة سنوات. وبالمقارنة، تبلغ قيمة المساعدات الانسانية السنوية لمخيمات اللاجئين الصحراويين حوالي 30 مليون يورو.

ما هي وجهة الفوسفات بعد مغادرته ميناء العيون؟ أو، وبعبارة أخرى، من هم ممولو الاحتلال؟ تتتبع منظمة المرصد الدولي لمراقبة ثروات الصحراء الغربية (WSRW) حركة الملاحة في جميع مياه الصحراء الغربية يوميا. وبهذه الطريقة، يمكن للمنظمة نشر تقارير منتظمة عن الصادرات المغربية من الأراضي المحتلة وتحديد جميع شحنات الفوسفات.. وصدر التقرير الاخير، P for Plunder 2016، في نيسان/أبريل 2017.[7]

وتعتقد منظمة المرصد الدولي لمراقبة ثروات الصحراء الغربية أنها استطاعت من خلال هذا الرصد اليومي الكشف عن جميع البواخر التي غادرت ميناء العيون منذ النصف الثاني من عام 2011. أما بالنسبة لعام 2017، فقد بلغ مجموع حجم الصادرات من الصحراء الغربية وفقا للمنظمة حوالي 1.6 مليون طن. إن حساب الكميات دقيق. إذ أن حساب كمية الفوسفات الذي يتم تحميله تبلغ عادة 95% من محمل الحمولة الكلية للسفينة. وفيما بعد ذلك، يتم تتبع السفن والتأكد من وصولها إلى وجهتها المعينة. وإذا ما أمكن، تقوم المنظمة أيضا بفحص الحمولة التي تم تقديرها بالنظر إلى وثائق الشحن، والتي تشمل سندات الشحن وسندات الميناء الذي تصل الحمولة اليه.

كما ولا يتغير نمط الزبائن من عام إلى عام إلا تغيرا ضئيلا. وبالنسبة للعام 2017، فهناك خمسة مستوردين رئيسيين للفوسفات الخام لا غير: اثنان في نيوزيلندا، وواحد في كندا، وواحد في الولايات المتحدة وواحد في الهند. ويقوم المستثمرون الذين يقيمون للجانب الاخلاقي اهتماما بوضع المستوردين المسجلين في البورصات العالمية على قوائم سوداء بسبب هذه التجارة.

وفي عام 2017، نجحت الحكومة الصحراوية لأول مرة في احتجاز سفينتي شحن عملاقتين مؤقتا في جنوب افريقيا وفي بنما. هزت عمليات التوقيف هذه أسواق الفوسفات، ومنذ 1 ايار/مايو 2017، وهو اليوم الذي تمت فيه أول عملية احتجاز، توقف ثلاثة من المستوردين عن الشراء على ما يبدو. ووصلت التجارة عام 2017 إلى أدنى مستوى لها منذ عقدين على الاقل.

بأن منجم بوكراع يشكل 1% من احتياطي الفوسفات المغربي فقط، فإن مصدر ما لا يقل عن ربع صادرات المملكة من الفوسفات الخام تُستخرج من هذا المنجم الذي يقع داخل الصحراء الغربية قريبا من العاصمة العيون.[ii] وتجتذب الجودة العالية الاستثنائية لفوسفات الصحراء الغربية الخام شركات تصنيع الاسمدة الأجنبية.

بيد انه يبدو لمستويات الانتاج المرتفعة السابقة الاقتراب من نهايتها. تتكون رواسب الفوسفات في بوكراع من طبقتين. وحتى وقت قريب، تم استخراج الفوسفات من الطبقة العليا فقط. وتحوي هذه الطبقة على أفضل نوعية من الفوسفات الخام في جميع احتياطات الفوسفات التي تسيطر عليها شركة OCP. وفي عام 2014، انتقل استخراج الفوسفات في بوكراع إلى الطبقة الثانية والتي تحوي فوسفات ذي جودة منخفضة. لقد باع المغرب حتى الآن كل الفوسفات ذي الجودة العالية والذي كان ينبغي أن يكون من نصيب الشعب الصحراوي لو أنه حصل على حق تقرير المصير. وفي المستقبل، لن يكون هناك المزيد من الفوسفات الخام لاستخراجه.

يعتبر الفوسفات المستخرج بشكل غير قانوني مصدر الدخل الرئيسي للحكومة المغربية من الصحراء الغربية، التي ما زالت تحتلها بما يتنافى مع القانون الدولي. ولا يكف ممثلو الشعب الصحراوي عن التعبير الصريح عن احتجاجهم ضد هذه التجارة في الامم المتحدة ولدى الشركات المعنية. إذ لا يحصل اللاجئون الصحراويون الذين يشكلون نصف الشعب الصحراوي على أي مردود من هذه التجارة. لقد أُجبر العديد من الصحراويين الذين كانوا يعملون في وحدة انتاج الفوسفات غداة الغزو على الفرار مع باقي المواطنين الآخرين. وقامت شركة OCP بتشغيل المستوطنين المغاربة بدلا عنهم.

وفضلا عن ذلك، يستغل المغرب فوسفات بوكراع تحديدا للقيام بضغط سياسي يسعى للحصول على موافقة غير رسمية من الدول الاخرى على الاحتلال اللاشرعي. وتنص وثيقة رسمية مغربية تم تسريبها عام 2014 صراحة على أنه يجب استغلال موارد الصحراء الغربية، بما فيها الفوسفات، "من أجل توريط روسيا في نشاطات في الصحراء الغربية". وتضيف الوثيقة أنه يمكن لروسيا في المقابل أن تضمن تجميد ملف الصحراء الغربية في الأمم المتحدة.[iii] ومن خلال سيطرة المغرب على احتياطات الفوسفات المغربي بالإضافة إلى فوسفات الصحراء الغربية فانه يتمركز في موقع بالغ الاهمية من ناحية جيو-سياسية. فالحكومة المغربية تسيطر اليوم على نحو 74% من احتياطيات الفوسفات العالمية.[iv]

مع عدة شركاء آخرين من اجل استكشاف النفط في مياه وأرض الاقليم، وأبرز هؤلاء شركة كلينكور السويسرية.

لم تسع أية من هذه الشركات النفطية للحصول على موافقة شعب الاقليم.

الطاقة الخضراء القذرة

في الوقت الذي يعتمد فيه العالم على الوقود الأحفوري، عادة ما يحصل أي مشروع حكومي للطاقة الخضراء على الثناء. بيد ان هذا لا ينطبق على عدد متزايد من المشاريع التي بدأت بها الحكومة المغربية. لا ينتج المغرب النفط والغاز، ولذلك لا تتوق الحكومة إلى التنقيب عن الهيدروكربونات فحسب، بل إلى توفير الطاقة الخضراء أيضا. وهل يوجد مكان أفضل من شواطئ الصحراء الغربية المحتلة لإقامة منشئات لإنتاج الطاقة من الرياح والشمس؟

ستكون لمشاريع الطاقة الشمسية هذه وطاقة الرياح الكبيرة التي يجري بناؤها حاليا عواقبا وخيمة على الشعب الصحراوي. صحيح أن انتاج الطاقة نفسه أخضر. ولكن وعلى الرغم من ذلك، فسيتم استخدام الطاقة من اجل زيادة الاستفادة من الموارد المستغلة حاليا في الصحراء الغربية. وعلاوة على ذلك، فمن خلال تصدير الطاقة الى المغرب، تربط السلطة المحتلة الصحراء الغربية بشبكات الكهرباء المغربية والاوروبية. يخطط المغرب لبناء محطات طاقة الرياح تصل قدرتها إلى أكثر من 1000 ميجاواط في الصحراء الغربية. وبحلول عام 2020 سيتم انتاج أكثر من 40% من طاقة الرياح في المغرب في الاراضي التي يحتلها. فيما لم تكن مثل هذه المشاريع موجودة على الإطلاق قبل عام 2013.[i]

شركة سيمنس الالمانية هي شريك الحكومة المغربية الرئيسي، وهي تقوم بإنشاء طواحين هوائية بالاشتراك مع شركة يملكها العاهل المغربي نفسه—وذلك على الارض التي احتلها والده منتهكا بذلك القانون الدولي وبما يتنافى مع رأي محكمة العدل الدولية وقتها.

الفوسفات الخام

بعد اسابيع فقط من غزو المغرب لما كان يسمى الصحراء الاسبانية عام 1975، ابتدأ بتصدير الفوسفات الخام المستخرج من منجم بوكراع في الصحراء الغربية إلى شركات الاسمدة في الخارج. ومنذ ذلك الوقت، تسيطر على العمل في المنجم شركة الفوسفات الوطنية المغربية، OCP SA، والتي تقدر طاقة الإنتاج القصوى للمنجم بحوالي 2.6 مليون طن سنويا. وعلى الرغم من ادعاء OCP

شركاء المغرب للتجارة معروفون جيدا للجميع. فجميع المعلومات عنهم موجودة على الانترنت. ومن السهل معرفة عناوين الشركات وأسماء مديريها وأصحابها. وكل واحدة من هذه الشركات مسؤولة جزئيا عن استمرار الصراع. وفي مقدرة كل واحد منا ايقافها.

سنوجز فيما يلي مختلف المصالح التجارية المتورطة بالأراضي المحتلة في إطار الشراكة مع الحكومة المغربية.

النفط

كتب مساعد الأمين العام للأمم المتحدة للشؤون القانونية في 29 كانون الثاني/يناير 2002 في رسالة وجهها إلى مجلس الامن: "إذا ما استمرت عمليات التنقيب والاستغلال في تجاهل مصالح ورغبات شعب الصحراء الغربية، فسيشكل ذلك انتهاكا لمبادئ القانون الدولي". لا تزال هذه الوثيقة، المسماة "رأي كوريل" بحسب اسم مؤلفها، تشكل حجر الزاوية لفهم حكومات الدول المختلفة لشرعية واخلاقيات الاعمال الاقتصادية في الصحراء الغربية المحتلة. فمنذ بضعة أشهر فقط، وقّع المغرب على أول تراخيص النفط التي تشمل الاقليم. وخلصت الدائرة القانونية التابعة للأمم المتحدة إلى أن المسير في هذا الطريق لن يكون مشروعا.

لم يلتفت المغرب وشركاؤه إلى ذلك. وبعد 12 عاما من التحضير، بدأت أول عملية حفر في كانون الاول/ديسمبر 2014. وتشير عمليات المسح الأخرى في عام 2017 إلى أن الشركة تعتزم القيام بحفر جديد آخر في عام 2018. وحتى الان لم يتم العثور على النفط إلا أن هذه التطورات تظل مقلقة.

وتقوم الشركة الامريكية كوزموس للطاقة مع شركة كايرن للطاقة الأسكتلندية بالعمل في ترخيص المنصة البحرية "البلوك" (''block'') التي صارت اليوم تحمل الاسم 'Boujdour Maritime'. ومنحت شركة النفط الوطنية المغربية ONHYM الترخيص لهذه الشركات. تم نشر العقد الذي لا يشير إلى الصحراء الغربية بتاتا على الانترنت. كما ولا ترد فيه أية اشارة إلى الشعب الصحراوي.

وعلى الرغم من أن شركة كوزموس للطاقة لم تحرز تقدما يذكر، فإنها ليست الشركة الوحيدة التي تنقب عن النفط في الصحراء الغربية. لقد وقّع المغرب خلال السنوات القليلة الماضية على اتفاقيات

الخلافات التجارية

شـــركاء المغـــرب للتجـــارة هـــم الرابـــط الأكـــثر ضـــعفاً في الاحتلال الغير شرعي للأراضي نعترف بارتكاب خطأ. من المقلق جداً المساهمة في دعم قوة احتلال

تم تقديم نسخة سابقة من هذا الفصل كورقة في المؤتمر: " ,International Conference on the Decolonization of Western Sahara", Abuja i
Nigeria, 2-4.06.2015

الحياة، 2013.01.14، وزير الاتصال المغربي لـ«الحياة»: الجزائر و«بوليساريو» يمنعان إحصاء اللاجئين في مخيمات تيندوف ii
http://alhayat.com/Details/472155.

انظروا ايضا Court of Justice of the EU, C-104/16 P, 21.12.2016, Council v. Front Polisario. iii

http://www.wsrw.org/a243x3695.

iv https://www.stortinget.no/no/Saker-og-publikasjoner/Sporsmal/Skriftlige-sporsmal-og-svar/Skriftlig-sporsmal/?
Qid=25729

وزارة المالية النرويجية، 06.06.2005، استثناء شركة من صندوق البترول الحكومي، iv
https://www.regjeringen.no/no/aktuelt/company_excluded_from_the_government/id256359 v.

وزير خارجية السويد، 18.09.2007. انظروا ايضا vi http://www.wsrw.org/a127x587

WSRW.org، 09.05.2008 ، الحزب الليبرالي يدعو الى الاستثمار الأخلاقي في مجال صيد الاسماك، vii http://www.wsrw.org/a128x715

من اطفال مخيمات اللاجئين سنويا، ولكنها تحتضن مقرات لشركات تلحق ضررا شديدا بالصحراويين بسبب ضغطها على الحكومة الاسبانية بصدد اتفاقية صيد الاسماك.

على كل الحكومات أو المجتمعات الاهلية التي تعنى بالعمل على احترام القانون الدولي أن تأخذ بعين الاعتبار الأمر التالي: حث الشركات من حولها على الابتعاد. توضيح الحدود الجغرافية في الاتفاقات التجارية. اصدار تعليمات للمؤسسات المالية ووكالات ائتمانات التصدير بألا تمول نشاطات في الاقليم——أو الشركات العاملة هناك. ادفعوا صناديق التقاعد العامة نحو الابتعاد عن الشركات الدولية التي تشارك في النهب. اوقفوا التعاون مع الشركات التي تتجاهل حقوق الانسان الاساسية والقانون الدولي في الصحراء الغربية. وليكن ذلك علنا. فمن شأن هذه الجهود أن تسهل التغطية الاخبارية والضغوط من طرف المجتمع المدني بشكل كبير.

تشكل محاربة الشركات الاجنبية التي تعمل على تقويض جهود الامم المتحدة على انهاء استعمار الصحراء الغربية فرصة ذهبية وفريدة بالنسبة للقضية الصحراوية. وإذا ما استغل الصحراويون وغيرهم هذه الفرصة، فسوف يؤدي ذلك إلى زيادة الوعي الاعلامي وسيجلب معه اسقاطات سياسية بعيدة المدى. كما وسيؤدي ذلك إلى ايقاف المساعي المغربية لحشد التأييد للموقف المغربي، كما وسيقدم دعما يحتاجه الصحراويون لإبراز حقهم المشروع في تقرير المصير.

وفي الحقيقة، ليست الجهود الرامية إلى جعل الشركات والحكومات تتوقف عن دعم الاحتلال المغربي عن طريق النهب صعبة بشكل خاص، فالحجج التي تدعم العزوف عن التجارة وشراء موارد الصحراء الغربية المحتلة مقنعة تماما. فالأمر لا يتطلب إلا استراتيجية دفاعية مدروسة وهادفة.

الحلقة الأضعف

يتظاهر الصحراويون والناشطون أمام السفارات المغربية منذ اربعة عقود. هل ينفع ذلك؟ هل يؤدي ذلك إلى كتابة مقال في وسائل الاعلام العالمية؟ هل يصغي المغرب عندما يصرخ الصحراويون؟ ربما. إلا أنه من المؤكد أن الشركات الغربية تصغي جيدا إلى الاحتجاجات ضدها. ففي العادة تسعى الشركات إلى حماية صورتها. وعندما تتكثف الاحتجاجات بشكل كبير، فحتى الشركات الأكثر لا-اخلاقية في الصحراء الغربية لا تجد أمامها خيارا سوى التخلي عن نشاطاتها القذرة.

وفي العادة، يعطي النشطاء الصحراويون أولوية لمسائل مثل انتهاكات حقوق الانسان مقارنة بمسألة الموارد الطبيعية. مما لا شك فيه أن حملات الدفاع عن حقوق الانسان ذات أهمية بالغة. ولكن، اذا ما كان الهدف هو الحصول على الاهتمام والتعبئة السياسية والنتائج السياسية، فمن الواضح أن تأثير استهداف المصالح التجارية المغربية في الصحراء الغربية أكبر من حيث الزخم السياسي والآراء القانونية والبروز. تشكل الموارد الطبيعية الأداة التي يجب أن يستخدمها الصحراويون لجعل العالم الخارجي يرى الانتهاكات الخطيرة لحقوق الانسان والنضال المشروع. يشكل شركاء التجارة المغربية الاجانب الحلقة الاضعف من الاحتلال المغربي اللاشرعي.

إن حكومات النرويج وهولندا، والدانمرك (جزئيا) هي الحكومات الوحيدة في العالم اليوم التي تحث الشركات الخاضعة لها على الابتعاد عن الصحراء الغربية. كانت هذه الدول الثلاث تمتلك صناعات كبيرة في مجالات صيد الاسماك والنفط والشحن أو الطاقة المتجددة في الصحراء الغربية. إن لمواقف الحكومات تأثير مباشر على خروج الشركات من الصحراء الغربية. لماذا لا تتبع حكومات اخرى هذا النهج ازاء الشركات؟ فحتى الحكومات التي تقف في طليعة الدول التي تدعم الشعب الصحراوي——أي تلك التي تعترف بجمهورية الصحراء الغربية كدولة——لا تتبع مثل هذه السياسة اليوم.

تعتبر نيجيريا وغانا وانغولا من بين أكبر خمس دول في العالم التي تستورد من المغرب السردين المعلب الذي يتم صيده في الصحراء الغربية. يشتري حلفاء مهمون للشعب الصحراوي وحكومته في امريكا اللاتينية الاسماك من الصحراء الغربية المحتلة. وتعتبر الشركات السويدية أهم الشركات التي تشحن النفط إلى الصحراء الغربية، وهناك شركة فنلندية تبني البنية التحتية هناك. ويشارك عدد من المدن الصغيرة في اسبانيا بنشاط في دعم الصحراويين، وهي تستقبل سنويا وضمن برامج تضامنية، المئات

يمكن لذلك أن يحدث في أي مكان في العالم بأسره. لقد أدت مسألة مشاركة الشركات المحلية في عملية النهب الكبيرة والآخذة بالاتساع للموارد الطبيعية في الصحراء الغربية خلال السنوات القليلة الماضية إلى إصدار الالاف المقالات في وسائل الاعلام الغربية. حتى أن الموضوع يتلقى تغطية تلفزيونية منتظمة في عديد من الدول، حتى في أوقات الذروة. فالموضوع لا يعتبر ذي صلة فحسب، بل أنه يحظى بتغطية الصحفيين الاخرين في غرفة الاخبار من الذين لا يختصون بالشؤون الخارجية: فالجانب الاقتصادي للصحراء الغربية قد يحصل على تغطية مماثلة من الصحفيين في القسم الاقتصادي أو قسم السياسة الداخلية. وبعبارة اخرى، تزيد بذلك احتمالية الحصول على اهتمام وسائل الاعلام.

وربما كان نصف مجموع المقالات الاخبارية الاسكندنافية خلال السنوات الاخيرة عن الصحراء الغربية يصدر عن القسم الاقتصادي للصحف وليس عن قسم الشؤون الخارجية. وكانت معالجة أغلب البرامج التلفزيونية حول النزاع في قنوات الاعلام في دول أوروبا الشمالية خلال العقد الماضي ينتهج وجهة النظر الاقتصادية. كما أن التقارير الاخبارية التي تتناول عمليات نهب الموارد الطبيعية في الصحراء الغربية عادة ما تنتهج نفس التوجه. وتكون بداية الكشف أو انتقاد صفقة تجارية: قيام شركة محلية بالمشاركة في اعمال قذرة في بلد محتل. ومن ثم، يفصّل الصحافي حيثيات الاحتلال المغربي في عام 1975، ويشرح سبب الخطأ الكامن في مثل هذه الصفقة التجارية. وفي النهاية يشرح حالة حقوق الانسان او الوضع في مخيمات اللاجئين: هذه هي الهيكلية المتبعة دائما. يشكل الرابط التجاري الجانب ذي الصلة بالنسبة للصحفيين——ويشكّل بالتالي أهمية الأمر بالنسبة للقراء: أي السياسيين ومنظمات المجتمع المدني على حد السواء.

يرتبط اهتمام وسائل الاعلام بالضغط السياسي ارتباطا وثيقا. فما كان لحملات مناهضة الفصل العنصري في ثمانينات القرن الماضي لتتمكن من الحصول على حركة احتجاج دولية متواصلة بدون حركة التجارة الوطيدة بين جنوب افريقيا والدول الغربية. فمن خلال العلاقات التجارية القذرة مع جنوب افريقيا أصبحت انتهاكات حقوق الانسان في دولة الفصل العنصري فجأة ذات صلة محلية بالنسبة للصحفيين في جميع انحاء العالم الغربي. وبكلمات أخرى: أصبحت نفس العلاقات التجارية التي سمحت لنظام الفصل العنصري بالبقاء في السلطة السبيل الذي أدى إلى سقوطه.

ومن المؤكد أن تُخصص مساحة صغيرة للقضايا التي لا تعتبر "ساخنة" في نطاق الصفحات القليلة المخصصة للشؤون الدولية. وفي الواقع، يمكن تصنيف معظم الصراعات في العالم كصراعات "منسية" من قبل وسائل الاعلام--فيما يحصل عدد ضئيل منها على بعض الاهتمام.

بل قلما ما يتم التطرق إلى حقوق الانسان في وسائل الاعلام الدولية. وبوجه عام، هناك عدد قليل من الصحفيين في العالم الذين يكتبون حول حقوق الانسان. أما إذا ما حصل انتهاك لحقوق الانسان في جوار الصحافي أو القارئ فسيحقق ذلك معيار الاهمية. وفي بعض الاحيان، قد نجد صحفيا متعاطفا معني شخصيا بالكتابة عن الصحراء الغربية، إلا أن معيار الصلة فيمكن أن يكون ضعيفا لا يسمح للصحفي بإقناع المحرر بالأسباب التي تجعل القصة جديرة بالكتابة.

تخيل أنك صحفي مختص بالشؤون الدولية في دولة اوروبية. وأمامك ثلاث ساعات لكتابة مقال للصحيفة يوم غد. لماذا يجب ان تكتب عن الصحراء الغربية؟ فجمهور قرّائك لم يسمع عن الاحتلال إلا بالكاد. فهو على مسافة سنوات ضوئية منه. لم يمت أحد اليوم. وهناك العشرات من الصراعات في العالم التي عايشت احداث اسوا من ذلك بكثير من حيث الوحشية والخسائر المباشرة. إذا، من الأسهل عليك كتابة مقال عن انتهاكات خطيرة لحقوق الانسان في سوريا او جمهورية الكونغو الديمقراطية.

فللأسف، لا يمكن اعتبار مظاهرة للعاطلين عن العمل في بوجدور، أو تقارير توثق التعذيب في زنزانات السجن في العيون، مثيرة في الواقع الاعلامي اليوم. ويثبت ذلك التغطية الاعلامية المنخفضة للانتهاكات الجسيمة والمنتظمة في الصحراء الغربية. والمظاهرات لأجل حقوق الانسان والتعذيب يحصلان يوميا في العالم. فما الذي يجعل الصحراء الغربية أهم من أحداث مماثلة في مكان آخر؟ هنا يأتي أو يكمن دور الموارد. ففي حالة تورط شركة محلية في جوار أحد الصحفيين في نهب غير اخلاقي لبلد أجنبي، فستستحق بذلك مباشرة القاعدة الأساسية للصحافة: الصلة. فهنا يعرف القراء الشركة، والتي قد تكون شركة كبيرة أو شركة سلسلة سوبر ماركت كبيرة ومعروفة. وقد تقع في نفس الشارع الذي يقع فيه مقر الصحيفة نفسها. وبالتأكيد سيقدر القراء إعلامهم فيما إذا كانت هذه الشركة متورطة في اعمال تجارية قذرة في الخارج.

يعني التوجه للأعمال القذرة، بالإضافة إلى توسع الصناعات على اراضي الصحراء الغربية، توفر امكانية حصول معاناة الشعب الصحراوي على الاهتمام المحلي الذي تستحقه. ومن ناحية جوهرية،

تشكل "بشكل خاص، انتهاكا خطيرا للمعايير الاخلاقية الاساسية لأنها تعزز مطالبة المغرب بالسيادة وتسهم بذلك في تقويض عملية السلام التي ترعاها الامم المتحدة".[v]

أما في السويد، وردا على سؤال مماثل بشأن ملكية شركة سويدية تتخصص في الصناعة النفطية في الاقليم، فقد صرح وزير الخارجية انه "عندما يتعلق الامر بفهم القانون الدولي، فإن موقف الحكومة السويدية بصدد هذه المسألة واضح. فالمنطقة التي نسميها اليوم الصحراء الغربية، والتي كانت سابقا مستعمرة اسبانية، يحتلها المغرب. [...] لا يمتلك المغرب حق استغلال الموارد الطبيعية في الصحراء الغربية لصالحه".[vi]

أما الحزب الماوري النيوزيلندي فقد صرح تلقائيا لدى شيوع خبر أن شركة نيوزيلندية تمتلك جزء من أنشطة الصيد البحري في الدخلة: "اننا ندعم حق الشعب الصحراوي في تقرير مصيره في الصحراء الغربية، كما ونؤيد نداءات الامم المتحدة التي تطالب بإنهاء الاحتلال المغربي".[vii] لقد كانت تلك هي المرة الاولى التي يقوم فيها حزب نيوزيلندي بإطلاق تصريح بمثل هذه القوة.

وقد يكون الأهم من هذا كله هو تزايد المعرفة والنقاش حول الصحراء الغربية في المؤسسات الاوروبية التي يرجع معظمها الى المناقشات التي أعقبت صفقات الاتحاد الأوروبي القذرة في الاقليم.

وفي جميع الحالات المماثلة، فمن الواضح أن قضية الموارد الطبيعية تثير الجدل حول القانون الدولي: لا يمتلك المغرب حقا قانونيا مشروعا في الصحراء الغربية. وإذا ما تم تجاهل النقاش، فسيكسب المغرب، أو سيعتقد أنه يكسب، نقاطا في الشرعية السياسية. وبمجرد فتح النقاش، يحظى الجانب الصحراوي بالدعم. فقضية الموارد الطبيعية عبارة عن منجم الذهب لكلا الطرفين، الصحراوي والمغربي، إذ يسعى كل طرف إلى زيادة الدعم لموقفه.

أما الطريقة الثانية التي يصبح فيها النهب فرصة ذهبية للصحراويين فتعود إلى جذبه إلى وسائل الاعلام والرأي العام الدولي الواسع. فهو كنز بالنسبة لوسائل الاعلام. يثير نهب الموارد الطبيعية الاهتمام خلافا لمعظم الجوانب الاخرى للصراع. من النادر أن يثير كفاح سلمي وشرعي للتحرر أو مفاوضات سلام ترعاها الأمم المتحدة أو حتى انتهاكات حقوق الانسان أي اهتمام في أي مكان في العالم. أما الصفقات القذرة التي قد تقوم بها شركة في الجوار فتفعل ذلك.

فالقاعدة الذهبية في الصحافة والتي يدرسها كل طالب في مجال الصحافة هي أن المنتوج الصحفي يجب أن يحمل جانبا ذي صلة. إذ تشكل الشؤون الدولية جزءا صغيرا جدا من صحيفة متوسطة،

إذ أن تناول السياسيين والحكومات والامم المتحدة لحالة حقوق الانسان في الصحراء الغربية اليوم لا يأتي بالذكر على سياق الاحتلال الغير الشرعي بتاتا. وعلاوة على ذلك، عادة ما يتم طرح قضية حقوق الانسان من خلال نهج "غير متوازن": فعلى الرغم أنه من الواضح أن واحدا من الأطراف يتحمل مسؤولية التسبب في النزاع وانتهاك حقوق الانسان أكثر من الطرف الآخر، يتلقى الطرفان توصيات تبدو متوازنة لتحسين الوضع. وفي الواقع، فإنه على الرغم من تردي حالة حقوق الانسان في الصحراء الغربية التي تسببها سلطات الاحتلال المغربي، يواظب حلفاء المغرب الدوليون على امتداح المغرب على جهوده المزعومة لتحسين الوضع. وما المشكلة في ذلك؟ المشكلة هي أن المغرب بصفته سلطة الاحتلال اللاشرعية ليس الطرف المطالب بضمان حقوق الانسان لشعب الصحراء الغربية، والذي تنتهك حقوقه من خلال حرمانه من حق التحرر من الاحتلال. من جهة أخرى، لا يمكن تحليل مسألة الموارد الطبيعية للصحراء الغربية خارج إطار الوضع القانوني للإقليم. فهي مرتبطة بجوهر القضية مباشرة: ففي المقام الاول، لا يمتلك المغرب الاسس الشرعية للمطالبة بالسيادة الاقليمية على الصحراء الغربية.

وعلى هذا النحو، حصلت خلال السنوات الاخيرة تطورات ايجابية واضحة في موقف الدول والاحزاب السياسية وذلك كنتيجة مباشرة للنقاش حول نهب الصحراء الغربية.

والدول الاسكندنافية هي أبرز هذه الدول. فحتى عام 2002، كانت سياسة الحكومة النرويجية بشأن مسألة الصحراء الغربية تشابه إلى حد بعيد سياسة أية دولة أخرى في العالم. صرحت الحكومة النرويجية انها تدعم حق شعب الصحراء الغربية في تقرير المصير، إلا أن سياستها لم تتطور عن هذا الحد. لم تعط الحكومة الصحراء أولوية فائقة.

وتبين ابتداء من عام 2002 أن شركة نرويجية قد كانت تشارك في دراسات المسح الاولية للتنقيب عن النفط التي كان المغرب يقوم بها في الصحراء الغربية. ومنذ ذلك الوقت، التزمت النرويج سياسيا وأخلاقيا بمسألة الصحراء الغربية. ووقف سؤال واحد من وراء التطورات في السياسة النرويجية تجاه قضية الصحراء الغربية. "ما هو رأي وزير الخارجية في عمل شركة نرويجية لتسهيل استخراج الموارد الطبيعية أمام شركات النفط في أراضي [الصحراء الغربية] المحتلة؟". [iv] وخلال السنوات التالية، تعززت السياسة التي يتبعها النرويج في كل مرة يتم فيها اكتشاف علاقة تجارية مع النرويج. وبلغ الأمر ذروته في عام 2005. وصرح وزير المالية النرويجي أن أنشطة شركة النفط الامريكية في الصحراء الغربية

فطنت الحكومة المغربية إلى الكيفية التي يمكن لإدارة الموارد الطبيعية في الصحراء الغربية أن تتحول شيئا فشيئا إلى وسيلة لتوفير إشارة إلى تقديم الدعم السياسي لموقفها.

وقد لا تتفق حكومات اخرى مع طلب وزير الاعلام بشأن الإدراج التلقائي للصحراء الغربية في الاتفاقيات مع الحكومة المغربية. وفي نهاية الأمر، لا تعترف أية دولة في العالم بمطالبة المغرب بالإقليم. لقد أقرت محكمة العدل التابعة للاتحاد الاوروبي عام 2016 أن المغرب والصحراء الغربية منطقتان "منفصلتان ومستقلتان ومتميزتان"، وأن الاتفاقات التجارية مع المغرب لا تشمل الصحراء الغربية.[iii] إلا أن الرباط تعتبر الفشل في التعبير عن الاستثناء الصريح للصحراء الغربية من الاتفاقيات مع الحكومة المغربية دعما لمطالبتها بالإقليم.

النعمة

يمكن قلب المعادلة بسهولة. ففي الحقيقة، من الممكن أن تصبح الموارد الطبيعية في الصحراء الغربية، والتي ينهبها المغرب بطريقة غير مشروعة، منجم ذهب بالنسبة لنضال الشعب الصحراوي. فمن خلال توجيه أصبع الاتهام الى الشركات المتورطة، يستطيع الشعب الصحراوي ان يرفع بشكل كبير الدعم لقضيته ليعطيها الاهتمام الذي تستحقه. فمن الممكن مع القليل من العمل تحويلها الى نعمة. وهناك جانبان لذلك. يتعلق اولهما بإبراز ضعف الموقف القانوني المغربي. تجبر حملة الموارد الطبيعية الدول والاطراف الاخرى على تقييم شرعية مطالبة المغرب المثيرة للجدل في الاقليم. أما الجانب الثاني فليس إلا جذب الانتباه: تؤدي الحملة ضد النهب القذر الى زيادة الاهتمام الدولي والى التركيز على الصراع. سنناقش هذين الجانبين ادناه.

أولا، بركة القانون الدولي. يقف المغرب على رمال متحركة بالنظر إلى القانون الدولي. فلا اساس من الصحة لمطالبة المغرب بالصحراء الغربية———أي بحقوق اقليمية فيها———وهي مرفوضة دوليا. ومن الممكن ابراز مسألة الموارد لإلقاء الضوء على نظرة المغرب الخاطئة إلى الاحتلال.

من المهم الإثناء على العمل الممتاز الذي قام به المجتمع المدني لتسليط الضوء على قضايا حقوق الانسان في الصحراء الغربية على الصعيد الدولي. فمن الممكن الحصول على تصريحات قوية وواضحة ضد التواجد المغربي في الصحراء الغربية من خلال توثيق الانتهاكات التي تقوم بها السلطات المغربية. إلا أنه من النادر أن تؤدي معالجة حالات انتهاك حقوق الانسان الى النقاش او التحليل القانوني لمسألة الادعاءات المغربية اللاشرعية بالسيادة على الصحراء الغربية، مقارنة بمفعول مسألة الموارد الطبيعية.

هكذا عبرت شابة صحراوية عاطلة عن العمل عن أمنيتها بألا يتملك وطنها المزيد من الثروة. والمتحدثة لاجئة، ولدت وترعرعت في مخيمات اللاجئين في الصحراء الجزائرية. عبر والداها الحدود فارين من الصحراء الغربية حين غزت القوات العسكرية المغربية الصحراء الغربية، في الحين الذي كانت لا تزال فيه مستعمرة اسبانية.

وتصور أمنيتها هذه الأثر المؤسف لاستغلال الموارد الطبيعية للصحراء الغربية. فبعد مرور 40 عاما على الاحتلال، يقوم المغرب بالتنقيب عن النفط بمشاركة شركة نفط أميركية. وتعرف اللاجئة جيدا بأنه إذا وجد المغرب مزيدا من الموارد في الصحراء الغربية، فسيقل احتمال تخلي المغرب عن ادعائه بالحق على الصحراء الغربية الذي لا أساس له من الصحة.

وفي نفس الـوقت نفسه، يعبّر أبناء جلدتها من الرازحين تحت الاحتلال عـن محنتهـم. كمـا ويدرك النشطاء البارزون أن الثروة تباع فيما لا ينالون هم شيئا سوى الضرب على ايدي الشرطة المغربية. لذلك من الطبيعي أن الشعب الصحراوي ينظر إلى الموارد الطبيعية للصحراء الغربية كمشكلة. فغالبا ما يشار الى موارد الصحراء الغربية كلعنة تقف عقبة أمام تحقيق حقوقهم. وهم محقون بشكل ما. لقد حصل المغرب خلال السنوات الماضية على حوالي 200 مليون دولار سنويا مقابل تصدير المعـادن وحـدها. وبالإضافة الى ذلك، يستفيد المغرب بشكل كبير مـن اصـدار تراخيـص الصيد للحكومات وللشركات الاجنبية، التي يشكل الاتحاد الاوروبي أحد أعمدتها. وإلى جانب التنقيب عـن النفط، يقوم المغرب ايضا بتطوير برامج بنى تحتية متجددة كبيرة في الصحراء الغربية، وهي برامج تتحكم بها الشركة التي يمتلكها العاهل المغربي.

ومن خلال جذب الشركات الاجنبية إلى الصحراء الغربية المحتلة، يوفر المغرب تمويلا جزئيا لتواجده العسكـري المكلـف، ويحـرز نقاطـا سياسيـة، ويرفع بشكل غير قانوني مـن أعـداد المستوطنين المغاربة المـدنيين. تطيل هـذه العمليـات مـن امـد معاناة العاطلين عن العمل والمنفيين. فلو لم يحتل المغرب الاقليم ولم يسمح بتدفق المستوطنين، لكان هناك الكثير من فرص العمل.

وصرح وزير الاعلام المغربي ذات مرة: "تشكل الاتفاقيات التي لا تستثني "الصحراء المغربية" تأكيدا على أن الصحراء مغربية".[ii] وهكـذا يلخـص الـوزير بكياسـة الشـرك الظـاهر للعين الـذي تقـع فيـه الحكومات والشركات لدى توقيعها على اتفاقيات مع المغرب. المغرب عبارة عن سلطة محتلة. لقد

تحويـل النقمـة إلـى نعمة[i]

نهب المـوارد الطبيعيـة للصحـراء الغربيـة وفـرص القضيـة الصحراوية

"نأمـل ألا يعـثروا علـى النفـط لأن ذلك سيجعل الأمور أسوأ".

الموارد الطبيعية في الصحراء الغربية. يعالج هاجن أهمية استغلال الموارد في الاراضي المحتلة بمجملها، وكيف كشفت المفوضية الاوروبية عن دوافعها الحقيقية، السياسية، القائمة من وراء نهب الصحراء الغربية. يستعرض هذا الكتاب منشأ اتفاق الشراكة في ميدان الصيد البحري التي وجدها لمحكمة العدل التابعة للاتحاد الأوروبي في العام 2018 غير قانونية.

ويشرح سميث كيف أدى الحكم الذي أصدرته محكمة العدل التابعة للاتحاد الاوروبي عام 2016، إلى الاحتجاز الاستثنائي الذي قامت به السلطات الجنوب افريقية لسفينة تمتلكها شركة المانية، وهو الأمر الذي بادرت إليها الحكومة الصحراوية في جنوب افريقيا. إن مسألة المحاكم الوطنية المحلية لحاسمة. فبشكل متزايد، تجد الشركات التي تعمل في الاقليم من خلال عقود مغربية غير نافذة قانونيا، نفسها تقف على أسس قانونية ضعيفة، سواء في المحاكم الدولية أو في المحاكم المحلية الوطنية.

كما ويهدف هذا الاصدار الى القاء الضوء على اهم اللاعبين الأوروبيين الذي يعمل اليوم في الصحراء الغربية من خلال عقد مغربي: شركة سيمنس. تعجّل هذه الشركة الالمانية متعددة الجنسيات في ربط الاراضي المحتلة بالاقتصاد المغربي من خلال بناء طواحين الهواء. تدّعي الشركة أنها تعمل في إطار القانوني، إلا أنها لم تحصل على موافقة ممثلي الاقليم، وهو الأمر الذي يشترطه كل من قوانين الاتحاد الاوروبي والقانون الدولي. ونحن نرحب بكم لدراسة الكيفية التي تقوم سيمنس من خلالها بشرح نشاطاتها في الاراضي المحتلة.

نأمل أن يساعد هذا الاصدار في اظهار الخطورة الملحة للنزاع للعيان. كما ونأمل أن يلاقي هذا الاصدار اهتماما في الدول الناطقة بالعربية، وبما في ذلك مخيمات اللاجئين الصحراويين، ليساعد في توفير معرفة فكرية وخطابية. والأهم من هذا كله، نطمح أيضا أن يشكّل هذا الكتاب اسهاما متواضعا بالنسبة للشعب الصحراوي، ليتمكن من تقرير مصيره بنفسه من خلال التصويت الديموقراطي الحر والبسيط.

المحرران --ماريو بفايفر واريك هاغن، برلين

قضت المحكمة العليا في جنوب أفريقيا بـأن حمولة الفوسفات القيمة ومقدارها 55.000 طن والمتواجدة على متن السفينة التي تم احتجازها في بورت اليزابيث تعود للشعب الصحراوي، لتمنحه بذلك نصرا قانونيا استثنائيا. يرسم هذا الإصدار الطريق نحو هذا النصر التاريخي. ففي عام 2016، أصدرت محكمة العدل التابعة للاتحاد الاوروبي حكما تاريخيا يؤكد على أن اقليم الصحراء الغربية "منفصل ومتميز" عن المغرب، وأن الاتفاقيات التجارية التي يبرمها المغرب لا يمكنها ان تنطبق على الصحراء الغربية الا إذا ما أعرب ممثلو الصحراء الغربية على موافقتهم. وشددت المحكمة على ان المغرب لم يمنح اي تفويض دولي لإدارة الاقليم.

إلا أن الأهم من ذلك، فهو أن محكمة العدل التابعة للاتحاد الاوروبي قد قررت في 27 شباط/فبراير 2018 —والذي يصادف من قبيل المفارقة، العيد الوطني للشعب الصحراوي—أن اتفاق الشراكة في ميدان الصيد البحري بين المغرب والاتحاد الاوروبي غير قابل للتطبيق على الصحراء الغربية. لقد وصل أربعون عاما من السياسة والظلم القذرين إلى خط النهاية. فقد أكد المحامي العام للمحكمة أن الاقليم موجود تحت الاحتلال المغربي، وأن القانون الانساني الدولي ينطبق عليه.

أدت التطورات في المحكمة إلى فوضى عارمة في مؤسسات الاتحاد الاوروبي. ينشغل الاتحاد الاوروبي، تحت الضغط الفرنسي الكبير، بالحفاظ على علاقات جيدة مع المغرب، وبمنحه موافقة مُضمّنة على احتلاله اللاشرعي. وفي الـوقت الـذي يصدر فيـه هـذا الكتـاب، تضطر المحكمةُ الاتحادَ الاوروبي التفاوض من جديد على اتفاقياته التجارية مع الرباط.

لا يخوض هذا الكتاب في تفاصيل هذه التطورات القانونية في الاتحاد الاوروبي. لكنه يعرض إطارها.. الى أي مدى يمكن أن تسمح المفوضية الأوروبية لنفسها بتقويض مبادئ الديمقراطية وقوانين حقوق الانسان من اجل ارضاء جارتها الجنوبية التي تحتل الصحراء الغربية؟ ما هو دور الموارد الطبيعية في هذه اللعبة الدائرة حول الصحراء الغربية؟

هذا الاصدار عبارة عن ثمرة التعاون بين الفنان البصري والمخرج ماريو بفايفر وبين اريك هـاغن، العضو في حملة منظمة المرصد الدولي لمراقبة الثروات في الصحراء الغربية، والذي يهدف إلى جمع تسلسلات زمنية ومقالات ومحادثـات تتناول الجـوانب السياسية والاقتصادية للصراع في الصحراء الغربية. تتناول المقالات التي كتبها اريك هاغن والمحامي الكندي جيفري سميث جوانب مختلفة لمسألة

يحدث كل يوم رغما عن ارادة الصحراويين فيما يتم تجاهل مبادئ القانون الدولي الاساسية بشكل مطلق. لقد وصلت جهود الامم المتحدة لحل النزاع إلى طريق مسدود. وفي عام 1991، اتفق طرفا النزاع، المغرب وحركة التحرر الوطني – جبهة البوليساريو، على إجراء استفتاء حول الاستقلال. ولكن، وبعدما أتمت بعثة الامم المتحدة المختصة بالاستفتاء في الصحراء الغربية قوائم الناخبين، اعترض المغرب على فكرة الاستفتاء. ومنذ عام 2012، امتنع المغرب عن المشاركة في مفاوضات السلام التي ترعاها الامم المتحدة. لكن ما الذي يدفع المغرب للمشاركة في مثل هذه المحادثات؟ فللمغرب حليف قديم يدعمه على جميع الاصعدة: فرنسا. فبحكم كوفما عضو دائم في مجلس الامن الدولي، أعاقت فرنسا فعليا عملية الاستفتاء ومنعت نشاط الامم المتحدة في الاقليم الهادف إلى رصد انتهاكات حقوق الانسان. كما وتضغط فرنسا على الدول الاخرى الاعضاء في الاتحاد الأوروبي وعلى المفوضية الاوروبية لاتخاذ مواقف مؤيدة للمغرب.

أما بالنسبة للإدارة الاميركية الحالية، فلا يمكننا أن نتوقع إلا القليل من الضغط من طرف واشنطن. ولكن المشكلة ليست بالولايات المتحدة، بل بباريس.

منذ نهاية عام 2017، تم تعيين الرئيس الالماني السابق كولر كمبعوث الامم المتحدة الخاص للصحراء الغربية، حيث كلفه مجلس الامن بإعادة "الأطراف" إلى طاولة المفاوضات. لقد حاول ذلك عدة مبعوثين خاصين من قبله، إلا أنهم لم يحصلوا على الدعم اللازم من مجلس الأمن. هل سيتمكن الرئيس الالماني السابق من خلق زخم جديد فينهي الايقاف الفرنسي–مغربي للعملية؟

يتحدّر كولر من دولة تفتقر إلى معرفة معمقة بالصراع. فأخبار الاحتلال لا تحوز على اهتمام وسائط الاعلام الالمانية الرسمية إلا فيما ندر. تشارك المانيا في بعثة الامم المتحدة، وقد احتد النقاش حول اللاجئين في البرلمان الألماني في مناسبات عديدة، وذلك فيما يخص مسألة إمكانية اعتبار المغرب بلدا آمنا يمكن للاجئين العودة اليه. بيد ان لدى المانيا حساسية فيما يخص حكم القانون. هل ستكون الحكومة معنية بالوقوف في وجه التعطيل الفرنسي لحقوق الانسان ولحق الصحراويين بتقرير المصير؟ يصدر هذا الكتاب في توقيت مميز من تاريخ الصحراء الغربية. فمنذ عام 2012، رفعت جبهة البوليساريو ومنظمة غير حكومية في بريطانيا قضايا في المحاكم المحلية وفي محكمة العدل الاوروبية (CJEU). ولهذه الإجراءات القضائية اسقاطات بعيدة المدى. في 23 شباط / فبراير 2018،

إذا ما وقفت في يوم صافٍ على أعلى قمم جزر الكناري، فيمكنك رؤية اقليم الصحراء الغربية في الأفق. على الرغم من أن أفريقيا قريبة من اوروبا، لم يسمع الكثير من السياح الذين يزورون جزر الكناري والبالغ عددهم 13 مليون سائح سنويا، بانتهاك حقوق الانسان والظلم الفادح في الاقليم الذي يسمّى الصحراء الغربية.

تعتبر الصحراء الغربية آخر المستعمرات الاوروبية في افريقيا. ويكفل دافعو الضرائب في الاتحاد الاوروبي استمرار الظلم في الاقليم. يعنى هذا الكتاب بالتورط الأوروبي والكيفية التي تدعم بها الشركات الاحتلال المنسي.

تتعامل الأمم المتحدة مع الاقليم، الذي تفوق مساحته مساحة المملكة المتحدة، كقضية إنهاء الاستعمار.

كان الإقليم جزءا من اسبانيا، لكن الحكومة الاسبانية لم تعن بإنهاء استعماره بالشكل الصحيح. فبدلا عن ذلك، دفع نظام فرانكو المنهار به إلى أيدي المغرب في منتصف سبعينات القرن الماضي.

لقد طالب حتى اليوم ما يربو على مائة قرار من قرارات الامم المتحدة باحترام حقهم في تقرير المصير. يريد الشعب الصحراوي إدارة ثروته السمكية واختيار نشيده الوطني بنفسه وبناء مساكنه فوق أرضه.

إلا أن الصحراويين محرومون من التمتع بهذا الحق. لقد فرّ نصف الشعب، الذي لا يزال يعيش منذ أربعة عقود في الخيام وفي المنازل الطينية ويعتمد على المعونات الانسانية. تقع مساكن اللاجئين المؤقتة إلى زمن لا نهاية له في المنطقة الصحراوية المنبسطة قرب مدينة تندوف الجزائرية والتي تحكمها ظروف مناخية قاسية لا يمكن تخيلها. تتجاوز درجة الحرارة في الصيف 50 درجة مئوية. المياه شحيحة هناك، ومعظم الشباب فيها من العاطلين عن العمل. يعيش في هذه المخيمات أكثر من مئة ألف شخص ينتظرون عودتهم. وتجدهم يتابعون من خلال حسابات الفيسبوك أخبار انتهاكات حقوق الانسان المرتكبة بحق أبناء عمومتهم في مدن الصحراء الغربية المحتلة التي فرّ منها آباؤهم ذات مرة.

تنشر قوات الاحتلال المغربية مئات الالاف من الجنود في الصحراء الغربية وتقوم بإدانة النشطاء البارزين بالسجن مدى الحياة. وتقوم الوزارات المغربية بالتوقيع على اتفاقيات تجارية على موارد الاقليم مع الشركات الأوروبية والدولية: بيع الفوسفات الخام أو الزراعة الصناعية الغير قابلة للاستمرار أو انتاج الطاقة المغربية المتزايد. ويمكن رؤية سفن من شبه الجزيرة الايبيرية تعمل قبالة الساحل. وهذا

تمهيد

أريك هاغن عضو في حملة منظمة المرصد الدولي لمراقبة الثروات في الصحراء الغربية ومدير اللجنة النرويجية لدعم الصحراء الغربية. يتابع قضية نهب موارد الصحراء الغربية منذ عام 2002 من خلال عمله في الصحافة التحقيقية وكناشط في المجتمع المدني.

ماريو بفايفر فنان البصري ومخرج يقيم في برلين، ألمانيا. سافر منذ عام 2011 عدة مرات إلى الأراضي التي يحتلها المغرب والأراضي المحررة التي تسيطر عليها جبهة البوليساريو في الصحراء الغربية، وكذلك مخيمات اللاجئين في جنوب الجزائر.

جيفري سميث أستاذ القانون في مدرسة نورمان باترسون للشؤون الدولية، أوتاوا. عمل في السابق مستشارا لدى الأمم المتحدة في تيمور الشرقية أثناء انتقالها من الاحتلال الاستعماري إلى الاستقلال. تعنى بحوثه وكتاباته بالصحراء الغربية في القانون الدولي، وبما في ذلك إقامة الدولة الصحراوية، والقضايا الاقليمية ومسائل حماية البيئة.

الربح أهم من السلام في الصحراء الغربية

كيف تقوّض المصالح التجارية
تقرير المصير في أخر
مستعمرات إفريقيا

أريك هاغن ماريو بفايفر

Sternberg Press *